CONFIDENCE,
OR THE APPEARANCE
OF CONFIDENCE

CONFIDENCE, OR THE APPEARANCE OF CONFIDENCE

THE BEST OF THE BELIEVER MUSIC INTERVIEWS

EDITED BY
Vendela Vida & Ross Simonini

BELIEVER BOOKS
a tiny division of

M^cSWEENEY'S
which is also tiny

BELIEVER BOOKS
a division of
MᶜSWEENEY'S

849 Valencia Street
San Francisco, CA 94110

Cover illustrations by Charles Burns

www.believermag.com

Printed in the United States by Edwards Brothers Malloy

ISBN: 978-1-938073-83-0

TABLE OF CONTENTS

Notes and Apologies:

★ The *Believer* is a monthly arts and culture magazine published by McSweeney's in San Francisco. It includes essays and interviews that are frequently very long and almost always untimely. Three double issues focus on film, music, and art, and come with special, ever-changing bonus items. You can subscribe at *believermag.com* or by calling our offices at (415) 642-5609.

★ The conversations in this collection occurred between 2003 and 2013. They were all conducted on their own terms: one took place over lunch purchased by Pat Benatar, another on the way to *Herbie Fully Loaded*, another over one and a half bottles of wine, and another the day before a scheduled hypnosis. They appear chronologically here, by the date of their appearance in the *Believer*.

★ If you are looking for a *Believer* conversation from 2003 to 2013 that does not appear in this book, please visit the archive on our website: *believermag.com*.

★ The interviewees in this book are musicians, singers, and songwriters. *Believer* interviews with writers of fiction and nonfiction are included in the collections *Writers Talking to Writers* and *Always Apprentices*.

JACK WHITE

[MUSICIAN]

"YOUR FURNITURE'S NOT DEAD."

Materials mentioned:
Metal
Wood
Styrofoam
Silk

Furniture has been comfortable for thousands of years. Among the artisans who carried us out from the Dark Ages, among the blacksmiths, the tailors, and the cobblers, there were the upholsterers. The Believer *sat down with a former practitioner of the trade to learn more. Of particular interest was the upholstery business as it stood in the Midwest in the '80s. Though upholstery as a trade was on the wane, several active practitioners could still be found, driving their multicolored vans around suburban Detroit, connecting deeply with the textures of the time. Jack White's experience with upholstery—from his apprenticeship with Brian Muldoon to his enthusiastic and ultimately abortive entrance into the field as an autonomous player—offers a fascinating and instructive*

glimpse into a young person's simultaneous encounters with the worlds of business, art, and furniture.

—Dave Eggers (May 2003)

THE BELIEVER: The best thing we can do is talk about upholstery.

JACK WHITE: I was an upholsterer. I worked at a bunch of upholstery shops the whole time I was a teenager. I ended up having my own upholstery shop, called "Third Man Upholstery."

BLVR: How did you learn that trade? You apprenticed?

JW: Yeah, I apprenticed for this guy named Brian Muldoon in Detroit for three years or so. Then I went out to the suburbs, and I worked in a big shop called "Beaupre Studios." Then I worked in a couple of other little places, for a few days at a time. I finally got a little studio and opened up my own place. I was working on sculptures, too, in the same space. I wasn't really business-minded, though. I didn't really have a love for money, which kind of hurts the drive to keep working. I would get a check for something and I would just say, "Oh," you know, "Big deal, I'm just going to use this to pay bills or something." I never really loved the money part. I guess it started to hurt my business attitude.

BLVR: What kind of materials did you work with? Metal, wood?

JW: I wanted to work on more mid-century modern things like Noël and Herman Miller furniture when I first started apprenticing, but it's the most difficult upholstery you can do—I wasn't experienced enough to get into that yet. Also, the person I apprenticed for in Detroit had the market locked down and I didn't want to compete with him, so I was mostly doing antique furniture, you know, people's settees and chaise lounges and stuff like that. The clientele is mostly older people who could actually afford it, because it's pretty expensive.

BLVR: It's incredibly expensive, isn't it?

JW: Yeah. I initially thought I could hook up my friends with cool furniture, stuff they got at Salvation Army, but I couldn't afford it.

BLVR: Why is it so expensive?

JW: Say you want to re-upholster a couch. The couch is like twelve yards of fabric, and if you've got cheap fabric for $10 a yard (which would be really cheap), that's $120 already. Then it takes thirty-five to forty hours of work to upholster a couch, so even if you work for $10 an hour, it would end up being like $560 to do a couch, not counting the padding, the cushion, all that stuff. So you couldn't just cut a deal; you can't upholster someone's couch for less than $1000.

BLVR: So the piece has to be worth a lot to begin with.

JW: Yeah, exactly. Someone who bought a couch at Salvation Army for fifty bucks isn't going to spend $1000 to re-upholster it, unless they're rich. Then it's probably OK.

BLVR: Is it an investment? If you have a nice piece, like an actual Herman Miller original or something from that era and you re-upholster it, is it of the same value, or does it go down in value?

JW: No, if you have an original piece and you re-upholster it, it maintains the same value; it's worth more than a reproduction or a reissue of the same chair from nowadays.

It used to be that you got your parents' furniture when you were married or whatever and you had their mattress re-upholstered and it would last for thirty, forty years. You spent a lot of money on it initially, but you never got rid of it. Now, the whole method of how people get furniture is just disposable. You go to Art Van or whatever and buy a $400 couch and throw it out a couple of years later. That whole method just killed the upholstery trade, and it became a rich person's thing.

BLVR: Is it not as much of a trade as it used to be?

JW: It's very much a dying trade. If you're an electrician or a plumber, you can get work on every house on the street. With upholstery, though, especially in Detroit, you have to get all your business from the suburbs. It becomes a specialty thing, because nobody really needs to get it done, like they used to. Back in the day, you needed to get it re-upholstered, but now it's like, "Why would I bother? I'll just buy something real cheap."

BLVR: What do you think about Ikea?

JW: Oh, it's really cool, man. It's bringing more affordable style to people. It's pretty sweet. So many places ignored that for the last forty years or so. Then all of a sudden places like Target started making things. What else can you do when you don't have any money? At least you can get something cool if you don't have that much.

BLVR: Did you have trouble starting the business by yourself?

JW: Not really. I was in this warehouse with a bunch of artists in their studios, and as soon as I started, they were giving me work, and word of mouth spread around. I was never out of work. I started doing lots of different things; I did a piece for a psychiatrist—a psychiatrist's couch with a matching chair.

BLVR: That makes sense, the matching.

JW: Things just sort of springboarded. It's like that old saying: if you're doing something that people want, they'll find you. It's pretty funny that way, because that's exactly how it worked out. I didn't really advertise or anything.

BLVR: Would people truck in their couches to you, or would you have to go out and pick them up?

JW: I would go pick furniture up and take it back to the studio. My whole shop was only three colors: yellow, white, and black. I had this yellow

van, and I dressed in yellow and black when I picked up the furniture, and all my tools were yellow, white, and black. It was pretty cool. I got so much into the cartooniness of the business, almost to the point of it being a joke to the people who would see me, and they wouldn't really trust me to do a good job.

BLVR: They thought you were kidding about the whole thing.

JW: Yeah. I starting trying to make an art form out of giving someone a bill for my services, like writing it with crayon on a piece of paper, or having a yellow piece of paper with black marker saying, "You owe me $300." People would be like, "What the hell is this?" and I'd be like, "I don't know, I just want you to sign this and give it back to me and pay me, and that way I can have it as a… um…" People just didn't dig it. It was two different worlds colliding. When I'd re-upholster furniture I'd take off the old fabric and I started to write poems and things inside the furniture, so if it was ever re-upholstered again one day they'd get little messages from the last person who upholstered it. I thought it'd be cool if we all wrote each other messages.

BLVR: It's like mail art.

JW: The guy who I apprenticed for, Brian Muldoon, was heavy into mail art. He was one of the big guys in the '70s doing that.

BLVR: How old were you when you were working in furniture upholstery?

JW: I started apprenticing when I was fifteen, and I had my own shop when I was twenty-one.

BLVR: It must have really looked strange. Someone so young, and with the three colors…

JW: I think so. My business cards were yellow, black, and white. Each one

had an upholstery tack on it with red paint that looked like blood. My slogan was right below it: "Your Furniture's Not Dead."

BLVR: [*Laughing*] Oh no.

JW: Most people didn't think it was funny. The guy I used to apprentice for, he saw the card and was like, "Do you want *anybody's* business?" [*Laughs*]

BLVR: What was your van like?

JW: I got this yellow Ford van at a used car place that was like $1200 bucks; I had someone loan me the money. That van was the best thing: I already had the yellow and the black hand tools and power tools, so once I had that, I was set. I built a fabric table that I'd seen at an upholstery shop I worked at. It had Styrofoam underneath the cloth of the table and you could pin the fabric down right to the table so you could measure things perfectly. I built one of those with my older brother. It was yellow and black, just huge and really, really nice. I have it in my basement now. When I closed the shop down, all of that stuff ended up in my basement.

BLVR: Do you ever do upholstery now, for fun?

JW: No, it's not fun. [*Laughs*] It's not fun at all. It's hard work. I've talked to a lot of other upholsterers, and it's considered one of the most difficult trades. I was having a lot of trouble, and I would talk to these guys when I went to pick up supplies. I asked how long they thought it would take me before I could whip out a chair really fast and start making better money and not have it be a huge problem every time I got a new piece. They told me it was probably going take me between eight and ten years before I'd be really comfortable. I was like, "Ah, man, I just can't do it."

BLVR: Because each piece of furniture posed a completely different set of problems.

JW: Yeah. I had apprenticed for a few years, but a lot of shops won't teach you how to do stuff because they can't waste time and show you how to sew a cushion or how to tie springs up properly—they just have you doing more menial things to ease you into it. By the time I started my own shop, when I was like, "Fuck it, I'm going to go on my own and try to do this," I was so inexperienced about so many types of problems. Things would come in and I just wouldn't know what to do. I'd take something apart and the springs were just destroyed and I didn't know what kind of springs I should put in there, I just didn't know every single thing. I would have to call Brian Muldoon, and a couple of times he had to come over and bail me out. It was really stressful, especially for being twenty-one, and being by yourself, in this like warehouse building with this couch they want done by next week, and…[laughs] it's really stressful!

BLVR: But it's all about the bluff, right? You have to sort of pretend like you know what you're doing.

JW: Yeah, you've got to pretend. I remember a couple of times when I re-upholstered someone's whole chair and charged them $600 and delivered it, and I sat down when I was finished and said, "Aw, shit, this is the wrong foam in here, it's way too stiff. It's like sitting on wood," and there was nothing I could do, I had to deliver it. I just had to talk my way out of it. This customer was like, "Whoa, this is really hard," and I'm like, "Well yeah, you know, don't worry, the foam is going to break down, you gotta let it settle in." I didn't know what to do. A lot of stuff like that went on.

BLVR: Did you ever get into taxidermy?

JW: Yeah, yeah, definitely. I have a huge taxidermy collection at home.

BLVR: All antique?

JW: A lot of them are. I've got a zebra head, two gazelles, an eland, a kudu, a giant white elk…

BLVR: How about a dik-dik?

JW: What was that? What?

BLVR: Have you got a dik-dik? It's like a small antelope. They have them all over East Africa. Did you ever do any taxidermy yourself?

JW: At one point I thought, Well, while I have my own shop I should really get into every mode of upholstery I can and learn what I can about everything. So I remember calling up a bunch of places that were upholstering coffins, three or four in the Detroit area. I called them all up and they just would not hire me. I was like, "I'm an experienced upholsterer and I've been working in the trade for years," and they were like, "Why do you want to upholster coffins?" They thought I was some sicko or something, but I wanted to learn that part of the trade because there are certain techniques used in tufting and working with silk in coffins that you don't get to do in regular upholstery, but they just wouldn't hire me. They were like, "You know, a lot of this stuff is prefabricated and we just glue it together when it gets here and you don't want to work here."

BLVR: And there's not a whole lot of re-upholstering going on there, either.

JW: [*Laughs riotously*] No, there's not. I didn't think of that. ✷

PAT BENATAR

[MUSICIAN]

"I'M THE OTHER KIND OF ANT. I PUSH THE ROCK UP AND IF I SEE THAT THE ROCK'S NOT GOING I GO, 'FUCK THIS ROCK. OK, I'M FINDING ANOTHER ROCK.'"

The tones of Pat Benatar:
Passionate
Rousing
Theatrical
Sexual
Earnest
Party/Celebratory

id *you know that Pat Benatar got her start in an off-Broadway sci-fi musical composed by Harry Chapin when she was twenty-two? It's true. It was called* The Zinger. *After that, of course, Benatar put out a nonstop procession of Top 40 hits, among them* "Love Is a Battlefield," "Heartbreaker," *and* "We Belong."

The gal with the four-octave voice grew up in Long Island, New York, and started singing in elementary school. At the age of nineteen, she married her high school sweetheart, then several years later divorced him but kept his last name ("Benatar" sounded slightly more rocking than her given name of Andrzejewski). In another fortuitous twist of events, she decided not to attend the Juilliard School of Music, which, she reasoned,

would just delay her career as a rock singer. After some stints in theater, including the aforementioned Zinger, she was discovered by a record agent while singing cabaret at the New York club Catch A Rising Star.

Now Benatar is fifty and is, as you will see, still a Long Island rock chick—tough but good-hearted, very funny, with an impressive command of swear words. As you chat with her, the years fall away and soon you're back in high school, sitting in the cafeteria with the defiant girl who was never afraid of the teachers. At five feet tall, she's slightly built, and when we met she was sporting a fetching sort of homegirl getup: track pants, a large red warmup jacket, a bandanna tied on her head, hoop earrings, and long, wavy hair (which was probably extensions, come to think about it). Our rendezvous took place last August in Minneapolis, a stop on her summer tour, which was a low-key meander of outdoor festivals and casinos. Refreshingly, she insisted on paying for lunch, which never, ever happens.

Benatar will go on the road again this summer in support of a June album called Go! As usual, she will be accompanied by her husband and collaborator, Neil Giraldo, her two daughters, Hana and Haley, a spinning bike, and an on-bus washing machine. Benatar doesn't like using anonymous washing machines ("I can't let anyone touch my laundry") and has been known to throw a load of clothes in as she is being urged onstage.

—Jancee Dunn (May 2003)

THE BELIEVER: Why do you think gay men love you so much?

PAT BENATAR: 'Cause I wear big eyeliner. I don't know. I have no idea.

BLVR: Do they often approach you?

PB: Yes.

BLVR: What do they say to you when they see you?

PB: They say, "I don't just love you, I want to be you." I'm just assuming

it's the eyeliner. I don't know. They're the best, though—we just did Gay Pride in Long Beach and in Tampa. And they're the best audience. They're so enthusiastic. They come dressed up—it's really fun. They're crazy and I love them. They're sweet as can be. Even my macho husband, he has a great time, too. He's so cool, he doesn't care. He loves them.

BLVR: What do you hope to be doing in ten years?

PB: I hope to be on the Hana Highway selling leis and pineapples or something, wearing a muumuu. That's what I'd really want to be doing. I have no idea, because I had no idea I would be doing this. At fifty. I thought I would be done. I thought I'd be finished by now. So I have no idea. I just leave it.

BLVR: And why did you think you would be finished by now?

PB: Because when I started it still wasn't OK to be this age and still make this kind of music. And believe me, I consider our stuff to be much poppier than—we're not on like cutting edge, that kind of thing anymore. And even though we're not doing Britney Spears music or 'N Sync, it's still what I consider to be pop music. So that does give you a little bit more longevity, I guess. But if somebody told me I'd be getting up there and singing "Heartbreaker" at fifty I'd laugh. So I don't know, I have no idea.

I figured I would have my kids and I would be married and—how long could this possibly last, popularity-wise? I don't know what the hell I thought I would be doing but I didn't think it would be this. I'm surprised. I'm very happy. I feel grateful as shit that I still get to do it.

BLVR: And they'll always be glad to see you.

PB: I guess. It's great fun, it is, because they are—the audience is really diverse, I mean—it goes in these cycles, too, which, you know, you just have to relax and not worry about this shit. No, really, you do, because it goes through cycles and not every record needs to be a hit record. It's

not meant to do that, and people's careers go through cycles and if you want to be the last man standing, you have to be fierce and tenacious and you just have to stand there and you have to let it do its thing. If you try to force it, then it won't go in the natural progression that it's supposed to. If you just leave it alone it's really interesting, because I got to tell you, it used to piss me off that people used to say that what we did was manufactured and things like that, because I swear that we always just let it flow. And I always leave it like that. And it really works because this way there's no fabrication. If you try to chase it, if you try to follow trends and anticipate what the next thing is going to be, you will fail. You just have to leave it, you have to go with what it is. You have to be true, you have to be honest. This is the most important thing, this is what I tell Haley. I say, "You know what? Don't even think about, or listen to what's out there. Don't do anything, just figure out what it is that is true to you, what makes you happiest to do and be out there. And if it doesn't work, then you just have to call it a day and go find something else. But don't make it up. Don't go out there and pretend to be something you aren't. They will smell it on you and they will know." And it's wrong, too. It's wrong to do. Because this is about conversation, what we do for a living. I want conversation back and forth. I want the common thread. I want to know—do you feel this the same way as I do? If you don't, tell me what you feel, 'cause I want you to know what I feel, and I want to know what you feel and I want to do it back and forth. And that's why if you're not honest, you can't get the answer. So it makes…

BLVR: …a real dialogue with your audience. Does she recognize that as good advice?

PB: I think so. I mean, I'm her mother, so she always takes everything I say with a grain of salt. A lot of the time, she thinks I'm full of shit.

BLVR: I have to say, talking to you is so much easier than trying to coerce answers out of some of the younger bands that I interview. Younger bands can be really difficult.

PB: Oh yeah. Well, they have to try and be cool.

BLVR: They're scared underneath, I think.

PB: They are scared. We're all scared—are you crazy? You never know what the hell to say. I was talking to my daughter this morning, and I said, "The greatest thing about being almost fifty is that you get to this point in your life and you don't give a shit." It's really great. I said, "You kind of know that when you're young, but you're so freaked out—on the outside you're being so hard-ass and so cool, and on the inside you're going, [*sharp intake of breath*], 'What am I supposed to be doing now? What am I supposed to be saying? What the fuck am I supposed to be doing right now?' That kind of thing. And you get to this part and you don't even give a shit anymore."

BLVR: Freedom!

PB: Yeah, it's really liberating, and you know what? It's really fun. It's unbelievably fun.

BLVR: Do you have to condition your voice in any special way?

PB: No. Because I just sing.

BLVR: What motivates you creatively at this point?

PB: Kind of the same stuff. I still get crazy—this thing that just happened with this little girl in California—I spent most of my adult life as some-one's mother and the rest of my life trying to make sure that children are safe. So this to me is—we wrote *Hell Is for Children* in 1979. I had hoped by this time that it would have no relevance, you know what I'm saying? And I go insane, I just—I can't even tell you—so the same thing that motivated me then motivates me now. I can't stand what people do to each other. I think we're brilliant as a species. I think we are amaz-ing. I think that God is incredible, that He just gave us everything.

Everything in our face. Everything for us to use. And sometimes we're such shitheads. And it makes me crazy.

I read somewhere that we are all more than we know. And I really believe that. Everybody is worth something, and think of all the amazing things that you could be to each other, to people you don't even know, of all the things that you could accomplish. So I get crazy. And that's the same thing that motivated me when I was twenty-six. It doesn't change. It's just that I understand it a little bit better now. That doesn't make me any less hyper about trying to make it better. I have different reasons for the way that I react to things now that I have kids. It's not about me, it's about my children going out into this world that makes me say, "What the hell are you all doing?" You know, that kind of thing. I have to put them out there, and then I have to worry. I try to do the best I can but then I have to worry about some schmuck that she meets and she falls in love with, and did his parents do the best they could do? And what's their story? All that stuff. And—you have kids?

BLVR: No.

PB: Live it up now, OK? Because this is the best—it's like the Peace Corps. You probably don't remember, you're probably too young, but there was a commercial on TV when I was a kid about joining the Peace Corps. It said it was "the hardest job you'll ever love."

BLVR: Oh, sure. I remember that.

PB: This is what parenting is, as far as I'm concerned. This is parenting. That is the friggin' Peace Corps. Because you don't love doing this—this is the thing you love the most in your life, it's the best thing you ever do. And then you want to kill yourself because it's so hard. It's so hard and no matter how old you get and how experienced you get you're always scared you're going to screw it up and you're going to make a mistake. Every day you wake up and it's something else, they find some other way to drive you insane.

BLVR: Has your daughter Haley turned eighteen yet?

PB: Almost. Almost. It's horrible.

BLVR: On your last tour she did a mini-set with the band. How about this time?

PB: No. Uh-uh. She's on hiatus because she has to get in focus. She's going to be a senior this year and the singing thing and all that, that's really nice, but she has a job. Her job is school, OK? She has to figure out what she's going to do and I don't care if she takes a year off next year and travels, tries to figure it out. But we have a job to accomplish here and I want her focused. So they're on hiatus. That's it.

BLVR: Does she want to go to college?

PB: I don't know what she wants to do. She's trying to figure it out. Because she really wants to be a musician. It's really hard for me to stand there and say, you have to go to a four-year school and blah-blah-blah-blah-blah. Because I know that in reality it's not really necessary. But I want her to have a life and I want her to figure it out. So, as her parent, I have to help her figure out where she wants to go and if she wants to take a year off and decide, that's OK with me. I don't care. I think it's ridiculous that kids have to try to decide at eighteen years old what the hell they want to be. I was going to be—first of all, I was getting married, OK, thank you—I was getting married, my husband was going into the army because he got drafted. And then I was going to be a school teacher at this stage. At eighteen. That's what I was going to do. So this has nothing to do with anything I wound up doing. So to me I'm OK with her taking a year and trying to figure it out.

BLVR: Let's talk about your upcoming album, which you've been working on for a while.

PB: It's really hard to make records and concentrate and have a free

mind, because I have this whole other life. If you don't have kids it's a whole other thing. I think you can be fifty and still have a rock and roll lifestyle; you can still perpetuate that. But when you have children [Haley, eighteen, and Hana, seven] your life—this is my job and that's my life. So it's a totally different thing. They're my priority, they have to be, and they always will be. I have to do them first. So this always gets pushed in the back. Neil's working all the time, but he needs me and I can't be there all the time. So it takes a lot longer.

The great thing about taking this much time is that stuff gets to evolve better. There's two schools of thought and sometimes one works really great. There's that one school that you go in and just crash and burn and you get all these really incredible moments that would never occur again, because you're just doing them once and that's it. And then the other is that you take a really long time and you spend a lot of time reworking and then you move on to the next one, which is a pretty interesting thing that we've never done before. And the songs become something else. And I think that they grow more and they become further advanced. Pain in the ass, it takes a really long time. It's not my favorite thing to do.

BLVR: I know it will be your classic sound, but what's the boldest track on the album?

PB: I don't know that I would even say it is the classic sound anymore. People will know it's us, obviously. It's very guitar-driven, this record, as opposed to the last few that have a little more keyboard and stuff in them. But you use so many different ways of doing things now with looping and everything. A lot of the time we don't use real drums, a lot of the stuff is mechanical, so it's different. I don't know that I would say that it sounds "classic." It just sounds like us, but I think it sounds modern. I do. We're trying to do this independently. I really don't want to sign to a label to do this. I want to put this out ourselves. God bless Ani DiFranco is all I got to say. But we did play it for somebody and after one song we played, he said, "Let's try putting it out under another name and see what happens." Because he thought it was so current and modern sounding.

He thought that we could actually just put it out under an assumed name and that we could actually do something with it. I thought that might be interesting. Maybe we will do that with some of this stuff. But I don't know. So that to me is a good indication that it's not too retro-sounding. Everything that we do I pretty much want to be organic, so if that happens, then that's OK with me. But I'm not interested in trying to re-create what once was. That doesn't interest me; it's boring.

BLVR: You're very forward thinking, it seems, Pat.

PB: Yeah. I play ten, twelve weeks out of the year, five times a week, and I really still love to do it. But that's not what I'm interested in doing now. Even though I love it. It's not one of those things like "Oh, I don't want to ever hear that shit again." It's not like that. 'Cause I do love that stuff. I love "Heartbreaker." "Heartbreaker" stands up for me still. It still works to me. The sentiment is still timely and it just works. But I don't want to do that again. I'm not interested in re-creating that. That was great and I'll just leave it there. It's like making *Men in Black 28*. Why bother? You had a great thing. Just leave it.

BLVR: You and your husband Neil first started working together in just a professional capacity, right?

PB: Yes.

BLVR: I was wondering if you remember specifically when sparks started to fly...

PB: The minute he walked in for me. I was just mad. I went crazy. I called up my girlfriend, I was living on, like, Eighty-first Street and First Avenue, in this little apartment. And I was getting divorced and everyone was really happy. Because it was—he was a problem. And they didn't want everything to get screwed up. We could see that it was happening, the record was made and it was going to happen. And I was excited—I had been married since I was nineteen. I was twenty-six, and I had spent all

those years of my life in this marriage that wasn't so great. And I was about to be famous. I was young, I was going to be single, that kind of thing. I was probably going to be rich, I was like, yeah! All my friends, my family, everybody was like, Oh, thank God. She's going to go out and she's just going to have a blast. He walks in to join the band, I called up my girlfriend, I go—[sigh] "I met the father of my children." She slams down the phone, comes over to my apartment, and says, "are you an idiot? What do I have to say? What is wrong with you?" I go, "No, no, no, you don't understand." She goes, "I do understand." She goes—and this is the best—she goes, "It's 1979, you don't have to marry him to sleep with him." But I knew. I was in love with him instantly. I was crazy for him.

BLVR: You once said that you two are very in sync in the studio, and it's when you're talking about what you're going to have for dinner that you squabble.

PB: Actually, the only time we ever fight is about music. We never fight about personal stuff, ever. No, we fight about music. So we get it all out of our system. And we pretty much get along really well, which is a plus. 'Cause we have to spend twenty-four hours a fuckin' day together. But we get along really well on a personal level. And the big issues—this is key, girls, too, one of the things you really need to know—the real secret is, talk this out. Dr. Laura is right. OK? Spend time, talk it out before you get married. And figure it out. Make sure your really big issues you agree on. How you're going to raise your kids. If you're going to have kids. Your religion. All this kind of stuff. What do you think about money? Your morality? All these things. The big shit. Make sure you talk this stuff out, because this is the stuff that counts, not whether or not he picks up his clothes. Does he think he's still going to be a single guy and go out with his friends every Friday night and blah-blah-blah? All those things count. And on those things we're allied. We fight about music because I have opinions, and so does he. And they're very strong.

BLVR: What kind of reaction did you get after you were on *Behind the Music*?

PB: Everyone was really happy because we're the only people who didn't go to rehab. So they were really happy, they were like, "Wow, look, an uplifting version."

BLVR: Apparently, you were ambivalent about the whole thing.

PB: That's what I said to them. They approached us five years in a row. We said, "What are you going to talk about?" I don't have anything. I don't have any of this—I know how these things end up: "…and they lost everything, and the shit hit the fan." I don't have this. What do you want me to tell? I said, "And you can dig too, baby, cause there ain't nothing, you ain't gonna find shit. My life is very boring." So they scrambled to try to find an angle. They used the angle of how difficult it was in the beginning.

BLVR: Have you ever thought of quitting entirely?

PB: Oh yes. Actually, this morning I was thinking that there were two really low points. That was during the making of *Seven the Hard Way*, which is the reason it was called that. The record company was—if you look up *dick* in the dictionary, their faces will be there. They are so sickening. It made my life so difficult. I'd just had a baby, I didn't know what the hell I was doing. This was the worst time of my career, I think, because I was scrambling and trying to do the right thing for everybody. That's when I still cared. But I wanted to do the right thing as a performer. I felt I had a responsibility to do the right thing. And then I wanted to do the right thing by my family and there was no handbook. I mean, Chrissie Hynde had a baby and she wasn't talking.

I'm sure she was struggling the same way. It was like, "What do you want me to fucking tell you? I don't know what the fuck I'm doing either." So no one cared. No one had any sympathy that your life was totally changed. No one looked at you as a human being, no one looked at you as a woman, no one looked at you as a person. And it was just horrendous. They didn't care, it was just like, "OK, great, you had the baby, that's nice, can we just get on with it"—that kind of thing. And they

wanted the record immediately. We had nothing done. I was not in the frame of mind to write songs. I was not in the frame of mind to make a record. It is a huge mistake to force somebody. But we had the contract from hell and a record had to be made every nine months and—

BLVR: Like a baby.

PB: Yeah. Except that a baby's much cooler, trust me. It was a nightmare. That's why we had to go to court. We had to do all this stuff because they just were crucifying us. And we weren't ready and they forced us into it. They had a really nifty little clause, thanks to our legal system, where they could put you on suspension if you didn't comply. And that meant no royalties, no money. So you were virtually unemployed, that kind of thing. And you couldn't go anywhere else to sell records or anything. That's it. They held you like this, unless you made the record. So we made the record and it was a nightmare and it was an awful record and there were probably two songs on there that belonged there and the other ones should either never have gone on there or they should have been left alone to wait to evolve into a better thing than what they were. And you know what? It was the costliest record we ever did and it sold the least. And they got exactly what they deserved: shit. OK? Unfortunately, I did also. So that was a nightmare. And it really hit the fan then and we were at each other's throat. We put out *Wide Awake in Dreamland* and that did semi-OK; I had a better grip by that time. But still, it was the same thing. We were fighting and fighting and fighting. Then the blues record—it was *Gravity's Rainbow* and then the blues record.

Chrysalis was a revolving door. A president stayed maybe two years and then split. And the only person that had been there as long as the company had was me. So you'd get these young princes. Once I had kids, my whole attitude changed. I was like, "You make a spinal cord from scratch and we'll talk." And these young bucks would come in and start telling me, "Oh, you should be doing this and that…" All that kind of stuff. And I would just say, "Well, that's really great, but in two years you'll be gone and I'll still be here." And so it was unpleasant. And then these two new guys came in, and we could smell blood. And I knew that

they didn't have any grip. And I said, "Here's the deal." Neil wanted to make this blues record for years and I was terrified to do it. And he said, "Come on, come on, you can do this." So we went in and we said, "You let us make this record or we quit. That's it." So that was the first time that we were going to quit. And they were like, "No, no, no, no, no"—these are two new guys—they said, "You are the record company." And they're standing there, they just got—it's like buying the store and then you tell them you have no merchandise to sell. So they said OK. 'Cause they had no idea. So this worked in our favor. We did a blues record. And the blues record did exactly what it was meant to do. It wasn't meant to be a commercial record. We knew full well when we started it that it wouldn't be that. It was meant to kind of inspire us again to play. Otherwise I was out. And then we made *Gravity's Rainbow*, and that wasn't an unpleasant experience but it wasn't the same thing. And then we just split. That was it. So we wanted to quit a few times but after *Gravity's Rainbow* we knew that we had to go independent 'cause at my age and after all that time that had passed and all that water under the bridge, there was no way that I was going to stand there and let a twenty-five-year-old tell me what to do. That wasn't going to happen

And they weren't getting it and I didn't want to pretend I was twenty years old. I wanted to go to the natural place that I was supposed to be. I wasn't interested in fabricating things and altering what I did to make hit records. They don't want to hear that.

BLVR: No more big labels from here on in, then?

PB: I'm pretty much through. If I can. If I don't have to do it, I won't do it, 'cause I don't want to do it. I don't even care about that. The unfortunate thing is that sometimes you need their muscle to get things played. And of course, you're not making records in a vacuum. I'm not making them for myself. It would be nice if I could get more people to hear them. But if I have to sell my soul to the devil to do it, I won't. I'll take less of a population. I'll take it. And I'm really a relentless motherfucker. I am. And if you tell me that I can't do it this way, I promise you that I can. And I will.

BLVR: Radio has such a stranglehold on the playlists now with Clear Channel and so forth…

PB: Yeah, but you know what? My whole thought about the world is that the world is divided into two kinds of people. Just pretend that we are ants, there are two kinds of ants. There's an ant who just puts his nose to the ground and says, "I am an ant and I am meant to push up rocks and I'm going to push this rock up, even if I die." I'm the other kind of ant. I push the rock up and if I see that the rock's not going, I go, "Fuck this rock, OK, I'm finding another rock." So that's the reason that I just— that's how I do it. Don't forget, I started like this. They told me I couldn't do this to begin with. They said, "What are you talking about? You don't want to be like Grace Slick, you want to be the band? You want to sing this music, you want to get up there and scream and point your finger and—you want to do this?" So this is how I started. This is the only way I know how to do things. That's it.

Listen, it's the same age-old shit. For some reason, somebody—and I don't know who it is, probably some geek—said that when a female gets to a certain age, all her sexuality goes. She's not a vital person anymore. If you're somebody's mother you're not vital. This is such crap, because you're still a person. You still have all the things that you came into childbearing with and all that kind of stuff. And I'm not saying that there aren't women who do that, and that's fine too, if that's what they want. That's cool. But I'm saying, don't lump everybody together. People still have lives. People still have ideas and thoughts and ambition and things like that. You just have to temper it because you have a really important job to do. My most important inspirational job that I do is raising those kids. That's my job. And that's where my ambition goes. But I have a life. I'm not only their mother. I'm still who I was before, I just don't get to be it all the time. I tell my girls, I say, "You got a long road ahead of you all, but thankfully you have your mother in back of you who's going to counsel you and help you with all the things I have learned," I say, "It's tough out there. Things have really changed, but not everything." I know, I see these things I can't even believe. I already did the gauntlet. You're doing it now. I did the gauntlet, now I'm telling you that it was fucked

up. It was hard, it was—I was a woman who with so much power making this record company $15, $20, $30 million dollars a year. And back then when you sold five million records, this was a lot of shit—this was a lot of records, OK? And I would be at a table with all these men and we'd all be sitting there—educated people. Businessmen. Old guys, not twenty-year-olds, forty-year-olds. I was twenty, they were all older men. I was thinking, OK, they have life experience, they know what they're doing. They'd lean across with that lecherous look and go, "What are you going to wear for the video?" And I would look at them stunned, like, "You've gotta fuckin' be kidding me. I just made you guys like $25 million fuckin' dollars, you ask me what I'm going to wear in the video?" I used to go nuts. I would go nuts. So it was just—it was so disgusting. And I know it's better, I know it's changed, but it's not enough.

BLVR: What do you think about some of the clothes young girls wear now?

PB: Unbelievable. On the Glow tour last year, I said I saw more butt crack than a plumber's convention. On stage the other night, I wore— I have these little rider pants that I wear. I have my pack on and the pack's heavy so it pulls them down. I wear it on the side 'cause otherwise it pulls them down in the back. I'm in really good shape but we don't need to see that. And I'm out there and I'm constantly yanking my pants up. I sat down on the stool because we were doing the acoustic set and I said to the audience, "You know, I wonder how these frigging teenagers are keeping these pants up, because I'm, like, constantly pulling them up." They were hysterical. ✶

QUESTLOVE
[MUSICIAN]

"I ACCEPTED THE ROLE OF CHEWBACCA WITHOUT KNOWING WHO THE HELL CHEWBACCA WAS."

Things that make for good hiphop:
Crack cocaine
Money
Ronald Reagan
al Qaeda

Things that make for bad hiphop:
Bill Clinton
Peace
Chiseled male bodies

If hiphop were like high school (and on too many days it is just like high school), it would be a wild public high school with ice detectors: if you're not wearing any, you can't get in. Like most high schools, the most popular kids would be the toughest kids and the richest kids, the ones who go to class bling-blinging or don't go at all. But every high school has its nerd element; the kids looking to actually learn something; the kids so unashamed to be smart, they sneak into the library on weekends. The Roots are not nerds. Ever since De La Soul Is Dead, hiphop's so-called alternative groups (which means they're not exalting the world and values of the ghetto) have been making it clear that just 'cuz they're smart doesn't mean you can kick their ass. But the Roots have carried on the legacy of De La Soul and A Tribe Called Quest

by making hiphop that's artful, unconcerned with alpha-male machismo, and unafraid to show its intellectual side. They are so important to the overall well-being of hiphop, if they did not exist, we would have to invent them.

The Roots began in 1987, as a quartet called the Square Roots. For three years the art-school students played on street corners in Philadelphia to build their skills. In six years they've released six albums, two of which are classics—their major label debut, Do You Want More?!!!??!, *and their latest,* Phrenology. *Their leader, in front of and behind the camera, has always been Ahmir Thompson, a.k.a. Questlove or Questo, the widely loved, big-Afro'd musical dynamo who owns every episode of* Soul Train *and thousands of videos of the legends of soul in performance (these are the people he calls "the Yodas"). He's worked on some of the greatest albums in modern music, including D'Angelo's landmark* Voodoo *and Erykah Badu's* Mama's Gun.

Our interview took place on a Tuesday, between 11:30 a.m. and 2 p.m., in his room at the Paramount Hotel in Manhattan. He wore a yellow Muhammad Ali T-shirt and a red, black, and green wristband. His tall, thin sister sat nearby. As we spoke, his various phones rang repeatedly: his tour manager asking when he'd be done and ready for the next appointment, the hotel asking what time he'd be checking out. At least four times he told the hotel he'd be down in five minutes, while rolling his eyes, then went on with the interview.

—Touré (August 2003)

IT'S BLASPHEMY TO SAY THIS, BUT CRACK IS RESPONSIBLE FOR HIPHOP

THE BELIEVER: So you have a theory that black people make better music when Republicans are in office. Explain the theory and how it's playing out now, in the midst of this regime—I mean, administration.

QUESTLOVE: My theory is that nine times out of ten, if there's a depression, more a social depression than anything, it brings out the

best art in black people. The best example is, Reagan and Bush gave us the best years of hiphop. I think had Carter and then Mondale won, or if Jesse [Jackson] were president from '84 to '88, hiphop wouldn't have been the same. Hiphop wouldn't have existed. I think you would have more black Tom Waitses. Marsalis would be goin double platinum. There would be more black Joni Mitchells. [*Gets impish grin.*] The Roots would sell ten million.

BLVR: You think that if the Democrats, instead of Reagan and Bush, were running America in the eighties, then hiphop would not have been invented.

QL: Probably, but it would depend on who was replacing them. I don't know if Gary Hart really had a special place in black people's hearts.

BLVR: But hiphop was already being built as early as 1972, and some even say '69.

QL: As a result of Nixon. But you have to understand, it's not just him being there, but what was allowed to go on. I really doubt that if Jesse Jackson had become president in 1984, he would've let the crack epidemic flood in, Niagara Falls–esque, in the ghettos. It's such blasphemy to say this, but crack is responsible for the hiphop movement. It's a direct result. The politically correct way of saying it is that Reagan's neglect of the inner city is responsible for hiphop. Hiphop is created thanks to the conditions that crack set: easy money but a lot of work, the violence involved, the stories it produced—crack helped birth hiphop. Now, I'm part conspiracy theorist, because you can't develop something that dangerous and [have] it not be planned. I don't think crack happened by accident.

BLVR: Don't be p.c. Spit it out. You're saying the government pushed crack on us, those of us in the inner cities in New York, L.A., Detroit, D.C., and so on.

QL: Yes, and as a result created the lifestyle in which the wordsmiths and the turntablists and the great African tradition—created hiphop.

BLVR: But when you say crack is partly responsible for hiphop, what exactly are you talking about? More money in the community in the pockets of young dealers? A higher level of determination in certain people because of the climate on the street? Great stories to tell?

QL: First of all, there's upstart money. Eazy-E wouldn't have developed Ruthless Records if it weren't for the crack game. So Dr. Dre would've just been a Prince clone. One of the greatest works of art, *It Takes a Nation of Millions to Hold Us Back* [by Public Enemy], would've never got made. Half the narratives of hiphop would've been erased, the street cred, the danger, so hiphop would've been more of a jazz thing with virtuoso rhyming, and it could've easily faded away.

BLVR: Crack makes the world of the street that much more tenuous and fast and dangerous and filled with money.

QL: Crack offered a lot of money to the inner-city youth who didn't go to college. Which enabled them to become businessmen. It also turned us into marksmen. It also turned us comatose. Let's not forget that people actually used the shit!

BLVR: But the ones who actually used it, are they really the ones who're impacting hiphop? Isn't it really the dealers and the friends of the dealers?

QL: I know about maybe five people in the entertainment industry who did their peak work as a result of crack usage.

BLVR: Are you serious?

QL: Melle Mel will admit it. Melle Mel made "White Lines" high.

BLVR: He used coke while making the record?

QL: No, no, I'm talking about *crack*.

BLVR: He did crack while doing "White Lines"? Do you mean, during that period in his life, or that night in the studio?

QL: He said, "The most ironic thing about doin' 'White Lines' is, I was doin this anti-drug message, but was snortin the shit as I was doin it. That was the most ironic thing about doin 'White Lines.'" He said he was makin the quintessential antidrug song while drowning in his own shit.

BLVR: Wow.

QL: I've seen two people in my life actually do crack. One was just a passerby on the street in San Francisco. The other was in the studio. Like, it's time for a break. Some of us say, "Oh, I gotta eat." This guy says, "I gotta get my mojo on."

BLVR: Before you do the song, he's beaming up.

QL: He said, quote, "I gotta get my mojo on," and excused himself from the room. I happened to go in the hallway, and it was the foulest stench I ever smelled. I was like, "What the fuck is that smell?" People were like, "Oh, he's smokin' rocks." It's somethin you see on TV, but never in your real life.

BLVR: Was he able to be a productive member of the session after that?

QL: I'll put it this way: His whole career is based on that.

BLVR: Wait. Here's a yes-or-no question. Was it Flavor Flav?

QL: No.

BLVR: Was it ex-Root Malik B.?

QL: No. Wow, I forgot about Malik. Shit, my best song came from crack! ["Water," on *Phrenology*, the new album.] [*He laughs.*] Anyway, the guy was highly productive, and I would dare to say that it still fuels this person to be a creative entity. To this very day.

BLVR: Does black art need social strife in a way that white art does not?

QL: Well, black music is often used as a survival tool. It's not an expression of art for many people. It's not, Yo man, I can sing. It's, I need help, I need to survive, I need to make money; if I can't do this, my life is over. So black art needs extremes. We can't be halfway crooks. The social conditions have to be so drastic that it brings the creativity out of us.

BLVR: So, following your theory, the reason why much of black music got a little stale during the nineties, all obsessed with bling-bling, is because of Clinton.

QL: I mean, the Clinton days were a collective sigh of relief, but what were we celebrating? Remember when Chris Rock said we're celebrating O.J.'s victory, but where's my O.J. prize? What did we win? That's how I feel with Clinton becoming president. We were like, Whew. One of our own finally made it. We really thought he was black. My vision of Clinton is him in Kentucky Fried Chicken, soppin his bread, eatin his greens. I was like, we are finally in the White House.

BLVR: Toni Morrison wrote that he was the first black president. In the *New Yorker*. Toni Morrison.

QL: And we all believed that.

BLVR: I remember talking to politically connected D.C. black folk and them breaking down all the ways you could see he was truly part black. And their biggest piece of evidence was, you never saw his birth father.

The second-biggest piece of evidence was Chelsea's hair. They all said it was too curly for her to be all white.

QL: When Clinton came in, there was a false sense of relief that black people probably hadn't felt since Kennedy. When Kennedy was president, there was some iota of hope. Black people felt, with this guy we have some sort of chance at dignity.

BLVR: At what point in history does the theory begin? Nixon presided over the most incredible soul music of the late sixties and early seventies. Carter led to disco.

QL: Well, I would start back in the Great Depression.

BLVR: That's interesting, because the Depression and the Harlem Renaissance happened around the same time.

QL: No matter how far back in time people wanna go it works. Start with King Oliver or Ma Rainey or Louis Armstrong. The worse the social conditions, the better the black music. I'm not sayin' strictly, a Republican has to be in office. Social depression, financial depression, and an overall hopelessness brings the best of art. Gospel starts in slavery. The blues start around the Depression. Jazz starts in the post-Depression period. At the beginning of the civil rights movement you had doo-wop, rock and roll, and soul. The glue that held that together was a spiritual bond. That's what's missing from today. That's what made hiphop great in the eighties. Now, with Bush in office and the war and al Qaeda and everything goin' on we should be seeing the best music. But…

"ARE WE GONNA HATE THE HOUSE NIGGER BECAUSE HE GETS AIR CONDITIONING? HE'S STILL A SLAVE."

BLVR: How do you feel about hiphop today?

QL: Does it speak volumes that I listen to the White Stripes more than I listen to anything in hiphop? The only album I'm listening to from start to finish right now is *Elephant*. I'm at this Rubicon in my life where I'm trying to figure out, am I rebelling to rebel or am I honestly choosing this? Am I searching for something new or am I dried out with hiphop? I don't know. But I'll listen to anything, and I'll listen to it a lot, whether I like it or not. I have this ritual of buying *Straight Out the Jungle* [the Jungle Brothers' classic debut] a billion times, acting like it's the first time again.

BLVR: What?

QL: I buy records only to lose them, on purpose maybe, in hopes that I'll wake up and go, "Oh, lemme go record shopping again."

BLVR: So you'll have that first-time-getting-it feeling again and again.

QL: There's no classic hiphop record that I've not bought ten times just for that feeling. When I opened up [Public Enemy's] *Apocalypse '91* and I heard "Lost at Birth," the first song, and that siren going off, that was the last great adrenaline moment in my youth. I opened it up and didn't know what to expect. I just put on my headphones—they happened to be on ten—and when that sound came through I was like, oh, shit! One day I walked past Tower and I said, "I know I have the shit at home, the shit's on my iPod, my iPod's at the hotel, but I gotta hear it now."

BLVR: So [*incredulously*] you went into Tower and bought it?

QL: My logic was, to me buyin' a record's like voting for president. I helped you get up one on the SoundScan, so maybe Chuck will get a two million plaque by 2014 when I buy my 500th copy. That's pretty much how I operate.

BLVR: Why do you listen to things you don't like?

QL: I don't believe in good music and bad music anymore. I'm through with that phase of my life. Sometimes I just wanna feel good, so I put on a good record. But mostly I'm more of a businessman than a music fan, so I'm listening to music in terms of, is this effective or not effective? In other words, I can get Ashanti's new album and say, OK this is effective, I see how this is infectious, I see why this works. I mean, are we gonna hate the house nigger because he gets air conditioning? He's still a slave. Yeah, I get mosquito bites, but he didn't ask to come here, either. The thing is, we, the Roots, have mastered the groove element. We've mastered virtuoso lyricism. We've mastered the art element. But we haven't mastered the pop craftsmanship of writing songs. You like Prince because he wrote great songs. And what that leads to is, I walk past a couple. Guy stops in his tracks, girl keeps on walking. Guy looks back. He says, "Questlove?" I turn around. He says, "Ohmigod!" The girl keeps on walking. He's like, "Baby wait! It's Questlove from the Roots." She's like, "Who?"

BLVR: So, you're respected, but you want to be loved instead.

QL: Damn. You really hit it. I was trying to figure out what one sentence could sum up all these feelings, and that's it.

THE FRO

BLVR: So let's talk about your hair. Your hair is iconic, and I have basically the same style, so what's your hair-care regimen?

QL: Really, nothing. It's absolute neglect. I think I stroked this hair maybe ten times when I woke up, washed it, maybe. If something important is coming up, I'll braid it the night before so I can take it out and make it look full. This hair is a result of laziness and not really wantin' to sit in a barber's chair for two hours. It's so not a statement. Now it's a marketing angle. There've been moments when I was ready to get rid of it, but now I'm stuck.

BLVR: I use the Kiehl's leave-in conditioner. I won't leave the house without it. I love that shit so much, I'd do a commercial. I can't believe you don't have some product you rely on.

QL: I don't. I'm supposed to put it in braids every night and then take it out in the morning, but I don't. I've not cut this hair since my prom night, June 2, 1989.

BLVR: You haven't had a haircut in fourteen years? You lie.

QL: 1989 was the last time I had hair of shortish, Malcolm-Jamal Warner proportions.

BLVR: Shouldn't your hair be much longer?

QL: Exactly. If I did what I'm supposed to do—oil it every night, braid it up every night, take it out—it would be the size of a lion. It's actually bigger than this. It does take effort to make it look unkept.

BLVR: Believe me, I know.

QL: What I do is, I spend five seconds in the shower so it can shrink and then just let it go. I'll shape it however I want it to be designed and then go on with my day.

"HAD [D'ANGELO] KNOWN WHAT THE REPERCUSSIONS OF 'UNTITLED' WOULD'VE BEEN, I DON'T THINK HE WOULD'VE DONE IT."

BLVR: So, who are the Yodas?

QL: Back in '97, D'Angelo and I were sorta living through Star Wars episodes. But the thing is, I'm probably the only man alive who has not seen *Star Wars*.

BLVR: Shocking.

QL: I went to see it when I was six, and I fell asleep. When it got re-released in '97 I went again and fell asleep.

BLVR: Do you normally fall asleep in the movies?

QL: Ever since *Rain Man* I've realized that if I sit still for more than two hours, I'll fall asleep. Anyway, I never saw *Star Wars*. So one day D says, [*his voice gets deep and growly, a solid impression of D'Angelo; he pantomimes pulling on an imaginary joint twice, three times*], "Yeah nigga. The way I see it [*pulls on the joint again*] the radio stations and the media is like the Death Star, and I'ma be Luke Skywalker. It was this whole revolution that was going to save music. Q-Tip was gonna be Harrison Ford. Lauryn [Hill] was gonna be Princess Leia. Erykah [Badu] was Queen Amidala. I said, "Who am I gonna be?" D said, "You're gonna be Chewbacca." I said OK. I accepted the role of Chewbacca without knowing who the hell Chewbacca was. But I knew that Yoda was the wise figure. I said, "Who's gonna be Yoda?" He said, "We gotta divide Yoda up into different people and they'll just be collectively known as Yoda." So, it was Jimi [Hendrix], Marvin [Gaye], James Brown, [Bob] Marley, George [Clinton], Stevie [Wonder], Al [Green], Aretha [Franklin], Miles [Davis], and Nina [Simone]. We had a token white entry. Who was it? Oh, Joni [Mitchell]. The youngest one of all the Yodas is Prince. They are the elements that we refer to when we talk about Yoda.

BLVR: Who's out here now who'll be a Yoda for your kids thirty years from now?

QL: D'Angelo. Quiet as it's kept, the reason why I worked on *Voodoo* was because I wanted to be a part of something that could possibly be on that level. [QL played on most of the songs and was musical director for D'Angelo's tour.] One day my kids could say, "Wow, my Dad was a part of that." My involvement was never monetary. I didn't get the rest of my check.

BLVR: Are you still owed money from *Voodoo*?

QL: Stop playing.

BLVR: How much are you owed?

QL: Stop playin! You know I can't go there.

BLVR: Four figures? Five figures?

QL: If creating music were a political party, then we were sort of being socialists. But it should be that way. Here's a funny sidenote. John Mayer is incredibly underrated. Ohmigod. Severely. His whole Abercrombie & Fitch, nice guy, moms love him, that's whatever. He wants to do his Voodoo so bad it hurts. I just finished workin with him and the songs we were doin were John Mayer–esque, but it was the stuff we were doin' in between. I mean, it was like *Voodoo* all over again. We worked on his song for an hour, and then we worked on five other songs that were just crazy awesome. Then my manager calls and says, "How's it going?" I say, "Man I ain't had this much fun since *Voodoo*. Man, we did this one song, and then we created like five other songs." He said, "Whoa, whoa. How many songs you work on?" I'm casually like, "Maybe six." The next day all the jamming stopped. His manager was like, "Do the song you're supposed to do. All this extracurricular jamming you're doing is costing us money." See, the way you're supposed to do business is, if you add a chord or something significant, you might be a songwriter, or if you do whatever you might be a producer. We blurred those lines during *Voodoo*. It was just, let's get it done. We'll deal with the business later.

BLVR: So you're a writer and producer on *Voodoo*, but you were neither paid like that nor credited as a producer.

QL: I was paid for my work on *Voodoo*.

BLVR: You were paid as a worker, a session drummer. Not as a writer and producer.

QL: I wasn't.

BLVR: How much are you owed?

QL: I can't tell you, Touré. But my point was that I saw him as the chosen one...

BLVR: A lot of people thought that.

QL: I still think it. Even though we're not cool, I still think it.

BLVR: Was there a fight?

QL: It's just me becoming a new person, and one of the roles of the old me was my role as enabler. But I can't control my world and then go do maintenance on his world.

BLVR: Making music with D'Angelo is more than going to the studio and jamming?

QL: It's so much more than that. It's a whole lifestyle.

BLVR: Because he's a genius? Because he's troubled?

QL: He's all of that; but more than that, he's amazingly insecure. I mean, everyone's insecure, but he's insecure to the level where I felt as though I had to lose myself and play cheerleader. Some nights on tour he'd look in the mirror and say, "I don't look like the video ['Untitled,' which featured nothing but a chiseled, naked D'Angelo from the waist up]." It was totally in his mind, on some Kate Moss shit. So, he'd say, "Lemme do two hundred more stomach crunches." He'd literally hold the show up for half an hour just to do crunches. We would hold the show for an hour

and a half if he didn't feel mentally prepared or physically prepared. Some shows got canceled because he didn't feel physically prepared, but it was such a delusion.

BLVR: It was the trap women often fall into, thinking they're fat when they're not.

QL: Yes. In the world of karma, it was sweet poetic justice for any woman that's ever been sexually harassed, that's ever had to work twice as hard just to prove she could work like a man. Literally. When we started this *Voodoo* project, we were like, "Man, we're gonna give a gift to the world, and not on a pretentious level. We're gonna create something that's totally our world, and we're gonna bring people to our world and they're gonna love it, and it's gonna be art." But the first night of the *Voodoo* tour the "take-it-off" chants started not ten minutes into the show. This is a three-hour show. And he had mastered all the tricks from the Yodas. The Al Green Yoda tricks of him giving a wink to the drummer, and all the music stops, and Al Green goin' away from the mic and singing to the audience without the microphone. We planned every trick out. But the girls are like, "Take it off! Take it off!" That put too much pressure on him.

BLVR: To be the sex god.

QL: Yep. And by night four he was angry and resentful. He was like, "Is this what you want? Is this what you want?"

BLVR: He was being viewed as a sexual being and not as a genius.

QL: They didn't care about the art, they didn't care for the fact that Jeff Lee Johnson was doing the note-for-note "Crosstown Traffic" solo in—

BLVR: They wanted to see the abs, the bod.

QL: They wanted "Untitled." He hated every moment of that. So… to motivate him past night four became problematic. He'd say, "Well,

[*frustrated*] let's do 'Untitled' earlier." We'd say, "No, you gotta end with 'Untitled.'" Then it became just compromise. How can we stop the bleeding so that we can at least get the show out [of] the way before the "take it off" chants come? But no night was unscathed. Three weeks into it, it became unbearable. Absolutely unbearable. So as a result, the cheerleading starts. If we need him to get out of his disappointment, depression thing, you might have to start at four o'clock in the afternoon like, "What's up, man [*with exaggerated happiness*]! Yo, let's go record shopping!" Like, let's con him into being happy all day! We go record shopping, then it's like, "Let's go to Roscoe's! Oh, that's right, you can't eat, so you go exercise. All right, Mark [*the physical trainer*], you're it." Mark comes, trains him. I come back. "Yo, man! I got this new Prince joint!" We watch Prince. We get amped. Rewind it a couple times. "Alright, you ready? I'ma get dressed, and in fifteen minutes we'll get in the car, go to the venue." Some nights that would work. Other nights he'd just be psychosomatic. Like, "Yo man, I can't do it." I'm like, "What?" He's like, "I can't do it." I'm like, "Just go out there. They love you!" He's like, "They don't love me, man." That's the respect and love thing. He wants the respect. I want the love.

BLVR: Everyone wants what they don't have.

QL: He was like, "They don't understand. They don't get it. They just want me to take off my clothes." So every night for eight months it was how to solve this Rubik's Cube in one minute, before the bomb detonates. Every night. And sometimes I failed.

BLVR: And the show did not go on.

QL: The show didn't go on.

BLVR: How many shows did you cancel?

QL: Maybe three weeks' worth. We threw away at least two weeks of Japan.

BLVR: That's unbelievable. What's going on with him now? Is he retired?

QL: He's recording. I heard he's got, like, four songs done. I know him, he'll stop at song twelve. But what he wants is to get fat. He doesn't want his braider braiding every nook and cranny of his hair. He doesn't wanna have to have ripples in his stomach. He doesn't want the pressure of being "Untitled" the video.

BLVR: So we'll never get that kind of unbridled sexuality from him again.

QL: I don't know.

BLVR: Do you think "Untitled" was a mistake? Because I remember when he was shooting that, and he did not want to make that video. They had to coax him into doing it, and maybe he was right to not want that if it created expectations that he wasn't emotionally prepared to shoulder.

QL: Had he known what the repercussions of "Untitled" would've been, I don't think he would've done it.

"I SAW DE LA SOUL AND WAS LIKE, 'YEAH, THAT'S ME.'"

BLVR: It's very easy for a hiphop historian to say, "Oh, yeah, the Roots are a post–Native Tongues band and they follow in the line of groups like De La Soul." But how does that work for you? Is there an actual connection for you, or are we making that up?

QL: The same way a white kid would look at Eminem and say, "Hey, that's me," I saw De La Soul and was like, "Yeah, that's me." I saw it with the Jungle Brothers at first, but De La pushed it over the top. They were full of inside jokes, full of inside cultural references that only I got. They had Led Zeppelin samples...

BLVR: They weren't afraid to be suburban, weren't afraid to be polyglot, weren't afraid to be intellectual.

QL: They wore it like a badge of honor. They were my entry into hiphop. I worked at Sam Goody when *3 Feet High & Rising* came out, and my first act of theft at that store was taking the promo cassette. I took that cassette and made a lifestyle with it. With *Nation of Millions* I heard my father's record collection inside the record. I said, "How can I utilize that so I can make that work for me?" Then De La totally introduced me to the lifestyle that I could relate to. They validated me.

BLVR: They allowed you to feel comfortable being yourself, being non-ghetto, non-thuggish, non-anti-intellectual.

QL: Exactly. I welcome people calling us post–Native Tongues. I wanna be a Native Tongue! We were very much like De La Soul in our theory and our lifestyle and the way we dressed and the way that we just wanted to be different for different's sake and then came into our own and found our own niche.

"PHRENOLOGY EASILY COST $2 MILLION TO MAKE."

BLVR: If you were the commissioner of hiphop, what would you institute as new rules?

QL: My life's goal is to find a happy medium for sampling to be not only legal but for the right parties to benefit from it. There have to be sampling laws. The survival of hiphop is based on that. Just make it legal and have an actual scaled rate for it. I mean, Pete Rock is wasting some of the best years of his life right now because he's being handicapped because he can't sample. It's way too expensive. The reason why Jay-Z was able to make *The Blueprint* [filled with great soul samples] is because the motherfucker's got a $2 million recording budget. He could pay for samples like that.

BLVR: Do you have that kind of budget?

QL: Well, each Roots album has cost $1 million plus, which is unheard of. Each album has cost between $1 million to $3 million. *Phrenology* easily cost $2 million to make.

BLVR: What adds up to $2 million?

QL: Mostly studio time. I use the best studios. The type of mics I use are expensive. If you want the shit from 1940 that Louis Armstrong played on that's still in great working condition, that might cost you $300 a day. Engineers aren't cheap. Bob Power [perhaps the most legendary hiphop engineer] charges $5,000 just to have a conversation. Things add up. It's damn near five figures a day for every day at the studio.

BLVR: What do you think *The Blueprint* cost with all those samples?

QL: Wow. Well, it really depends what people are charging for samples. The reason George Clinton gets used a lot is 'cause his charge is cheap.

BLVR: What's cheap?

QL: You can nibble off of George for a flat rate of maybe $5,000. He'll actually go above and beyond the call of duty and send you the master tape. I'd never do that, but he goes above and beyond the call of duty so you keep coming back. He's like a smart crack dealer. Why do you think his sound was so prevalent? George allowed people to sample him. He's smart with his. Prince doesn't let anyone touch his stuff, because the way his deal is with [Warner Bros.], they would get the lion's share of the money. He even goes so far as to tell people, "Don't cover my shit because I'm not getting the money."

"THEY DON'T EVEN HAVE TURNTABLES IN CUBA, BUT THEY HAVE HIPHOP."

BLVR: Everyone in hiphop has a list of their top five emcees of all time. What's your list?

QL: Five is Posdnous [from De La]. The most untrumpeted hero of lyricism. Four is KRS-One. Three is Biggie. Two is Melle Mel.

BLVR: Wow, you went way back with him.

QL: Well, you have to. Everyone is derivative of Melle Mel. Number one is Rakim. He's the Christopher Columbus. There are people more complex than he was, but him being first, he has to have it.

BLVR: You claim your life as an enabler is over, but tell me, whose life are you saving in your spare time?

QL: Right now in Cuba it's 1981 in terms of hiphop. They're just getting started. They don't even have turntables in Cuba, but they have hiphop. I'm gonna do to Cuba what Dizzy Gillespie did to Cuba: totally reinvent the arc. I'm gonna buy Cuba its first set of turntables. I've always wanted to find a place where they have little concept of hiphop. If you go there and reinvent the wheel, you'll be the shit. ★

STEPHEN MALKMUS

[MUSICIAN]

"YOU START ASKING YOURSELF HOW IN
TOUCH YOU WANT TO BE. DO YOU WANT
TO BE THE GUY WITH THE BALD SPOT
AT THE SEVENTEEN-YEAR-OLD'S PROM?
MAYBE IT'S BETTER TO JUST GO ONLINE
AND LOOK AT *MAKEOUTROOM.COM* OR
SOMETHING LIKE THAT TO FIND OUT WHAT
KIDS LIKE. JUST PROWL THE INTERNET
LIKE A CHILD MOLESTER SO YOU CAN
FIND OUT WHAT THE NEW MUSIC IS."

The two strains of influential California hardcore:
Serious, puritan bands (Black Flag, Minor Threat)
Jokey, insolent bands (the Adolescents, Wasted Youth)

I t was with only a slight tremor of bitterness that, at the start of
this millennium, I read and accepted the news that Pavement
had played their final show in London at the end of November,
and were no longer working together. Although they were one
of the most entertaining and important bands of the nineties,
having produced a string of ridiculously great records including Slanted
& Enchanted, Crooked Rain, Crooked Rain, *and* Wowee Zowee *(my
personal favorite, and an album that has become a sort of indie-rock*
White Album *for fans—a brilliant, expansive, uneven record that show-
cases Pavement's best and worst ideas), I knew it was time for them to go.
The nineties were theirs—let the new century belong to someone else.*
* Now it's 2003, Stephen Malkmus is in a new band called the Jicks (the*

name derives from the intersection of Jerk *and* Dick *or* Mick Jagger *in reverse, depending on who you ask, and when), and Pavement is just a milky shadow hovering at his back. With the Jicks, Malkmus has created two strong, quirky albums, the newer of which,* Pig Lib, *was released and warmly received earlier this year. Even for the most devoted Malkmus fan, however, these records will always be evaluated, ultimately, for how they do and do not match up to his former band's output. This is unfortunate, because Stephen Malkmus is one of the truly great songwriters we have.*

When I spoke to him on the phone, a day before he and the Jicks were to begin a high-profile, convention-center-style tour supporting Radiohead, Malkmus was relaxed and congenial, dryly humorous, despite the fact that I was somewhere in the middle of an extensive list of interviews he would have to endure that day. The disarmingly casual trajectory of the conversation reminded me of a line from the Pavement song "Stereo," in which Malkmus ponders the private life of Rush frontman Geddy Lee: "What about the voice of Geddy Lee / How did it get so high? / I wonder if he speaks like an ordinary guy?" We learn, in the next line, that, yes, Geddy Lee does hang his falsetto on the dressing-room mirror offstage. With Malkmus, though, I could only barely tell the difference between the man and his songs, and that lack of distinction has always been at the heart of his work.

—*Matthew Derby (October 2003)*

WATER SAFETY

THE BELIEVER: I know that, living in Portland, you're pretty close to the ocean, and there's that song on your new record where you warn the listener not to feed the oysters. Does the ocean make you nervous? I mean, did you hear about that thing that washed up on the shore in Chile?

STEPHEN MALKMUS: Was it a giant, octopus-type thing?

BLVR: Yeah, it was a—well, it was basically just a big mound of translucent flesh, the size of a school bus. None of the scientists who saw it in

person could figure out what it was.

SM: I heard about that secondhand.

BLVR: Do you go in the ocean?

SM: Oh yeah. I like the ocean. I try to go in whenever I can. It's too cold, though. I just went to Maine and it was too cold to go in the water, really, unless you were trying to make a statement, or you're trying to get your heart rate to go down or something.

BLVR: You don't worry about what's down there.

SM: Not too much. Just watch out for the rays and stuff, in certain bays. Don't step on them. I'm actually more worried about the coral than the animals. Or, like, a bad rip tow.

BLVR: Have you gotten caught in one of those?

SM: No. I mean, I've been in them before, and the people I was with said they were happening, but I've never experienced the thing where I was really getting dragged out to sea. I've always thought, Well, this is a rip tow, so I'll just keep my feet on the ground, you know? And it will push me a little bit, but I haven't felt one of those ones they talk about where [*lowers his voice*] "It's no use," you know? "Don't fight it, let it carry you out, and then swim to the right," or something. Have you ever been in one?

BLVR: No. I'm terrified of the ocean. I think that if I ever got caught in a rip tow I'd be so terrified that I would just shut down—I'd become a human log.

SM: You'd probably be smart to do that.

BLVR: Really?

SM: Yeah, you should just let the rip tow carry you out. Don't try to fight it. Because you'll waste your strength. And also, sharks don't like worried animals that move too much. They can smell your stress, so if you were fighting too much they would know. They'd find you.

BLVR: It's good to know that paralysis sometimes can help.

SM: It works. Animals like to play dead.

ON BOB PACKWOOD

BLVR: I was amazed and thrilled to hear former Oregon Senator Bob Packwood's name mentioned in the song "Vanessa from Queens" on your new record. It's been a few years since Bob Packwood has shown his face, though.

SM: I know. I haven't thought about him in a long time. But I do remember that that was sort of the original sex scandal of the early nineties. In that song, I wanted to drop in a sort of a shout-out—that doesn't sound right in my voice, I know—to the people in this town called Gresham out here where we live. It's kind of a redneck suburb—well, not necessarily "redneck," but kind of on the outskirts of Portland. A lot of great people come from there so I don't want to say it's Tonya Harding–land or anything. Anyway, I chose Packwood because of his sexual aggression.

BLVR: He became a big part of my life for a while—I was living in Washington, D.C., with a friend who worked as a spa salesman, and Bob Packwood always left long, indignant messages on the store's answering machine about how upset he was with their service. He would always start by saying, "This is Packwood." This all happened during the scandal, or right after. It was amazing to me that he could be so arrogant and aggressive even in the midst of the controversy. Like there was no shame or humility involved at all.

SM: Yeah, I guess by that point he just didn't care. The guy at the spa

store didn't vote for him. He didn't want to become president, or he had no chance at that point. That's too bad. But he just had that insatiable sex drive, you know? He just couldn't get enough.

BLVR: It's interesting because he was so sexually aggressive without exuding any sort of sensuality himself.

SM: Yeah, he just pursued it. He must have had no shame. I've been thinking about that a lot. If you have no shame, and it's your goal to get people into bed, how much higher could your success rate possibly be? Because I'm sure his attitude was "whatever it takes," and that seems to have worked. You just use power or coercion, and a shamelessness about what you want, right up front.

BLVR: He's such a great character for one of your songs. He's got an attitude but no appropriate outlet for it. His actual personality is too small to matter in the larger figure he projects over himself. You play around with that tension a lot in a really humorous way. You write about characters that are irate about the injustices of situations that they've usually created for themselves. I was trying to think of what sort of models you had for that strategy growing up, and aside from maybe Jonathan Richman or something, I really couldn't come up with anything. I mean, who was writing funny songs, aside from Weird Al Yankovic or, like, John Valby?

SM: Who was that second person?

BLVR: John Valby? He was this sort of bawdy troubadour from the seventies. He toured with Gallagher, I think.

SM: Oh. Maybe the influence for me, well, the original music that I liked, the music that I used to define myself as a young adult, was the hardcore music from California from 1982.

BLVR: Really? Like Black Flag?

SM: Well, there were two different strains. There was the more serious, puritan style of bands like Black Flag or Minor Threat, but mainly there were these sort of jokey punk bands, like the Adolescents and Wasted Youth. There was a whole slew of these bands back then that didn't have anything drastic or political to sing about. Their problems were really personal and suburban, and they mainly wanted to write songs for their friends—to make their friends laugh and have a good time. They didn't feel like they had to explain their problems to outsiders.

BLVR: The Minutemen played with those bands, though. They seemed to involve humor in a more enduring or complex way—

SM: Yeah, they had that intellectual background, but I didn't like them at all back then. I thought they sounded too weird. It just sounded like white funk to me. By the time I was seventeen or eighteen, I thought they were an unbelievable band, but I remember buying the Punchline album because it was on SST and thinking it was just horrible.

BLVR: I think I read in an article once that your writing style was influenced early on by Barry Hannah.

SM: Well, yeah, he has a certain comic style that I really remember being transfixed by. I haven't read him in a really long time, but I'm still a total fan. I think David [Berman, cofounder, with Malkmus, of the band the Silver Jews] first met Barry down in Mississippi. Barry heard some of David's work and said he liked it. I think he likes to think of himself as a rock guy: he wears a leather jacket and rides a motorcycle, and in his first novel the main character tries to have a marching band, and the marching band is an African-American marching band, and the book is all about the beauty or the weirdness of this music. I should stop—I guess I'm kind of making fun of him—but he definitely has a rock-and-roll thing, and I think we sent him the first Silver Jews CD in appreciation of his writing. We were both really drawn to his characters: you know, the drunken outlaws. You can always relate to them as a young man. Or at least I could.

BLVR: There's also that tenderness, though, that undercuts, or maybe fills out, the bravado of the drunken outlaw.

SM: Yeah, he's got a human side. Men are men and women are women, but the men are dumber than the women, usually. He came to Portland to read once and he said [adopts a convincing Southern accent] "I never understood why women were worried about these equal rights—in my family the women were always the strong ones—they controlled everything." I don't know, maybe his mom didn't want him to get an attorney or something.

BLVR: [*Laughs*]

SM: I don't blame her.

THE NAME "PAUL RUDD"

BLVR: Do you think there's something wrong with the name "Paul Rudd"?

SM: Who is that, anyway? Is that an actor?

BLVR: He was in that Neil LaBute movie, *The Shape of Things*?

SM: Oh, I saw that for free out here. It was in the test market. I rated the woman really poorly. I gave her, like, a one.

BLVR: Really?

SM: Yeah, I gave her a one. I thought she was very unappealing. That guy was good, though. He was good enough.

BLVR: Good enough to have the name "Paul Rudd"?

SM: Yeah. Well, I see what you're saying. *Rudd* relates to *ruddy* and *ruddy*

is one of those words, like *husky,* that is just not very appealing in any way. Or *clammy.* There are just words like that.

BLVR: Where did that name even come from?

SM: There are other people named that, though. There's a Rudd in Foreigner, isn't there?

BLVR: Really?

SM: There is some music person named Rudd.

BLVR: It's got to be Foreigner.

SM: It seems like there are others.

BLVR: I wonder if it's some sort of an Ellis Island truncation, and whether there could now be a kind of—maybe the government could institute a sort of reverse Ellis Island program, where people could go and get their original names back, you know?

SM: Reclaim what it used to be before it got shortened to *Rudd.*

BLVR: Yeah.

SM: [*Pause*] There's nowhere you could go with that, really. *Ru.* If you're trying to shorten *Rudd,* you're in trouble.

BLVR: Oh, no. I'm saying it would be longer.

SM: Yeah, I know you want to do that, but I was just thinking—I guess I would just change my name to Rutherford, maybe.

BLVR: That name commands respect.

SM: Exactly.

BLVR: I was at a film festival last night and I saw this film by a guy named John Putch, and I just thought that that was really wrong.

SM: You know, he probably likes it. His friends probably have a lot of jokes about it. I bet he gets a lot of attention.

BLVR: Yeah, in college he probably had a football jersey that just said PUTCH on the back. Or maybe THE PUTCH.

SM: Yeah, double zero.

THE POINT MAN

BLVR: *Pig Lib* sounds a lot different than your other work. Did you consciously decide to go off in a different direction? Are you worried about how that might mark you, in terms of your future?

SM: I'm not too worried about it because, well, I guess I'm old enough to not be too worried. I'm not really interested in those self-aware questions of "Where is it going?" or "What is it?" With this band I didn't really know what I was going to do. The people just kind of showed up, in that way that bands just sort of happen.

BLVR: The effect Pavement had on kids in the nineties was a lot like the influence that the Replacements had in the eighties. Each band weathered a single decade before breaking up, and both were unpredictable and sloppy, but somehow managed to produce heaps of brief, perfect songs. But while Paul Westerberg has been using his solo career to establish himself as a serious singer-songwriter, you seem to be embedding yourself as a component of the Jicks.

SM: I'm just guessing, but Westerberg is probably just doing what he wants. He probably just couldn't stand those guys in the Replacements

anymore, but he still wanted to write songs. I don't know if he's bitter about any of it. He sounds bitter sometimes. He's probably happy. I don't think his career was calculated.

I mean, you can always say, you know, "What do I want to do next? Do I just want to do the next record without the band, or stay with the band?" There *are* questions you ask yourself but they're generally not commercial questions. Unless you have a manager, or you're a megalomaniac. I mean, if you really want to get into your career, you start thinking that way seriously—you get someone in L.A. and start fighting your way into people's minds, but it's a tough battle, you know? You need to have somebody on your side, talking you up and stuff.

BLVR: That phenomenon of people in the music industry becoming really careerist—does that come out of that nineties thing where the forty-year-old guys at all the record labels stopped trying to guess what kids liked and instead just hired the kids to make the decisions about what got produced?

SM: Well, in the music industry, I think they've always co-opted young people. The guy who signed the Stooges and the Doors—this guy named Danny Fields—he was this seventeen-year-old. They've always had a point man down there at the bottom of the chain.

BLVR: Do you think it's gotten more intense, though, or more pervasive in any way? I'm thinking about that car, the Honda Element, which was designed by surfer kids to appeal more comprehensively to the youth market. A lot of music coming out now has that feel to me. There's a sheen to it, like when you take off the shrink-wrap there's another, impermeable layer of shrink-wrap.

SM: Yeah, you're right, when you imagine all these guys around a table, all these seventeen-year-old kids looking at press packets or magazines or whatever, saying, "I like that," "I don't like that," "That's good," and then the label guys kind of roll with it. And probably in Hollywood, too, they've got these younger agents that try to bond with the star and make

him feel cool. You know, they need to find someone who's willing to go to all these boring parties and watch people dance. Get the free drinks.

But if you're starting to get out of touch—and it's inevitable if you're really in the music scene—even for an indie music person there's a point at which you become too old. Like the Matador Records guys—they're going to be pushing forty soon. And at that point you start asking yourself how in touch you want to be. Do you want to be the guy with the bald spot at the seventeen-year-old's prom? You don't really want to do that. Maybe it's better to just go online and look at *makeoutroom.com* or something like that to find out what kids like. Just prowl the internet like a child molester so you can find out what the new music is.

BLVR: That's sad.

SM: I don't know. It depends on what you want to do, whether you want to make music for a dwindling market or not. You know, like trying to sell music to the people that are having kids and going out less and buying fewer CDs, except the ones they already bought when they were twenty. People are really stubborn about sticking to what they know. "Stones Forever" or whatever. Or Nirvana. The people that liked Nirvana will get a box set when they're fifty, or someone will get it for them for Christmas, and that will be it.

THE END OF THE CONVERSATION

BLVR: Well, do you have an address where I can send the finished interview for your approval?

SM: I have faith.

BLVR: OK, you're sure?

SM: Yeah. Actually, that's the first time anyone's asked me that. Thanks.

BLVR: Really?

SM: Usually they just print it. But I guess the *Believer* must be a bit more ephemeral. I'm guessing—is there glue on the spine?

BLVR: Yeah.

SM: I figured. I haven't seen it yet but I've heard about it.

BLVR: Maybe when you're on tour you can find a copy.

SM: Yeah, I bet those guys in Radiohead are into it. I bet Thom Yorke is lying prone in his solar-powered tour bus right now, reading the *Believer*.

BLVR: Do you have to pass some sort of voiceprint identification to get onto the tour bus?

SM: I don't know about that. We'll see. They're British, you know?

BLVR: Yeah.

SM: Actually, they're really great guys. They're carrying all our gear for us. I have absolutely nothing bad to say about those guys. Except when I'm making fun of their solar-powered tour bus. ✶

ICE CUBE

[MUSICIAN/ACTOR]

"MUSIC IS A MIRROR OF WHAT WE'RE GOING
THROUGH, NOT THE CAUSE OF WHAT WE'RE
GOING THROUGH. IT'S A REACTION, IT'S
OUR ONLY WEAPON, IT'S OUR ONLY WAY TO
PROTECT OURSELVES, IT'S OUR ONLY WAY
TO FIT, IT'S OUR ONLY WAY TO GET THERE."

Before rap music, New York might as well have been:

Paris

Africa

Australia

A thousand miles away from a thirteen-year-old Ice Cube

O*nce upon a time, the name Ice Cube was analogous to explicit lyrics, guns, women as "bitches," South Central, and attitude. Bad attitude. Not to mention mind-blowing rap music wrapped in raw emotions. But those were Ice Cube's teen years, before he married Kimberly Jackson, became father to four kids, and turned into a true Hollywood player. A legend long before he turned thirty, Ice Cube, together with his fellow N.W.A. members, revolutionized not only the rap/ hiphop genre, but all music, by making it OK for musicians to speak their minds and then some.*

Over the last decade, Ice Cube, whose given name is O'shea Jackson, has made more waves in the film business than in the music business. This

is no coincidence. Ice Cube's Hollywood game plan has been to produce reasonably budgeted films featuring themes and characters an audience would actually go and see. The Friday *franchise, of which he is the backbone and originator, has made over $200 million. After revamping the* Barbershop *script and tailoring his role as barbershop owner Calvin, the film grossed almost $80 million. And that was before the DVD release.*

As an actor, Ice Cube is well on his way to the Hollywood A-list. His performances in Boyz n the Hood *and* Three Kings *were astounding. Next year, Ice Cube is replacing Vin Diesel in the* xXx *sequel. He has a starring role in the upcoming film* Torque *(January 2004) and is in preproduction of his own script,* Are We There Yet? *His new album,* Terrorist Threats, *will be out on December 9th.*

On a recent Monday afternoon, Ice Cube talked to the Believer, *for almost two hours, from his home somewhere outside L.A.*

—Linda Saetre (December 2003/January 2004)

I. "THERE WERE KIDS WHO WERE LOOKING FOR TROUBLE AND THERE WERE KIDS WHO WEREN'T LOOKING FOR NO TROUBLE, AND I WASN'T LOOKING FOR NO TROUBLE."

THE BELIEVER: Where does the name Ice Cube come from?

ICE CUBE: I was given the name by my brother when I was about eleven or twelve years old. He was older than me, and around that age I was starting to get into girls, and when they would call the house for him, and when he was not there, I would try to talk to them. I was trying to be the man and trying to get them to come and see me, not worrying about him. When he found out… he started calling me Ice Cube as a joke because he said I was trying to be too cool. I just liked it and started telling everybody in the hood "my name is Ice Cube."

BLVR: How much older is your brother?

IC: He's nine years older than me.

BLVR: [*Laughing*] So the girls were in high school?

IC: Yeah.

BLVR: Good thinking. I know you don't like to speak about your private life, but I'd like to ask you about your parents. Do you see them often?

IC: All the time. I see them at least once a week. I look forward to seeing them. It's kind of like, the more mature I get, the more I understand how important it is to be around my family as much as I can.

BLVR: When you spend time with your dad, what do you guys talk about?

IC: We talk about all kinds of stuff. For instance, we talk about how we are both doing personally and healthwise. You know, I always bring him up to date about what I am doing in my work—what movies and records are in the works—and we talk about the family, the neighborhood that I used to grow up in, where he still lives. Basically just enjoying each other.

BLVR: Were your parents ever worried when you started mingling in the rap scene?

IC: No, they loved it. You know, what they loved about it was the fact that I was doing something constructive with my time, that I wasn't just hanging out drinking and smoking weed and basically looking for trouble. The fact that I was doing something constructive and creative, something exciting and new, they encouraged it. Anything but me hanging out in the street trying to crib it or run around with the gangs that were there right there in front of you. I always found different ways to occupy my time that took me away from the day-to-day hanging out all the time.

BLVR: And did you get into rap because you felt a drive to move in that direction, or were you looking for an alternative way to stay busy, aside from hanging out with the crowd?

IC: No, you know, I wasn't really looking for rap to do anything of that. At the time I was really getting into the music, I was playing high-school football and I was just a fan of the music. I loved everything about it and just tried to get my hands on everything that had to do with the culture of hiphop. In the early eighties, when I was in junior high, going into high school, it was rap music's best era. It was just an explosion of new energy and creativity. It wasn't just rap music, it was the whole culture. It was DJing, graffiti, breaking, a whole new way of dressing. I was engulfed by the whole culture, so you know when I started rapping, it was all about getting to meet somebody who could show me that this could be more than just a hobby, that this could be a career, and that's when I met Dr. Dre.

BLVR: When was that?

IC: I met Dr. Dre in 1983 but I didn't really start working with him until late 1984, early '85. [Ice Cube was born in 1969, you do the math.]

BLVR: Do you remember your first meeting with Dr. Dre?

IC: Yes. His cousin, Sir Jinx, who also worked on some of my early projects, he lived down the street from me. So Sir Jinx and I were good friends, you know, and we were hiphop buddies. Jinx had DJ equipment, I had the lyrics, and we started to form a team. He said his cousin was Dr. Dre and I knew Dr. Dre just from his reputation in Los Angeles. He was DJing at parties with his DJ crew. Meeting him was high on my priority list as far as just being around L.A. hiphop, because at that point, most of the efforts came out of New York. This was a chance to be around some L.A. hiphop, so I just jumped at it.

BLVR: Did you ever consider going to New York and joining the rap

scene there, or were you purposely looking for people like Dr. Dre in L.A.?

IC: Well, if you really think back to the culture or just black America before rap music took off, New York could have been Paris. New York might as well have been, you know, Africa or Australia, and the idea of going there was just a thousand miles away from where I was as a thirteen-year-old starting to get involved in the music. Going to New York for me wasn't even an option. You know, nowadays, the country seems so small because, through music magazines and videos, we get to see what everybody is doing all over the country. Back then, it wasn't like that. You never heard about New York unless the Dodgers were playing the Yankees. I never even really thought about New York or any other place in the country. I just thought about L.A. In the late eighties, there was a lot of gang-banging and drug dealing going on in my neighborhood, so I was preoccupied, so going to New York wasn't even a thought.

BLVR: Were you preoccupied with staying out of trouble?

IC: In a way, yes. I was trying to do something positive with my life around so much negativity, and it's a challenge to find things that you can do that won't get you killed or in jail or have you kill somebody. You know, at thirteen or fourteen years old, I wasn't ready to kill nobody, or shoot at nobody. I wanted to do something constructive, productive.

BLVR: Did you stand out in your neighborhood and at school, trying to keep yourself out of trouble, or was there a group of you who were on the same wavelength?

IC: A lot of people have a misconception of what the ghetto is all about. You know, it's only a small percentage of the people that are bad. Everybody else is good. So the criminals you see on TV or whatever, that's just a small percentage of what the neighborhood has to offer. Most of the people are doing what they're supposed to do. I didn't stand out like a sore thumb. There were kids who were looking for trouble and

there were kids who weren't looking for trouble, and I wasn't looking for no trouble. I could deal with it if it came my way. I used to fight a lot in my neighborhood, because it was all boys, and there was a pecking order, and you had to figure out where you fit in. I could fight real good when I was young; that wasn't the issue. It was more like, "Yo, I don't want to fight every day."

II. "YOU KNOW, WHEN YOU'RE IN THIS POOL OF POVERTY AND LOWER EDUCATION, PRETTY SOON YOU START WEARING ALL THAT AS A BADGE. 'I'M FROM THE POOREST AREA, I'M FROM THE SLUMS, I CAME FROM NOTHING.' THAT BECOMES A BADGE OF HONOR."

BLVR: You quit N.W.A. in 1989 and moved to New York, where you formed the backing group Da Lench Mob, am I right?

IC: No, not really. I quit the group but I didn't move to New York.

BLVR: You didn't?

IC: No, I quit the group and I was still trying to negotiate with the management of N.W.A. to get Dr. Dre to produce my solo record. They said it wasn't possible. So I had met Chuck D from Public Enemy on the road in 1988 and '89, and we bonded real good. We had a good talk. You know, it was one day after the show when Pubic Enemy had performed and N.W.A. had opened up. He was real cool, right down to earth. We exchanged numbers and I knew that if I couldn't get Dr. Dre, who was the best producer on the West Coast, then I was going to try to get the Bomb Squad and Chuck D, the best producer on the East Coast, to do my album. They said yes, they'll do it, so I went out to New York to work on the album in the early nineties, at Green Street Studios. I just hibernated out there, did nothing but work on the record.

BLVR: *Amerikkka's Most Wanted.*

IC: Yeah, *Amerikkka's Most Wanted.*

BLVR: Was it different working as a rapper in New York as opposed to L.A.? Did you feel a different vibe from people? Was the energy level and inspiration different from what you were used to?

IC: Just being in that city made me focus a lot more than I would in L.A. It was pretty much just me, Sir Jinx, and New York. It was a culture shock, a little bit… coming from a place where you had neighborhoods, manicured lawns and stuff like that, to basically the concrete jungle of New York. You know, my senses were heightened. When your senses are at a high, you're absorbing more information than you probably would when you're at home, so I think I was a little bit more focused. There was nothing I really wanted to do out there but be in the studio with the Bomb Squad and have them produce me, so the nightlife and that didn't get to me.

BLVR: You didn't go clubbing at night?

IC: No, because of the hours we were at the studio. Chuck was real smart; he would have us come in the studio at 6 p.m. and work until 6 a.m., and that's club time. Working those hours, you slept all day, waking up around 3–3:30, making sure all your lines were together for when you were going to the studio at 6 p.m. And that was my routine for thirty days straight.

BLVR: Would you write a rhyme every day you went into the studio?

IC: No, I had a lot of rhymes written already for the next N.W.A. album, so what I did was just make those rhymes mine and mine only. And you know, there were a few things I wrote there, but the whole album was mostly written before I got there.

BLVR: Was there an East Coast–West Coast controversy among rappers when you were in studio with Chuck D?

IC: No, no, and here's why: At that time, around 1989, L.A. hiphop was like a blip on the radar. And I think that the only thing we had coming out of L.A. at that time that was nationwide was Ice-T and maybe the L.A. Dream Team, so we were no threat to the industry in New York, so it wasn't really rivalry. It was kind of like, you know how the big brother pats the little brother on the head and says, "Nice job," that's how it felt. "You all finally got some shit that we want to listen to." So there was no rivalry then. The rivalry came once we were successful, in the late eighties and the early nineties, coming along with N.W.A. and Ice Cube. As a solo artist, I was, you know, at the height of my rap career and so was N.W.A., and here comes Death Row Records with a whole other explosion of West Coast–influenced hiphop, so I think that's where a lot of the resentment came in, and that's where the real beef took its shape, because you had a real changing of the guards of what became hiphop then, and I think the industry in New York said, "Yo, we have to support each other, we can't support this outside music." And it started from there. You know, there's always been New York arrogance, but what else is new? [*Laughs*] You know, I think we can deal with the New York arrogance, that's just what we've grown up on, and I'm fine with a little arrogance, ain't nothing wrong with that. But it became like an industry thing, a secret constitution. Because the whole industry is back there, you got most of the magazines from the *Source* to *Vibe*, and then you have MTV and BET. All these major outlets for the music are in New York, and when you're in New York, you're influenced by New York groups and kind of don't want to hear it from nowhere else. So, you know, it started becoming a real thing where our music was criticized but people like Biggie Smalls and the Jay-Zs of the world were getting praised by the same magazines where we were getting dissed for doing the same kind of music. We really didn't understand that, so it started heating up.

BLVR: I remember moving to New York from Europe in 1995 at the

height of my personal gangster rap infatuation. People at school were laughing at me and nobody played West Coast, which we in Europe had been jumping up and down to for years. But the rap landscape has changed a lot since then, and you hear West Coast many times a day now, even on HOT 97 [a New York radio station], which is so conservative.

IC: And that's a beautiful thing because here, I grew up on music where if it was good, it got played no matter where it came from. In L.A., if it's good, they're going to play it. No matter where you're from. We heard music from New York, from Skywalker in Florida, you know, from Sir Mix-A-Lot in Seattle, Too $hort in Oakland, the Geto Boys from Houston, you know, we heard hiphop from everywhere. It wasn't like, "OK, you're not from L.A., so we're not going to play your stuff." That was the feeling we were getting in the mid, late nineties from New York. But it seems like it has blown by and hopefully it has.

BLVR: In the mid nineties, rap music and particularly gangster rappers were blamed in the media for the increase in crime amongst the youth. Were politicians and the media on to something or were they looking for scapegoats?

IC: They were looking for scapegoats. Most of the problems that we have are brought on by the government and not by music. Music is a mirror of what we're going through, not the cause of what we're going through. It's a reaction, it's our only weapon, it's our only way to protect ourselves, it's our only way to fit, it's our only way to get there. But that's all right, music kind of thrives on talking about what's the problem, you know, sometimes glorifying it. You know, when you're in this pool of poverty and lower education, pretty soon you start wearing all that as a badge. "I'm from the poorest area, I'm from the slums, I came from nothing." That becomes a badge of honor. So, there were killings and social problems, people going to the penitentiary way before rap music ever came into existence, so we can never be the cause of that. And, one more thing, if the government stops spying on its citizens, the concept of America will be more than just a myth.

BLVR: Do you think that's ever going to happen? Do you have hopes for that?

IC: I have no hope for that because the government is driven by its own interest, you know, of supremacy and that's what they always established and they haven't changed in the past, so why would they change now?

BLVR: Have you seen a change since the Clinton administration left office?

IC: No. To me, the biggest change in the government's behavior has been because of TV and its ability to show to the world what has happened in this community… that's the biggest change. But without TV… the separation between the government and the people would be much worse than it is.

III. "WE SPREAD LIKE A FIRE. IT WAS ALL UNDERGROUND; THERE WAS NO PLACE TO PLAY THAT STUFF BUT ON UNDERGROUND RADIO STATIONS, AND THAT'S WHY IT PICKED UP FAST. IT WAS LIKE A FORBIDDEN FRUIT."

BLVR: Who's producing your new record?

IC: There were a lot of producers. It's a Westside Connection record, so it's with me, my guy Mack 10, and my other guy WC. Mack 10 spearheaded the production as far as finding the producers. I am more or less executive producing it and it will be out December 9. The name of the record is *Terrorist Threats* [Priority Records].

BLVR: I read somewhere that you were planning on doing a new record with Dr. Dre. What's going on with that?

IC: Our schedules, you know, could prevent that record from happening.

Just because I'm deep into what I'm doing and he's deep into what he's doing. We know that if we did a record together, it would have to be great, and if we don't have the time to hang with each other and get a vibe going, how could the record be all that great? So, our stardom and status might be the thing that's keeping this record from being put together right. Let's see if it comes through.

BLVR: Over the last decade, there's been a globalization of hiphop. I read in a French newspaper that there are over one hundred rap groups in Algeria alone.

IC: All right!

BLVR: In Norway, Russia, Italy, Africa, and of course Cuba, the rap they produce now is unbelievable. Did you ever think that rap would spread throughout the world like this?

IC: No. Just because of the language barriers. I never studied other languages or knew that they could rhyme like that. In English, the words are right there to be rapped in a rhythm. One thing I knew was that rap energizes all the kids who can't sing. With rap music, kids still have a shot at being the artist they want to be or envision for themselves, so it woke up another pool of talent, and rap is the music of the youth. But back then I didn't know that this could be pulled off in other languages. I went all over France and saw a lot of local rap groups, and they were damn good. Rapping is rhythm you have to capture, whether you understand the rap or not. If you capture the rhythm, that can sometimes be enough to let others know that he's a good rapper. There are a lot of Jamaican songs where you don't understand half the shit they're saying, you just know the rhythm is right. When I went to Africa in 1993 or '94, I saw a lot of African rap groups who were huge out there, so yes, I've felt it coming on for ten, fifteen years. But I never thought it would be this big. Rapping is talking and communicating, and that's always good.

BLVR: With N.W.A. you revolutionized not only hiphop in the United

States, which we've covered, but all of a sudden it was OK to be real and to voice one's opinion and anger and frustrations.

IC: And become a major group. I think you can always do that, but nobody believed that you could do that in front of twenty thousand people at a venue. With N.W.A., I think our biggest legacy is that we made it alright for you to say whatever you wanted to say on your record, and be whoever you wanted to be on your record. Marilyn Manson and all the people who came after N.W.A. are definitely products of what we did in the late '80s.

BLVR: What musical forms influenced you early in your career?

IC: Soul, funk, a little disco. I grew up in the seventies and disco was big. That influenced me the most. Also, you know, comedians of the day. People like Richard Pryor, even people like Muhammad Ali. All these people are pre-rap, you know what I mean? You heard someone like Richard Pryor saying the things he said on stage—and getting a reaction. You figured if you're rapping and if you're saying exactly what's on your mind, you would get a similar reaction—and it happened. So I wouldn't discredit what the comedians of the day, even Eddie Murphy, contributed to the music and us having the attitude we had.

All the bragging and the bravado of Muhammad Ali, man, that's where the rappers started getting the attitude from. Seeing black men up there basically saying what they had on their mind, and it subconsciously gave us the courage to do what we were starting to do.

BLVR: How did you go from being a neighborhood star to a global superstar?

IC: Well, what we [Dr. Dre and I] started doing was making mixtapes to make some extra money. We got the best songs and put them all on one tape and mixed them together. We had explicit raps, you know, one verse. Dre said, "Put that on my mixtape, that one verse you got," because we didn't think we could sell this stuff. Throughout the neighborhood,

people had the tapes going and playing them, one day Eazy-E said, "Let's do a record like that." We were all in different groups, so we all formed what we called an all-star group and named it N.W.A. We would do hardcore explicit records with N.W.A. but then we would go back to our original groups and do our mainstream records, you see what I mean? Because we never thought this stuff [N.W.A.] would sell... or that anybody would be interested in us. In a short amount of time, after we got the first record pressed up, we realized this is what people want, right here, not the other stuff we're doing. So we broke up with the groups we were in and formed N.W.A. We started growing, and our buzz went through Los Angeles, San Diego, Oakland, Phoenix, and Denver. We spread like a fire. It was all underground; there was no place to play that stuff but on underground radio stations, and that is why it picked up fast. It was like a forbidden fruit.

BLVR: How soon after did N.W.A. go on its first tour?

IC: A year and a half. It took two or three singles to come out, because people needed to know we were a group and not a fluke record. We started out in Southern California, then Chicago.

BLVR: And how did you finance it so early on? It must have been expensive.

IC: Eazy-E had money.

IV. "[*THREE KINGS*] DISCUSSED THE POLITICS OF PAPA BUSH, AND NOW WE ARE DEALING WITH BABY BUSH, AND I THINK THE FILM IS PROBABLY MORE RELEVANT TODAY THAN WHEN IT CAME OUT."

BLVR: How did you get cast for *Boyz n the Hood*? Did you know John Singleton before?

IC: Not really. I had seen him a couple of times, and he knew me from N.W.A. He said he was in school and that he had a movie that I was perfect for. I was looking at him like, "Yeah, right, ain't nobody going to do a movie with you." Back then, the only people doing movies were Spike Lee and Robert Townsend, maybe. So I didn't really believe him, but I didn't brush him off either. I gave him some numbers. About two or three years later I received a script, but I didn't remember him. I read the script and after a couple of auditions, I took the part.

BLVR: Would you do a sequel to *Three Kings*?

IC: Absolutely, because I think that movie is much more understood today than when it came out. I think it was hell of a movie. Me and Mark [Wahlberg] became friends, Clooney was always cool even when I was whipping his ass on the basketball court. David [O. Russell] was real cool.

BLVR: Is *Three Kings* relevant in the current political climate?

IC: Hell, yes. It was a social commentary of what was going on. That film discussed the politics of Papa Bush, and now we are dealing with Baby Bush, and I think the film is probably more relevant today than when it came out.

BLVR: Which movie did you star in that had most impact on you? I mean, did any film change your perception of the subject matter or did you ever discover something about yourself?

IC: There are a few for different reasons. *Boyz n the Hood* introduced me to a whole new way of creating, just being part of something bigger. Friday was the first time I had written and produced and put a movie together from scratch; *Players Club* [written, directed, and executive produced by IC] was the first time I saw how time-consuming it is to direct, and how much energy and focus you have to have. It was like a marathon.

In other movies, as far as subject matter or movies changing my perspective, nah. I do movies I think are cool anyway, so before I get involved, I pretty much know about the subject matter anyway. I haven't really gotten into a movie where I go: "What the hell am I doing?" [*Laughs*] *Three Kings* opened my eyes to the Iraq situation, dealing with the Shiites and what that was all about, so you get a different perspective. I thought I knew about the war, but doing a movie like that, you really get to learn how it was on the ground, and not how it looked like from the edit room at CNN. So yes, I was learning more about the subject matter as I was doing that movie, but as far as changing me or giving me a different outlook, no.

BLVR: In *Barbershop*, there was a comment about Rosa Parks not giving up her seat on the bus because she was old, and not because she wanted to fight segregation. Jesse Jackson was very outspoken against the film. What was your reaction? Do you understand his reaction?

IC: I don't know what his motive was, but I can understand his reaction, but in the context of the movie, I think it was a nonissue. It was one man's opinion, which is Eddie, the character played by Cedric the Entertainer, and the whole barbershop went against him. No comments were made [in the media] about how we jumped on him and said: "That isn't right." We're talking about a fictional movie, fictional characters, and ultimately, I don't care what you've done. You have to be able to laugh at yourselves a little bit. If you take yourself too seriously, nobody else will. With all due respect, and I respect Jesse Jackson a lot, I think he's done a lot, but on this issue he jumped the gun a little bit and made an attack that didn't have him sit well with black folks, because most people loved the movie and most people thought it was a nonissue until he brought it up.

BLVR: You've developed a very successful film business, particularly the *Friday* franchise, which has brought in over $200 million.

IC: Oh yeah? I wish I had gotten some of that. [*Laughs*]

BLVR: Welcome to Hollywood!

IC: [*Laughs*]

BLVR: Your move from music to movies has been astoundingly smooth. Did you plan it like that? Do you have a game plan? And if so, can I see it?

IC: [*Both laugh*] I don't want to share my overall game, but this I can say: being true to myself as a movie fan is part of it. I'm not taking the role of "I'm Ice Cube, I know what people want." Instead, I ask myself: "What films do I want to see as a consumer?" For me, that's where you start. Of course, I've always recognized opportunities, from 1989 and N.W.A until present. I'm not holding myself back and I'm exploiting opportunities that are there, working hard and staying true to myself. This has translated well with the audience. It looks like people want what I want, and I give them that and it all works out.

BLVR: I know your wife Kimberly is very important to all aspects of your career. Do you, in addition to her, have a circle or friends or associates that you run things by before you start developing projects and exploring ideas?

IC: My wife and I come up with the ultimate game plan. I then give marching orders to my team, which is a really good team. They're now starting to understand what makes me tick, what I'm all about and what I want, so now they bring things to the table that they know I'm interested in. For so many years I've been a self-guided missile, but now I've opened up a little bit more to suggestions from other people about what I should do with my career, what's the next step. Some of the advice I take, most of it I don't. [*Laughs*]

V. "YES, IF PEOPLE ARE LOOKING AT YOU AND THINKING: THIS IS BLACK, THEN YOU HAVE TO FIGURE OUT A WAY TO TURN BLACK INTO GREEN."

BLVR: Do you have a strange creative process? Do you get up at 4 a.m. and have hot chocolate and write, or are you a nine-to-five kind of guy?

IC: I used to schedule my writing by going home to write at set times, but that doesn't work. That's borderline mediocre writing, when you set times. I just go with the flow. If I feel it, I write, if I don't feel it, I don't write. You know, I don't beat myself up for not being able to write. The hardest period for a writer is the period in-between writing. That's when you can go crazy if you don't allow the creative juices to flow. Yes, I've popped up at 3 a.m. and run down to my office and starting writing until 6:30 a.m.

BLVR: Which of your various incarnations or careers do you like most? Actor, writer, producer, rapper, director? Do you tend to favor one over the others?

IC: I love them all because I'm a creative person. I was the kind of kid who would draw posters when my team won a championship.

BLVR: Can you draw?

IC: I'm not as good as I used to be, but I can do more than a stick figure… Creating is really what I like to do. The best thing in the world is to have an idea in the back of your head and then to make that idea into a movie and have people all over the world enjoy it. It can't get much better than that. And you can make a living of it.

BLVR: Can you multitask and work on different scripts at the same time?

IC: Yes, that's not a problem. It can be a situation where I'm writing something I feel I have to write, and there are also times when film companies come to me and say: "Look, we have this script. It needs to be worked out a little bit, but if you can get it to a place where you like it, we will shoot it with you." In that case, I dissect the script, which is real fun, pulling out the good parts and add some flavor on top of what's already good, and sometimes you come out with a hell of a movie.

BLVR: How many scripts have you written that have been filmed? How many have you written in total?

IC: Oh man, I've lost count. *Friday, Next Friday...*

BLVR: *Friday After Next...*

IC: ... *Players Club*, that's four.

BLVR: And the new one I read about: *Are We There Yet?*

IC: It's not shot yet. That'll be five. I've written about twelve so there are a few out there that haven't been filmed yet.

BLVR: Did your interest in storytelling form in your childhood? Was it through books in school or talking to elders or what?

IC: I'm the youngest, so when you're a kid talking to adults, you have to get their attention, you know what I mean? The more animated you are and the better the story, the more you can captivate and keep them guessing what the punch line is,the more entertaining you are, the more you get heard. So by being the youngest and really wanting to be accept-ed and to get the attention of my older siblings and my parents, I was the one who came in: "Look, look, guess what happened, check this out," and I would be the one with the best stories. Not necessarily the best story, but I kept the others captivated. I would never come with a story where the adults would go: "Is that it?" My stories always had to be something

big, or next time I came in, everybody would keep talking. Those situations brought out the storytelling talent in me.

BLVR: How are things going at Revolution Studios? Has access to power for black executives, writers, directors, and producers in Hollywood increased since *Boyz n the Hood*?

IC: There's an upsurge of opportunities on both sides of the camera. Of course, there's always room for improvement, but since *Boyz n the Hood*, there are more black movie stars doing more movies that are accepted by worldwide audiences. There are more black directors, producers, writers, grips, cameramen, wardrobe, and makeup. All around better. Hopefully, it'll just keep on increasing.

BLVR: Do you think the upsurge had anything do with the explosion in rap videos?

IC: I think rap music is the sole reason for a lot of black acceptance in pop culture; because the music is very popular, it gets our image out in other ways than in movies. Daily, you can see young black people doing our thing and now we're also spearheading fashions and everything else we think of as cool. This translated into more opportunities in the film business and more acceptance from the powers that be, as well as the general audience.

BLVR: I want to ask you a few questions about being black in Hollywood. I have an impression that you have moved a little bit beyond that—

IC: I'm not black no more?

BLVR: No, no, I don't mean it like that, but I have the impression that you just go, "I'm just going to do what I have to do, whatever."

IC: I definitely don't get caught up. If you know there's an obstacle in the road, do you go around the obstacle or do you go the other way? I know

that there are obstacles; I know that there are hills to climb, I know there were people before me that made my journey easier and there are people behind me that I have made the journey easier for. You know, when you try to dig a tunnel, it tends to get dirty, but it's cool, because I figured it out for most part. If you make green—

BLVR: Dead presidents...?

IC: Yes, if people are looking at you and thinking: This is black, then you have to figure out a way to turn black into green. When you do that, then no one cares that you're black, you see what I mean? So I figured, when I make a movie, especially earlier in my career, one thing I was going to make sure was that the movie doesn't cost a lot and that it has potential to make a lot of money. That's how you get respect in Hollywood. You make a great piece of art that makes a hell of a lot of money at the box office, and I've done that without compromising how good the film is. Who cares that Movie A costs $200 to 300 million if it's a piece of shit, and who cares if Movie B costs $12 million if it's brilliant? Audiences don't care. All you want is that the finished product is worth your time and money, and that is what I make sure of. In the end, I'm happy, the studio is happy, the audiences are happy; the movie has made money and people have enjoyed it. ✶

JOANNA NEWSOM

[MUSICIAN]

"THE TRUTH IS THAT IT WAS WITH SUCH
SHOCK AND DELIGHT THAT I DISCOVERED
THAT THERE WERE PEOPLE IN THE WORLD
WHO WOULD WILLINGLY LISTEN TO THE NOISE
I WAS MAKING, THAT IT OVERSHADOWED
THE FACT THAT I WAS TERRIFIED."

Endured by a harp:
Drags in dirt
Settlings
Creakings
Strainings
Leaks
Canning of sound waves

Trying to describe Joanna Newsom to people is difficult. It's a bit like the parable of the blind men trying to describe an elephant. You could start by saying she's a harpist and singer. But when most people hear the word harp *they immediately imagine classical music, or tinkling music-box stuff, and their eyebrows go up. You say: No, no, it's sort of folk music, but sort of not, has a touch of Appalachia but really it's a style all its own. That just makes people more skeptical. You tell people she's got an incredibly unique voice, singular in the way Björk's voice or Cat Power's voice is, and people get even more confused. You try to describe the lyrics, the intricate constructions and marvelously obscure words. Catenaries and dirigibles! you cry. By now your listeners have*

*given up and are backing away, nodding politely. Finally, in desperation,
you shut up. You make them listen to Newsom's music, which is what you
should have done in the first place. Because now the confusion drops away.
Because whatever it is, however you describe it, it's really, really, really
good—haunting, sad, lovely, a bit scary, and wonderfully peculiar. The
following interview was conducted, in person, in San Francisco. Newsom's
new album* The Milk-Eyed Mender *has just been released by Drag City.*
—*Judy Budnitz (June 2004)*

CLAM, CRAB, COCKLE, COWRIE

THE BELIEVER: You use words that I've never heard in songs before.
It's so cool to hear words like *poetaster* and *ululate* in a song.

JOANNA NEWSOM: I really like playing with interior rhymes, not just
rhyming the ends of lines. And playing with different syllabic empha-
ses. That's something I love about writing words for music—there's this
immense freedom to play with language in a way that I felt hindered
about when I was writing prose. Nowadays, there's not a great deal of
respect given to rhyming, in prose or poetry. But I'm really interested in
rhyme patterns, the sonnet form. With music, hardly anyone notices that
you're doing that stuff. So it doesn't get analyzed, it doesn't get picked
apart, it doesn't get labeled "neoclassicism" or something. Because no
one's paying attention.

BLVR: Your lyrics are very thought-out. You write like a poet.

JN: Well, I love to write. I haven't finished school yet, but when I was
studying in school I was doing creative writing. But I would say that if I'm
influenced in my writing, it's less by poetry and more by prose. It sounds
silly, but Nabokov has been a huge influence. The way he strings words
together. There's something about English as a second language... and
with him you have a person who is hypersensitive to language, hypersen-
sitive to the effects that different words have when they bump up against

each other. And an extremely rich vocabulary. The way that he refracts a sentence, plays around with it, rethinks it, is really inspiring to me.

BLVR: When you're writing your songs, do you start with music first? Or lyrics first?

JN: There isn't a system for me. I've had the lyrics to some songs sitting in a notebook for two years before they found a home, and then other times I'll be writing music and have a melody and words in my head at the same time. And other times I'll have placeholder words, where I'll sing a melody with nonsensical words, and then the words will assert themselves at some point. Most of the songs were music first. I've been writing on the harp for years now, and that's a familiar process, whereas singing is not a familiar process at all.

BLVR: Some of the lyrics are really tight, they follow a really strict form, say, a lot of four-line verses, where each end rhymes, or…

JN: Some of them. And some of them are loose, sloppy, stream of consciousness.

BLVR: Can I ask you about some of the songs, or would you rather not pick them apart?

JN: Some of them are easier to talk about than others, not for emotional reasons, but because some of them are more deliberate, hyperconscious, and others are more stream of consciousness. But ask away! I'll do what I can.

BLVR: The one called "Inflammatory Writ"—I could really relate to it as a writer. The image of getting an idea, and then hunching over it at 4:30 in the morning—you really captured that feeling perfectly. All the writers I know would agree—that 4 a.m. hour is a little magic hour when you think you're really inspired, and then you re-read it in the morning and it's crap.

JN: Yes, that was definitely part of it

BLVR: That image of Great American Novels, fleeing across the plains like buffalo or something… it's fabulous. I wondered what your intention was with it.

JN: All the things you said were definitely in my mind, as well the sort of aestheticism that comes into play with some people when they think they're going to write the Great American Whatever-it-is… and the irony that when people are trying to write sometimes they shut themselves off from living because they're working so hard at writing, and then they don't experience the things that they're supposed to be writing about. They're writing from a sort of sterile, contained tower. I had the image in my head of someone scribbling all night and then looking out the window in the morning at all this… wild messiness outside.

BLVR: You make that point in another song too: "Never get so attached to a poem / you forget truth that lacks lyricism."

JN: It's funny, because it's not something I intended to hammer in, in song after song after song. But it's a constant struggle for me.

A LOOM OF METAL, WARP-WOOF-WIMBLE

BLVR: Why'd you pick up the harp? When did you start?

JN: I was five. My parents took me to the teacher in the town I grew up in, Nevada City, which is very small, and there's one harp teacher. She said, "Have her take piano lessons for a few years, and if she still wants to play the harp, then I'll teach her." Because it's an investment of energy and time, and money as well, to get a harp. So I studied piano. I was a really really shabby student, because I didn't care for piano. I was ten when we went back and I still wanted to play, very much, obsessively. So they rented me a small Celtic harp and I stared taking lessons from this teacher, who from day one emphasized improvisation and composition.

From the very earliest lesson she would play a simple chord pattern with her left hand and she'd have me improvise with my right hand. We'd spend whole lessons that way.

BLVR: Yes, I was curious about how you learned to compose on it…

JN: There's this folk-music camp I went to with my mom every summer for years. It was really casual—it was basically dragging the harp around from class to class in the dirt, to different campsites. One of the things I learned one year, from a harpist named Diana Stork, is this West African harp figure—*kora* is the West African harp—and it's a rhythmic pattern with a four-beat pattern in the left hand and a three-beat pattern in the right hand, so they come together every twelve beats. It's a very non-Western, jarring, disorienting thing. She taught it to me, and it took me three days to get it—stop thinking about it and just let my hands do it. Once I did, it was this enormous moment for me. It was like adding—it's a clichéd thing to say but it's true—it added a new dimension. I went home and started putting five against four, instead of three against four, so then it would come together every twenty beats; and seven against four, all these different patterns. I started quilting that into my own compositions, having folky melodies, broken up into this new rhythm.

I went to Mills College because I heard that was the place where the best composers taught, and it had this history in the Bay Area of experimentation in music. And I went, and immediately discovered that what I was doing was not really considered experimental at all in light of the ideas being studied at that school—atonal music, non-pitched music, conceptual stuff, intuition… but I certainly found some great musical inspiration while I was there. I took an American music class and got exposed to obscure folk music, field recordings. Like Texas Gladden, whom I had never heard before, and who became a huge inspiration to me. Because her voice is so powerful and so affecting and so devastating and so untrained and so different from the conventional idea of a pretty voice. It was around that time that I stopped studying composition; I switched my major to creative writing, and somewhere in there I started putting words to my music and singing.

BLVR: So how do you tune a harp?

JN: There's a little tuning key—

BLVR: For each string?

JN: There's a peg at the end of each string. I use an electronic tuner to measure the pitch because I don't have perfect pitch. It has to get tuned every time it gets moved, and that includes getting moved across the room. Any time any stress is on the wood, it causes settlings and creakings and strainings… and there are forty-six strings that all reorient themselves.

BLVR: A technical question: my husband, who's a musician, wanted to know—how do you mic yourself when you're using the harp, mic the harp and also get your voice, without getting a lot of feedback?

JN: That's an excellent question, actually. It's been an ongoing struggle. For live performances, we always had problems with feedback, always had problems with sounds bleeding through. They make a pickup for the harp which is a contact microphone that's really sensitive. I saved up for one for about two years. I finally got it, and it's my new best friend. In addition to that I use an air mic, to get a more organic sound. There's potential for it to sound a little canned if it's just the pickup, because that only picks up the sound waves directly on the harp, it doesn't pick up any of the ambient noise, any of the sounds after they've softened through the air a little bit. I have the vocal mic right here, right on my mouth, angled away from the strings. And then I have a condenser mic in the air pointed at the strings. And it usually works out.

OUR MUSIC DESERVING
DEVOTION UNSWERVING

BLVR: You've got this really distinct singing style—I wondered if you taught yourself that, or whether you had training.

JA: Definitely no training on the voice. It's kind of intuitive.

BLVR: Who are your inspirations, influences?

JN: Ruth Crawford Seeger is a huge influence. She was an American composer who was working from about the twenties to the forties, and she was part of the whole group who were working on creating a new American sound—classical composition, but a sound that was specifically American rather than Eurocentric. She eventually married a composer, Charles Seeger, and stopped composing, because she didn't believe at that time that you could be a composer and a mom. Her kids were Mike Seeger and Peggy Seeger and Pete Seeger, and all of them became very involved in the folk movement in the sixties. So I feel like she's representative of the intersection of art music and folk music. Also, I love Karen Dalton. She was a singer in the sixties who ran around with Fred Neil and Bob Dylan a lot, and had a beautiful voice. Devendra Banhart introduced me to Vashti Bunyan's music—she was an English singer in the sixties, and I love her songwriting style. I love Donovan, Kate Bush, Leonard Cohen. Dylan, of course.

BLVR: Do you like performing? Do you get nervous?

JN: I do get nervous. It sounds sappy, but the truth is that it was with such shock and delight that I discovered that there were people in the world who would willingly listen to the noise I was making, that it overshadowed the fact that I was terrified… It was never a stated goal of mine to be a professional musician. But it would be incredible, now that it's been dangled in front of my face as a possibility. I toured with Bonnie "Prince" Billy last year, and he turns his tours into these incredible road trips. We all went to the Grand Canyon on Easter, and he'll always say, "Go to this hot spring on the way to so-and-so"; he'll route his tours to little strange towns in the middle of nowhere.

BLVR: I love his music. What's he like in person?

JN: He's wonderful. I was terrified to meet him because I thought he would be very somber… he's not. When I was making my record we had email exchanges through a lot of it and he was one of the most comforting people to speak to, because he told me: it'll be OK, you've just got to do exactly what you believe in and not worry about how people are going to receive it.

I knew I believed in my music but I was worried that other people might be listening to it for the wrong reasons, because there's this indie aesthetic that the more shoddily recorded a piece of music is, the more strange the background hiss is, the more nostalgically low-fidelity it sounds, the better received it will be. And I had made two home recordings already (prior to the current album), by necessity, and it's not my style. I don't believe in leaning on that sound to provoke an emotional response from an audience. I think that's cheating. I'd had a few people listen to early versions of the recordings for this new album and they'd say, "I like it, but it just sounds too clean, it just sounds too professional."

Also my voice has changed since the very earliest recordings. I honestly had been singing for about a week when we recorded those first songs, and there's a sense of terror you can hear—you can hear me teetering and trying to catch my balance. Since then my voice has dropped, it's settled, it's become more what I want it to sound like. But it has lost a bit of what some people lean toward—a lot of people were excited about the earliest recordings because I sounded like I was five years old. That's not what I was trying to do. You sound like you're five if you've never had a singing lesson in your life! I was so afraid that I would put all this energy and love into this record and then it would not be liked because it wasn't strange enough for the people who flocked to it originally for its strangeness… They're interested in it as a novelty; they're not interested in the lyrics or instrumentation, they're just listening and saying, "Look, ma, she sounds like she's five years old! Shucks!" I still maintain that I do not.

BLVR: Your voice is definitely unique. That's not how I would describe it.

JN: Texas Gladden, who was an influential singer to me, she was a grandmother when she got recorded. She was in her seventies. And I've had some people say they couldn't tell if I was seventy or thirteen. Which I prefer. I like hearing that. Because it's closer to how I feel when I sing.

BLVR: The songs do have this sort of wise, fairy-tale-telling tone.

JN: I'm certainly not interested in innocence at all. I get very upset when people tell me that my record's all about innocence. If I'm interested in childhood, it's not the innocence, it's the part of childhood where you have this huge capacity to be sad. You understand an innate sadness in a lot of things, and you also understand an innate beauty in a lot of things. You pick apart something dead that you find on the side of the road, or you ask really embarrassing questions at the dinner table. There's this curiosity and this lack of embarrassment and lack of self-censorship— that's interesting to me. But not innocence, because I think innocence in music is something that exists in a vacuum, like it hasn't been exposed to any ideas. And it would be a huge affectation, too, because I'm twenty-two, I live in San Francisco, I watch television, I drive a truck—

BLVR: Do you?

JN: I do.

BLVR: What kind of truck?

JN: Chevy S-10. But I'm looking for a new car because my truck leaks on my harp when I drive it around. I have a camper shell and padding, I have it all tricked out for my harp, but it's leaking persistently. There's a pernicious leak somewhere—I've had it fixed thirteen times and no one can find it. It's going to destroy my harp one of these days.

BLVR: One final question—if you could know the day and time of your own death, would you want to know? Or would you rather not?

JN: If I could be assured that I'd be old, then yes I'd want to know. But I'm so easily made sad that if I found out I was going to die on my thirtieth birthday I'd probably cry every day between now and then. I can't fathom myself making peace with that idea. I really like being alive. A lot. I'd never want to know, because of the possibility that it's sooner than I'd want it to be. I'd be grieving for my own death every day. I don't think it would make me more productive. Some people get empowered by it and live these really rich beautiful lives. But I don't need the fire behind me, like "You're going to die on your thirtieth birthday, so get cracking, kid!" I'm perfectly happy to just exist. ✷

EDDIE VEDDER
[OF PEARL JAM]

talks with

CARRIE BROWNSTEIN
[OF SLEATER-KINNEY]

"YOU'RE FINDING YOURSELF ON THE COVER
OF 'THE ALL-GRUNGE SPECIAL ISSUE' OF
SOMETHING OR OTHER, WITH PULLOUT
POSTERS AND THE WHOLE DEAL. AND YOU'RE
THINKING, 'WELL, WHO ARE THESE PEOPLE?'"

Places, and what they were not:
California suburbs: The San Diego punk scene
London: Mars
Hershey, Pennsylvania: Appreciative of political commentary

I met Pearl Jam's Eddie Vedder in Seattle in 1998, outside a club called The Crocodile Café. My band [Sleater-Kinney] was playing that night and Eddie walked up and stood in line behind me and my bandmate. He introduced himself to us and said he felt like he was standing next to Jagger and Richards. It's a compliment a girl doesn't hear too often.

It's not that his comments fed my ego, or were commensurate to my own sense of self, but they were indicative of something that I would later learn is intrinsic to Vedder: he is unafraid to be a fan, and music is an entire universe for him.

Whether he's bringing the Buzzcocks along on tour to introduce his audience to some English punks who were there at the beginning, or

playing a cover of the Clash's "Know Your Rights," doing a pretty good job of imitating Joe Strummer's hoarse and plaintive cry, Vedder is all about sharing. On the tour we did together in 2003, I watched musicians from the likes of Steve Earle to the Dead Boys' Cheetah Chrome take the stage beside him. Well, actually, in front of him, since he often slips into the background to watch. Even when it's just his own band on stage, he'll step aside during a Mike McCready solo, steal glances at the crowd, rock back and forth; sometimes it's more like he's part of the audience than the lead singer.

We were all on stage one night, playing Neil Young's "Rockin' in the Free World," which was typically Pearl Jam's last song of the encore. We got to the break in the song, and I guess the drummers thought the guitarists would keep playing and vice versa, but it turned out that none of us did. We all stopped. For a moment, it was just Eddie. "There are a thousand points of light," he sang. There was nothing behind him. It was a clumsy and beautiful moment. He turned to us, smiling, as if to say, "What the fuck?" and we came back in on the next beat. I remember thinking later that he could probably do all of this on his own, but I know he'd rather be part of something bigger, and he'd rather have music filling the space around him, so that he can be a performer and a fan at the same time.

—Carrie Brownstein (June 2004)

I. IT'S AN OCCUPATIONAL HAZARD JUST TRYING TO LIVE.

CARRIE BROWNSTEIN: Is tomorrow the day you're quitting smoking? Do you want to discuss that at all?

EDDIE VEDDER: Yeah, let's see. Well, it's shameful that I thought that we should talk before I quit. I'm still at the point where I think that I get my best thinking done when I've got a fucking cigarette in my mouth.

CB: Do you quit today or tomorrow?

EV: Well, I'm going to be hypnotized tomorrow. To assist in my quitting. And I'm also going to ask her if maybe she can throw in something

about writing and being able to write a better bridge. You know, better bridges for songs.

CB: [*Laughs*]

EV: We'll see. When I think about it, man, I've got all kinds of things I'd love some subconscious help with.

CB: Is the process that she hypnotizes you and then talks to you about your smoking and about how you could go about writing better bridges?

EV: You know, I'm just kind of going to go in open to it. And I think I'm fairly malleable. I think I can be talked into something like smoking or writing better. I just know that I'm over smoking. You know, I feel like I've gone on long hikes and gotten to the top of the mountain and I'm looking at something beautiful, some great huge landscape, and there's some of the cleanest air that's on the planet. And then I light up, and say, "Ahh, what a great smoking moment this is!" So it's something evil that's taken over, and I want control over it.

CB: When you play, can you feel that you're a smoker in terms of singing or jumping around on stage?

EV: No. That's the problem. It hasn't really affected any of that. And I feel I can get away with it. But now I've smoked since right around when Kurt died or whatever.

CB: That's when you started smoking?

EV: That created some kind of neuroses that I needed to pacify.

CB: Your band and music community have suffered numerous losses over the years, from the events at Roskilde [Nine people died in the mosh pit at a Pearl Jam concert in Roskilde, Denmark, on June 30, 2000.] to the death of friends. Do you ever feel that it's an occupational hazard

to play music? What helps you to move forward?

EV: Along with those who aren't around anymore, I include relation-ships in the same loss column. It's sad and it's tough. But it is for those in sales jobs who have to travel, and those in the military. For most people, I guess. It's an occupational hazard just trying to live. So there's nothing to do *but* move forward. Everything's in a constant state of change, so the challenge is to accept that and be moving with it. That Howard Zinn line sums it up: "You can't be neutral on a moving train."

II. "I DON'T UNDERSTAND TELLING ANY KIND OF ARTIST THAT YOU DON'T WANT THEIR PERSONAL OPINIONS INVOLVED."

CB: Not to necessarily launch into politics right away, but I wanted to ask about your last tour. In Denver, a comment about Bush elicited a slightly negative response from some of the audience. [*During a perfor-mance of the song "Bu$hleaguer," Vedder, who had been wearing a George W. mask, removed it and placed it atop the microphone stand. He then continued singing the song to the mask. Afterward, he took a moment to share his feelings about our president with the crowd.*] How difficult was it for you to voice dissent?

EV: Well, actually that was really our tour, wasn't it? Because you were there—

CB: Yeah. I was with you and felt it. You don't have a small audience, and when you voice dissent or voice an opinion, it's heard by upwards of ten thousand people.

EV: Well, we should clarify that that first night in Denver when that happened we didn't really hear anything negative. And I think that I talked to you guys the next day when we were kind of shocked by some of the reports that were coming out. "Concertgoers jam exits in response to anti-Bush comments during Pearl Jam concert." And, you

know, when I showed that to you and we talked about it, you guys said that you didn't see any of that at all.

CB: No. In terms of the audience not wanting to be there anymore or it affecting their love for you or the music, that was completely false. I think there is a kind of silence that comes over the crowd when you talk about politics, mostly because people really want to hear what you say. And I think in Denver there were some people who maybe disagreed with you, but I don't think that caused them to walk out.

EV: Well, that's what I thought. What I think was really interesting to go through was watching the effect that improper reporting, or even irresponsible reporting, had on people's perception. That stirred up the right-wing conservative radio and everything else that was on the ticker tape of CNN or Fox News. That was the scary part. That's when we had to talk as a band, and, you know, a couple of members had wives, homes, and a couple kids and they live in a normal area that's not really secure. And you get this heat built up behind you, and you hear all these kinds of crazy stories like the Dixie Chicks, their houses being vandalized, and their grandparents being accosted at the seniors' home.

CB: There's so much skewing of the truth. And now, in retrospect, knowing about the lack of weapons of mass destruction, it seems that the media is also partially accountable for never asking this administration the right questions, for never challenging them. I think people's eyes are opening up to a lot of these things right now.

EV: I remember when this was all kind of happening and showing up for our first shows. At sound check you guys were playing "Fortunate Son," and Jeff [Ament] and I were sitting in the back and smiling, because we had been playing that one in Australia. And at some point we started playing it together. And at the end, it felt like real solidarity in the face of no matter what. We had our convictions, and no matter what the paying audience was there to see, or what they were open to, just to play that song or to stand at the end of "Rockin' in the Free World" or something,

and to hold Corin [Tucker, of Sleater-Kinney]'s hand. It was exciting, too, being representative of male and female, and stand there with our peace signs up, and just kind of stare at the crowd at the end of this song, at the end of this night. The strange thing about it was that at the time it was frightening and felt like a really bold stand to do that. What's interesting now is it wouldn't seem to be a problem a year later.

CB: Yeah, I agree. Obviously with a crowd or audience as large as yours, not everyone is going to agree with you and your personal politics. Does that ever bother you? Because it feels like, for other bands, that can feel really alienating.

EV: Yeah. I think the most frustrating thing is that I don't know how many. Sometimes I'll get letters or something. I like to see both sides of everything, and I'll get something nasty like, "Just shut the fuck up and play your guitar."

CB: Right.

EV: And that's one thing I don't really understand. I feel like if Kurt Vonnegut, or anybody else whose art I appreciated, volunteered some personal viewpoint, whether I agreed or not, I think I'd just be curious to hear and then take it from there. I have every right to disagree. But just to say, "He shouldn't do that" or "That's going to keep me from reading his books." That, I don't relate to at all. I don't understand telling any kind of artist that you don't want their personal opinions involved. Every time I mention rock-and-roll music as art, I just know that Mark Arm [of Mudhoney] is kicking somewhere. Which is good, because it's a good barometer. I just think that it's something that, for the people whose music and work I've always appreciated, that's always been part and parcel. So, I'm actually someone who's the other way. I want to hear that kind of stuff, especially if they've worked hard to educate themselves on the issues.

III. "THIS ADMINISTRATION HAS MADE OUR COUNTRY INTO A LIABILITY UPON THE EARTH."

CB: Do you think that music still has the capability of being political, spearheading political movements, or bringing people together?

EV: Yeah, you know, I talked to someone who was making music during the sixties, and they felt that even then it didn't do any good, and that it was only the body bags coming back from Vietnam that ultimately stopped this thing. And Walter Cronkite, being the kind of respectable adoptive grandfather of our nation at the time, coming out at some point to say that what we're doing is wrong. That held more sway than all the peace movements. Whether I agree with that or not, I don't know, but I think it's interesting. I'm just always shocked by the number of voters there are, and that Bush was elected by less than a quarter of the voting public. That's a very small percentage of the people that agreed to vote for him and to put a president in office. And even that, what were those people thinking? And I don't know if people were so ignorant that they thought that Bush Jr.—a silver-spooned frat boy, doing deals all his life, failing at these business deals, rescued out of every bad business deal he ever did, getting the deals because of his last name—how people thought he was someone that they could relate to as a working guy, or as someone they could sit down and have a beer with? I don't get it. If you think about all the people that aren't voting… It could be the power of music. I don't know what it could be to get people to vote.

CB: Right now the way the music industry is, there are bands that seem to be sort of punk or indie, and they're on the mainstream airwaves and on MTV. For the most part, these bands aren't involved in politics.

EV: I think there's one kind of cool thing going on, it's called *punkvoter. com,* and between that and *MoveOn.org,* those are two really interesting things. They're kind of doing Rock Against Bush tours. They're actually talking to people about what they can do.

CB: Is this like Bands Against Bush?

EV: Yeah, sort of. I think what's neat about that is that they're actually billing it like that. You know, you almost have to do that, say, "We're actually going to be dealing with this stuff tonight, in some way or another."

CB: I think, partly, though, they might be preaching to the converted, when you have a bunch of people showing up because they're obviously against Bush. There's something to be said about not billing it like that and including it in your set wherever you play. Sometimes at our show I'll say something and I realize, Oh, OK, everybody just cheered, well that was easy.

EV: Yeah. Putting it in a context where maybe you're not necessarily preaching to the converted. But I guess even if you are preaching to the converted, as you said, it's making sure that people who want Bush out of office are actually voting and not just cheering at your show.

CB: What are your thoughts on why people aren't turning out to vote, especially those who seem to want things to change?

EV: Well, today I went to the hardware store, and I put a couple of things in the back of my truck. And drove home, which wasn't very far. And then I got out and went to take them out, and they were gone. They were missing. There were these aluminum poles and they just flew out of the back of my truck. So, I drove all the way back looking in the gutters to see if I could find these poles and didn't find them, so I had to rebuy them. As I was driving back, a little more cautiously this time, I started thinking about the youth vote. And that made me think, that's kind of what it is, this incautious driving, it's like people not voting. I think they just think that that's all kind of taken care of. Maybe the college youth vote is different than the unemployed youth vote, and I don't even know if it's indifference, but there's an idea that grown-ups are taking care of it or something. Or it's stuff that that they don't understand.
 Well, a lot of it isn't that hard to figure out, especially with the advent

of the internet. There's a lot of information out there, and obviously it's the same information that you won't get by just watching the regular news. And you might not pay attention to it, but it's there, and you can get to it. There's people speaking across the country, and there's access to this information. And I feel like they have the country's future on the back of their truck. And they're up front driving fairly recklessly, thinking that it's all going to be OK. And then when they finally stop and look in the back of the truck, it's not going to be there. And then when they turn back and try and get it, they might not even be able to replace it. I think that it's such an important time to be participating in the process right now.

Really, it is the time to be involved. This is one of those times. This is one of those times, yet I don't necessarily feel it coming together.

CB: I agree. I feel like, what are people waiting for? One problem that I see is that despite the fact that people have information at their fingertips with the internet, it almost seems like the information is too diffuse. News about Britney Spears getting married was more watched than the State of the Union address. I feel like it is a double-edged sword to have so much information available at all times. Now people can tune out the thing that maybe they should be focusing on.

EV: I feel like they maybe look at *MoveOn.org* and just think, Oh, someone else is taking care of it. Because a lot of the things that seem to indicate a lot of people getting together or building means of protest seem to be happening in this sort of virtual world. And I know that there are real-world counterparts, but I just wonder if there's some sort of passivity that's created where we just look at *MoveOn* and think, Oh, OK, it's happening somewhere, you know?

BLVR: How do you think we can we remove the disconnect between virtual involvement and real-life involvement? What would you like to see happen?

EV: The one thing I think is that to vote the Bush administration out of

office would be such a tremendous thing. It would be such a tremendous message internationally, as well. I mean, if you're going to have control over something, you've got to treat it with respect. I think right now, this administration has made our country into a liability upon the earth.

IV. "IF THERE WAS A REVIEW, IT WAS JUST ABOUT HOW WE DID THIS THING AGAINST TICKETMASTER."

CB: I think, for some artists, the fear of taking on a political identity stems from not wanting to be pigeonholed as a political actor or a political musician. It becomes this thing where somehow your art can no longer exist on its own and be multifaceted. It seems like some people are afraid to venture down any road of political activism because of that, especially with how the media starts to represent you.

EV: That was part and parcel of the conversations that the band and I were having at that time about what was happening. Because after we went through the Bible Belt, we went up through Jersey and we thought, OK, now we can even talk a little more freely.

CB: Right, or play "Bu$hleaguer" again.

EV: And when we did, then that was the biggest negative reaction that we got, I believe.

CB: Oh, that show. It was Hershey, Pennsylvania.

EV: I think after that show, when there was a large contingent chanting "U. S. A.," there was a bit of a standoff at the end of the Bush song at that moment. At that point, that's when we were having conversations about how it's true that we're involved, it's true that we kind of all share these same beliefs. But we remembered how we went through a tour after we went up against Ticketmaster and then it became, like, the Ticketmaster Tour. Anything that people were talking about, or if there was a review,

it was just about how we did this thing against Ticketmaster, and not only did it but failed. Because there had to be a winner and a loser. It felt like it had taken away from the music. And we felt, selfishly, that we were working hard and playing well, and that wasn't what we were about anymore. It was about something else.

V. "I'VE ALWAYS BEEN THANKFUL THAT I WAS LET IN AND ACCEPTED."

CB: For how many years after you started did you guys do interviews with the media?

EV: Well, I think everything changed when we started the second record. I think we still kind of cut down, but we did some then. That's when everything started feeling really strange. Because that's when you get the process, at least in our kind of journey, that had that really sharp spike upwards at the beginning. It was kind of a strange feeling of being co-opted, and you were kind of just a product. You're finding yourself on the cover of "The All-Grunge Special Issue" of something or other, with pullout posters and the whole deal. And you're thinking, Well, who are these people? Do I know them? And not that you're concerned but, Do we even get paid for this? It's just out there. And the only frightening thing is even to myself this is overexposed. I'm overexposed.

CB: And probably don't know who you are anymore. Do you ever look at a magazine with yourself in it and just think, "That's not even me"?

EV: Well, back then, it felt like that. Or going to a Halloween party, and having someone with the pullout poster, he's cut it out and made it into a mask.
 [Both laugh]

CB: Did that happen?

EV: Yeah, yeah. He thought it was going to be funny. But I was way too

sensitive at the time. It's just like, ordinarily it might be funny, but it's not right now. And it was hard to keep a sense of humor about it. It felt like, I think there's a line in *Death of a Salesman*, "You just can't eat the orange and leave me the peel." And there were also just ideological issues that came up with either the music-television station or something else, where they had plans and they did things a certain way, and I just kind of didn't want to do them that way. So in order to say no to a few people, you kind of had to say no to everybody.

CB: Did you guys have a sense of what kind of music you were playing before it was labeled "grunge"? I feel like right now there are so many genres of music; it's become even more compartmentalized. And then this label "grunge" was placed on this certain sound coming out of Seattle. How did that feel to have a genre created for you by outsiders, instead of naming your own?

EV: I think that I felt secure, because I felt that we had our own musical language that we were kind of working with. And Stone [Gossard] and Jeff had played together for so long, and we were all integrating in this new relationship, and doing it in a way that I felt was different. I felt like it was our kind of thing. And then, as far as being put in with all the other bands at the time who happened to be from the same geographical location, I used to look and listen and read about the Who and the early days of the mod scene. This was when I was like fifteen, and I would just think, Oh, you know, god, if I could have just *could have* been involved! How great it would be to have been a band that grew up in that kind of a community thing? At this point I was in San Diego, and there were a couple of things going on, but it wasn't an intertwined kind of community. It was too close to Los Angeles. The community's kind of laid-back and wouldn't come out and give themselves up at a rock show. So, to just kind of end up in a situation where there was a community, and there was all of a sudden a little bit of a movement, a musical movement, anyway. There were some really strong bands, at this point, when the attention was still kind of healthy, it was really kind of exciting. And because I was always kind of an implant, I felt like once I started to feel

kind of accepted, I was always just so proud of being from here. And I still love Seattle and this area and the people. I really love Seattle and the Northwest. I've always been thankful that I was let in and accepted and really proud. I remember, at one point, thinking, god, OK, I used to read about the Who, and I used to think about this time of music and that time of music and think, Wow, we're in one of those right now—this is pretty exciting.

CB: So you moved to Seattle before *Ten*, then?

EV: Yeah, I think it was September or October, or sometime late '90. We kind of got right down to business. The Mother Love Bone band had just about been ready to hit the road or whatever after their first real record, when they lost Andy [Wood]. He passed away because of the heroin thing. I think that they were kind of ready to go on something. There was a lot of energy there, from their loss and their expectation. They had a band, and then they didn't have a band, so they were ready to kind of have a band again.

CB: Right. And did you audition for them, or were you just friends with them and said, "I sing"?

EV: Yeah!
 [*Both laugh*]

EV: It was a tape that I sent up through my friend Jack Irons. They said, "If you know any singers…" That was just kind of a random tape that I sent up to Seattle. They had an instrumental set of tracks that I think they recorded with Matt Cameron. And I think that half of that was on *Temple of the Dog*, and the ones I wrote were on our records.

CB: What's the first song that you wrote with Pearl Jam that you felt really proud of?

EV: I think the first one on that tape, there were three songs on that

tape; I think that "Alive" was one of them, and "Black" was one of them, and I think "Once" was one of them. "Alive" and "Black" are the same as they were then. And they're kind of cool. We recorded a lot, we practiced for a week and we recorded on the last day. I think I went home with a tape of ten or eleven songs, and most of them were on the record. And again, it seemed like a lot of stuff I'd participated in before was kind of derivative or overly derivative, and this kind of had its own thing.

VI. "I GOT STARTED WITH THE JACKSON FIVE. I GREW UP IN A GROUP HOME KIND OF THING."

CB: You and I played Scrabble a few times on tour and I noticed that you are one of the least competitive people with whom I've ever played a board game. It could have just been the wine, but are there any areas where you are competitive?

EV: Certainly not with music. Competition is healthy, if you can turn it off and on. When someone gets too cocky in victory, that can ruin the positive aspect. Then they must be destroyed. [*Smiles*] Justice must be served. The trouble is, sometimes I'm that guy.

CB: Do you ever watch up-and-coming bands who are heaped with praise and hype and wish you could go back and be there again?

EV: No. Not at all. If it's a band I like, I just hope they will survive it all. And I'll admit that if it's crap music, I hope they won't and it'll go away. Simply because there are too many great bands who should be heard in their place.

CB: Did you play in bands in high school? When was the first time that you performed in front of people?

EV: I remember some kind of block party or something. Some kind of keg party in San Diego. We had a couple of little bands like that. It was

five guys and we all had jobs at drugstores and whatever. That was really bad, because one guy was really into the Cars, and I was into the Who, and the other guy really liked the Eagles. So, ugh, god!

CB: You can't do Eagles-Cars-Who.

EV: No, it was awful. It was just awful.

CB: So your drummer sang, and you had a keyboardist?

EV: Yeah, who was into Styx.

CB: Yeah?

EV: So this is good. You need to go through this.

CB: It's true. Do you remember the first time that you heard your voice recorded?

EV: Well, that I was probably doing from a pretty young age, because I was always like into tape recorders and things like that. So I was always kind of writing, and I actually remember writing songs when I was like *really* small. Writing a sentence and writing arrows over it, and then two arrows if I go really high. And this is when I'm like seven or eight. My dad died of MS, and I didn't know my father until after he died. And I guess he was a musician, so that maybe speaks something of genetics. He was a lounge singer.

CB: Really?

EV: Well, he played with the cup on the piano and that kind of stuff.

CB: Did you ever hear anything that he had recorded?

EV: Yeah, I got one tape. And it had like a Gordon Lightfoot song, he

kind of had a Gordon Lightfoot kind of voice. And then there was one that he wrote and he put my name in it, which was kind of cool to hear.

CB: When you were born, was he around? Or were your parents divorced?

EV: I guess he was. I guess he was around a year or two, which I don't recall. And then by the time they had split up, my mom got remarried. And then he was never spoken of again.

CB: That's pretty intense.

EV: Which was interesting. Because the theory was, because I had three younger brothers, they didn't want us to feel like we were different. And I think it worked: I mean, we were really close.

CB: Did you ever play music with your brothers in any kind of family revue?

EV: Yeah, we played a song for my mom on her sixtieth birthday. We played "Long May You Run" and "Let My Love Open the Door," I think. That was very nice.

CB: I love that Townshend song. What kind of music did you listen to growing up, specifically vocalists? Who was inspiring to you?

EV: Well, I got started with the Jackson Five. I grew up in a group home kind of thing, where we had like black brothers and Irish brothers, and there was a basement down there. That was the late sixties and early seventies, there was tons of Motown around. It was in Chicago. Sly and the Family Stone, and anything on a Motown label. And Stevie Wonder. And then there was the Jackson Five, which I could relate to because they were kids. So it went from that to *The Last Waltz*, and all those people in that movie. There was Bob Dylan, Neil Young, Ron Wood, Muddy Waters, and Van Morrison. All these people just kind of got ingrained

in my head as being just great. And then I used to steal records from my uncle, and he would let me, which was great. He would just call my mom and say, "Is *that* where the record is?" And she'd say, "Yeah." It was nice at age eight or seven, I could listen to Woodstock and put on Country Joe and the Fish with all my friends.

CB: Were you in the Southern California punk scene at all? When you talk about block parties, was that indicative of your scene? Or was it skaters and surfers?

EV: You know, there was no scene. I was just in some kind of suburb, and the waves didn't reach that far or something. And I think the other thing is that my parents split up when I was a teenager and I had a job. So I couldn't have a mohawk. There was one other kid in my school who was kind of punk-rock, rebel-type guy, and he had the look. The only thing I could do was wear my mod shirt or my PiL T-shirt. But I had to work at the drugstore and construction jobs and stuff. Yeah, I was the ripe age for it. Even Thurston Moore asked me about it. He was like, "God, you were just ripe for that." And I said, "Yep, missed it."

CB: It was going on around you.

EV: You know, I wish I was part of that. It would have been great, and it probably would have changed for me musically a little bit. The most exciting thing to do where I was, was maybe go see the midnight show-ing of *Dance Craze*. I relate to all those tons of kids out there, who at least now can maybe buy their music over the internet or something. I think Jeff Ament was the same way, ordering music from catalogs; he grew up in a super small town. You had to find it out on your own. There wasn't really a scene, and you were probably ostracized a bit, or people didn't relate to you. I mean, everybody else was listening to, god, I don't know what—Journey.

VII. "IT'S TO THE AUDIENCE'S CREDIT THAT THEY STUCK WITH US."

CB: Is attempting to have music be very accessible the idea or impetus behind all of the live-show bootlegs that you've put out? Or is that more in response to curtailing the massive amounts of illegal bootlegs or downloads?

EV: Yeah, it was kind of twofold. I mentioned before that I was just really into tape recorders. I worked at this drugstore, I worked there when they came out with the first Walkman. I'd buy that with my paycheck. And then the first recording Walkman, I'd sneak those into shows for just my own personal kind of thing. I never made copies or anything. I was just so into it. I was just so into being able to relive. So much energy comes out of concerts sometimes, especially good ones that are really moving. And that energy, no matter how great the show is, it dissipates within two weeks or a month. And that was my way of being able to put myself back there into a great space. The first time I saw the Who was in 1980. I was fifteen or something; for the first half of the show, I couldn't get around the fact that those four guys were standing in the same room in San Diego. At that point, the way I thought of geography and the way I was being brought up, I was intimidated by the rest of the world. I never thought I'd travel. It just wasn't part of my upbringing. London might has well been Mars, you know?

CB: Right.

EV: And that's where the rock gods came down and blessed us. Really, the excitement of that, seeing them for the first time. To get a good tape out of a show is hard to do. There's inevitably somebody screaming next to you or arguing with their girlfriend next to you. Even the people that you're with keep talking in the mic. And you're like, "Oh god, I know this is just a show, but I'm going to listen to this thing 350 times!"

CB: Yeah, and also it's so interesting when I think about people bringing

in their own recording equipment. I can understand the reasoning behind it, but the sound is so bad. I remember doing that in Seattle, just going to shows when I was a teenager and recording things and listening to them over and over again. They didn't have any fidelity whatsoever, just static.

EV: Yeah. No, you really had to put on the headphones and close your eyes. Your ears had to do the work, and then you could get something out of it.

CB: It's totally more about capturing the experience and having some kind of document of actually being there. After we went on tour with you I got some of the bootlegs. Just being able to hear a more nuanced show, to hear something that I didn't hear the first time around, or even to have your stage banter on tape, it's exciting. And I can see that for your fans, in some ways that must make them feel really special. They're allowed to experience any show they want, whether or not they can be there. It seems like that's one of many things that you guys do, in terms of having a more direct connection to your fans, that a lot of other bands don't. It seems to me that not doing interviews back then created a closeness with your fans. There was a connection that was just going to be between them and you. There's really nothing mitigating that. They weren't going to read about you or read an interview. They weren't going to see a video on MTV. Suddenly the experience became about the live experience, which is pretty unique.

EV: Well we certainly scaled down our crowd quite a bit, especially our record-buying crowd, to the point where we succeeded in a perfect act of sabotage.

CB: Do you remember when you decided, as you were saying earlier, to say no to the media and to MTV? Did these institutions criticize you? And did you experience criticism from your label and your manager?

EV: I think what happens is when something becomes successful,

then a lot of people take credit for it in such ways that it takes credit away from you. I don't even think it's ego, but you're thinking, you're just saying that we were a successful marketed product. And that flies completely in the face of what we're seeing when we're playing and getting reactions from a crowd that I don't think that you would get just normally. I really think that something pretty special was happening. So it was an insult, you know obviously there was some marketing involved and some MTV exposure, and there was all this stuff. But once people were in, they didn't have anything to do with that. You want the power to be in the music and the credit to go to the music, and your connection with the people coming to the shows. You want to kind of wrestle it away and say, "OK, we're not just a bar of soap with a package that you created that is now selling copies and making you a bunch of money." Do you know what I'm saying? There's more going on here, and that's the thing, I don't think they get it. Or they were getting it, or they would kind of say they got it.

CB: In some ways, you proved that that was true. Your success and your fans' connection to the music was not dependent on the media. You somehow maintained, through no videos, not as much mainstream radio play, and not a huge press blitz concomitant with the release of your albums, a completely devoted following. It does seem like in some ways you've tapped into a way of thinking about music, an ideology, that fans share with you. Going to your shows and seeing your fans, I realized that nobody there cares about MTV. It made all those things feel really futile.

EV: It's to the audience's credit that they stuck with us. We couldn't have done any of it without them. And I think it's happened before. Maybe even with the Monkees. You know the Monkees wanted to play on their record and they wanted to play their own songs, and no one ever heard that record. I think bands have done it and tried before, but I kind of think that we were just fortunate.

CB: Do you feel like it's been worth it? You've traded some of these

things, massive amounts of money and stardom in this broader sense, for having a lot of control over your art.

EV: Well, the nice thing about money is that you can do good things with it. I still feel like if something needs to be done or we need to raise money for someone on death row, like in the West Memphis Three case, we can find ways to do it. It's harder that just writing a check, but you can still go out and do it. ✷

ROBERT POLLARD

[OF GUIDED BY VOICES]

"I MADE IT MY GOAL THAT IF MY MUSIC WERE EVER RECOGNIZED IN ANY WAY, I WOULD WANT IT TO LURE PEOPLE INTO MY WORLD."

Things not seen:
UFOs
Tornadoes
American Splendor

Robert Pollard has written an estimated ten thousand songs, both on his own and with his band, Guided by Voices. It's difficult to imagine what ten thousand songs might look like, or how a person could carry all that music around for so long. It would take a person with courage and fortitude, I think, and the ability to kick one's leg straight up on a downbeat while swinging a microphone cable in Roger Daltrey–sized arcs. It would take a person who has been focused on songcraft for twenty-plus years—a person capable of generating pure, devastating pop music at the rate most American men shed skin cells. Robert Pollard is that person, crammed to the heart with song.

Guided by Voices emerged like a bottled message out of the slick

sea of early-nineties post-rock with an intricate and deceptively fragile record called Bee Thousand *(Scat Records, 1994), recorded entirely on a 4-track, which sounded like the brilliant, faded home demos of a forgotten British psychedelic band from 1968. Though it was generally received as a debut, the band had actually been holed up in Dayton, Ohio, since the early eighties, and had already recorded six albums in isolation from the cultural whims of the world. Listening to* Bee Thousand, *then, was like uncovering an artifact from a remote, hinterland village, a land ruled by superstition and witchcraft—startling and enlightening, and maybe a little terrifying. Most importantly, though, the album managed to rock, effortlessly—despite (or maybe because of) the prohibitively crude nature of the recordings and the endless queue of perfectly executed hooks.*

In the years since, Pollard has released well over a dozen more records. He's been so willfully prolific that, for a while, it seemed as though he would simply go on releasing songs forever, without interruption, maybe into the grave, but this past May he announced that the new Guided by Voices album, Half Smiles of the Decomposed, *would be the band's last. It is an incredibly diverse and heavily textured swan song—easily the band's best record since 1996's* Under the Bushes Under the Stars—*in short, a wild, passionate suicide note from one of the all-time greatest rock acts in Western history.*

—Matthew Derby (August 2004)

LAND OF THE DEVIL WIND

THE BELIEVER: You live in Dayton, Birthplace of Flight and home of the Wright-Patterson Air Force Base, which raises the question: have you ever seen any experimental aircraft of any sort in the skies over your city?

ROBERT POLLARD: I've had friends that have seen things. Sometimes things that have even come really close to them, but I've never seen anything like that myself. I've seen things zip by really quickly on occasion, but nothing in any detail.

BLVR: I'm asking because this man I know used to live in Virginia, near the Norfolk Naval Base, and he said that whenever he went to the beach he would see these experimental military aircraft over the ocean. One time he saw what he described as a floating cube the size of a compact car—it was just hovering over the ocean. The first line I ever heard you sing was, "Sitting out on your house / watching hard-core UFOs," so I've always assumed that you must have been influenced somehow by mysterious, inexplicable objects hovering in the sky.

RP: The imagery that I've injected into the songs is really more about a yearning to see those sorts of things. I wish I could—I mean I'm very envious of my friends that have seen that kind of stuff. I wish I could say that I've seen something that's surprised me like that—I mean, hell, I've never even seen a tornado. Actually, there's this place called Xenia in Ohio, and it's supposed to have the worst tornado activity in the history of the United States. There's even literature from the eighteenth century of Native Americans who are said to have called that area the Land of the Devil Wind. People say that it's cursed. I guess that doesn't really have anything to do with flight, but my point is that I've never really seen anything strange in the sky.

BLVR: Have you seen *American Splendor*?

RP: Not yet.

BLVR: I just saw that film again the other night, and I noticed all these commonalities between Harvey Pekar's comics and your songs. Aside from the Ohio connection, you're also both describing a bleak, postindustrial landscape, populated by a slew of memorable, idiosyncratic characters, for whom you feel, in equal parts, admiration and pity. While I was preparing for this interview I had the pleasure of listening to all my GBV records, end on end, and I realized that your songs are densely populated with oddball characters, some of whom are based on people you know in Dayton and others you've made up, who seem to survive on a threadbare hope for the future. And, like Harvey Pekar, you seem

to draw energy from these people—you keep them close to you because one day you know they're going to surprise you with some profound insight.

RP: Early on, I made it my goal that if my music were ever recognized in any way, I would want it to lure people into my world, the way music has affected me in the past, like when I first heard R.E.M., and there was the mystery of the South, with the kudzu growing over everything, and the people—it made me want to go down there and experience it for myself—there was a sort of magic to it. So I wanted to incorporate what it was like to live here in the Midwest, in Dayton, where there's really nothing to do but drink and watch airplanes. I wanted to convey the mundane nature of the place. It's restrictive in a way but it's also what keeps me here. It's what keeps me coming back here. There's a comfort in it. I've thought about living in New York City or Austin, but I know I could never do it. I've got too many people here that provide me with ideas. I mean, I've always been more interested in creating alternate worlds rather than literal ones. I feel like there's a spiritual component to that as well. I write about these alternate worlds that I believe might exist, but I'm also doubtful. I think it's a good-and-evil thing. I've always thought of Guided by Voices on those terms—the devil and the angel sitting on my shoulders, both whispering things in my ear. And I never really know which way to go. And to me, rock and roll has to have that darker side. Positive all the time is boring.

BLVR: I think that's precisely the quality that differentiates your work from a lot of other pop music—there's always something malevolent creeping at the periphery of your songs, even the brightest ones.

RP: The emotions have to be mixed on a record. It should be an emotional roller-coaster ride. Music, as your art, should reflect all the different aspects of your character, and, you know, I am a bit of a moody person. I have a temper; I can be mischievous at times.

BLVR: And sometimes you can be really happy to be pissed off.

RP: Yeah, and so any album should reflect the spectrum of emotions that I've experienced in the year the album was made. That's the spiritual aspect of the music. I think that you have to be aware of that and diversify the sound of an album as much as possible in order to reflect that phenomenon.

BLVR: That really comes across on the new album. All of the songs seem set apart from the others, and each seems consciously different from its peers.

RP: I actually put ten seconds between each of the songs, because I wanted each one to stand out on its own. There's something different going on with each song.

THE WISDOM OF OHIO CHILDREN

BLVR: So, your decision to pull the plug on Guided by Voices has a personal, emotional core?

RP: Even though I really like the new album, I really like the way it sounds, I feel like Guided by Voices, as a band, as an entity, has maybe gotten a little bit old hat, you know? Like, "OK, time to make another record." "How does it compare with the last record?" "How does it compare with *Bee Thousand*?" And everybody's a little… I'm not saying my band is complacent—I'm saying that *I've* become a little complacent. I don't think I'm being innovative enough in the studio, or as experimental, and that's really why I've made the decision—I want to get back to that. It got to the point where I was delegating roles for everyone in the band, asking for them to contribute ideas instead of coming up with ideas myself. Instead of taking an active role in the studio, playing guitar or whatever, I'd say, "OK, Doug, you're better than I am, so why don't you play this part?" I wanted to challenge myself, and I realized it was up to me to end the band and see how I might stand on my own as Robert Pollard and not as Guided by Voices.

BLVR: I think that's a really courageous move, and one that doesn't really have a model in rock. It seems like most musicians find a way to work that one trick that they've mastered and beat it to death, for years on end, touring even though half of the members of the band are dead...

RP: Yeah, that is exactly what I was thinking of—I'm forty-six and I'm going to be forty-seven soon, and how much longer can I do this? To continue being in a band to me just seems sort of silly—almost Rolling Stones–like. There seems to be more integrity and more maturity involved in carrying on as who I am, Robert Pollard, instead of being the leader of this band. To continue just because we've had some success with it and some people seem to be into it—that doesn't make any sense to me at this point. It's just really evident that there comes a time to stop, and I've actually been trying to stop for many years now—I even tried to kill Guided by Voices after [the sixth Guided by Voices album] *Propeller* came out, way back before anyone had even heard of us, but then we were signed and there was this new enthusiasm, and all these people who were interested in what we were doing, where before there was no one. So that carried us along for a while. But basically, you know, one day I just decided I was tired of looking at myself, and if I'm tired of looking at myself, then there must be a lot of other people who are just as tired.

BLVR: Tell me more about that time, right after you released *Propeller*, because, as I understand it, you'd been recording albums for over ten years, without ever really attracting an audience, and it was just by chance that you were discovered at that moment when you were thinking of throwing in the towel.

RP: I remember, around that time, a friend told me that at a Drag City party someone had said, "Have you heard about this band from Dayton called Guided by Voices? They have this album called *Propeller* and it's insanely great," and I felt it in the pit of my stomach that nothing was going to be the same after that—it was no longer going to be this fantasy world where we were making albums for ourselves, doing interviews

with ourselves and photo shoots with ourselves. And, to tell you the truth, it was much more fun when it was like that.

I was a fourth-grade teacher at the time, surrounded by ten- or eleven-year-olds for eight hours a day, and when you spend that much time with kids that age, you start to develop a similar mentality, and it's an immature mentality, but there's also a certain wisdom in it. And so I was reading them fairy tales all day, and just doing the general work you have to do with education at that level, and that got me thinking in that childlike mindset. And then I would go home and hang out and drink with my friends and some of them, you know, their maturity level wasn't much higher than the fourth graders'. And neither was mine, in truth. I mean, when we got down into the basement, late at night, we'd basically just turn up all the amplifiers and we'd make up things, and we'd get inebriated to the point where we were totally uninhibited, and we were making this music knowing that nobody would ever hear it. Which is maybe the best way to do it. And I don't think I'll ever be able to recapture that sense of innocence. Now I know that there's always someone listening, and it's very difficult to make that kind of music.

Once we started getting into the 4-track recordings, the short attention span I'd developed from working with the fourth graders really came out. We just started cramming all our ideas onto tape, just recording everything—I mean, I would come in with a song—there would be no rehearsal or anything—I would just teach the drummer the changes, and then we'd record the guitar and the drums at the same time, and then add in bass and vocals, and that was it. The whole process would take about twenty minutes, so we could record, like, twenty songs a day that way. I think we had something like a hundred songs written for *Bee Thousand*. And there was something really pure about that process. The closer you can get a song onto tape from the time you conceive it in your mind, the better.

BLVR: Like translating a dream the moment you wake up, so that you can preserve the detail...

RP: Yeah. And with that, what you get, and what became a sort of Guided

by Voices trademark, are mistakes. That's another thing that I missed when we started going into the studio more and working with producers. We lost the freedom to keep the mistakes that we made when we were recording. I love when I'm listening to a song with friends and I go, "Hey, did you hear that guy just fuck up on drums? That was a fuckup!" I love that. That adds character to a song. We were getting to the point where we were recording a song and everything had to be perfect—every syllable had to be sung correctly and on pitch, and everything had to be in place, and I think you can really squeeze the life out of a song that way, you know?

BLVR: I've always been captivated by those errors. One of my favorites is that moment at the beginning of "King and Caroline" from *Alien Lanes* where you start to sing the melody, but the vocal track cuts out right before the end of the phrase—in a way, right when the listener wants it the most. That moment has always been so mysterious and powerful to me—it still surprises me every time I hear it. It seems so bold a move, to just cut out right when things start to unfold.

RP: Accidentals, as I call them—like on "Hardcore UFOs," when the tape starts screwing up and it starts phasing in and out, and it was just an error in the recording, but because it was called "Hardcore UFOs" people thought we were laying in some sort of sound effect. But eventually, I realized that we were sort of using that as a crutch—you know, people came to expect these fuckups—it was like we could do no wrong, because if we messed up, people thought we did it intentionally. I wanted to try to get away from that for a while, so we started taking more time in the studio.

SING FOR YOUR MEAT, LEON

BLVR: I'm interested in the title of the new record—*Half Smiles of the Decomposed*—coming from a line in the second song, "Sleep Over Jack." It's maybe your best, most complex album title, within a career of amazing album titles, because it describes an emotion that's perceived in an

object that isn't capable of producing an emotion. We look at the drawn-back flesh of a corpse, and it seems to express an emotion to us, but we know that it's only the brutality of time.

RP: Well, I inserted that line at the very end, after I wrote the song. I had it lying around for a long time, and I felt that it was the most appropriate title for the last record, being a sort of bittersweet reflection of the band. It's dead, it's bloated, it's had enough, but it's still kind of smiling. It went out on a good note—it's kind of sad, but it's also thinking it did all right for itself in life.

BLVR: I can't help making this sort of grisly connection to the images from Abu Ghraib, especially those photographs of the corpse wrapped in ice. I'm sure it was unintentional…

RP: Yeah, I saw some of those photos. This album definitely incorporates a lot of stuff that's been pissing me off lately. Especially the second side— the second side has more of an intense political dimension, I think.

BLVR: Like the song "Sing for Your Meat," which starts out with the lines "When you write about the boys / Under friendly fire / Dress 'em up in suits / And seek her to kill / Freedom of the will / Ours and yes yours / Yesterday today / Onward marching on."

RP: That song has to do with what's going on with our country, and our involvement in Iraq. I mean, my son is twenty-four now, and so obviously I'm concerned about the possibility of him going over there. But it also had a lot to do with the music industry. Originally the song was called "Sing for Your Meat, Leon" because I'd read this article about Kings of Leon, about how they were signed to a big label, and all ready to follow in the footsteps of the Strokes, but they weren't quite willing to play the dog-and-pony game that goes with being on a major label. I feel sorry for young bands like Kings of Leon who may be too young to be able to fight for themselves—although I've read interviews with them where they've said that no one tells them what to do, so it's going

to be interesting to see what happens with them—I think they're a good band. But because I'm a bit jaded at this point, having gone through all of that, I was thinking, Hey, you know, if you're going to go get on a big label, you've got to be aware of what you're in for—you're going to have to go all the way, you'd better be ready to sing for your meat.

BLVR: What type of meat will you sing for next?

RP: I just finished a double album, my first post-GBV solo album. I was digging around in the boxes of tapes in my basement that go back to the seventies, and I'd found about fifty songs I'd totally overlooked when I wrote them and I was like, "Wow, I can't believe none of this stuff made it onto an album at any point." So I had a shitload of songs that were all too personal to do with a band. I don't feel like there was any way I could lay them on a band and expect them to interpret them the way that I know them. I worked with [Guided by Voices producer] Todd Tobias— it was just the two of us, with no distractions, no partying, no one sitting around waiting to do their part, and it just worked out really well.

I'm feeling pretty good about my decision. There are some people who are pretty apprehensive about it, you know, these people who are saying, "Well, what are you going to do now?" As if I can't continue musically as Robert Pollard. I've always considered Guided by Voices to be a collaborative effort, but I've sort of been the lone thread throughout the whole history of the band—it's basically my art, you know, my songs, my covers, my sequencing, and my voice. So my solo stuff isn't going to be that drastically different than Guided by Voices, other than the fact that there's going to be a more personal touch. ✶

KAREN O
[OF THE YEAH YEAH YEAHS]

"WE ALWAYS FEEL LIKE THE WEIRD BAND WITH THE WEIRD SONGS WITH A FEMALE LEAD THAT SOMEHOW MADE IT."

You'll eventually find out:
Your idols won't live up to your expectations
Indie labels can be just as shitty as major labels
The band you ignore today will be gone tomorrow
Slow-moving blood does not necessarily predict a Grammy nomination

I *have seen Karen O and her band, the Yeah Yeah Yeahs, perform to sold-out crowds in New York City, Oslo, and Melbourne. And then I have seen her play to a half-full venue in my home-town of Portland, Oregon. No one likes the feeling of being stood up, staring out from the stage and wondering why your* other half didn't bother to show. But instead of making us aware of who wasn't there, Karen O reminded us of what it feels like to be present. As a performer, she looks for the anomaly; she seeks out the dancer unhinged, the misshapen, the underused, and she pursues them. And that night, we the crowd were the anomaly.

There is the audience and then there are the cracks in the audience; the vulnerable fragments, the individuals that make up the whole. Karen

performs for both. She gets into the spaces that are dangerous, bridging them and then splitting them apart again. She is an adhesive and an agitator when most performers are neither. Karen O understands that there are so few moments like these; ones that are spontaneous, alive, and visceral. She asks that the audience join her, and if you're waiting for a polite invitation, then you've missed the point.

I talked to Karen by phone while she was at her home in Los Angeles. The formality of an interview can be awkward for two people who are used to relating to one another in a different, more casual context. It took a while for us to feel comfortable. Soon, however, it grew into a conversation about the vulnerabilities, the frustrations, and the caprices of music, but mostly about holding onto a sense of immense hope.

—*Carrie Brownstein (June/July 2005)*

I. "IF I HAVE TO BE THE SLIMIEST, MOST MANIPULATIVE POLITICIAN ABOUT DUPING PEOPLE INTO STAYING IN THE PRESENT AND JUST EXPERIENCING US FOR WHAT WE ARE, THEN I'LL DO IT, MAN."

THE BELIEVER: How long have you been living in Los Angeles?

KAREN O: I moved out here in early February last year, right before the Grammys.

BLVR: Did you go to the Grammys? You did. You guys were nominated. Was that surreal for you?

KO: That was definitely surreal. For one thing, there was no talk whatsoever of even the possibility of us getting nominated. It wasn't like, "It's really in the bag, guys." It didn't occur to us at all. When we found out, I was still living in Closter, New Jersey, and I was having a really weird day. I went to the doctor and had my blood drawn. My blood was coming out really slow for some reason.

BLVR: They noted it was coming out slow?

KO: They went into the vein in my right arm, and it was coming out so slow that they decided to tap a vein on my left arm, which is pretty traumatic.

BLVR: That stuff actually makes me pass out.

KO: Yeah, yeah. So they went to my left arm and it was still coming out slow. So they had to go back to my right arm. [*Laughs*]

BLVR: Ugh.

KO: That's what set the tone for me. I got home and I was kind of out of it and dizzy and that's when I got a call about the nomination. Because I'd been the victim of a few pranks recently, I seriously thought that someone had pulled one over on us. It just didn't make any sense at all.

BLVR: Because of the large amount of media that's been following you guys since the beginning, a person could think that the Yeah Yeah Yeahs have been around a long time. But really, you've only made one full-length record.

KO: Yeah, it does feel like that. It seems like everything is accelerated these days, especially when it comes to the shelf life of a band. In general, social trends seem to keep accelerating faster and faster. So even though we've been around since 2000, that's nothing for most bands.

BLVR: Like compared with the Kaiser Chiefs or the Killers or some band that feels like they were born yesterday.

KO: And also compared with bands that have been around for eleven, twelve years. I feel like everything moves so fast these days that it sort of chips off, which is totally ridiculous.

BLVR: As a music listener, I find it really difficult to keep up.

KO: Yeah, me too. The disturbing thing to me is a trend that goes along with how accelerated this culture is moving. It's this real distrust of the present moment. That's what I feel most regretful about in terms of what's happened with us. Our heyday—2002, 2003—something really special and something really electric and kind of cathartic was happening at that point in New York City. And half the time, I'd allow myself to feel that and be like, "Wow, this is incredible." But half the time I was questioning it, and thinking: "Oh, is this derivative? Oh, is this the real thing?" I was just really self-conscious about it and didn't allow myself to enjoy it for what it was. Also, in the back of my head I knew it wouldn't last very long. I didn't really know how much I'd miss it until it was over, which was like a year and a half ago. My biggest regret is that while I was doing it, I was only kind of halfway there. I was so self-conscious about that whole movement—people were calling it a movement—and about everything that had to do with something that actually felt real.

BLVR: In terms of the whole distrust of the present, what I find is that people are so busy trying to document and capture a moment, whether it's racing home from the show to put it on the internet or taking photographs on their camera phones during the show, that the documentation comes at the expense of the moment itself. They miss out on just living it.

KO: I just went out to Tower Records and bought some records. How often do people go out and buy records anymore?

BLVR: They don't. I totally forget that people don't buy records anymore.

KO: It's nuts, right? And that kind freaks me out a little bit, too. I guess this is a huge, transitional technological period. I just bought four albums, three of which are oldies. Roy Orbison's *Love Songs*, Lesley Gore's *Greatest Hits*, and then Dusty Springfield's *Dusty in Memphis*, which is a classic. It's stuff that has nothing to do with right now. I've kind of been feeling like, "Oh, yeah, there's nothing going on right now,

there's nothing worth buying, there's nothing exciting." What's so tragic about me feeling that is that I can't go see Roy Orbison playing. I can't go see Lesley Gore play anymore. Well, maybe I could.

BLVR: In Vegas.

KO: [*Laughs*] Yeah, in Vegas, or in some dinner theater. I feel like there's nothing as powerful as experiencing a band in the present moment. It's tragic how many people let these bands pass them by. After the fact they're like: "Oh, yeah. Actually, that's good. I like that album." After the band's broken up or they're not playing that album anymore. It's cheating yourself. To stay in the present is really the most powerful kind of experience. It really bums me out that it's so hard to do that these days.

BLVR: People go on about, "Oh, back in the day, I wish I could have seen Minor Threat," or, "I wish I had seen Black Flag." Well, you should go to shows *now* and enjoy them for what they are.

KO: Yeah, go to shows now! Exactly. If I have to be the slimiest, most manipulative politician about duping people into staying in the present and just experiencing us for what we are, then I'll do it, man. I'll do it. I'll be completely amoral about it if I have to.

II. "A LOT OF THE TIME I KICK MYSELF FOR EVER WANTING TO TALK TO SOMEONE WHO I REALLY KIND OF ADORE."

BLVR: When you're performing, do you feel that you're able to be present in it?

KO: Oh, completely, yeah, 100 percent present. To a point, it becomes kind of painful. There's no detachment when I'm up there. I don't allow myself the distance. I'm fully putting myself out there for the people and for the sake of trying to lure them into the experience and out of that

sort of detachment that you're talking about. I think that's why it takes so much out of me. And I think that's why I resent it to some degree. I feel like I'm picking up the slack for a whole generation of nonbelievers.

BLVR: The nonparticipants.

KO: And trying to win over and convert every crowd, every time.

BLVR: Have you played to a crowd where you guys feel like you're a movie up there?

KO: Oh, yeah.

BLVR: When that happens, do you just go inward and focus on you and Brian [Chase, on drums] and Nick [Zinner, guitar]? Or can you still look at the audience? Is there a wall that comes up?

KO: Sometimes. I don't go into some automatic mode. I never really let myself get to that point; I'm always trying to stay there in the moment. So then it becomes an exercise in amusing myself. I can get really bratty, and really antagonistic. Not really toward the crowd, almost in spite of the crowd. I'll just block them out a little bit, like that really fucked-up way of being angry at someone, when you pretend they're not there, but only to make them be really bummed out and have no control anymore. I always have something going on with the crowd even if it's not directly giving out love and being right there with them. I'm always there, trying to play off of them.

BLVR: I was looking at that book that Nick did [*I Hope You Are All Happy Now*], of all of his audience shots, which are amazing. From a distance, there is a sameness. But up close, the differentiation between people becomes apparent. There are times when I'm on stage and I'll find myself just looking out at people and thinking about their lives. Are you ever wondering: "Who is that person right there? Why are they glaring at me, or why are they laughing?" Are you able to have regular streams

of thoughts while you play, or do you feel like you're somewhere else?

KO: More than meditating on that random person in the crowd, I usually use them. There's always one person who really doesn't give a shit about how the rest of the crowd is acting, and it's completely genuine. I'll just zero in on them. I'll go over to them and ask their name and then dedicate a song to them and it'll make all the difference in the world to me as far as the performance goes. They're not always in the front, really. They're all the way in the back and they're going crazy.

BLVR: Do you prefer to connect with your audience when you're onstage? Or do you prefer offstage encounters, like after the show? Because you're different offstage. Well, all of us are different onstage than we are offstage. Which interaction is more comfortable for you?

KO: For sure, I prefer the one while I'm performing. It's like a tornado, or one of those things where we're both in this same sort of zone. I think that's more meaningful in some ways than meeting them outside of that experience. Nonetheless, I really enjoy talking to fans and hanging out with the fans. It's just that—I'm sure you guys have this too—all the teenage fans, they don't really know where the line is, or they don't really care where the line is between being respectful and then just wanting a piece of you.

BLVR: There's also that thing offstage, where suddenly you're confronted with a person that you don't know, but who thinks they know you pretty well, based on your lyrics or how you are onstage. I don't know about you, but that's uncomfortable for me. Do you ever feel like, "Oh my god, I'm not meeting their expectations right now of who they thought I was?"

KO: Oh yeah, completely. A big reason we feel that is we've been on the other side.

BLVR: We've been the fans.

KO: Yeah. And a lot of the time I kick myself for ever wanting to talk to someone who I really kind of adore. I mean, what do I expect is going to happen? That we're going to become best pals, and they're going to blow my mind, and they're going to tell me something that changes my life? No. They're not very interested in talking to me at all.

BLVR: I agree. At this point, there are certain people that I would never want to meet, certain famous musicians or writers that I admire. I just know if the experience went badly that it might affect the way I listen to their music. Is your persona just an onstage persona, or does it also act as a screen in order to protect yourself?

KO: More than anything else, I think it's an onstage persona. It's not that it's unreal, that side of me. It's close to something more raw and angry and sexual and kind of bare. It's an extreme presentation of that.

III. "WE WERE RELYING MORE ON OUR EMOTIONS AND WHAT WAS GOING ON INSIDE. THE INNER TURMOIL RATHER THAN THE OUTER TURMOIL."

BLVR: What's the process in which you put the lyrics and melody over the songs? When Nick brings in a song, is it complete, or do your vocals and melody force the song to change?

KO: Our songwriting has definitely changed. It's definitely gone through certain transitions and evolutions since we started. It's been harder, lately, to come together with material to try to match up. That's something we had an easier time doing before. Now it works better, when we're just sitting there for the first time and improvising and messing around a little bit. My favorite way to write a song is to start with a drumbeat or a bass line. This is more of a recent thing, too.

BLVR: Do you feel more self-critical at this point? Or that you're editing yourself more than you would have before?

KO: Definitely. We spent so much time on the road and not writing music that it's really important for Nick and me to be getting along and feel comfortable with each other as friends before we can make music and not be as critical. It's crazy, Nick and I become strangers after a while, when it's just touring and doing these things that have nothing to do with creating. And the only way we can work and write together is to reestablish our friendship. Then I think we'll be able to write together.

BLVR: Your band was so closely tied to the New York scene and now you live in L.A. Do you think it's a physical landscape that defines your band, or is it an internal landscape within the three of you? Now that you're geographically removed from your bandmates [Chase and Zinner, who both live in New York], does that feel any different?

KO: Yeah. When we were all living in New York and we started the Yeah Yeah Yeahs, I was twenty-one. I was at the peak of being completely absorbed in the New York night scene and the New York music and social scene, although there wasn't much of a music scene at that point. But the whole hedonistic side of me was kind of trumping everything else. We were feeding off that manic street energy. It really did feel much dirtier and more antagonistic. And as the years have gone by, I think we're more removed from just being there. So we had to rely on other things that were more inside of us. I think that's when the second half of our *Fever to Tell* album started happening, like "Y Control" and "Maps" and this whole other side of us was starting to get nurtured. We were relying more on our emotions and what was going on inside. The inner turmoil rather than the outer turmoil. What feels the most different for me, as far as what's going to affect the way that we write, is my age, turning twenty-six. It feels like an old twenty-six.

BLVR: Did you feel a kinship with the New York music community? And if you did, is it difficult to be outside of that? Or is part of getting older not necessarily needing the same kinds of support that you did? Support might come from different places now.

KO: Right. It wasn't like the late seventies, when everyone would eat dinner in the same restaurant. But we did definitely have kinships with certain bands, with Liars and a bunch of Brooklyn bands, and also with a bunch of clubs and club owners and just people on the scene. And that scene doesn't exist anymore. A lot of people have migrated to Berlin, or to L.A., and some to San Francisco. Part of maturing as an artist is becoming less reliant on a music scene. That's not necessarily a better thing than relying on it; it's just a different thing. I think that we're just kind of doing our own thing now.

BLVR: You went to school at Oberlin, right? And Brian did, too?

KO: Uh-huh.

BLVR: I'm assuming at a place like Oberlin there was an ongoing political and ideological discussion that often ends up being at odds with one's ambition. Coming from that and going to New York, which is full of ambition and opportunities, did you feel like there were certain beliefs that you held onto from Oberlin that you were turning away from? Was there pressure not to go the way of Interscope, or did you feel comfortable with your decision?

KO: That kind of "fuck the system" point of view definitely influenced Brian and me. Especially Brian, because he's coming from even more avant-garde influences than I am. But for me personally, my main fear was going toward the system and losing artistic control. It's not that I didn't care about all the other things that go along with not selling out. But it was not in my best interest to limit our audience. I felt like being on an indie label; it was kind of inevitable, which has been disproved by—

BLVR: Interpol?

KO: Yeah, Interpol. And Arcade Fire and Bright Eyes. What became apparent to me wasn't really as black and white as it has been made out to be. "Major label bad, indie label good," you know? [*Laughs*]

BLVR: Right, of course not.

KO: It just became clear from fellow bands that were signed to indie labels just how shitty indies can be, and how shitty, obviously, the majors can be. There's shittiness all around. For us, if we could maneuver ourselves, we were in a great position. Not a position most bands are lucky enough to get. We really got to call our shots. We could have creative autonomy and have the first say in what they do.

BLVR: Plus, I just feel like the indie/sellout debate is so tired.

KO: Oh, yeah.

BLVR: But there's always a new crop of people that have this "You Sold Out" mentality. I think it's more complicated than that.

KO: It's totally absurd. And it's really upsetting. I could tell you, for fuck's sake, Interscope has not changed the way that we make music.

IV. "ONE OF MY OBJECTIVES IS TO TOTALLY FUCK UP THAT PROTOCOL ON HOW TO RELEASE A RECORD."

BLVR: Do you worry about whether your fans will stick with you through artistic experimentation or changes? Or have you reached the point where you shut them out and say, "OK, I hope that you trust us to do what we want and that you'll like it"?

KO: I think it's more that we just hope they'll trust us. It's hard to say. We have this really strange, contradictory self-image. We kind of feel like underdogs, despite coming out of New York and getting sort of clumped into that whole category of bands like the Strokes and Interpol and the White Stripes. And all of them, maybe even Interpol at this point, have far exceeded our popularity or sales or embracement by the mainstream. We definitely have put ourselves on the radar, but it took

much longer for us to get on the radar. So we always feel like the weird band with the weird songs with a female lead that somehow made it. But also it's unbelievable how many people have reached out to us despite how strange I think we are. Going into this next record, we're not self-conscious. It's more like we're just very serious about maintaining the same sort of approach as far as not watering it down, keeping within our personalities and ourselves and keeping within what kind of music we're into. And that's always changing, so our sound might change. I'm sure some fans might be disappointed. We don't have any idea what our next record will sound like, but we're pretty sure we're just going to start from scratch with it. And in that way, it might throw our fans off. But if they like us for what we do and who we are, I think they'll be with us.

BLVR: Whenever you guys do make your new record, there'll be so much speculation on message boards and in the media. People just spend so much time within the discourse that they forget: "Wait, we're talking about a record here. Don't we actually have to hear it to know what it's about?" God, just go to the show.

KO: Right, right.

BLVR: We're in a place where we just finished our record. I have to tune out the speculation and all that crap and just say, "OK, I'm really proud of this thing we did."

KO: I think everyone goes through that these days. It's part of that culture of consumption. Where all they really want is that fast, immediately gratifying thing where they can chew it up and spit it back out. People are ravenous for that, so much that they'll completely overlook all the subtleties. I think part of the problem is the protocol that goes into releasing a record. There's just this drab protocol that even the kids are totally sick of.

BLVR: Yeah. There's four months of just waiting.

KO: And then trying to build up some sort of buzz about it and then releasing it. It's almost sort of anticlimactic because people take press so much more seriously than actual substance. The process has superseded the music.

BLVR: And because of the internet, everybody's a critic. It's like people listen to the records so then they can get on their blog and write their own review. It's so reportorial, I feel like it's less and less about one's individual relationship to the music and more about being the first person to have an opinion about it. I wish you could record an album and the label would just immediately put it out there.

KO: That order from press buildup to releasing an album to touring— could there be anything more mindless and bland and soul sucking?

BLVR: It takes you so far away from the music. It becomes abstract. You're doing everything but performing it, doing everything except playing it. And you don't even know what you're talking about in the end.

KO: I think one of my objectives is to totally fuck up that protocol on how to release a record. Because I'm sick of it. I dread that ritual. I just think it needs to change. The process in which records are released needs to change. Once that changes, it will mix things up a bit, and people won't be so conditioned into feeling the way they do, and being as detached as they are to albums and new music.

BLVR: I think detachment is brought on by the continuous dialogue and by these discussions; it's above the music, but not in it.

KO: Exactly. And what's so sad is we're doing it to ourselves. That happens with records, and it also happens with shows. There's the whole crossed-arms, "OK, prove something to me" audience. One of the last shows we played last year was in Mexico City. The kids came and we were the only band playing. We were playing at 9:30 p.m. and they opened the doors

at seven and kids came running in and it was a huge line. Two and a half hours before we even hit the stage, kids were whistling and yelling, and it was just nuts. When we went out there, it was the most amazing crowd we've ever played, the most receptive and loving and enthusiastic. Totally the most sincere crowd we've ever played to. I was like: "Damn, if I could play to a crowd like this every night, I'd do this every day of the year. It wouldn't drain me. It wouldn't sap me. I wouldn't feel all these conflicts." I couldn't even believe it. It felt like another planet. Whatever I can do as an artist to try and move more toward that is what I want to do. ✶

AIMEE MANN

[MUSICIAN]

"WE'RE THE PETER FRAMPTON OF VIOLENCE AND RELIGION… THE TERRORISTS ARE LIKE THE RAMONES."

Inherent truths:
A nice suit should be enjoyed
People are attracted to confidence
A mime (in the right context) can be awesome

Remember the end of the video for *"Voices Carry,"* when Aimee Mann goes bugshit at the opera? She starts singing while her wife-beating boyfriend (who literally wears a wife-beater T-shirt and, like all domestic abusers, loves the opera) hides his curly head in shame. *That was back when Aimee was still the lead singer of 'Til Tuesday, spearheading the New Wave out of Boston in the early '80s.*

Here's a quick, Scientific American–*style bullet point overview of her career since then:*

1. *'Til Tuesday disbands. Aimee goes solo. First album,* Whatever…, *critically acclaimed. Record company confused. Second album,* I'm With Stupid, *even better. Her label collapses or goes bankrupt or*

something, and her third album, Bachelor No. 2, *gets caught in limbo.*

2. *Aimee buys back* Bachelor No. 2 *(which the label didn't like anyway) and forms a record label with her husband, Michael Penn. Releases the album. Critical acclaim. Songs used for* Magnolia *soundtrack. Oscar nomination.*

3. *Follow-up album,* Lost in Space. *Innovative song cycle. More critical and fan acclaim.*

4. *New album,* The Forgotten Arm, *came out in May. Continues quietly to show musicians and artists how to live with a solid DIY ethic.*

Also, here's a quick overview of my career:

1. *First open mic 7/18/88 at Garvin's in Washington, D.C. Gets a laugh with the one cancer joke near the end of the five-minute set.*

2. *Repeat for the next seventeen years. Add fart and zombie jokes to repertoire.*

Aimee and I went to dinner at Café Capo in Los Angeles, where we drank one and a half bottles of wine and recorded our conversation. We are fucking cool.

—Patton Oswalt (June/July 2005)

I. "AS DEMOCRATS, WE ALWAYS END UP GOING FOR THE GUY WHO IS A GREAT ACTOR AND NOT A GREAT MOVIE STAR."

THE BELIEVER: Let's get started. Actually, *Believer* readers, you missed out on some great conversation before this. We've already talked about deep psychological trauma, my minor victory in a comic book store, and Aimee listening to stereo noises in her ear and sorting out her head.

AIMEE MANN: And now we're on to cotton candy, corn dogs, and candy apples.

BLVR: Ironically, the first two words on her new album are "cotton candy." But it does manage to get really dark from there.

AM: Very true.

BLVR: OK, what should we talk about? I've been thinking a lot lately about how so many of us, people like you and me, are living in a weird post-defeat state because of the Bush victory. We have no choice but to be psychotically upbeat about everything.

AM: It's hard not to feel like we were totally screwed. The only thing left to do is say, "OK, let's tighten our belts and get it together." Because it's clear that we didn't do everything we could've done. I mean, I wasn't at the polling places, helping out and volunteering, y'know? I didn't contribute money to any of those campaigns.

BLVR: And we got behind a guy that we could not openly admit was gonna lose.

AM: I didn't think he was going to lose. I really thought Kerry had a chance.

BLVR: Oh, really? I always had a gut feeling we were doomed. Somebody sent me a tape of a performance I did months before the election. I was just laughing and saying: "Bush is gonna win, and there's not a damn thing we can do about it. We picked the wrong guy."

AM: But there's no right guy, really. That's the problem. The people who win are always puppet heads. You know what I mean? Bush was perfectly cast to win. As Democrats, we always end up going for the guy who is a great actor and not a great movie star. The Republicans have a movie star. All we've got are these actors from Australia that nobody has ever heard of.

BLVR: We've got Paul Giamatti, and they've got Ben Affleck combined with Colin Farrell.

AM: They're much better at casting.

BLVR: We just weren't smart about it, especially in terms of how we responded to all those morality arguments. We should have said: "Look, there's nothing wrong with caring about values. There's nothing wrong with that intrinsically. But we've got a better deal. You'll benefit from what we have to offer." What we did—and I did it too—was come out too aggressively. "You guys are fucking morons! Wake up and come over to our side." When you have that kind of attitude, people will go against you just out of spite, because then they want to see you fail. We weren't wrong; we just had the wrong approach.

AM: Bush was never really judged on his merits. It was all about image, and he played into it very well. I think there was something about Bush that reminded people of the dad they never had. He's more of a dream phantom president. He doesn't exist as a person; he exists as an image that people want to buy into.

BLVR: We were idiots. Just come out and say it. We were idiots.

AM: I think what Democrats need to do is keep their eyes on the ball. We're so easily distracted by weird, obtuse arguments. Or we worry too much about what the other side thinks of us. And the thing is, I don't believe the Republicans honestly believe half of what they say. During the Condoleezza Rice hearing, the Republican senators would say, "Democrats are just sore losers." But that's just bullshit. It's like the woman who walks down the street and gets bent out of shape when a construction worker calls her a bitch because she won't stop and talk to him. It's a tactic to get her to stop and talk to him. It has nothing to do with reality. It's a manipulation to get her to do what he wants her to do. All of that nonsense about the Liberal Media, it's a manipulation to get the media as attuned to the Republican agenda as possible.

BLVR: I realized something even darker when you mentioned Bush being the father that they never had. I think that actually applies even more to liberals. I know so many liberals who grew up with liberal parents that were always fucking around and using drugs. They were

very nice, permissive parents, but they didn't give them a homelife that they could rebel against. They were raised by parents who wanted to be twenty-two years old forever. So not only does Bush appeal to the Republicans, he cryptically appealed to liberals because he had that daddy image. Even though Bush is kind of an awful father who clearly doesn't like his daughters, there's something appealing about the way he sets boundaries.

AM: Or what appear to be boundaries.

BLVR: Yeah. Whereas my dad was always more concerned with being cool and being my buddy. As for a lot of liberals, the idea of a disciplinarian father figure has a very strong allure.

II. "I THOUGHT WE'D SELL A FEW RECORDS OFF THE WEBSITE, OR MAYBE OUT OF THE BACK OF A VAN."

BLVR: I want to talk a little about all the press I read about you back in the early nineties. A lot of these articles played on the same underdog story. "Aimee defiantly walked away from her record company and said, 'Fuck you, man! I'm doing it myself!'" I didn't know you at the time, but even then, it seemed a bit too simplistic. It probably wasn't that easy. I'm sure that you had doubt. It's actually more heroic if there were moments when you thought: What have I done? Oh my god! What the hell?! But then you found the courage and did it anyway.

AM: It was both positive and negative. It was so unpleasant dealing with those people [at Interscope Records] that I completely didn't care what happened to me. When I decided to put out *Bachelor No. 2* on my own, I didn't think it was going to be a big success. I thought we'd sell a few records off the website, or maybe out of the back of a van.

BLVR: There's something liberating about being in a situation where there's nothing you can do. Every door has been shut behind you; the

iron gate has been brought down; you have no choice but to go forward.

AM: Yeah, it is pretty liberating. It's like something out of the twelve-step program in Alcoholics Anonymous. You have to admit that you're powerless. What's awesome about that is you stop expending energy on things that you can do nothing about. It's amazing how much energy you have for other things—more important things—when you stop worrying about what some record company suit thinks of you.

BLVR: It's so easy to get caught up in that. And caught up in this race for fame and riches. I think that all of us, comedians and musicians, start out with that obsession to take over the world. When I was younger, I was so driven to become this huge star. But if you don't become huge fast enough, there's a part of you that goes, "Oh wait, this is bullshit." Or you get a taste of it and go, "Uh, this is absolutely not worth it." You had that more than me.

AM: I really didn't care for any of that celebrity nonsense. You lose too much of yourself. I just don't think the loss of privacy is worth it, to have strangers coming up to you at the airport and saying, "Are you somebody?" What is that worth? It's nothing. I think the problem, at least for us, is that whatever fame we achieved never translated into goods and services.

BLVR: Exactly! I got nothing out of it.

AM: Where are my free Marc Jacobs bags? And my Calvin Klein gowns? If we would've gotten more free schwag, it would've been a whole different realm.

BLVR: I didn't even care about the expensive shit. I don't need the J. Crew and the Humvees. I wanted my nerd stuff. I wanted Brian Michael Bendis to call me up and say, "How'd you like to get an advance copy of the *Powers* script?"

AM: I have a weird fondness for the goody bag. I got one when I played at the Oscars.

BLVR: The goody bag!

AM: You know what the problem with a goody bag is? A lot of it's like, "One free night at the most expensive resort." You know you're not gonna go for just one night. And if you do go, you feel like you're out of your element. Do I tip the valet dude? I don't know what to do!

BLVR: I was writing for the Oscars the year you performed. I was punching up something that Ben Stiller did. I remember being at a rehearsal and dealing with the producers and all these shallow assholes. I was sitting there and thinking, "This is everything that's wrong about show business." And then, as I'm leaving, I saw the goody bags lined up, and I thought, "Oh, that's why people sell out."

AM: I love getting free stuff anyway, even if I don't use it.

BLVR: I give everything away. I have a lot of friends who work for charities, and I can give it to them for their auctions. But it makes me feel like a gangster. [*In a mafia thug voice*] "Here's this lovely Rolex watch. Auction it off for the kids." I just feel like a crime lord. But I just can't keep any of that stuff. If I wore a Rolex, I wouldn't be able to do anything but look at it.

AM: I got a free watch once, and I wore the thing day and night. I wore it all the time.

BLVR: Earlier this year, I was finally at a point financially where I could conceivably afford to buy a tailor-made suit. I realized that this is why people become evil heads of corporations. It was amazing. I looked completely different.

AM: Oh, wow, that's great. You should enjoy it.

BLVR: Yeah, I know, but I literally spent ten minutes just standing in the store, thinking: Should I be doing this? It's such an unnecessary extravagance.

AM: Of course you should. The reason it's evil on the other side is that they don't enjoy it. They don't get any joy out of it. It's totally glorious.

BLVR: OK, fine. But it's hard not to feel guilty.

AM: You just have to remember to be grateful. Once you start taking stuff like that for granted, that's when it becomes evil. That's when you're just some oblivious bastard.

III. YOU CAN LITERALLY GET AWAY WITH MURDER IF YOU HAVE THE APPROPRIATE AMOUNT OF CONFIDENCE.

BLVR: Is it just about confidence, or the appearance of confidence? Is that all people want from their leaders or artists?

AM: That's probably at the heart of it. It's like training a dog. Just show a little assertive energy and they'll follow you anywhere.

BLVR: I suppose that's true. We're all just dogs underneath.

AM: It's not that it's enticing or seductive; it's kind of natural. If you're waiting to cross the street and some guy bolts past you and starts walking before the light turns green, you'll probably follow him. We're always looking for somebody to take the initiative, who seems like they know what they're doing. People really respond to that. I think you can literally get away with murder if you have the appropriate amount of confidence.

BLVR: I once knew this hack stand-up comedian, and his material was just awful. Just completely terrible. But he killed every night. He had the audience eating out of the palm of his hand. It used to mystify me. But

then I noticed, when he went on stage, he would lean back and thrust his crotch towards the audience's faces.

AM: Oh my god.

BLVR: That was it. That was his only secret. He would stand there with his crotch out front. And the audience immediately thought: OK, I'll listen to whatever this guy says. He must know what he's talking about. It was intimidating. I've seen so many mediocre rock performers do the same thing. If you think about it, everything about being on stage puts you in a position of power. You're raised above them, and your voice is amplified, and you're lit. I guess there's something to that.

AM: Everything about you says, "Pay attention: this person is important."

BLVR: And the Republicans have started to pick up on that. All these evil conservative demigod motherfuckers have stolen the language of rebellious rock and roll. They've taken the funky, cracker swagger and used it to their advantage.

AM: They've taken that cowboy flavor.

BLVR: They've also stolen the stance of black bluesmen and jazz musicians. You know the way jazz musicians will lean back with the horn in that really cool way? It's all about understanding what gets a reaction from an audience. Who do they stare at? They've created a version of that hip jazz poise. It's eerie. I've got to watch a Bush speech again and really pay attention to what he's doing.

AM: He has a speech tonight.

BLVR: Oh, that's right. I hope I remembered to tape it.

AM: I think it's all just about how he's going to take over the world.

BLVR: I hope he just comes out in a Dr. Doom costume. That would be cool. At least it'd be more honest. He should just start wearing a cape and a mask.

AM: I would probably like him more.

BLVR: Speaking of confidence, I was watching an old episode of Carson's *Tonight Show*. It was the one when Frank Sinatra was a guest. Right in the middle of the interview, Don Rickles walked out unannounced. The audience goes nuts, and he sits down and starts talking to Frank. They're both cranking out the funny, and Johnny just leaned back in his chair and lit up a cigarette. He doesn't say anything, just let them talk. He was like, "I can take a five-minute break." That's that kind of confidence we're talking about. It's amazingly powerful. And I think that's what Bush has tapped into.

AM: It always shocks me just how little Bush gives a shit. He doesn't care what people think, because he's pretty sure we can't rise up against him. That's what comes with thinking God is on your side. I guess we kind of gave him that sense of entitlement after 9/11.

BLVR: I remember watching those planes hit the World Trade Center, and it was horrible, and I thought, "Oh my god, those people are dying." There was about an hour where I wanted a fascist violent response. I wanted a Judge Dredd. I wanted a Dirty Harry to wipe out every fucking person in the Middle East. But then I thought, What do I believe in as strong as flying a plane into a building? You know what I mean? Everyone's first response to that was: "Those countries are all violence and religion. That's all it is." Well, yes, it's all violence and religion to the terrorists, but we're the Peter Frampton of violence and religion. We're the bloated, overproduced, Emerson Lake & Palmer, late-seventies Led Zeppelin of violence and religion. The terrorists are like the Ramones. "I'll carry my own amp, thank you. I don't need anyone to set up for me." They're willing to fucking burn it to the fucking ground. And that's why we had such an angry, violent response. Just like the mainstream music

industry's response to the Ramones. No wonder we went fucking crazy.

AM: Well, we didn't go crazy.

BLVR: I think we went crazy. We attacked the wrong fucking country.

AM: Yeah, but Bush didn't attack Iraq because it had anything to do with 9/11. He was planning to do that anyway. I think he just went: "Oh, thank god, this is the perfect opportunity. How can we parlay this into an attack on Iraq?" It wasn't a response; it was just an excuse.

BLVR: Do you think the music industry's secret plan to kill off Peter Frampton and Zeppelin fit in perfectly with the arrival of punk rock? A rebel sometimes justifies the establishment killing off the dinosaurs. The Iraqi regime was a dinosaur that the Bush administration had to get rid of. It was an albatross.

IV. SUPERMAN, *JAWS*, AND THE BIG BANG

AM: You know what I'd like to do? I'd like to do something totally selfish. Like have a movie night or something. I never get a chance to see movies anymore. I was going to see *On the Waterfront* a few weeks ago. It was playing down at the ArcLight theater. But I got sick and decided against it. I've always wanted to see that film.

BLVR: You've never seen *On the Waterfront*?

AM: No, never. That's really embarrassing, I know.

BLVR: You're gonna love it. Marlon Brando's acting is just startlingly good, even by today's standards. And some of my favorite scenes aren't even the famous ones. Everybody knows about that scene in the back of the car with Karl Malden.

AM: Oh, yeah. My father used to do a terrible impression of that. The "I coulda been a contender" line.

BLVR: But my favorite is the one where he and Eva Marie Saint are in the park. He's talking to her and he's trying to impress her by appearing smart. He's all heart and no brains and he really loves her. At one point, he picks up her white gloves and he's trying to put them on, and of course they don't fit. And Eva has this expression that's like, "What are you doing?" And I don't even think that was her character. The actress seems genuinely confused by him.

AM: I always want to watch movies and it's something that we [Michael Penn and I] never do. I really want to set a precedent for it. I just don't have the whereforall to set aside two hours to sit and watch something.

BLVR: OK, let's do a movie night. Next Sunday, get your ass in the car, drive up the five minutes to my house, and we'll do it. That's a great idea. I love watching movies with other people. You get so much more out of it. Even if it's a movie that you've seen a thousand times before, you get a different perspective on it if you watch it with somebody else. They'll notice things that I never saw before, or they'll say, "That was bullshit, and I'll tell you why."

AM: Let's have an evening where we watch only old boxer movies.

BLVR: You mean like *City for Conquest*? Oh, and *Champion*. And *Body and Soul*.

AM: I don't know those. *Champion* is the Midge Kelly film, right?

BLVR: Wait till you see it. Just remind yourself that Kirk Douglas didn't get an Oscar for that role. It's so brutal.

AM: I saw *Raging Bull* when it came out, but I barely remember it. It was so long ago.

BLVR: Oh, that'd be a good double feature, because *Champion* is like an hour and change. That'd be perfect.

AM: Yeah, especially with a bottle of wine.

BLVR: Speaking of movies, I read a cool theory about *Jaws*. Remember when *Jaws* came out? The people at Universal said: "This movie will do very well in the coastal cities. But in the Midwest, which is where we make our money, *Jaws* is gonna bomb. They don't know anything about the ocean." And then *Jaws* opened and it was fucking huge. They can't believe the money they're making. And the reason it was so huge is because *Jaws*, even if you've never seen a shark before and you don't live anywhere near the ocean, triggers something in our sense memory.

AM: How do you mean?

BLVR: The shark is a prehistoric animal that never evolved. It just got smaller. It used to be a hundred feet long, but it shrunk down to twenty feet. One of the reasons that we crawled out of the ocean was…

AM: To get away from the sharks.

BLVR: Exactly. So we have a DNA memory of sharks. Even people that were born in Kansas are like: "That's not good. That's bad. I remember that. I don't know why." And in the same way, if we can remember this shark from a hundred million years ago, I think we remember the Big Bang as well. Because all of our atoms were in some way culled out of that Big Bang from the dawn of time.

AM: Is that because all atoms are recycled? They all have a little bit of memory. That's like a lot of current psychological thinking, that we all have the sense memory of trauma floating around our bodies at a cellular level.

BLVR: And that's why we have explosions in every superhero myth.

Superman was born in the explosion of a planet. Or Batman, who was born in the explosion of a gun. It's an innate myth.

AM: I assume you have a fairly good working knowledge of superhero myths.

BLVR: The Hulk was born out of an explosion. Peter Parker, the explosion of a gun that kills his beloved uncle. Daredevil, a truck crashing and blinding him.

AM: Well, maybe they're all just imitating the first. Maybe it's just a retelling of the Superman myth.

BLVR: Yeah, but what was Superman imitating? They're all explosion myths. They all come back to explosions.

AM: It could be. Or maybe it's just the glass of wine that's making this more interesting. [*Both burst into laughter.*]

V. "HISTORY WAS HAPPENING AROUND ME, BUT I WAS OBSESSED WITH BIG TITS."

AM: I suppose we should talk a little about music, huh?

BLVR: So when does the new album come out?

AM: Sometime in the summer. May or June.

BLVR: I was really happy that it had this gritty, teenage garage-rock feel to it. And some of the lyrics, like on "King of the Jailhouse," had an almost over-the-shoulder snarl. It's like these weird, cut-off conversations where both of you want to say something and no one's gonna say it. It's what's unspoken that's more important than what's said.

AM: I'm very happy with it. And I like that it tells a little story. It was

kind of inspired by *Two-Lane Blacktop*. I must've seen it on TV at some point. I don't even remember it, except that it entails people driving around the Southwest.

BLVR: I own it. Maybe we'll do it on movie night.

AM: That'd be great. I don't remember anything except that it's a road trip. Oh, and the model with the gap in her teeth. I remember her.

BLVR: She committed suicide.

AM: Really? What was her name?

BLVR: I forget, but she killed herself after that film came out.

AM: You're kidding. I think I'm mistaking her for the other model with the gap in her teeth.

BLVR: Do you know what I just realized? The song "Lost in Space," which I also listen to way too much, had this very strong narrative about two people and their inability to communicate with each other. It's just a snapshot of their lives. For some reason, that reminds me of what you were saying about *Two-Lane Blacktop* and *On the Waterfront*. You remembered seeing them, you remembered certain scenes and moments, but you didn't remember the entire movie.

AM: Yeah, that's right. I only have these flashes of memory.

BLVR: But isn't that what a good musician does? They're just writing songs about these individual moments. It's not a full story, just a glimpse at a fractured scene. I mean, think about any great Rolling Stones album. I remember the songs, but I don't always know which album that came from. It's like: "Oh, I love 'You've Got the Silver.' What album was that on again?"

AM: That's true. My memories seem to come in small fragments. I don't know if that's a good thing, though. It can be disconcerting. It's happened a lot to me recently. There are times when I feel like I can't remember stuff. I know how a normal brain should work. You should remember things that happened to you recently. But I'll find myself thinking, "Wait, did I just say that?" I wonder, is this early Alzheimer's or something? I only remember bits and pieces from my life. Maybe it's all just too much for me, and I need to block most of it out.

BLVR: I can't believe I'm bringing this up, but I watched Fellini's *Amarcord* again recently, which is about growing up in fascist Italy during World War II.

AM: Yeah, I saw that. I couldn't tell you what the hell it was about.

BLVR: He was honest with his memories. He basically said: "I was a teenager. History was happening around me, but I was obsessed with big tits. That's all I remember."

AM: All I remember about that movie is the close-up of a woman's butt.

BLVR: I would like to write a screenplay about a kid in the mid-eighties, growing up and rebelling against all the New Wave shit, but really, I was just obsessed with big tits. I was obsessed with big-breasted girls at Howard Jones concerts.

AM: Remember Howard Jones had that dancer guy and the mime guy? What was his name? Jed something.

BLVR: And the mummies that would walk out during "Everlasting Love"?

AM: Are you kidding?

BLVR: I went to one of his concerts. I was trying to impress this girl who was really into him, so I soldiered through this whole concert.

AM: I just saw it on TV. He had a mime with him. That's awesome.

BLVR: I was just blown away by Fellini's honesty. There's something so great about embracing the fact that sometimes we miss the bigger picture because we're caught up in our base needs. *Amarcord* is all about that. It's the frustration of: "Goddammit, is that all I fucking thought about? Is that what I kept from that experience?" But there's a joy in that, too.

AM: I have this terrible feeling that my life is getting away from me. My life is just falling in half, and I'm focused on these crazy, stupid, mundane things. But in a way, it also stabilizes me, too. If you obsess about something, even if it's something small and trivial, it kinda brings your life into focus. It becomes your entire life. Everything else just becomes irrelevant.

BLVR: Yeah, but I think those small, trivial moments are what's important. Because those are the moments that everybody can relate to. And if you create art around that, it makes a person think, "Oh, shit, yeah, I know what she's talking about. I can't believe they wrote a song about it." They did a Seinfeld episode about trying to find a car in a parking garage. It was stupid and mundane, but it was also brilliant, because it's something that everybody has experienced. All this shit that we think gets in the way of being an artist is really what being an artist *should* be about. ✷

BJÖRK

[SINGER/ELECTRONIC MUSICIAN/PRODUCER]

"IN THE END WHAT DRIVES ME IS MY CURIOSITY AND HUNGER AND THE FACT THAT I GET BORED SO EASILY."

Songwriting cycle:
Write songs
Arrange them on computer
Have a party
Do videos
Go on tour
Become a mountain hermit

he phone rings. *"Hello?" I say. The voice on the other end responds: "Hello. My name is Björk." I glance at my notes. There are but four words on the sheet in front of me. They are written in fat red Sharpie ink on an otherwise blank lineless sheet of printer paper:* Talk slow. Listen. Breathe!

I have interviewed other talented artists, worked directly with some of my literary and musical heroes, and have myself been on the other end of such questions probably fifty or sixty times, but I cannot remember, ever, having to remind myself to breathe.

Björk has been a pop star since she was eleven years old. She won a Cannes Film Festival Best Actress award (almost reluctantly) for her work

in Lars von Trier's Dancer in the Dark; collaborated on ground-breaking videos with directors like Spike Jonze and Michel Gondry; cultivated an underground fashion movement; and left in her teenage wake a series of radical Icelandic art collectives and rock bands, the most notorious of which was the Sugarcubes.

Björk is currently in the studio working on the soundtrack for her husband Matthew Barney's Drawing Restraint 9, a film about sculpture which will premiere in Japan. She has also just released a CD benefiting UNICEF that features twenty cover versions of her song "Army of Me" as produced and performed by her fans.

There is a childlike quality to Björk's voice. Our conversation is in English, and occasionally she struggles to conjure words that match the sophistication, clarity, and frightening intelligence of her Icelandic thought process. She is plainspoken and generous and remarkably present. She is a surrealist punk prodigy turned grooved-out electronic nature priestess. She is on the phone.

—Jim Roll (August 2005)

I. E. E. CUMMINGS

THE BELIEVER: Can I ask you about the E. E. Cummings influence that shows up in your latest album? You've said that Cummings is the first English-speaking poet with whom you really connected. Was there an immediate appeal?

BJÖRK: Well, I sang in my own language for a long time. It wasn't until after five years of singing that I could actually start to say several very well-chosen Icelandic words. And after five more years I could sort of add in some English words. I didn't really start speaking English until I was about twenty or something. So it's been a very long journey for me to add words to my music.

And then I'm always reading poetry. Especially as a teenager, I was surrounded by poets. The kind of people I hung out with were, like, literature people. I guess they started the first surrealist movement in Iceland

during the punk years. It was half punk, half surrealist. They were called Medusa. It was a collective, and they did paintings and movies but mostly literature and poetry. There was a lot of people getting drunk and reciting their favorite poems, and people would either boo them down or say they were amazing. But there was all this passion surrounding language. That helped me, being such a musical person, slowly realize that the words are not necessarily only a brainy thing, but that they can be quite intuitive and impulsive. But it took me a while to believe that. It took me quite a while.

About five years ago someone gave me an E. E. Cummings collection, and it was the first time I saw English where I felt I could sing it. I remember being a teenager and reading translations by Paul Éluard and mostly French surrealists, and loving that very much. However, it wasn't something I felt like singing. Maybe it was a combination of it being translated, and perhaps that at that point in time I wasn't ready to sing using language. Now, having spoken English for about ten years, I feel more like I can sing it and take on other people's words and mean it from my heart.

I think the reason why I picked several of E. E. Cummings's words isn't necessarily because I think it's the best English poetry that has been written. I'm not even trying to make a judgment there. I'm not the right person to make that choice. It's more my feeling that it's just screaming to be sung.

To me, it's the syllables themselves and how he refuses to commit to a certain shape, and it's a lot of commas, and he leaves it open where a sentence starts and a sentence ends. That approach is something I can really relate to—it's more of a flow of consciousness rather than a really strict form. I also like the fact that it's quite humble and yet still very euphoric. I have always been attracted to things that are humble and euphoric at the same time. Usually euphoric things are very grand and even arrogant. But "arrogant" is hardly something you could ever accuse E. E. Cummings of being…

I also find it fun to sing in that particular mood. Like everybody else I have fifty different moods over the course of a month or whatever, but for some reason when I write melodies it's mostly with that mood that

I feel humbled and part of a big whole. Many of E. E. Cummings's poems are talking about that mood.

BLVR: What about Icelandic poetry? Had you much interest in putting that to melody?

BJÖRK: Yeah, we did sing some of those works. I was in this other band called KUKL along with the Sugarcubes. Most of them now have put down their instruments and become authors, but those two bands were full of poets that decided to start a punk band. I used to sing for them. I mostly sang my own lyrics but there were times I would sing their words.

BLVR: Right, but you wouldn't sing any historical Icelandic poetry, right?

BJÖRK: No, I didn't. It was probably because of the age I was at that time. We were rebelling against conservative things. People were proud of their sagas, and then there was this minority complex, especially when making pop music, where bands felt we had to sing in English and try to be the Beatles or U2. So we were part of this movement that was trying to be fresh and write about our own realities instead of old dead heroes. It was quite a big statement that the words were about us and what we were doing every day as opposed to some foreigners or old dead poets. And maybe now I'm in a different place where it's not all about rebellion. Or, actually, a different kind of rebellion now, where you're willing to unite with certain things.

BLVR: How do you maintain your creative freedom? One thing that other artists admire about you is that you are constantly creating the space necessary to create whatever you want. Is that difficult, or are you comfortable that you have carved out a big enough space that you can do what you feel on any given project without concern for corporate entities like record labels?

BJÖRK: Well, it's everything that you said. I go through a lot of hassle to create the right situation for a new album. I have to do research and set up a new environment—new place, new equipment—and move things about. Sometimes I end up wondering, Why can't I do two albums in a row that are the same, like other people? I want to say to myself, "Just stop it!" you know? I wish sometimes that it didn't have to be such a hassle. But when I just try to hold my breath and do the same thing I did last month or something. Well, I freak out because I get bored very easily. I think my attention span is worse than in the worst teenager. It's terrible.

So in the end what drives me is my curiosity and hunger and the fact that I get bored so easily. Fortunately or unfortunately, depending on which way you look at it, it seems to be what drives me. So I have realized that if I follow that, the rest falls into place. But if I go the other way around, avoid the hassle and do what I did before, it becomes a nightmare. I'm not driven and I get bored and I don't like it.

So what I'm trying to tell you is that I don't really have a choice—and at the end of the day it's fun! There's that beginning stage where you have already done a record and you're about to start a new one and you haven't a clue what it's going to be made of. There's a sense of freedom and I am like, "Wow! I can do whatever I like." And there is that moment of looking into yourself and asking what turns you on. It has to be exciting enough to keep you interested for at least a couple of years.

There's a side of me that's like a fickle teenager that wants new toys every album—but again the other half of me is pretty conservative. There's also a side of me that people may not easily see: a side my friends see more, how patriotic I am, and that kind of thing. Then, as I said before, there's the fact that it doesn't matter how different my albums sound; my voice is always the same. That is the aspect of the different projects that's always going to be the same.

II. GENEROSITY

BLVR: What about the culture of the music business? Are there any pressures to conform in any way?

BJÖRK: I am blessed to be working with people I got to know during my punk years in England when I was sixteen, and we still have a deal where I just bring them my album when it's ready. I don't have a time limit and I can finish a project any way I want. It's not like, "Oh, go back and write the singles." I don't get any of that. I thought most labels were like mine, but once I started traveling and meeting people who do the same job as I do, I have found that it is of course very rare. It's a shame, really.

BLVR: Are you more interested in the process than the outcome? You obviously have a lot of fun creating the records; do you listen to them when they're done, or do you keep moving on the creative front?

BJÖRK: It's a mix. There are so many levels. When I start a record I need to either hitchhike or go on walks, just be on my own for a few days. I have a solitary romantic side. When I write my melodies I am immersed in that side of myself. Then there's another side of me, which is just noodling in front of the computer arranging things, which is something I end up doing almost every day. It's like I'm working on a mosaic or a puzzle, which is a totally different mood from that solitary persona I described. In my case the solitary trips I take have a high-energy, euphoric, and active state of mind. The mosaic computer arranger mind-set is the opposite. It's like knitting a sweater. Like a nursing kind of motherly mood, which is also quite passive.

Then there is yet another side of me that reacts to the computer stage by calling myself a lazy git. So I wanna hit myself for being a lazy git and I wanna do as much as I can myself. Finally, there is always the last 10 percent of a record where I just wanna play music with people! I suddenly say to myself: "Wait a minute—music is not supposed to be something you do by yourself in your corner." So I always end up calling lots of people [*loud giggle*] and getting them in the studio and having a party atmosphere. Actually it can be a social gathering, or one-on-one, where we are singing together. It's blending yourself with another person or persons.

I guess I'm trying to say that there are so many levels to it. But luckily

the minute I've done too much of one thing, I'm in the other thing. For instance, there is then the part of the cycle where I do videos. And that's really collaborative, like being back in a band. And touring is yet another group thing. So then the minute you're bored stiff of touring you just go climb a mountain and write a song. It's just so different.

BLVR: Sounds like the rhythm of your lifestyle works for you. As opposed to someone who only tours or just sits in front of the computer… that can drive you nuts.

BJÖRK: Yeah, you can juggle it. Like I did after the *Vespertine* tour: I was able to listen to all of my live recordings. It took me a year and was more time-consuming than I thought. I became a bit of a librarian and then compiled the *Greatest Hits* album, so then I did another tour: the *Greatest Hits* tour, or whatever. So in a way, I did two tours in a row without writing new music.

Likewise, what I'm doing now is writing two albums without touring. So it doesn't have to always be the same cycle. And like anything, if you're really driven and really want to do what you do, at the end of the day you do it nine times better and it takes a much shorter time. So if you tour and are having fun touring, you do it well, and when it's not fun anymore it is best to stop. Because you're not doing anyone any favors if you are not doing it well anymore. So it's best to just skip it. And when you are in the studio and you are not enjoying being a hermit anymore and being an anal mosaic person then you should just stop, go out, get drunk, and have a party or something.

I am obviously lucky that I can just follow my whims. But then again I have to say there's a lot of hard work behind that to be able to be in that position. I think personally if you're lucky and get to be in a position where your music is put out and people listen to it and all your work is appreciated, you're also responsible for babysitting your hunger for music. You are responsible since people actually like what you're doing and want to hear more from you.

So if you go and tour for nine years because you think that is what certain people want, it's a waste. There is a peculiar blend of

self-indulgence in it, and in a way it is a service-oriented job. At the core, making music is all about generosity, and knowing yourself and knowing where you can be at your most generous at any given point. As much as it sounds like it would be selfish and self-indulgent, it is actually the opposite as well. I suppose that's like any job, at the end of the day.

III. ARMIES OF ME

BLVR: With your *Army of Me* benefit album you released twenty different cover versions of your song and are giving the proceeds to a UNICEF children's tsunami victim relief fund. I found the concept of so many people doing one song quite intriguing.

BJÖRK: Ultimately the ideas came from the people who did the cover versions. I started a website—I can't remember how many years ago—and people would send in versions of my songs, which is very flattering, and for some reason people would always send in the same song...

BLVR: It was always "Army of Me"?

BJÖRK: Well, they would send in all the other songs too, but what I found interesting was that that song is quite different from my other songs and probably the only one that is that confrontational. Like my only aggressive song or something. And I found it interesting that people would pick up on that one. And a lot of people would take a death metal interpretation of things—which I found really funny because that's a genre I haven't really done a lot.

So I thought, These people are creating something different in its own right, and so one of these days I'll do a charity record. It would be justifiable to release this if it would be for a charity, you know—it's not like I want to make money off of my fans. That would be slightly cheeky. The idea collected cobwebs, and many years passed and I forgot about the whole thing. Then the tsunami happened, and I thought, if ever there was a time to do this, this is the time. So I went on my website and I said, "Listen, if you could please send your versions back to me,"

because the technology has changed so much and people could send a version with higher-quality sound. Some of the people had sent me versions eight years ago. So everybody sent them in and we got around six hundred versions, which was much more than I expected. It just sort of happened.

BLVR: The tsunami issue is obviously a very delicate and emotional thing. These people were devastated, but it's an act of compassion to do a charity record. The aggressive nature of the song seems to reflect, perhaps, political climates and the state of the world—but you turn it into a compassionate act by harnessing that energy and sending the money to someplace it can directly help. How do you think about the juxtaposition of the anger of the song versus the outcome of helping the tsunami victims?

BJÖRK: It surprised me, the way people reacted to that song. As I wrote in the liner notes of the album, it was an unpredictable creative surge that hit my website. I have hopefully redirected it to children who had been hit by a very destructive force. But I see where you're coming from. I totally felt that way. If I had been asked "Can you write a song for a starving child in Africa?" I probably would have sat down and written a really mushy song. But maybe things aren't like that. I look at this project like only half of it is me, probably even less, and there are things here you can't control. My fans reacted to my most aggressive track. Funny enough, this song was actually written to a younger relative of mine who was being a bit naughty! So I am telling him off and asking him to sort of stand in line and be more considerate about other people, and not be selfish and self-indulgent. So you could say it has a prudent energy, or at least an attempt trying to fix things.

It's what I call a "finger song," like "Respect" by Aretha Franklin. You know those waving-a-finger numbers where you can imagine the singer waving their finger in the air and telling somebody off?

BLVR: Absolutely.

BJÖRK: So the song has that attitude where the singer has the right to address an injustice in the world.

BLVR: It works so well as a larger social cultural commentary, but now I do see it clearly on an intimate or domestic level too.

BJÖRK: Well, you have a point, and it does work on those levels. But another part of it is that the song melody is really tight and it's not a typical melody that I would sing. So recognizing that I have an idiosyncratic voice, I can imagine people thinking, Hey, this is a song that I can cover! Because the melody is probably more traditional. [*Hums the melody over the phone.*]

So part of what drives people to do the song is maybe trying to fix the world. But part of it is that the melody is so simple that people just take it on.

IV. BRAND-NEW, SHINY OBJECTS

BLVR: Did you sort through all six hundred versions yourself?

BJÖRK: The first round I went through it all myself. I felt that was the least I could do. At first I thought I would do a CD with ten death metal versions of "Army of Me." Which to me was pretty funny. Then, when I listened to everything everybody had sent in, well, it didn't seem fair.

BLVR: Yeah, you ended up with some nice ambient and country versions. There was quite a variety of approaches to the song.

BJÖRK: That's why I had to listen to all of them: to see where this project was going, because it's a cool operation. I thought of the idea because of people who were sending stuff in, so it might as well be the material people sent in that would direct the project.

BLVR: That song itself originally was a collaboration with Graham Massey.

BJÖRK: Yeah, we wrote it together.

BLVR: I watched a DVD of all of Michel Gondry's videos, which of course included some of yours. As I was thinking about your new charity CD I started thinking about repetition. Gondry uses variations on themes and repetition in an incredible way. Then I thought that a lot of great art is directed by repetition. Music is a short form, and you must restate a theme in that short period of time. Music is particularly obvious in its use of repetition. How do you use or think about repetition as an artist? Is there a natural guiding force to such things, or do you find yourself returning to certain themes?

BJÖRK: Well, I base a lot of my stuff on nature, and I think there is a lot of repetition in nature, like day and night, day and night, day and night—it's sort of a rhythm. The seasons are basically the same thing, but just really stretched out. Then again there are certain things that are always the same and others that are always different. All Aprils are different from each other, you know? I think there's a balance there. I think part of me is very conservative and wants to keep very grounded, and part of that comes from where I come from in Iceland—and also the fact that I am a singer. I mean, I will always have my voice. It doesn't matter how many fancy new objects I have in the arrangements; it's always gonna be my voice. That will always show if I am happy or sad, reveal my age and health and so on. It'll show if I am tired or energetic. All of this...

The other half is that things change and other things happen, and you bump into new experiences that you could never have anticipated. What I am trying to say is that it's a fifty-fifty contribution of repetition and brand-new, shiny objects that you never even could have fantasized about.

BLVR: Speaking of repetition, what was it like to hear six hundred versions of your song? Other than the drudgery of sorting through the sheer numbers, what were your emotions like?

BJÖRK: It was really flattering that people actually bothered; you could

just imagine all the work that went into it. I was on the twelfth floor of a house in downtown Manhattan. I spent two or three days listening to all of these songs, and I started looking inside everybody's windows and thinking, Wait a minute; if you think that apartment buildings are full of couch potatoes, just kind of sleeping and going back to work… Well, really all of these windows are full of very busy people doing all of these things that you never get to hear or see. So it made me very hopeful. I couldn't believe all of the energy that is going on out there. If this little project triggered all that, well, just imagine all the things people are doing.

BLVR: Did you hear anything in these versions of the song that depersonalized it and made it less your song? I don't know if that's possible after playing the song so many times yourself.

BJÖRK: I think the versions I chose were actually those kind of versions. They were versions where I can imagine somebody listening and never having heard my version and not knowing who I am, and hearing it would go, "OK, I get it!" I think that is the part of covering a song that is tricky. Making it your own.

BLVR: There was a great variety in the interpretations. In some cases you could actually picture the person in their apartment or room, and other times the production was fairly elaborate. It sounded ultimately like each one was clearly chosen on musical merit and general intrigue. The remixes are really strong and creative.

BJÖRK: I remember the thing that started to happen when music was first being remixed—there was a different emphasis in England. When I first came over to the States after living in London it seemed that remixing in London was really similar to jazz music. People would cover each other's songs. It would be like fifty different versions of "My Funny Valentine," but each person would try and make it their own. When I came over to the States, ten years ago or so, there was a lot of skepticism about remixing; people thought it was the record company

trying to market by cutting off all of the authentic bits to make it supermarket-style.

That's a difference between Europe and the States. What I found with this *Army of Me* experiment was that in all the versions, you couldn't tell if they were cover versions or remixes. The distinction was blurred. Some would use my original voice and change everything behind it, but then if you re-sing it then it's not a remix anymore—it's a cover version. Or the other way around, where they were sampling the original riff from my version and singing it themselves. Is that a remix? Is that a cover version? I think it was kind of nice and it came in a complete circle. Remixing can be a really creative thing. A remix does not have to be from the evil music industry machine. ✷

MARK MOTHERSBAUGH
[DEVO FRONTMAN/FILM AND TV COMPOSER]

"ALL OF A SUDDEN, DRUNK MUMMIES WERE
SHAKING THEIR FISTS AT US. DRACULAS
WERE SHOUTING OBSCENITIES AT US.
THAT MADE US EVEN HAPPIER, AND PISSED
THEM OFF EVEN MORE... IT MADE US FEEL
WE HAD TO BE DOING SOMETHING RIGHT
TO GET SO MANY PEOPLE PISSED OFF."

Things Mark Mothersbaugh has seen that you, most likely, have not:
The end of rock music
A sad elf named Barnaby
Lenny Kravitz providing the voiceover for a one-day-old child
Chairy, in person

"The Hardest Geometry Problem in the World" *is argu-
ably the most beloved piece of original film music to
hit the world in the last decade (or three). You may
not recognize the name, but the mischievous baroque
tinkling of the tune would be immediately familiar
if you heard it played. Perhaps you'd even begin to picture the scene it
underscores: the opener of* Rushmore, *during which main character Max
Fischer daydreams about solving the eponymous math challenge after
some lightning-speed blackboard scribbling. It's the moment that sucks
viewers into the film—and, for many, into the entire oeuvre of director
Wes Anderson—and the song has a lot to do with that: the melody itself
practically bursts with excitement and enthusiasm about what's to come.*

The musical wizard behind this captivating passage: Mark Mothersbaugh, lead singer of the influential New Wave band Devo and the indefatigable Hollywood composer whom Anderson has tapped for all his films.

Mothersbaugh's rich and unusual career began when he and fellow Kent State studio art major Jerry Casale founded Devo in the early '70s after witnessing the murder of four students by the National Guard during the infamous Vietnam War protest. Searching for an effective method to expose the rampant consumerism and conformity they saw in America, they created their songs in tandem with short films that illustrated their lyrics, anticipating MTV by over half a decade. And when the music network launched in August of 1981, a number of Devo movies became the channel's first videos. In the process, Devo scored a major hit with "Whip It"—and MTV, a channel designed to appeal to the masses, helped popularize a group that encouraged listeners to rethink the mob mentality.

Mothersbaugh has since written songs for more than a hundred television shows and movies, including Pee-Wee's Playhouse, The Rugrats Movie, *and* The Wacky Adventures of Ronald McDonald: The Visitors from Outer Space, *as well as a number of jingles—though he never misses an opportunity to adulterate. He's suggested that it's "entirely possible" he's embedded the words "Sugar is bad for you" into a cereal commercial; and he has admitted to sneaking the phrase "Question Authority" into a kids' show tune. "People are all hiding something," Mothersbaugh claims on his website. And while that statement certainly seems to apply to a man who plants secret messages in his music, Mothersbaugh is a refreshingly candid conversationalist. When I caught up with him, he was driving to a prescreening of one of his latest collaborations,* Herbie Fully Loaded.

—Maura Kelly (September 2005)

I. "THE BIG DRAW WAS A HALF-WOMAN, HALF-CAT WHO HAD SOMETHING LIKE TOURETTE'S SYNDROME AND WOULD ACT IN A FERAL MANNER WHEN SHE GOT ANGRY OR JEALOUS"

THE BELIEVER: When you get an assignment, does the director sit you down, describe the plot, describe the scene, describe the emotion, and then say: "Go for it"? Or do you watch the movie without a soundtrack before you start composing? Or do you spend a few days watching the movie being shot?

MARK MOTHERSBAUGH: Any and all those scenarios are possible, and have happened at one time or another. Let's say you need to write a song that one of the movie characters, or maybe a band, is going to perform on camera; in that case they need your song before the movie even starts shooting—

BLVR: Have you had to write a song like that recently?

MM: There was a song in *The Rugrats Movie* where that was the case. The scenario was that there were a bunch of one-day-old babies in a maternity ward, all singing to each other a song called "How Did I Get Here?" They were comparing statistics—how many were male, female, that kind of thing.

BLVR: That sounds like one of the songs off that old Marlo Thomas album, *Free to Be... You & Me*, which my sister and I listened to all the time as kids. We thought it was hilarious. Mel Brooks did the baby boy, I think, and Marlo was the girl.

MM: That sounds pretty good!

BLVR: Who performed on your song?

MM: A lot of musicians: Iggy Pop, Beck, Jakob Dylan, Lenny Kravitz, Fred Schneider, Kate Pierson and Cindy Wilson of the B-52s, Louis Freese from Cyprus Hill, Gordon Gano from the Violent Femmes—just to name a few. And they all had about two or three lines, and we had to record them all separately.

BLVR: No "We Are the World" scenario?

MM: Right. People came to my studio, or I went to other people's studios. I went out to New York to record the guys from Depeche Mode and Patti Smith.

BLVR: And you wrote the music and the lyrics?

MM: Yep, but I had help with the casting. There was a wish list of performers, and we got them depending on people's availability, whether or not they wanted to sing for a kid's movie, stuff like that. Though I was surprised how many people did. Like Patti Smith, who agreed to do it on one condition. She said, "You have to let me bring my daughter with me because she is a big *Rugrats* fan." And then she really got into it. She said, "You know, I don't think my character would shut up and only say two lines. I think she'd keep talking and make problems." I'd never worked with her before, and it was fun. She brought a lot to the job.

For some other projects I've worked on, I've searched for some of the world's worst lounge singers. I've found a couple good ones here in Los Angeles. One was a realtor and the other was a Frank Sinatra wanna-be, Nick Edenetti. Nick was in a couple things for me, including a pilot I was producing about three or fours years ago that was unfortunately too weird to make it on television.

BLVR: What was it about?

MM: It was an animated show, and I was working with a visual artist named Georganne Deen on it. It was about a nightclub in Vegas, in the seedy area, run by a guy who always wanted to be a nightclub singer,

but he was terrible. So instead he just bought a nightclub. And the club would close for the night after he sang because the whole crowd would leave at that point. The big draw was a half-woman, half-cat who had something like Tourette's Syndrome and would act in a feral manner when she got angry or jealous.

BLVR: That sounds like something I'd check out.

MM: Yeah, I think it was a really good pilot.

What do you think, am I going in the right direction to get to Disney right now? I think I am. I hate this part of Burbank over here; the roads get all twisted. Oh, here we go, yes, I'm going the right way. In a minute, the security guards at Disney will want to do a full-body check on me so I may have to set the phone down at that time.

II. "'THESE GUYS SHOULD BE STOPPED!' HE SAID. 'THIS ISN'T MUSIC! THESE GUYS ARE MAKING FUN OF MUSIC.'"

BLVR: OK. Speaking of the entire audience leaving a show, can you tell me a little about one of Devo's performances—didn't you open for Sun Ra at a Halloween party, and clear the house?

MM: Those were the early days. I think that was 1975. Nobody knew who Devo was except for maybe thirty people in Akron. But we had already come to the realization that we were an excellent lightning rod for hostility—hang on one second. [*MM talks to the security guards at Disney, who ask for his identification.*] All right, now he's got my driver's license. He is going to examine it in the little booth and probably wave me on through. If you hear gun shots, though, you will know the "wave me on through" part didn't happen. I'm here really early for some reason. I think I just wanted to get out of my studio. [*The guard directs MM about how to get to the studio where he needs to be.*] They have billboards for all the TV shows here. *Supernanny, Alias, Lost, Extreme Makeover: Home Edition*… Now I am parking the car and we are almost home free.

We've made it here without an accident.

BLVR: Are car accidents a regular occurrence in your life?

MM: No, I'm a pretty good driver. I haven't gone through a windshield in a long time. Where were we?

BLVR: You were talking about the realization that Devo was a lightning rod for hostility.

MM: Yes. We had a different take on things than people into music at the time. And the first people who we unleashed our wonderful talents on were either confused by what we were doing—because it was so different from what was happening in the mainstream music scene at the time— or actually scared, because they didn't understand us.

And the Sun Ra party—it was one of those nights that got a little creepy. Everyone at that party had long hippy hair, and liked bands like Joe Walsh, Michael Stanley, the Raspberries. I don't know why they even hired Sun Ra, but I guess he seemed like a hoot—weird, but in a safe way. They were all in the kind of outfits you might expect: people dressed as pirates, mummies, Frankensteins. And in Ohio fashion, they filled a garbage can up with Tequila Sunrise, which is fruit juice and tequila, right?

BLVR: Sounds right.

MM: And someone brought along a tank of nitrous oxide. Devo came out, wearing janitor outfits. And they just didn't think we were funny. [*Laughing*] We looked like a clean-up crew. And then we had songs like "Jocko Homo." [Example lyrics: "God made man / But he used the monkey to do it / Apes in the plan—we're all here to prove it / I can walk like an ape, talk like an ape / I can do what a monkey can do!"] It was in 7/4 time, and those people just didn't go for it, because it wasn't the kind of song that went along with the natural flow of your body. When we got to the end of it, when it gets into 4/4 time, they thought we were

going to let them off the hook—until they realized we were going to chant, "Are we not men? We are Devo!" for about twenty minutes. Or however long it took for them to get really angry. We went at it for a really long time until one of the DJ's—the local radio station was hosting the party, which was in an empty auditorium—grabbed the mic and made an impassioned plea. "These guys should be stopped!" he said. "This isn't music! These guys are making fun of music." And there were a lot of people in the audience who agreed with him. They felt what we were doing was dangerous. So all of a sudden, drunk mummies were shaking their fists at us. Draculas were shouting obscenities at us. That made us even happier, and pissed them off even more. It turned into a bit of fisticuffs. It was a mess. But it made us feel we had to be doing something right to get so many people pissed off.

BLVR: Did Devo develop in part out of anger that the hippie movement—which started out as counter-cultural—became so conformist? Was there a lot of pressure, after a while, to be relaxed and groovy? Or what were some of the things you were reacting to, with Devo?

MM: Well, even back then we were already predicting that the hippies would become the capitalists of the '80s.

BLVR: How did you figure that out?

MM: Because people, especially in the entertainment industry, were so quick to market themselves. The whole culture seemed to become very controlled by marketing. Everything had gotten co-opted—revolution had gotten co-opted. When Jerry [Casale, of Devo] and I first met, we joined Students for a Democratic Society, and we took part in demonstrations against the war in Cambodia and Vietnam. And after the shootings at Kent State, we watched the whole country fall asleep. People seemed to be saying to themselves, "Oh, we've gone too far." Suddenly, people decided not to have a social conscience. And in the music business, the Bob Dylans disappeared.

We are now in the official Walt Disney commissary right now, on

the Disney campus. I'm going to sit on a bench and talk to you for a bit, because I'm early. Anyway, there was nobody talking about what was going on and that inspired us. We wanted to be musical reporters. We wanted to talk about issues.

BLVR: Were you trying to wake people up with the *sound* of your music—not just the lyrics but the unusual beats, the loud singing, and so on?

MM: Here's what it was. Somewhere around 1974, a friend of ours, Chuck Statler, came over to where we were rehearsing. He said, "Check this out." It was a *Popular Science* article all about laserdiscs. "Everyone will have them next year!" it said. And they were described as whole albums which not only had sounds, but visuals. You could almost get a whole movie on them, the original ones, and they looked just like a vinyl record. And we thought, Damn! That's the end of rock and roll, because the great artists are going to be the ones who are into both sound and vision.

We became totally convinced then that we wanted to make art for that world—the one beyond rock and roll, which we were sure was going to be populated by people who had something to say both visually and musically. Which felt good to us, since we were visual artists in college. So we were writing music that was saying goodbye to rock and roll. That's what we thought we were doing: deconstructing music that was popular at the time—disco and concert rock, like Styx and Foreigner. The message for that music was "I'm white, I'm stupid, I'm a conspicuous consumer and I'm proud of it." Disco, on the other hand, was music that was like a beautiful woman with no brain.

You know, there are squirrels around here and someone must feed them because they're so tame. One just ran right up on my shoe. Oh yeah, I see what looks like almonds on the ground. Man, is this place beautiful. It's like paradise.

BLVR: Is it your first time there?

MM: No, just my first time being this early. I'm probably being watched on video, and the guards are probably saying, "This man does not have a destination. What is he doing? Follow him."

III. "THESE DAYS YOU PRETTY MUCH HAVE TO SIT ON AN ELECTRONIC DRILL IN A VIDEO FOR ANYONE TO REACT"

BLVR: So it really makes perfect sense that you have gone into writing music for movies.

MM: Originally, our goal was to make our own films. We made short films. Actually, we predicted MTV five years before it happened—we talked about the idea of music television in interviews. But we didn't realize it was going to be so awful. We were looking for a new art form, a new way to think about our relationship to culture, something smart, a light step forward. Instead we ended up with a Home Shopping Network for music companies.

The sad thing was that it didn't have to be that way. In the beginning, MTV was getting bombarded by artists around the globe with short films that were not just about a Fleetwood Mac–look-alike band mugging in front of the camera, or some kind of retrofitted Tom Petty song. They were getting original, unusual things. I know this because MTV would have these contests that they asked me to help judge. MTV knew me, knew us, because by the time MTV started, we already had made all sorts of clips—we'd started filming them in maybe 1974—and so you would see one Devo song just about every hour. Anyway, that's how I started helping to judge these contests. I remember one time, there was a band called Tone Set from Arizona. They were so cool. I was sure they were going to win. This was in the early '80s and they were playing stuff similar to what became trance and rave music. They didn't have guitars and they had an electronic drum kit. But I was voting with people from the music companies—managers, agents. And I think it was a band that just spoofed ZZ Top—spinning their guitars—that won.

I remember our first album had a song on it which didn't use any guitar.

And a reviewer, I think he was from *Rolling Stone*, was totally incensed by that. [*Laughing*] It was different times back then. These days you pretty much have to sit on an electronic drill in a video for anyone to react.

BLVR: Were there any bands taking advantage of the music-video medium in a way that you respected?

MM: Sure. People like Kraftwerk, for instance. It was just a major disappointment that bands were going for payola and sucking up to the existing record companies rather than trying to start something new. It was shocking.

BLVR: Do you think the internet and all the cheap, available technology of today has helped create a world that is closer to what you were hoping for back then?

MM: Maybe so. Because today, if a record company collapsed, who the hell would be losing, except the people who were out of jobs? Consumers aren't going to be losers. And if you're in music just to become a big, fat rock star, then I probably don't like your music to begin with. It's people who write music because they are obsessed that I like, because they have something to say and no other way to say it. And if you get rid of a lot of the poseurs by destroying record companies, maybe it's a good trade-off.

BLVR: Speaking of people who are making music because they are obsessed, what new bands or musicians do you like?

MM: It's almost harder today to keep up with everything. There is so much music out there. When I was a kid, I would go to the record store, where there was a bin of things they didn't know quite how to classify. Those were my choices. That's where you would find Captain Beefheart or an early electronic album. Nowadays there is so much stuff out there that the hard thing is weeding through it.

And albums are different than they used to be. Technology has taken its toll on albums in a tough way. The CD format and MTV really

played havoc on artists. Before MTV, if you put out an album that sold fifty thousand copies, your band could afford not to have day jobs for a while. That meant you could stick around, put out another album or two. Maybe it would be the second or third album where you'd make the statement you'd been trying to make all along. With MTV in the '80s, you made your album but then you needed to use any money you made to create a video—instead of being able to use that money to pay for you and your band to live on while you wrote new songs. So MTV upped the ante of looking for one hit. Conceptual bands who didn't have a hit were going to lose.

And with vinyl you had twenty-two minutes per side. CDs came along, and you had sixty, seventy, eighty minutes and people felt like they had to fill them up. They were like those Fuji apples from Japan. They look like perfect, super-gigantic versions of American apples. But when you bite into them, they're tasteless. They taste like foam. That happened to artists. Instead of writing forty-four really great minutes, honing it down, people let their waistbands out and threw the kitchen sink into their albums. You thought you were getting more; in reality, you were getting less. That was the dilemma of the '80s, if you ask me.

BLVR: Right.

MM: Oh, man, this has turned into a depressing conversation! What else can we talk about instead that's more uplifting? Can we talk about Iraq?

IV. "FOR *RUSHMORE*, IT WAS THE GLOCKENSPIEL AND CELESTE BECAUSE THEY REMIND ME OF EMOTIONAL THINGS FROM MY PAST. I NEVER USED THEM IN DEVO—WELL, EXCEPT MAYBE FOR DURING A BOOJI BOY SONG."

BLVR: How about *Rushmore*? I was wondering about how you created an emotional effect with the music you composed for that movie. You used instruments like the glockenspiel, the harpsichord, and the flute

for the original *Rushmore* songs—what effect do those instruments have on a listener? What made you choose those instruments? Did you talk about them with director Wes Anderson?

MM: Talking with Wes had a lot to do with it. He's a major collaborator. When I write music for his films, he likes to be around while I record it. For *Life Aquatic* he was sitting in the back room of the studio with a laptop, working on the script. He said at one point—and this is pretty typical—"Mark, I'm thinking about putting a guy into the film who is a composer. He writes music in the style of the '70s. So we'll need some outdated Casio instruments that we can write some of the music with." That character became Wolodarsky, the guy with the moustache [played by Noah Taylor]. And that's the kind of relaxed relationship I have with Wes.

Anyway, for *Rushmore*, it was the glockenspiel and celeste because they remind me of emotional things from my past. I never used them in Devo—well, except maybe for during a Booji Boy song. He was this masked character who would end our shows because people would stop clapping for encores after he came out and sang one song.

So when I was a kid, one of the saddest things I ever saw on TV was this show called *Barnaby and Me*, with this local personality Linn Sheldon. He'd put on little pointy leprechaun ears, a straw hat, and make-up that was too thick; he would show cartoons and talk to himself, be kind of funny. It was a show for kids. I'd watch it with my potato chip sandwich, with white bread and mustard, and a glass of milk, which should have made me throw up.

At the end of the show, a celeste would play the saddest music I'd ever heard in my whole life and Barnaby would come right up to the screen and say [*in a weeping voice*], "If anybody asks, just tell them Barnaby says hello." And he'd burst into tears. At the end of every episode. It would make me really upset, even though I loved the show.

So the celeste was sad to me.

BLVR: Are you saying "cellist," like the person who plays a cello? Have I been mispronouncing that my whole life?

MM: No. Celeste: c-e-l-e-s-t-e. It's like a glockenspiel. A three-and-a-half- to four-octave keyboard.

BLVR: So the celeste and instruments like it made you think of this childhood experience that was happy, funny, sad, and a little weird—which reminded you of *Rushmore*?

MM: To me, *Rushmore*—especially because it had the school plays inside it—seemed almost like something that had been written by kids for grown-ups to act in. That's partly because of Wes, and what he's like. Since I've known him, he's made quite a transformation, going from trying to get his first movie, *Bottle Rocket*, off the ground to having four films under his belt. And he's in Paris today, writing a new script. He was saying the other day, "Come on over, Mark! Visit! I have an extra bedroom!"

BLVR: That sounds really nice.

MM: But I remember Wes and Owen and the other Wilson brothers being the guys who would show up at a party and immediately run for the food and start shoveling the nachos in because they hadn't eaten all day. It went from that to, when we were doing the last movie, someone would come up to Wes and say, "Mr. Scorsese on the phone."

BLVR: How did you get to know Anderson?

MM: A woman I know who was working at Sony at the time called me and said, "Come to an advance showing of this film *Bottle Rocket*. It's really cool, even though everyone here is nervous about it. No one understands the director. But I think you might like it." That day, there was a record set for the most walkouts I ever saw at a screening.

BLVR: Are you kidding? I think that movie is one of the funniest things around.

MM: They had recruited local high school students, half of them gang members, to watch, and they were really bummed out there was no flesh or murder. But I thought the movie was excellent, and I was really impressed by his choice of temporary music because he wasn't trying to do what everyone else was doing. He'd picked obscure things, like Vince Guaraldi and stuff from other soundtracks. So I thought we should meet; and we did. That was the beginning of a very rewarding relationship. His films are four of my favorites that I ever got to work on.

BLVR: I can imagine that. You can feel the joy in those films. And I always feel very excited by the music he picks for the soundtracks.

MM: He makes great choices. He's really into music. He's interested in B-sides, things besides the hits. It makes for a much richer soundtrack than if you just make a deal with the record company about what they will give you. And Wes and I trade music, trade CDs.

I really like working with directors early in their careers because they're still excited about everything. It reminds me of Devo's early days, when we were in Ohio, doing things for the love of it. But after someone has done maybe half a dozen movies or so, they seem to get really jaded. I was happy that this new movie I worked on, the updated version of *Herbie the Love Bug*, which I am here at Disney to see, gave me the chance to work with a young director, Angela Robinson.

BLVR: That reminds me of something I read about you—where you said that after a certain age, rock bands should give it up and pack it in. Did you mean that if you've lost your passion for it, you shouldn't just be out there, hacking it up?

MM: Well, you know, after a while, being in a bus with six or seven guys, eating out of cans, sleeping on top of each other drunk every night, showering once every few days—that's something for twenty-year-olds. Devo is playing about a dozen shows this summer, and that's all I need to be fulfilled for a while.

V. "NOW THERE ARE SO MANY FILTERS THAT BY THE TIME ANY PROGRAM ACTUALLY AIRS, SO MANY PEOPLE HAVE PEED ON IT THAT IT'S A BIG YELLOW STAIN"

BLVR: When you left the band life, you started by composing music for television. Was creating the theme song for the Paul Reubens show *Pee-wee's Playhouse* your first big job after Devo?

MM: That's right. And then I would do music for the episodes. Paul co-wrote the theme with me, and Cyndi Lauper sang it.

BLVR: You're talking about the one that goes, "Sit down and pull your-self up a chair—a Chair-y!" And Chair-y was this character, kind of a recliner with a smiley face.

MM: See? You even know it somehow.

BLVR: As a little kid I was kind of scared of Pee-wee—the geisha skin, the red lips, the beady eyes, the ill-fitting suit. He creeped me out. But when his show came around, I was a little older, and I became somewhat fascinated by him. Maybe a little like how you felt about Barnaby.

MM: Something like *Pee-wee's Playhouse* couldn't happen again—some-one like Paul getting creative control over his show. Now there are so many filters that by the time any program actually airs, so many people have peed on it that it's a big yellow stain.

BLVR: What was Reubens trying to do with that show? To me, it was like Devo, in that both the show and the band were trying to say, "Think about what you are watching, what you are listening to"—taking advan-tage of the audience's comfort with a genre to do something slightly subversive, strange, interesting.

MM: Yeah. And at the time *Pee-wee's* was airing, there wasn't anything with an edge for kids. *Simpsons, King of the Hill*—they hadn't come along yet. The network was kind of freaked by how loose the show was, but it showed up at a time when it was perfectly needed. And for me, the creative cycle moved very fast. I'd get a tape of the show Monday night or Tuesday morning. I'd write the music Wednesday, send it back Thursday—and by Saturday morning, the show would be on. I'd think, That's nice. I'd just come out of the rock world, where there would be a whole year of working on just ten or twelve songs. For *Pee-wee's* I was writing just about an album's worth of music in under three days. It was a whole different kind of animal. It was really exciting. You'd hear some stuff and think, I don't even remember writing that, or, That's pretty bad. But sometimes it would be like, "Hey, that's pretty good!"

BLVR: I was just thinking: I'm always making up soundtracks in my head for my own life—Big Star is playing when I start to have a crush on someone, Pink Martini when I'm at the grocery store, Red House Painters when I'm down, and so on. But you can create a completely original soundtrack for your own life, without relying on someone else's music. Do you ever do that?

MM: Yes. I can never find anything that is exactly what I want to listen to. And I just wrote my own five-CD collection. Do you know those organs people used to have in their living rooms, with a beat box and sound effects and organ sounds? They were popular in the '60s and '70s.

Well, for *Royal Tenenbaums*, I thought I was going to use some of those synthesizer organs. And these organs, that once cost thousands, you can now buy for $50 or $100 at piano stores like West L.A. Piano. I thought Wes would be interested in that sound, but we ended up not using them. I've used them in a couple other movies, but just very short bits so far. But I had the organs because of that, and had been playing them in my studio. And three months ago I started doing stream-of-consciousness Muzak with them, and very rapidly, I had about five and a half hours' worth of music. So that's what I am listening to in my car these days.

Listen, I better get going. It's time for me to watch this screening. If you want, I could leave the phone on while I'm inside. That way, you can tape the soundtrack and put it out on the black market in China. What do you think? ✭

ANGÉLIQUE KIDJO

[SINGER]

"AFRICA IS A CONTINENT; SOME PEOPLE IN
AFRICA DON'T EVEN KNOW THE DIVERSITY IN
OUR OWN CONTINENT. HOW CAN SOMEBODY
WHO COMES FROM AMERICA OR EUROPE
TELL ME WHAT I SHOULD SOUND LIKE?"

Some entities Kidjo has performed with:
Mom's theater group (age nine)
Kidjo Brother Band (age nine)
The Sphinx (early teens)
*Random local bands hired by her promoter in whichever
country she's performing in (late teens)*

I t's best not to speak about the purity of music with singer-songwriter Angélique Kidjo. She simply doesn't believe it exists. While this might sound odd coming from a woman born into a musical family in Benin who traces her ancestry to the female warrior Amazons, Kidjo couldn't care less about adhering to a "traditional" sound. Heralded by luminaries such as David Byrne, Gilberto Gil, and Carlos Santana as one of the most important singers to come out of Africa in the last twenty years, Kidjo, with relentless curiosity and mutability as an artist, yields a music composed of samba, zouk, rock, Afro-funk, world beat, Caribbean pop, and other less identifiable but equally surprising genres.

Kidjo's liberal upbringing was incompatible with the communist regime

that took power in Benin when she was a child, and so, with her father's encouragement, she fled to France. After a few years studying law in Paris, she began using music to speak to and for those forced into the margins of society. In the past twenty-odd years, Kidjo has topped the charts in numerous countries, written and recorded nine albums, and served as an honorary ambassador to UNICEF.

At a recent show in San Francisco, she jumped down from the stage and began mingling with the audience, asking them to sing along in a jubilant call-and-response. Chances are that most people didn't know what they were actually singing, as Kidjo's language of choice is Fon, Benin's primary language, but it hardly mattered. She swept though the crowd, and one could hear each section singing louder as she passed. Older blushing hippies found themselves calling out with beautiful, tone-deaf voices, while younger audience members challenged Kidjo to what seemed like a preemptive dance routine. The young clapped their hands along with the old and everyone followed the petite, strawberry-blond-haired woman like sailors to a siren's call.

This interview was conducted over the phone from Kidjo's house in Brooklyn. Her voice engaged even as it disarmed—as if she were singing her sentences.

—Patrick Knowles (February 2006)

I. "I WOULD BE WALKING BACK HOME FROM SCHOOL AND THEY WOULD SAY, 'LOOK AT HER. THE SINGER, THAT PROSTITUTE, PHEW!'"

THE BELIEVER: What was it like to grow up in Benin in the 1970s?

ANGÉLIQUE KIDJO: I grew up in a big town—well, compared to the rest of the country it was like a big city. [*Laughs*] When I was growing up, it wasn't as developed as it is now. I had more space to play in the street where I used to live. But now all of the empty spaces are taken. People have built things all around. The roads are modern and paved and you have internet cafés on all the corners.

BLVR: What kinds of games did you play?

AK: I played soccer with my brothers. I never liked to play with Barbie dolls or anything. I was a tomboy. I followed them around and climbed trees with them. I tried to do everything they did. I even tried to pee standing up, because I didn't want to be a girl. I just wanted to be like my brothers. They would be like, "Oh, sorry, but you're a girl and you're going to stay a girl." That would make me pretty mad. When you're young, you always want to be someone else.

BLVR: You eventually started singing in your brothers' band, right?

AK: I was number seven in the order of kids. My brothers' band would use me as a pickup player because I could sing certain songs that their singer couldn't sing. They had two different singers at the time. One sang regular, traditional African and salsa, and the second one completely copied James Brown—the step dancing, the screaming, everything. We called him James Brown, because he really looked like James Brown and he would sing wearing an Afro. It was absolutely another era—something that I really miss today, because the modern music scene in Africa becomes exactly like everything else—it's all just a format. When I was growing up, I was exposed to so many different types of music, language, rhythm. It was much more diverse, and nobody felt guilty for listening to different types of music.

BLVR: Do you remember when you first appeared onstage?

AK: It was with my mom's theater group. I didn't want to go, believe me. I opened the curtain and I saw the audience. And I was like, "You think I'm going to go out there in front of all those people?" And my mom was like, "Sure, you will." I was like, "Hell, no. I'm not." So I went and hid.

BLVR: Where did you hide?

AK: Behind the curtains. And she found me. I didn't know that because

there was a mirror behind the stage she could see all of my whereabouts. So when it was my time, she just went and grabbed me and sent me out to the middle of the stage. They opened the curtains and I felt so tiny there. I opened up my eyes wide, and I was so skinny that I could feel my heart going *click, click, click, click* against my jaw. People were so surprised at me coming onstage; this little kid, that they started to laugh. The moment they started laughing I said to myself, "Oh, I guess everything is cool. I can do this."

BLVR: You didn't take offense?

AK: No, not at all.

BLVR: The laughing actually helped…

AK: My mom had said, "Just do the same thing that you do at home. We all crack up when you're singing and laughing." So I did the same thing.

BLVR: What part did you play?

AK: I was the daughter of King Akaba of Benin, who had one of the most beautiful wives ever. He was so jealous—any man who even smiled at his wife got his head cut off. Once a month he tried the criminals, and one of the guys who was supposedly smiling at his wife was actually innocent. The queen put a scene together to distract the king. He loved to see his daughter sing, and that's where I came in. Once he saw his daughter singing and laughing, he let the prisoner off easy.

BLVR: How long after that did you start performing with the Kidjo Brother Band?

AK: The first concert I did with my brother, I was nine years old. They used to play every weekend in a club. My dad would take me there to sing, and right after I was done he took me back because they were serving alcohol and I was too young to hang around.

BLVR: What kind of people showed up to these clubs?

AK: Mostly tourists.

BLVR: Did you tour with your brothers?

AK: Well, I was too young for my dad and mom to let me go out of the country. But even before I started touring, when I was in high school, the communist regime decided that, every Friday from five to seven, every student should devote two hours to studying something other than history, math, or anything. We had to study something else, like gardening, sewing, poetry, theater, or music. At my school, there was this band called the Sphinx. I started playing with them and they would go from college to college playing in competitions. We would always win. We were very, very tight, and we were edgy. Every time we decided to cover a song, we would rehearse like crazy until it was perfect, until we could play it with our eyes closed. That was our power.

BLVR: So when did you start touring on your own?

AK: When I did my first album. I wrote my first song when I was thirteen, and I did my first recording for the national radio station in Benin when I was sixteen or seventeen, and then I did my first album at eighteen. That's when I started touring outside of Benin to other countries in Africa.

BLVR: What was that like? Did you travel by yourself?

AK: Oh-ho, no! By myself? You're kidding me!

BLVR: Oh—well, I mean…

AK: [Laughs]

BLVR: So, I guess not. Was the Sphinx your backup band?

AK: I recorded the songs with that band, but when the promoter hired me, they would hire a local band in the country where I was going to perform. I would send the music ahead of my arrival, four or five days before the show, and when I got there I would give them hell. I would know every part of the songs—the guitar, keyboards, and every single instrument. If they didn't get it, I would sing it back to them. They called me "white girl" because they would say, "You're always on time and you are too picky."

BLVR: Really?

AK: Yeah, because I was always on time and wanted my music to be done perfectly. In Africa, that isn't the custom at all. You can just forget it. [*Laughs*] Even today, they call my parents white people because they are very liberal. It was unique for me to have the parents I had in Africa, period. The house was always open to people.

BLVR: Is it still that way?

AK: Yeah. Sometimes I'll vacation there and I'll walk into their house and ask, "Who is this guy?" Nobody knows where the guy comes from. He's in the living room watching TV, just chilling out. Now I realize why my dad was yelling all of the time, "I don't work to pay for the food of the whole country. Why don't they stay home?" And my mom would be like, "If they are going to come, you can't sit and just watch them, you have to cook and feed them." My dad would say, "I don't care. Just get them outta here." And of course my mom would never get them out. [*Laughs*]

BLVR: You don't seem like the sort of person who would take being called "white girl" too seriously, but was that difficult for you at the time?

AK: The thing that was difficult was to be called "prostitute" for singing in public, because the '60s and '70s, when I was growing up, was the period of sex, drugs, and rock and roll, and everything that was happening in America and Europe in terms of image, sound, and the news. So

here you have the parents going, "Music? Hell, no. If my kid is going to look like those guys, the ones who can hardly open their eyes from doing drugs, and all of the half-naked girls, no way, no music." I was doing my music while I was going to school, which made it even harder, because most of the people who came to see me perform were the ones I had to deal with when I went back to school the next day. They would clap and have fun with me at the shows, but suddenly two or three days later, it completely switched. I would be walking back home from school and they would say, "Look at her. The singer, that prostitute, phew!" And they would spit on me. And sometimes it was hard. I didn't care what they said, but sometimes I would come back home and found myself crying to my mom and saying that I didn't want to sing anymore. And my mom would tell me, "Do you want them to run your life or do you want to run your own life? Just forget them. If they're not talking about you, that means you're dead. Rather have them talk bad about you than not talk about you at all."

II. "I PREPARED MY EXILE IN SECRECY. I TOLD MY DAD, 'I CAN'T STAY HERE ANYMORE—I CAN'T KEEP SITTING AROUND AND SINGING TO THESE SCUMBAGS.'"

BLVR: You eventually left Benin—was that because of the communist regime?

AK: Yes. My father was an intellectual. He had political views, of course, but he always refused to do politics. When the communists came into power, they wanted him to be part of the government, and my father said, "No, thank you. I've never done politics before and I'm not going to start today." So they became suspicious. The freedom we once had at home, where we could talk about every subject, was the rule. My father and mother decided that the house was going to be open to every type of subject and there would be never a taboo subject—even the most difficult things, we could discuss.

BLVR: Communism changed that.

AK: Communism came and put a strain on it. We couldn't talk because they would send spies to see if we were talking badly about the revolution and Communism. If you said something bad, you would find yourself in jail. So my father said, "OK. Now we have to watch it. Now is not the time to talk about what we think and what we want to do." So it was very odd to be in our house that was once so open, liberal, and comfortable.

BLVR: What tactics did the regime use against your family?

AK: Well, they knew they could get to my father by using me, because I was a public figure. They would ask me to do shows. I was always able to say, "No, I can't, because I'll be touring and out of Benin, and I'll be here or there instead." That was how they would try to be controlling, trying to see whether I was supporting them or not. There were two times when I couldn't find any excuses and had to do a show. Those were very hard, because there would be people in the dressing room asking me questions like, "What's your next move? What do you think about this? Do you have any songs you could sing about our revolution?" Every time I was put in this position I would think, "Oh, my god. I don't want to talk about my feelings about the politics of these people because what if I say something wrong?" You can't sing or say anything.

I hated it, and that's why I prepared my exile in secrecy. I told my dad, "I can't stay here anymore—I can't keep sitting around and singing to these scumbags." I couldn't take it. My dad said that I didn't have any other choice but to leave the country. I couldn't say what I thought, I couldn't do what I wanted, and no one could take that freedom away from me. So I fled. Only my dad, mom, brothers, and sisters knew, not my uncles, aunts, or anyone else. Because you didn't know who would give you up; it could even be your neighbors. At that time, it was still a good time, where you didn't need a visa to get to France and there was an African airline company that took that trip.

BLVR: How did you prepare for that?

AK: There was one last flight that would leave around midnight. A friend of mine was having a wedding that Saturday evening, and their house was very close to the airport, so I got dressed like I was going to the party. My dad brought the car inside the house and loaded my suitcase. The only other person who knew about this was my girlfriend, the one who was getting married. We got to the wedding dinner, had some food; I went to her room to change into my traveling clothes and drove to the airport. I waited until the last minute to go so there wouldn't be as many people. I should say that, at the time, not many people were allowed to leave the country. One guy, one police guy who was a friend of my family, was working there. He asked me what I was doing. I told him I was trying to leave. He said, "I'm going to help you, but never tell anyone what I did."

BLVR: He got you through quickly with the paperwork?

AK: Yes. He made it look like I was accompanying somebody. That was how I left the country. But people saw me with him so he never got— what do you call it?—a promotion. He never got promoted because he was on duty that night and helped me. They threatened him after that and he never saw anything good come of his job.

BLVR: Did you ever see him again?

AK: Every time I go back, I see him at the airport. He's still doing the same job for twenty years without any raises. I told him that I couldn't thank him enough.

BLVR: How did he respond when you said that to him?

AK: He said, "Don't even go there. I'm proud of what you're doing now, and the whole country is proud of what you're doing for us." We keep in touch. I try to send him money.

BLVR: What did you have lined up waiting for you in Paris?

AK: My two brothers were there as students. For two years, I couldn't speak to my parents or send them any letters. So my brother developed a code for when I sent letters or called them on the phone because the phone was tapped. I couldn't go back, even after a couple of years, when my grandmother died. She died in 1985 and the regime changed in 1989.

BLVR: What was in the suitcase?

AK: Just some clothes, some of my music, and that's it. I couldn't take more than that.

BLVR: Was Paris a culture shock?

AK: I spent a month there to record my first album, but I rarely left the studio. I knew the subway, but that was about it. The real shock came when you said hi to people on the street and they would not answer back. That was a very, very hard thing for me to deal with. These people are living in the same building; you see them every day. You say hi and nothing. I wished the walls around them would just open so I could grab them. You could be run over by a car and no one would stop. I thought, This is what they called civilization, a developed country, where people live like animals? What kind of crap is this? My first album was about that summer and my experience in the developed world.

III. "THE SOUND OF THE BIRDS IS MUSIC BECAUSE YOU CAN PUT NOTES TO IT— SAME WITH THE WIND IN THE TREES. I THINK WE STARTED MIMICKING THESE SOUNDS BEFORE WE STARTED SPEAKING."

BLVR: You've always held the musical traditions of the Caribbean diaspora in high regard—in 2004, while recording *Oyaya!*, this passion led you to record and study in Cuba. What was that like? Was it possible to look

past the regime politics and see how the music enriched peoples' lives?

AK: You see the freedom in them when they start playing music. You see their lives come to light. Basically, that is what music can make happen. It can make you keep your identity straight, and the little happiness they can have, they have from music. Apart from that, I hated that feeling of being spied on, like when I was living in Benin. You never know who is going to report what you did. In Cuba, we weren't living at a hotel—we were living in somebody's house and we became friends with the neighbors. Once we left, the neighbors were questioned. They were checking to see whether the neighbor had made money from us, and how she knew that I was speaking French. Even the neighbor who seems cool to you, you don't know what they're reporting to the regime.

BLVR: You said that your father did not want to get pushed into politics. He was an educated man, well read and learned, and your house was a safe haven for liberal and progressive conversations. As an artist, are you hesitant to speak out directly against something specific, like the Bush administration, or do you find it more effective to set a more general tone and have listeners apply it for themselves?

AK: I have done that. When the Bush administration wanted to go into Iraq, I and a few other acts, like David Byrne, took out a full-page ad in the *New York Times* saying that the war in Iraq was wrong. The rest belongs to the population of this country. The first time around, they were given the benefit of the doubt; the second time around, everybody voted for him. When there is a majority, you have to respect the decision of the majority. The American people thought Bush should be in power, so let them go all the way through. People are meant to learn from their mistakes. We'll find out whether or not it was a mistake. For me, personally, I don't care, because I don't think he has any impact in my life. I don't give him that power—not him or Chirac or anybody. When I do it, my music gives strength to other people. That's what we need. We need strength, joy, and to believe that tomorrow can be better even if we are making mistakes today. If we don't have hope in the future, if we don't

think that we can improve our lives in a good way, then there is no need to believe in this instinct that we are talking about.

BLVR: What about the process of making music and implementing new genres and music in your repartee—I'm hearing rock, salsa, samba, Caribbean, pop, dance, Indian, Arabic, Afro-funk, call it what you will. How do you incorporate these seemingly incompatible sounds?

AK: I've been connected to so many different types of music ever since I was a child. When you have parents who are smart enough to encourage different types of music in the world, it helps develop your brain. I think I have a very good musical memory. So I will listen to Arabic music, Asian music… and whatever music is out there is mine. No one can tell me that in all the music of the world there is a "pure music." It's always a mixture. If the black slave was never brought to America, you guys would never have blues or rock and roll. You would have music, but it would definitely be different from what it is today.

BLVR: Do you believe that sound evolves with us? Or do you think that, at its core, music can speak to something greater, maybe something already inside us from our first waking moments?

AK: Singing comes before speaking. The first human being on this planet, even before he or she was able to speak, was surrounded by music. The sound of the birds is music because you can put notes to it—same with the wind in the trees. I think we started mimicking these sounds before we started speaking, so that is why music is so deeply involved. It speaks to us. Any music is mine. I don't care if I don't understand the language—I'm going for it.

BLVR: I assume that's how you'd respond to critics of your music who say, "Well, Ms. Kidjo doesn't sound African enough."

AK: Those people don't piss me off anymore. Most of the time, you see them writing or saying things like that, and they've never stepped foot

in Africa. Africa is a continent; some people in Africa don't even know the diversity in our own continent. How can somebody who comes from America or Europe tell me what I should sound like? Does the person speak my language? No. I probably speak his or her language. If you start getting into that, you play into that view of racism and categorization. But the human being is so complex, and our common language is music, so how can you categorize it? When I hear about purity, I'm just scared. Hitler had it in his campaign about purity of race, and we know the results. When it comes to music, how can we talk about purity?

BLVR: Many different musical traditions have been adopted in Benin over the years. It almost seems as if the act of sharing ideas across a country's borders is, by nature, "traditional."

AK: Yeah. One of the things I've learned from the traditional musicians in my country is that our music is something that we were born to see and born to hear. The way it was before we came into the world is no longer the same because we're no longer the same people. In Benin, a lot of instruments are disappearing from the traditional music because the youth are leaving the villages to go to the cities. So in order to make traditional music attractive to them, some musicians are incorporating reggae or whatever the young people are singing. You'll find elements of that when they play traditional songs, so everyone can sing along. Usually, older people are just sitting back laughing, but they're also learning what the youth is listening to.

For me, music is a matter of being flexible. Being open to absorb what comes your way and to be able to give back and see how it will rebound in somebody's heart. If traditional African music wasn't flexible, it wouldn't exist today. There's a saying in Benin: "Does your head know where your feet are taking it?" It doesn't. Your feet move and your head follows. So I'm just following my feet and keeping my heart steady. My identity comes with me, and doing hip-hop or R&B or anything tomorrow is part of the art form because it comes from my continent. I mean, why can't I do that? Why is it cool for Peter Gabriel, Paul Simon, or anybody else to incorporate African chants and rhythm into their

music? But as soon as you are African and your music becomes modern, you are seen as a sellout—you're no longer truly African, and some white boys are out there with record labels, deciding who's African enough to be signed on their label. Fuck them. I don't care. ★

ISAAC BROCK

[ROCK MUSICIAN/CHEF]

"THE SEA IS DELICIOUS."

For sale at Isaac Brock's proposed miscellaneous junk store:
Swedish Fish
A specific type of doorknob
Thirty or so records (satisfaction guaranteed)
A type of ginger ale that you can find only in North Carolina
Tea
A piece of old wood that looks usable
Greek yogurt with honey
*A copy of a Berenstain Bears book that someone
wrote a bunch of funny shit in*

s the front man of rock band Modest Mouse, Isaac *Brock makes music that is simultaneously caustic and elastic. Anyone who has witnessed his aggressive string bending and general instrument strangulation onstage may be surprised by the delicate touch* he applies to food preparation. Brock loses himself in food, the act of cooking providing a temporary respite from the noise of his chosen career.

Tonight Brock is preparing tilapia, a fish native to Africa but now grown mostly in South America. This particular cut was raised hormone-free in Ecuador and purchased from Whole Foods. Brock simmers the fish in coconut sauce. The main course is complemented by cumin-spiced black beans, cumin-coconut rice, and a dish of his own creation he calls "cabbage

crunch." His fiancée, Naheed Simjee, has mixed a robust guacamole for predinner snacking. For dessert, I have brought along homemade chocolate chip cookies. Since there was no butter to be found in my refrigerator, I made a substitution of applesauce.

While the meal simmered, Brock offered this disclaimer: "Try to remember this… my cooking is all based on a series of fuckups."

—Brian J. Barr (April 2006)

I. "I HAVE ALL THESE MUSHROOMS, RIGHT? WHAT AM I GOING TO COOK THEM IN?"

THE BELIEVER: How long has cooking been a passion?

ISAAC BROCK: Since I was in sixth grade.

BLVR: What was it that got you interested?

IB: I remember making this dessert called "Floating Islands" or something. It was kind of a weird, runny, custard-type thing with meringue floating around in it. I remember it being really good, but really gross at the same time—kind of goopy.

BLVR: What was the reason for making it?

IB: No reason. I was just making it for the hell of it. I was going through a cookbook at that point and it just seemed like an interesting one to try.

BLVR: Do you get most of your recipes from cookbooks?

IB: Not anymore. Usually I just steal people's ideas from restaurants. I'll go somewhere and eat something and I'll try and figure out what was in it. Or I'll try and engineer shit. Buy a bunch of ingredients. I'm really scattered when I shop at the grocery store, so I'll just be grabbing stuff at random, trying to figure out how it'll all come together. Like, I have

all these mushrooms, right? What am I going to cook them in? I'll cook them in, say, orange juice concentrate and Bragg's Liquid Amino Acids.

BLVR: Are you against following recipes?

IB: Sometimes you have to follow recipes. When it comes to baking things, you can't ad lib how much baking soda or baking powder you need. All those elements are truly scientific and you can't fuck with them. Anything outside of that, you make on your own.

You know, most of the ingredients I'm cooking with today are going bad—not going *bad*, but getting old. That makes me think: how rad would it be to start a compost restaurant? You'd just get health food stores to give you stuff that they pull just as it's starting to go bad. It'd be a recycle restaurant. That's a good fucking idea! People would feel good about themselves and… what was the question?

BLVR: Are you against following recipes?

IB: No. But take soup, for instance. Soup doesn't need recipes. One: soup is not that complicated, and two: it's all about what you want to put into it. If you want to put yams in the soup, put yams in the soup. I'm not against recipes, though. If someone makes something and you've had it a couple times and you decide you want to make it too, well, that's a good time to have a recipe.

BLVR: I've also read that in order to successfully create a new recipe, you have to first decide what flavors you want to represent, then you decide what ingredients you need to help you achieve those flavors. Would you say you follow a similar pattern?

IB: That was one person saying that. That was one person with one fucking opinion. Cooking doesn't work like that.

BLVR: Why not?

IB: Because all kinds of flavors can make an entirely different flavor, so there's no reason you have to fucking focus on the fact that you put rosemary in a dish and have that be the whole reason that the dish makes sense. Say you make rosemary-lemon-caper mash potatoes, right? Are you making sure that rosemary is the main flavor, or that lemon is the flavor, or capers? I mean, of course everything should work together in some way. Obviously, you're not going to make chocolate-raisin salmon pudding or something. Then again, who knows? Maybe that works out real well for you.

II. "I'M GOING TO APOLOGIZE TO YOU THE WHOLE TIME YOU'RE EATING."

BLVR: Did you grow up in a house where people cooked a lot?

IB: Yeah, both my mom and my dad were really good cooks, and I learned a lot from both of them. My mom was the head chef at a restaurant and I worked there as a line cook, you know, working on prep and making all the desserts and shit.

BLVR: What's your heritage?

IB: Irish and Scottish.

BLVR: Were there a lot of handed-down recipes?

IB: I remember this one called "Apple Pan-Dowdy" that the people who owned the restaurant stole and claimed to be their family recipe. They had my mom make the menu and she used one of our family recipes and so they were like, "It's our family recipe!" That was shitty.

BLVR: Do you think being a good cook is a gift you're born with or one you develop over time?

IB: I think it's something you develop over time. I actually still really

want to go to culinary school and learn all those neat little tricks. I want to learn some shit from Naheed's mom. I talked to her about it and she showed me some stuff, but she has all these recipes in her head. She goes through them really fast. I have the attention span of a two-year-old puppy.

NAHEED SIMJEE: [Slicing red onions for guacamole] A two-year-old puppy?

IB: Wait, a two-month-old puppy. I forgot… dogs… age… differently!

BLVR: Well, while you're cooking here, your attention seems pretty intact.

IB: I'm just showing off.

BLVR: Naheed, you've said Isaac's ultracritical of himself when he cooks.

IB: I'm going to apologize the whole time you're eating. It really kills the experience. Trust me.

NS: Sometimes he makes a really good dish and you're about to take the first bite and he just takes the whole plate away from you.

BLVR: Do you have any favorite restaurants?

IB: Yeah, Olive Garden. Sizzler's. Red Lobster.

BLVR: How do you handle eating on the road?

IB: Dude, what's the point in even talking about eating on the road? You're lucky to be eating whatever's at a truck stop.

BLVR: You find yourself eating from truck stops a lot?

IB: I find myself skipping eating a lot, or eating whatever's on the deli tray backstage, nibbling on fake meat and various vegetables dipped in ranch dressing.

BLVR: What do you think of the Slow Food movement's philosophy about how what we eat has an effect on our surroundings, especially the rural landscape? Do you take these things into consideration when you're preparing food?

IB: What do you mean?

BLVR: Well, people who eat when they're in a hurry usually end up eating from fast-food joints or truck stops. But if we were to really stop and think consciously about what we're eating, we'd see that food comes from actual farms. Farms, of course, have an effect on our rural landscape.

IB: There's actually a fast-food chain here in Portland that uses all local organic ingredients.

BLVR: Really?

IB: Yeah, Burgerville. It's like fucking McDonald's, but they use local organic stuff. That being the case, you're not going to allow something completely nasty around you if you're seeing it. I mean, people aren't psyched when there are shitty fucking cattle farms in their area that are always gross.

BLVR: I know that you feel very strongly about urban sprawl, particularly for the area outside of Seattle where you were raised. I'm wondering if you've ever thought about buying rural acreage and maybe just starting a farm?

IB: I don't know. It's hard for small farms to compete with factory farming. The idea of having my own restaurant where I have my own farm

and grow my own shit seems nice. But that's hard to do. It takes so much energy to grow your own fresh fruit or vegetables in a way that's decent, and then you have to sell them for even twice as much as what the factory farms are selling them for.

[*Brock heats coconut milk in a saucepan, folding dried coconut into the mix with a spatula. He then sprinkles dashes of cumin and Old Bay Seasoning before gently laying the tilapia into the shallow pool of sauce for simmering. In a deeper pan, he pours more coconut milk, again simmering it, but this time adding jasmine rice and cumin. Slicing two red cabbages in half with a butcher knife, he removes the cores and tosses the leaves into a Cuisinart, along with roasted almonds, green onion, garlic, Bragg Liquid Amino Acids, and Sriracha chili sauce. He opens two cans of organic black beans and empties them into another saucepan, showering them in cumin and cilantro. We finish off a couple bottles each of a Belgian white ale called Hoegaarden, waiting for the food to cook through. Once it is finished, he spoons even portions of beans, rice, cabbage crunch, and tilapia onto our plates, decorating them with artful slices of banana, green onion, and cilantro for presentation. It is close to midnight as we step outside onto the back deck to eat.*]

III. "IF YOU DON'T LIKE IT,
YOU'RE WRONG!"

BLVR: [*Takes first bite*] This is really good. [*Takes another bite*] Since you're your own worst critic, what do you think is wrong with this? Because I'm not finding anything.

IB: [*Chews, pleased*] Nothing is wrong with this, actually. I overcooked the rice, that's it. And it could be a little spicier.

BLVR: There are a lot of good spices in the cabbage crunch.

IB: Mmm-hmm. Boy, is that banana slice good! [*Bolts upright*] Does anyone want more banana?

BLVR: No, I'm good. Let's talk about this pipe dream of yours. You want to open a restaurant/store here in Portland?

IB: It's more of a miscellaneous junk shop that carries all of the things I like. Whether it's Swedish Fish, or something like that, or...

NS: Greek yogurt...

IB: Yeah, Greek yogurt with honey. Or you could find a specific type of doorknob, or something. I'd maybe carry some records. Like, maybe thirty records that come with a guarantee: if you don't like it, you can bring it back! There'll be none of this, "I've got a business. I've got to carry a variety of whatever's coming out." None of this, "Someone's coming in looking for Terence Trent D'Arby and I've got to have more customers coming in and more money, money, money!" No. This will be shit that I will fucking *guarantee*.

BLVR: So, not necessarily things that you like, but things other people are guaranteed to like?

IB: No, they might not. But it's guaranteed I'll like it. [*Laughs riotously*] If you don't like it, you're wrong! And I want to have a bar that seats about six people, like a little wooden bar. And there's only room enough for that many people. The junk shop would just have random shit. Just shit that I particularly like. If there's a book I like, I'll carry five copies of it. If there's a certain tea I like, I'll carry it. If I find a piece of old wood that looks usable, I'll sell that.

BLVR: A piece of wood?

IB: If I found a fucking rock that I thought was really interesting, I'd sell it. Or, you know, maybe a copy of a Berenstain Bears book that someone had written a bunch of funny shit in. I'd sell that. If it were a type of ginger ale that you could only find in North Carolina, I'd sell that. It would have a kind of general store feel to it. It'd be a two-story,

saltbox-looking building, like from the early 1900s, like the buildings around Portland, the ones with the square storefronts. Actually, I wouldn't mind it being three stories. One story I could turn into an apartment, one story to have as a studio/practice space, then the bottom floor would be the junk shop and bar. And a restaurant where the only two choices are vegetarian and not.

BLVR: Does the store have a name?

IB: I have to name it? Nah, I won't name it.

III. "IF SOMETHING IS NOT RIGHT IN THE HOUSE, IF IT FEELS EMPTY OR COLD OR AWKWARD, I'LL JUST COOK ONIONS."

BLVR: You recently had your kitchen remodeled. Can you explain some of the features you added?

IB: No better than you can. There's a prettier floor, a nicer pantry, an apothecary cabinet… nothing I can really explain. It's fucking all decorative mostly.

BLVR: Does this come close to your idea of a dream kitchen?

IB: No. Dream kitchen for me would have about four more feet lengths so I could have an island. The thing is, I want to have a house I can live in. The kitchen is the most important thing for me. I do want an old O'Keefe & Merritt stove because I like those things and they cook really evenly.

BLVR: O'Keefe & Merritt?

IB: Yeah, they made a lot of the big, old stoves, you know? They're just really well built, old gas stoves. You can get those motherfuckers that are

like sixty-four inches long and have a couple broilers, eight burners. You can get ones with just tea burners. They're beautiful.

BLVR: If we were to hypothesize an Isaac Brock cookbook, do you think you could fill it with enough of your own recipes and thoughts on cooking?

IB: Given enough time I could, but given enough time I could also write my own dictionary and make up words. It's all possible. But yeah, I'd probably feel best borrowing heavily from family recipes first and then going off on my own shit. I'm not saying I ever will, but I could. But I always cook for the moment, you know, "What are we having tonight?" "What do they have at the store?" I really like cooking with fish.

BLVR: More than anything else?

IB: Yeah. 'Cause I like fish.

BLVR: Is it a Pacific Northwest thing?

IB: It's a sea thing. I like the sea, I like fish. I like all things nautical. And the sea is delicious. There's something really clean about the sea, you know? I mean, maybe it's not as clean as I like to think, but it's fascinating to me. I wish I had gills.

BLVR: It seems to me that you're moving toward a more domestic lifestyle.

IB: Yeah, I'm trying. I just want to be at peace. I just want a situation where everything feels warm. If something is not right in the house, if it feels empty or cold or awkward, I'll just cook onions.

BLVR: Onions?

IB: Yeah, onions make the house smell better, makes it feel like people live there and are doing shit. My mom always used to cook onions. When my

dad was coming home from work and she didn't have anything made, she'd always put onions on the burner. It made everything feel better.

BLVR: Bread sort of has the same effect.

IB: Bread's great. It's just not easy to do last-minute. ✳

ISAAC BROCK'S TILAPIA

TILAPIA SIMMERED IN COCONUT-CUMIN SAUCE
In a shallow saucepan, cook a handful of garlic cloves in olive oil over low heat until soft. Pour in 1 can whole coconut milk, stir, and let simmer. As the coconut oils separate, add approx. 1 cup unsweetened, shredded coconut. Cook for 10–15 minutes, stirring often until sauce thickens. Add salt to taste.

Gently lay tilapia filets into the pool of sauce, add a dash of cumin, and let simmer for 15–20 minutes. (Due to the flaky consistency of tilapia, halibut cheeks—which are firmer in texture and therefore hold together—may be substituted.)

CABBAGE CRUNCH
In a shallow pan, roast 2 cups whole almonds in 2 tbsp. sesame oil over low-medium heat.

Add red cabbage, garlic, green onion, Sriracha chili sauce, and Bragg Liquid Amino Acids to taste in large Cuisinart.

Once almonds are through roasting, remove from heat and add to Cuisinart.

Dice well.

CUMIN BLACK BEANS
Add 2 cans organic black beans with juices to medium saucepan, cook over low-medium heat.

Add approx. 2 tbsp. cumin, a dash of Old Bay Seasoning, and a handful of diced, fresh cilantro.

Cook for 15–20 minutes, stirring consistently.

COCONUT-CUMIN RICE

Add 1 can whole coconut milk to 1 cup white rice, stir.
As rice absorbs coconut milk, add 1 tbsp. cumin.

Once all components are prepared, dish even portions onto plates, serve hot. Serves 4–6.

JUANA MOLINA

[SONGWRITER]

"I HAVE A PROBLEM WITH MY EARS."

How Juana Molina learned to listen carefully:
Imitating television commercials
Listening to songs in English
Listening to the sound of a loose manhole cover
Playing in coffeehouses
Working with Daniel Melero
Acting on television

J*uana Molina is an Argentinean songwriter whose fourth album,* Son, *teems with the lush atmosphere of her home outside Buenos Aires—it is a record touched by the symphonic chatter of birds and insects, which would overtake the songs altogether were it not for the hushed power of Molina's voice and her delicate production work.*

Before she was a singer, Molina was best known in South America for her comic skills on the Antonio Gasalla show and her starring role in the comedy series Juana and Her Sisters. *She abandoned the small screen in 1996, determined to write and perform her own music.*

This interview took place by phone on April 5, 2006.

—Josh Kun (June/July 2006)

I. SHAKY HANDS

THE BELIEVER: One of the things everyone likes to talk about regarding your career is that you began as a TV comedian and then went on to be a singer. Was there anything about being a comic working in TV that taught you how to be a singer?

JUANA MOLINA: No, I think they were two totally different careers, because when I was acting, I was always impersonating different people, so it was never me—it was never myself. When I started to sing, I suddenly felt naked. I mean, I knew that was going to happen, because that's the reason why I couldn't do it before—when I was a teenager, I just couldn't play in front of anyone at all—it was impossible, my hands started to shake, my voice was gone, and I was so self-conscious of what people would think about what I was doing. Because I didn't know how to play songs that anybody knew—all I knew how to play were my own songs, and so I had this feeling of having my own chords and my own things that weren't—I was afraid of being judged as doing nonsense music.

But then maybe what the acting did to me was that I got more courage to do what I really wanted to do, even though I had all these fears that were still inside me.

BLVR: When you hear actors talk about their craft, it's exactly how you said—it's about putting a version of oneself out into the public, but it's never exactly who you are. There's always some level of performance. And then singers say, "What I'm giving you is the raw me—I'm putting myself out onstage every night." But—isn't music also a kind of acting, a kind of performance?

JM: That's exactly the difference for me. I don't feel like I am performing when I sing. I think a performance—I might be totally wrong, because I have this understanding of the word *performance* that might be different from the English definition—Let's say, Peaches? I wouldn't say she's being herself onstage. She's obviously acting, she's performing, but if you see Cat Power, she's not performing, she's just playing her songs. I have

the feeling that, to perform, there's a part of it that's not you—it's still for the audience. It's not the real you.

BLVR: I think you're right—I think there are certain singers that decide that when they go onstage, they're going to take on an alter ego. So it's common to hear a singer say, "When I get onstage, I become a different person." But it sounds like, for you, the difficulty of being onstage is that you're not performing—you're bringing the private into the public.

JM: Exactly. That's the most important barrier I've had to go through. Because I feel that when some music moves me toward an imagined world, and a record takes me for a ride all along the record, and I play the record and lie down and go away with the record… I lost what I was going to say.

BLVR: You just went on exactly the sort of journey you were describing.

JM: [*Laughs*] Yes, I guess so.

II. DANIEL MELERO, RECORD CLEANER

BLVR: I've been listening to your music since your first solo record, *Rara,* in 1996. That record sounds really different to me from the work that's followed. Your newer work seems to be more of an all-encompassing sonic experience, drastically different from the first record.

JM: Yes, well, the first record, it wasn't me. I just wrote the songs and the arrangements, but the producer took control and he told me how it had to sound. We were in the middle of the alternative-rock era, and I think it sounds a little bit like that. If you listen to the demos of that record, even the ones that sound horrible, even when you can barely hear the voice or the drums or whatever, the spirit is more similar than the record itself to the other records I did.

BLVR: Because you had more control.

JM: Yes. Also the main difference was that *Rara* was recorded in one week in a studio where we were doing one, two, maybe three takes, all playing together at the same time, after a lot of rehearsal, whereas *Segundo* was recorded over the course of two years, when I didn't even realize I was making a record. We'd entered a new era, where the home studio was good enough to make records with, and, well, I didn't notice that when I started to record the songs of *Segundo.* I thought I was just putting some ideas together, all these first takes that were looking for something. It was like a kind of research.

BLVR: One of the things you mentioned about the first record was about the pressure of trying to fit your sound into the Latin alternative-rock world of the '90s. But on *Segundo,* some of the production work was done by Daniel Melero, someone known for his associations with alternative rock.

JM: What happened was that I thought I had the record done. But when I played the record in somebody else's house it sounded horrible. It only sounded good at home, and that was because I didn't know about EQ. And so everything was recorded and left the way it was recorded: plain, rough, with nothing—no EQ, only pans and volume. So I met Melero, and he listened to the recording and he said, "Oh, here is a conflict—there's a huge conflict between the guitar and the vocal." I was so overwhelmed and so frightened from my experience with *Rara*—that someone could change my music—that I was on guard, so I told him, "There's no conflict at all—what are you talking about?" And he said, "No, no, no, calm down. I'm talking about frequencies." And I said, "What?" And he showed me that you have to EQ instruments so that you can hear them all without having one disturbing the sound of the other ones. He was originally going to master the record, but he ended up going through a sort of cleaning process. I hired Daniel Melero to clean my record.

BLVR: The reason I bring him up is that he seems to be an interesting figure in Argentinean music but also in the transformation of alternative rock in Latin America, in that he obviously has roots in alternative-rock

culture, working with Soda Stereo, for example, but he's now gone off and done so much electronic music, and almost avant-garde music in some cases.

JM: He's a guy who is always looking for new things. He's a very interesting man to spend an afternoon with, just talking. I learned a lot by watching him work. He removed the veil from over my ears so that I could hear all these frequencies he was talking about, so that, when I recorded *Tres Cosas,* I could hear them already, and I didn't need anyone to mix or EQ because I was able to do it by myself.

III. THE SHAPE OF WORDS

BLVR: When I first heard your music, I worried that you were going to get lost in an unfortunate marketing shuffle in the United States, that because your music colored outside the lines of so-called "Rock en Español" on the one hand, and so-called electronic music, or even world music, on the other—you weren't overly "ethnic" or "folkloric" or anything like that—that you couldn't easily be sold at Starbucks. I was worried that you were going to get lost in the machine, and I'm so thrilled that you haven't.

JM: I wasn't afraid at all because I didn't know any of that existed before I made the records. The Americans and the English are so spoiled by having everything done in their own language, and I didn't understand that that was so important. I didn't realize it until I was playing live, because I could feel that people were enjoying it but also, at the same time, were a little bit lost because they were watching me, looking at me singing all of the time, without understanding anything. I grew up that way—I grew up listening to music without understanding what they were talking about, and I didn't care, because I was enjoying the music. So, once in a live show, I said, "Well, you know, I grew up listening to foreign music all my life, and I never understood a word of what you were saying, so welcome to my world," and everybody laughed, and I felt something—it was a little bit like breaking the ice, and everybody

started to feel more comfortable afterward. They maybe understood this different way of listening to music.

BLVR: Because when you don't know what words mean, you end up paying attention to the shapes of sounds.

JM: Exactly.

BLVR: The way you shape sounds in your mouth—especially onstage, because you don't try to hide what happens in your face or your throat or your body when you're singing—watching you sing is watching sounds being shaped.

JM: I think I also never like when the words go beyond the music, like when you get the feeling that the words are attacking you, like "I WANT TO SAY THIS!" OK, OK, OK, but say it softly, please—I don't need you to tell me what has to be heard. Or sometimes people will use words that don't fit with the music, so that the words become like cats in a bag that want to come out, but they can't.

IV. MOLICO

BLVR: I saw you play here years ago at McCabe's Guitar Shop, and I remember being very impressed with your skills at imitating a dog howling and barking.

JM: Yes.

BLVR: And on *Son,* there are birds chirping at the beginning, and midway through another song, there's a sound like cats meowing, but it's actually you, correct?

JM: Yes, exactly.

BLVR: Do you practice animal sounds?

JM: No, I don't practice. I don't sound very humble saying this, but I've always had the skill of imitation. My work as an actress was to impersonate any kind of character that one can find in Buenos Aires, and I had to speak in exactly the same way that they did. I think that sometimes, form leads you to the content. It's not only the content that gives you form. So when you find a way of speaking, you can understand what kind of person you're imitating.

Further back, my cousins and I would play a game—I don't know what commercials used to be like in the States, but in Argentina—it wasn't like now where you have all the images and music—the mouth and the tongue licking the ice cream, and everything's more about image and sound and editing. When I was a girl, the commercials were little stories. You had a girl who came into the room to ask her mom something, and the mom answers, and then you have the product that was advertised. My cousins and I used to imitate those commercials. And they had to be exactly the same—they had to have the same intonation, everything. We had two teams, and it would be like, "No, no, no, no, no, you lost—that *m* was too long."

BLVR: [*Laughs*] You were serious.

JM: We were totally serious. We spent hours playing the commercials game. There was a particular commercial that was a guy selling powdered milk, and he kept shifting the can of that milk from one hand to the other. The milk was called Molico, and the times he said "Molico," pointing to the label, and the length of time he spent pronouncing the *m* in *Molico,* was a whole world in itself. We could spend an afternoon just trying to say it exactly the right way.

BLVR: I realize now that the question isn't "How do you learn to make your voice sound like something else?" but rather "How do you learn to listen that well?" That's what it seems you just described—you weren't only mastering the vocal imitation; you were also mastering close listening.

JM: You're right, yes. I didn't think about that.

BLVR: I really hear that on your records—you really hear that sound—even when you're not singing, your records feel like records made by someone listening very closely to the world around her.

JM: I have a problem with my ears. I really have a problem. When I was living in the city, I threatened people because of some noise they were making that was bothering me. It sounds psychotic, I know. Once it was a beep from a fax that I heard in the night, very far away. I went to every floor, to every neighbor, putting my ear to the door, until I discovered where the sound was coming from. Then I would tell them, "You have a fax machine that's making this sound and it's driving me crazy." "You're four floors away from me—how can you hear that?" they said. "You're crazy, you're a hysterical woman." Whatever, call me whatever you want, but I hear it, and I can't sleep because of it.

And then there was another noise. I was in my room and I heard "*tck-tck... tck-tck...*" always two like that, in a very random frequency, and when I opened the window to listen more closely, the sound was gone, because it was a frequency that you couldn't hear with other noises. And after weeks of research, I found out what it was. It was a manhole in the street that was a little loose, and whenever a car went on top of it, it was the sound of the two wheels driving over the lid, the first wheel and then the second wheel, and sometimes the cars didn't go exactly on top of the thing so I couldn't hear it all the time. So what I did was I took a piece of cardboard and stuck it in the manhole...

BLVR: So you're really kind of an interventionist—you're not going to just let that sound exist. I love that you went out and actually tried to change the environment so you didn't have to hear it anymore.

JM: I know it's a very psychological thing, and also kind of whimsical. If I hear a cicada in the night, I don't mind, but if it's the sound of a light that's not working well on the street, I go crazy.

V. BECAUSE EVERYTHING BECOMES MUSIC

BLVR: On this record there are natural sounds and unnatural sounds, and now that you've been living out in the country, I know you've been listening very closely to birdsongs, studying their patterns and how they take shape as frequencies. So that seems important to you: making the distinction between natural and artificial, or man-made, sounds.

JM: Yes. And what is interesting, too, is that once I decide to listen to the noises of the birds and noises of the whole thing, then noises don't bother me anymore. Because it's like an experiment. So if I was recording the birds, and there was the sound of a car horn interrupting the recording, but when I put that recording on the computer on a track in the song, all these random sounds become arrangements—they aren't random anymore because, now that they're in the song, they're always going to occur at the same time in the same place.

On "La Verdad," I'm changing from the day recording of birds to the night, and you can hear crickets in the middle, just at the end of one verse, and at the beginning of the crickets, there's a noise—I know what the noise is, but nobody else knows—it's someone pouring dog food into a metal dish. It's like "*da-da-da-da, ch-ch-ch-ch*"—it's like a rhythm.

BLVR: And that's from your house?

JM: It was someone feeding the dog—she poured the food on a metal plate, and I remember thinking, when I was recording, Oh, she's feeding the dogs right now—why? Right when I'm recording! but then, when I listened back, I didn't care. Because in the song, everything becomes music.

BLVR: On the one hand you allow chance to play a big role in what you do, because you put these random sounds into your songs and allow that randomness or chance to affect the outcome of the song, but at the same time, you'll go out of your way to put cardboard under a manhole cover to make it stop, so there's this mix of whimsy and a sort of compulsive control.

Have there been moments onstage when you've heard things in the audience, or maybe a siren outside, that adds something to the live performance?

JM: Yeah, I remember exactly that—I was in San Francisco, playing at a beautiful venue, and the siren of an ambulance came through, and it fit so well with the song that I started to play more to draw it out. I like to play in more noisy places so that I can take advantage of all the sounds helping me to build new things. But the one I remember the most is that siren in that venue. Sometimes I'll play in venues where they'll have coffee machines or milkshake machines—all these noises that I hated maybe five years ago—I love them now.

BLVR: It positions you—it's a wake-up call to how little a part musicians play in a much larger sonic world. I mean, there's a kind of arrogance that, if you're not careful, you can develop as a musician, where you forget that the sounds you make are part of a symphonic world that exists every single second that you're making music. And that to forget that kind of connection dampens the effect of your music.

JM: Because it gives you opportunities to create new ideas in music. I take them as gifts now. ✶

BUN B
[RAPPER]

"TELL YOUR HOMEBOY TO CURB HIS ENTHUSIASM BEFORE I POINT MY MOTHERFUCKIN' UZI AT HIM."

How to out-rap someone whose song you are guest appearing on:
Use more syllables per line
Attack the song in the same way as your mark, but with more intensity
Rhyme more words, and rhyme multisyllabically

hey rap different in the South. The urgency and foreboding that dominate the sounds coming from the coasts are all but eliminated, traded in for an almost chilling casualness. At its best, Southern rap sounds warm, charming, and deliberate. Even the threats sound like easy conversation.

Bun B might just be the chief architect of that style. Born Bernard Freeman, Bun is one half of the Port Arthur, Texas, rap group UGK (Underground Kingz), one of the region's—and the country's—most revered groups. Over five albums beginning in 1992, Bun and his partner Pimp C helped craft the template that would catapult numerous artists of the next generation to success. Bun, in particular, emerged as a mercenary lyricist,

227

*capable of intense rhythmic complexity and astute narrative construc-
tion. Innovation, though, can be rough business strategy—nationwide
notice came slow to UGK, who first came to wide prominence guesting
on Jay-Z's gargantuan 2000 single "Big Pimpin.'" Soon after, Pimp was
incarcerated for a probation violation, and Bun became one of hip-hop's
most in-demand guest artists, rapping on scores of records and helping to
kick-start a new generation of Texas hip-hop. Last year, he released his solo
debut, Trill, and a few months later, Pimp was released from prison—they
hope to have a new UGK album completed by year's end.*

*This interview was conducted over the phone in late March. Bun was
at his Houston home, resting in between show dates. BET was playing on
the television in the background, and he was preparing to take his mother
to a Houston Rockets game that evening.*

—Jon Caramanica (June/July 2006)

I. IF YOU AIN'T QUACKING,
YOU AIN'T NO DUCK

THE BELIEVER: What was Port Arthur like when you were young?

BUN B: Port Arthur as a town was incorporated in the late 1800s. It
did fair business as a port town. But what really caused the explosion
of the area in general was the discovery of the Spindletop oil derrick
in Beaumont, Texas. The Spindletop oil derrick was the most fruitful
derrick in the world. At its peak, it gave up about a hundred thousand
gallons of oil a day. They were shipping it out from Port Arthur, so the
oil industry, of course, brought a boom to the small town. If you go to
the town now, you will see what are now-defunct Chevron, Texaco, and
all these other refineries. Pretty much everyone in the Beaumont part
of the area from probably the early 1900s on up about to 1985—when
everything in the oil industry went downhill—was employed by the
refineries or made their money off the refineries. Either you worked for
the refineries or you provided some service for the refineries or for the
people that worked for the refineries.

BLVR: And the people would basically live in Port Arthur and work at the refineries—it wasn't a commuter town.

BB: If you go to Port Arthur today, you see these big-ass fucking tanks, right in residential areas. And in the past there's been a few times where we've had some problems with that.

BLVR: That's what I was going to ask. First of all, the smell. I've never smelled a town like Port Arthur. It's so distinctive, and so you know that has to do with the oil. There must be health repercussions with that.

BB: Every now and then something will leak… I had a brother who moved to Port Arthur, and he was living a little closer to the refinery than we did. There was some kind of chemical leak or whatever, and a lot of people got sick. And I'm like, "I bet this happens a lot more than people know." But you can't go biting the hand that feeds you.

BLVR: Did your parents work for the refineries in some capacity?

BB: No, my stepfather was a janitor and my mother was a private nurse for invalid patients. She would do personal care, which basically means wiping their ass and bathing them and feeding them. And my stepfather was a janitor, which basically means cleaning up after people who *can* shit and feed themselves, but don't know how to do it like regular people.

BLVR: Your mom and your dad split when you were relatively young, right?

BB: When my parents were together, my father was an alcoholic. It's not like I'm speaking ill on the man—if I put you on the phone with him, he would tell you this. He's reformed and rehabbed now. He's a preacher. But in spite of him being an alcoholic and a gambler and adulterer and whatever these things he was—understanding the nature of people, if I know him to have all three of these things, I'm good for one of them.

BLVR: You never held it against him?

BB: Once I got older I understood, yeah, I have a propensity to drink. Yeah, I love a good dice game. Yeah, I love the hoes. Once I got to an age where I understood these things, which was like probably twenty-one or twenty-two, I was like, "You know what? I understand you a lot better now, because I understand me. And I am of you."

BLVR: Were you a good student in school?

BB: I was a pretty smart kid; I always made good grades. Most of the kids that made good grades, I didn't like. I was like every other kid trying to figure out what he wanted to be and where he wanted to go. And what was going to work with where his friends wanted to go and who they were trying to be. You figure, OK, I want to be *this* when I'm around my friends and when I'm home I kind of want to be *this*.

BLVR: What was that split—public versus private Bun—like for you?

BB: It was a pretty big difference because in high school, there weren't too many young black kids watching David Letterman. I was into Rich Little. If they were out there, they didn't admit it.

BLVR: What about acting? I know you did some acting when you were young.

BB: I did *A Raisin in the Sun*, a couple of other plays. My drama teacher told me, "You know what? You got a lot of foolishness in you, but it's not bad foolishness." I ended up getting two college scholarship offers—one academic and one for acting.

BLVR: So you forwent both of them to rap?

BB: Once I'd accepted that that was what I wanted to do. It was all about proving my parents wrong, and you can totally understand the tenacity

of a teenager trying to prove his parents wrong. That's 151 percent. I was like, "I got to make it now, otherwise they're right. And I'm not going to give them that."

BLVR: When they first heard *The Southern Way*, what was their response?

BB: From my parents? My parents never actually heard *Southern Way*. My mother didn't really understand I was a rapper 'til probably around "Big Pimpin.'"

BLVR: Really?

BB: My parents are from a whole different culture. My parents are from small-town Louisiana. It's like, "If it walk like a duck, talk like a duck, then it's a duck. And if you ain't quacking, you ain't no duck." My mom's whole thing was, "Why ain't you on TV? Everybody else that makes music is on TV." So I'm like, "Well, they don't really deal with Southern people." And she's like, "That's not true, 'cause Ray Charles is from the South and James Brown is, too."

BLVR: So how did she think you earned a living?

BB: Drugs.

BLVR: So her assumption was that you earned a living exclusively from the street?

BB: Yeah.

BLVR: And at that time, what percentage of that was true?

BB: By the time *Southern Way* came out, 50 percent, tops. After that album, we started doing shows, and it declined.

BLVR: Do you miss the street at all? People sometimes get nostalgic,

romantic for shit like that. Do you ever have that kind of semi-irrational response?

BB: No, because whenever I sit back and think about the dumb shit I did, I honestly cannot believe I got the fuck away. I know guys who are gone forever who did the same dumb shit I was doing. And I think I may have did it a little worse than them. Like, I was literally on the highway, with cocaine on the dashboard, car on cruise, with my feet out the window, smoking a blunt. Begging a state trooper to take me away for the rest of my fucking life.

II. YOU CAN'T WRITE A BOOK IF YOU'VE NEVER READ A BOOK

BLVR: So when you realized "OK, this is a career option," what rappers did you want to model yourself on?

BB: At that point, KRS-One. This was really before KRS got, what most people would say is—

BLVR: Insane?

BB: Nah, not insane. But at least contradictory, on certain points—

BLVR: I'll say insane. You don't have to say insane.

BB: I really don't want to disrespect the man because the man was great. He'd done many great things before I did. So kudos to that. Just because he had a few bad ideas maybe after the fact, you can't knock what he'd done before. He is my OG.

BLVR: Yes, I hear that. At a certain point he was your OG.

BB: He's still my OG. I say this right now to you and I hope you put it in print. KRS is my OG. Simply because he was the first guy that was like,

"Fuck it. I'm a rapper. I'm in the hood. Me and my homies got guns, but you know what? I'm not ignorant. This is a personal choice some of us have made, and as soon as we can get away from it we will." Like Andre [3000] said, every cat with braids ain't down for the cause. You know what I'm saying?

BLVR: And in terms of your actual rap style, what were you thinking in terms of how you put words together?

BB: Now here's the thing, Jon. Here's where we come to a bump in the road.

BLVR: Tell me.

BB: I honestly never gave it that much thought.

BLVR: Really?

BB: I honestly never sat down and said, "OK, here's my style," because my whole thing was knowing everyone's style. Everything I've ever written has bits and pieces of everything I've ever heard. Any rapper that tells you different is a liar. You can't write a book if you've never read a book. And if you've read five books and you try to write a book, your book will mainly encompass the themes and the context of the five books you've read. Now, the more books you read, the more you can bring to a book when you decide to write one. So the more rap I learned, the more I was able to bring to rap when I decided to rap. But this was all subconscious.

BLVR: How did you know that you were getting better?

BB: People were telling me. That was the only fucking clue I had. Everybody was like, "Man, you killing it." I didn't honestly believe I was a rapper, like a real fucking rapper, probably until I met Biggie [Smalls] and Biggie knew who I was.

BLVR: How did he know who you were?

BB: From the "Pocket Full of Stones" remix on the *Menace II Society* soundtrack. I met Biggie when he was on promo tour with Craig Mack. This was the time when "Flava in Ya Ear" was the hottest record in the country. Craig had gone gold, and Biggie was still at three-something. And I met him at BMG, so of course with the label, they was all about Craig. But I'm a rapper. It's all about Big. So I was like, "Yo Biggie, you're a bad motherfucker." I had to tell him. Biggie was the first real bootleg, the first time everybody wanted somebody's album before it came out. He was like, "I heard your shit too, I know who you is." I was like, "No shit." And he was like, "Yeah, 'Pocket Full of Stones' is my shit." Wow. [*Pause*]
 I'm sorry. I'm distracted—I'm listening to myself talk on TV right now.

BLVR: What's it like listening to yourself talk?

BB: Surreal.

BLVR: Do you feel like you sound like you actually sound when you see yourself on TV?

BB: Yeah, I do. But I can't believe I look like that.

BLVR: What do you look like?

BB: Every time I see myself in print or on TV, I feel like a little white girl. I feel fat.

III. "IF HE USES TEN SYLLABLES IN A LINE, I'M GOING TO USE FIFTEEN."

BLVR: So a lot of the work you've done in recent years—before your solo album dropped—has been guest appearances on other people's records. I'd like to know a little bit about the practice of writing those rhymes.

BB: Well, the first thing I do is I try to listen to whatever rapping is already on the track. I listen for cadence and melody to see how the track's already been written, and to make sure that whatever flow or flows I decide to run with, or patterns or melodies that I decide to put into the song, that they're not already in there. Then I try to see if there's a different part of the subject matter that I can talk about. If there isn't, I try to see if I can analogize it, break it down, flip it another way. If that can't be done, the best thing I can do is pretty much out-rap the guy. And when I say out-rap the guy—say, if he uses ten syllables in a line, I'm going to use fifteen. If he uses fifteen, I'm going to use twenty, twenty-five. If he's rhyming two or three words within two bars, I'm going to rhyme four or five words in two bars. I'm going to out-skill you.

BLVR: Treat it as a technical exercise.

BB: And just put more into it. Basically, I'm going to take what you did, the bare-bones structure of what you were trying to do, how you were attacking the song, and attack it in pretty much the same way, just with more intensity to show you that you could've come harder. Like, I've been in situations where I've had to tell a cat how to rhyme his rhyme.

BLVR: He didn't know how to spit it.

BB: Saying it all wrong. You know, like, that's not how that bends. Which is pretty funny to me, because it means that subconsciously, you can rap, but your conscious mind won't let you go hard. It might be that they get intimidated. I've been intimidated before, you know, but I stepped up to the plate.

BLVR: In what situations were you intimidated?

BB: Well, you know, the first time I rapped with E-40, because, first of all, you're not going to out-rap him. If E-40 is going to invent a word, you know what you got to do to take away from that.

BB: Sure. What about Jay-Z?

BB: Absolutely. Jay was intimidating to the point where I was totally intimidated before I even got to the booth. But I was like, "This is going to be a test of my mettle." In the South, I'm regarded as the guy who, quote unquote, out-rapped Jay-Z. A lot of Southern rappers would say that. Not saying that I'm a better rapper than Jay-Z, but I was able to out-rap Jay-Z on a track. The reality is that I probably took that song ["Big Pimpin'"] a whole lot more seriously than Jay-Z. Because that was a lackadaisical, laid-back party track, and I attacked it. You know, for me, I'm a rapper. And I'm on it with Jay-Z.

BLVR: You'd better be hot.

BB: Yeah. In all fairness, I did hear it first. I got there and I realized he's playing with it. Like, didn't he even think to think that I would take into consideration the fact that I'm rapping with Jay-Z and might go—

BLVR: And try to devour him.

BB: Not even that much. Like, I know Jay-Z. The reason he called us to get us on the song was because of respect for what we do. So I know that he knows, on some level, in some form or fashion, that I tend to think of myself as a lyricist. And he had to know that, rapping on a song with Jay-Z, I was probably going to give it my all. But I don't even think he thought that I was going to try to do anything, try to get my rap on. I honestly don't think he took that song as seriously as I did.

BLVR: Let's talk about that example in particular. When you heard his verse, how long did it take you to put yours down?

BB: Probably fifteen, twenty minutes. No longer than any other rhyme I've written. The hardest thing for me to do, as far as writing a rhyme, is figuring out how it's going to go.

BLVR: Meaning?

BB: Once I get in my mind that it's going to go "*da da da dadada da da,*" then it's kind of like filling in the blanks.

BLVR: You figure out the pattern first, the pattern and cadence first, then the words?

BB: I take the typical words, or I pick a two-word, three-word pattern. One of the things I'm known for is I was one of the first rappers to end their bars rhyming multisyllabically. The other day I put *Curb Your Enthusiasm* in a rhyme.

BLVR: What's the rhyme?

BB: It's "Tell your homeboy to curb his enthusiasm before I point my motherfuckin' Uzi at him."

BLVR: [*Laughs*]

BB: I'm sure that would tickle Larry David.

IV. "I WOULDN'T DARE PUNCH IN MIXED COMPANY. JESUS."

BLVR: Are there things that you want to bring into your raps, but you have felt for whatever reason that you couldn't or shouldn't?

BB: No, I just haven't gotten around to making those records yet.

BLVR: But you could go into the studio tonight and make a record about whatever and find a home for it. You could put it on a mixtape and put it out there.

BB: Yeah, but I wouldn't want to take away from it. Like, for the longest,

UGK and dead prez have talked about making a song. They expect dead prez to say "fuck the government" and shit like that, but when dead prez and UGK say "fuck the government" and we're both breaking it down in our own respective ways, I think it makes it that much more of an impactful statement. We could actually make a major statement in the hood. That's the thing that I think we all took away from "Big Pimpin'." Like, this is a good record, but this isn't the record that it could've been. This is UGK and Jay-Z. We are major representatives of our culture, our region, and our people. We could make a much more impactful record for the streets, to motivate niggas.

BLVR: Do you see motivation as a big part of your role?

BB: Initially, we were the guys from a town that nobody came to. So we would do a show in Jackson, but then we would also do a show in Prichard, Alabama, or Tuscaloosa. We were the cats going to towns where people wouldn't go. There was that small-town camaraderie, especially on the chitlin circuit in the South. You didn't see us on TV, you didn't see us in the magazines, but you could still see us onstage. We're all country boys. I'm up there talking just like you talk, acting like you act. So, goddamn, you could probably make it, too. At that time, I was eighteen. Pimp was seventeen. There were no young guys really repping for kids, for young adults. You had Pimp representing for the fly boys, who the women liked. And then you had me, who was there for the rough cats as well as people who respected the art form. So really, there was no stone left uncovered.

BLVR: What do you think a 2006 UGK record is going to sound like?

BB: I think you're still going to have records close to a lot of what you heard on *Ridin' Dirty* and *Dirty Money*. But then I know that Pimp, he's going to want to compete with the likes of Just Blaze and Pharrell. Pimp understands that, as a producer, the kind of energy that's being brought is the kind of energy that's being demanded of the song by the producer. Pimp made "Murder." "Murder" is a song that demands more of you as

a rapper. He made that because I told him "I want a song that I can go off to," and he was like, "OK, well, I'm going to give you a song to go off to." After I did that record, I went to sleep. That song put me to sleep.

BLVR: Because it was that tiring?

BB: Because it was that demanding. And this was back when I had certain rules I went by. Like I didn't punch in. I don't punch in on verses.

BLVR: Very old school.

BB: So that was like thirty-two bars, and it was like eighty-eight, ninety BPMs.

BLVR: Did you punch on "Big Pimpin'," or was that also one shot?

BB: I wouldn't dare punch in mixed company. Jesus.

BLVR: [*Laughs*] Yeah, but it was thirty-two bars.

BB: I wouldn't dare.

BLVR: I'm just saying, thirty-two bars, you might be allowed a punch.

BB: Sorry. I maintained my integrity to the fullest in them days. Back then, when I needed the monster on the track I said, "Get me some Henny in there. I'm gonna eat it up." Every now and then I've walked into the booth and I've had some cats tell me, "Yo, you're not going to beat me. I know you been out here wrecking niggas. You're not wrecking me today." And I'm like, "Don't underthink me, and don't overthink me. Don't underestimate me, and don't overestimate me. Just do *you*." That's all you can do up against a guy like me.

BLVR: Who do you feel, right now, is lyrically impressive?

BB: I still think Eminem. I listen to Em and I'm like, "You know what? You're just playing with it now."

BLVR: Oh, no, he is. It's like he's not even trying.

BB: I listen to Em right now and I can almost see him rolling his eyes in the booth. And I'm not knocking him for it, because when you're so fucking good at what you do—it's the same reason why Andre 3000 won't rap anymore. He's like, "OK, gimme a challenge in rap. Because what they're doing right now isn't challenging. I can do that with my eyes closed." What some people don't understand is that maybe you're the one to bring the challenge to rap.

BLVR: That you're obliged to bring it.

BB: The problem for Andre 3000 is that there is no Andre 3000 for him. And that's what bothers him. It used to be people—the Big Daddy Kanes, the Chubb Rocks—people who just attacked the game differently. And I don't think there's enough people doing that now. I've definitely had different people pushing me, a lot of people that don't let me rest on my laurels. I got people like Young Jeezy, who are taking street music to another level. He's calling me "OG." "You gotta get 'em, OG. You gotta go out here and get 'em. Show us how it's done." Even these people who are changing the game, you know, expect me to change it after they've come. "That's what you do. You come out and change the game." And it's like, yeah, but that's what some of you cats are doing now. "It don't matter. You taught us how to change, and you still gotta change it again. You gotta make me rethink me." ✲

WAYNE COYNE

[OF THE FLAMING LIPS]

talks with

BEN GIBBARD

[OF DEATH CAB FOR CUTIE]

"THIS IDEA THAT THE MAJOR LABELS ARE OBVIOUSLY THE ENEMY OF INDIE MUSIC— WELL, WHOEVER STILL BELIEVES THAT IS OBVIOUSLY TRIPPING ANYWAY."

Is it worth it to pay:
Two dollars for bottled water?
Six dollars for a bag of popcorn?
Three hundred dollars to see the Rolling Stones?

Ben Gibbard fronts Death Cab for Cutie, a band from the Pacific Northwest whose moody, rigorously introspective music rose up in the patch of scorched earth left by '90s alt-rock behemoths Nirvana and Pavement, coming into play as a sort of post-millennial soundtrack for young people. After releasing several successful records on indie label Barsuk, they made the decision to enter the major label arena in 2005, releasing the wildly successful Plans on Atlantic Records. Gibbard also shares songwriting duties with laptop innovator Jimmy Tamborello in the Postal Service.

Wayne Coyne has been, for the past quarter-century, the central creative force behind the Flaming Lips. Their most recent album, At War

with the Mystics, *finds them at war with contemporary popular music, as they retool and reverse-engineer the form with an invigorating reckless-ness. The Lips' determination to make music as vast and cataclysmic as a Venusian storm front will not surprise auditors of albums such as* In a Priest Driven Ambulance, Clouds Taste Metallic, *or* The Soft Bulletin, *but the crazed vocal harmonies and startling atmospheric flourishes of* At War with the Mystics *remind us that we haven't yet mined a fraction of what's possible in rock.*

The following conversation occurred by phone; Coyne sat in a hotel room in San Francisco, having just taken part in the Noise Pop festival. Gibbard had just arrived in Austin as part of a tour of the Southwest.

(June/July 2006)

I. ARENA ROCK

WAYNE COYNE: Hey, Ben. I'm sitting here in San Francisco. Where are you at?

BEN GIBBARD: We just pulled into Austin about fifteen minutes ago. We're in the midst of our first full-production, arena-style tour. We're carrying a PA and all that kind of stuff, and we're co-headlining with that band Franz Ferdinand—

WC: Oh, right—cool! Do you guys play after them?

BG: We're flip-flopping. It's kind of intimidating, playing after a band like that, because they're so high-energy. We have our rocking moments, but we're nowhere near as high-energy as these guys are. But I'm getting this impression from the crowd that people are coming to see us be us, and to see Franz Ferdinand be Franz Ferdinand. I think that we're both learning about ways to integrate the other band's elements into our own, to kind of make the show seem more cohesive, if that makes any sense, you know?

WC: Well, right. You want to make the whole show good. That's what I think bands forget a lot of the time, that you don't want the opening band to suck. You want the opening band to be good. You want the whole night to be good for the audience, not just your ninety minutes of stage time. It sounds like you have an interesting bill. Do you guys feel like you're sort of becoming arena rock bands?

BG: You know, I think the whole experience for us so far has been very surreal and—I would never want to say "uncomfortable," but I think that we're all kind of trying to determine whether this is something that we want to pursue on this level. I mean, Franz Ferdinand is a huge, massive band that's known all around the world, and I think that coming to the States, for them, is kind of a step down from what they're used to. Their shows are kind of geared toward bigger venues, and while I think that things are going pretty well for us so far, by the time we're done with this tour we'll have a better understanding of the kind of venues that we want to play. Because you guys could, if you wanted to, probably walk into San Francisco and play, you know, the Bill Graham, and sell it out, and I'd pay, but it seems like—

WC: Right, I know what you mean about the bigger venues. All the logistics of "how much do you sell tickets for?" You know, I still feel weird when people have to pay thirty-five dollars a ticket. You're kind of like, "Oh, damn." And a lot of people think that that's a great price.

BG: We've been just looking around at bands that are around the same size as us to determine who's on the high end, who's on the low end, and trying to come up with something in the middle, where we're not totally cutting our costs to the point where we're losing money, but where we're also not raking people over the coals.

WC: I think that that's the perfect way to do it. I'm always surprised that people will buy a fucking T-shirt for thirty dollars. You know, it's just a damn T-shirt, but then I'll easily go to the movie theater and watch some dumb Hollywood movie and buy a bag of popcorn that costs six dollars,

you know what I mean? And I think, Well, that's fine. And then I'll go down to the store and buy a fucking bottle of water for two dollars, you know? It's water, Ben—you know?

BG: Yeah, you know, the six-dollar bag of popcorn, it's kind of built into the experience of going to a movie theater. It's going to be ten bucks to get in, and it seems kind of futile to say, "Ten fucking dollars to get in? Are you kidding me? There's no way." There's no point to even bitching about it, you know? That being said, it can get out of control, like when you know you're paying three hundred dollars for the Rolling Stones—

WC: People do it, I know! I mean, I wouldn't do it. But people do it and they do it sort of gladly with, like, some sense of pride, like, "I paid three hundred dollars just to see the Rolling Stones."

BG: Yeah. At the same time, though, I know enough people who would pay that much to see them, who would say, "You know, actually, it was worth every penny because they were the Rolling Stones."

WC: I think it comes back to that experience. They get to go to some place where Mick Jagger is actually standing, and he cares about them, and maybe that's what matters, you know, that it's whatever you make of the experience. So let's hope some of that is working for you and me, right?

BG: I hope so, yeah. [*Laughs*]

II. THE SANTA SUIT

BG: Even though the profile of our band has sort of grown over the past couple years, my opinion of myself hasn't really changed one bit, but it seems like people—and I'm sure that you probably get this even more than I do—like, you know, you walk around in life as a pretty normal person, and then all of a sudden it's time to climb onstage and there are thousands of people there who see you as more than just Wayne Coyne, you know?

WC: I think most crowds still think that rock stars are born, and then they're just carried around on pillows all their lives, and then there are the regular people who just get what they deserve. And you and I know that we just do it because we like it, that it's just dumb luck that these people like what we do, and we just go with it. And maybe our audience knows that too, but I just beg them to play along. The reason that people love the Rolling Stones shows is that when the Rolling Stones come onstage people go crazy, like it's the greatest thing that ever happened. And I try to play up our shows that way. If we make our show seem like it's the greatest thing that ever happened, it'll just be a lot of fun. We know that it's not the greatest thing that ever happened, but if we *act* like it is, we get to do that thing. And so I just beg them to play along, like we're the greatest cultural event that ever happened, and, you know—

BG: And a lot of times Flaming Lips concerts *are* the greatest concerts that have ever happened.

WC: [*Laughs*]

BG: I mean, I really—I feel bad for any group that has to go on after the Flaming Lips because I don't think that there is any band that can compare with the experience that you give the people in the audience. I just can't believe that you guys can pull that off—that *any* human being can pull that off. I remember the first time that we ever played with you guys at this festival in Spain, maybe four or five years ago. I remember watching you guys and being like, Wow; it was as if this guy Wayne Coyne came off a spaceship and landed onstage, played the show, and then was beamed back up. We were watching your DVD, *The Fearless Freaks*, in the tour bus, and we were all talking about how we'd always wondered things like, "I can't imagine Wayne Coyne mowing his lawn, or doing his nails," and you put it all out there in the film. I was really impressed with the amount of access that you were giving Lips fans to your personal life. I mean, you go so far as showing the cross streets where you live.

WC: Maybe we'll live to regret that, but, you know, most of the people in Oklahoma City who would be watching that movie already know where I live. It isn't one of those cities where there are a lot of people coming through. I've thought occasionally about some kid driving from Chicago to Los Angeles feeling compelled to stop by—but, you know, I've done that same thing. I remember we were on tour and we were going to be driving through the town where Dr. Seuss lived, and I thought, We should drive by his house! I thought, Maybe he's going to be out there mowing the lawn or something. Me and one of my older brothers, we were going to drive up to New York to see if we could spot John Lennon walking around Central Park—just a couple of months before he got shot. So I can see where people—and I don't look at myself as being some fanatical weird fan—I just think it's interesting to see, "There's their house, and that's what kind of car they drive, and look, they got some trash over there on the side of the house that they haven't picked up." Anything that gives you a bit more insight into what they're really like.

BG: I would assume from the movie and just from what you've talked about now that you've had people roll up on your house. How do you deal with that?

WC: Well, the analogy I use is, let's say you're at the shopping mall with your girlfriend, and you guys have a fight. You know, you're arguing about something—you know how those things go—and some friend of yours comes up that you haven't seen in a year and is like, "Hey, Wayne and Michelle, how's it going?" You just pretend that you're not really fighting. You get through it in the best way you can. You say, "Hey, good to see you again!" and then when they leave, you get back to your fight, you know?

And, in a way, I look at all these people, these Flaming Lips fans, as someone who, you know, they kind of know me. I'm putting music out there, I'm telling them about my life, I *want* them to know me. I want them to be fans of our ideas and our art or whatever, and so it doesn't surprise me that they might think, Hey, I know that guy, and I'll just go up and say hi. But I take the responsibility of saying, "It's up to me to

deal with them." It's not their problem of how they deal with me, it's my problem of how I deal with them. I should be the one who knows how to handle it. And so I treat it like: if I was going to meet some rock star that I really liked, how would I want them to be?

BG: I really kind of envy that position you're able to have, because I just find that whatever mood I'm in, whether I got enough sleep the night before or whether or not we had a bad show, or let's say I had a fight with Joan on the phone, or whatever else, I tend to let that affect the way I deal with people.

WC: Sure.

BG: And I've sometimes felt, when somebody walks away, that they didn't get the experience they wanted from me, you know? And not in the sense of like, we're not going to become best friends, but just, maybe I was a little curt, or I didn't, you know—

WC: In the end I kind of look at it like, what did you want when you met Santa Claus for the first time? You didn't really want to know that he was just some guy who was lucky to have a job being Santa Claus for two months around Christmastime. You wanted it to be the real Santa Claus. And at some point, you and I, we put on a little bit of the Santa Claus costume and go out there and do the show. So I can look at it like, if I met Santa Claus, would I want him to be tired and grumpy and say, "Hey, little kid, leave me alone, goddammit"? I would want him to handle it and let me walk away with that image and that belief still in my mind. And so, I don't know, I think in that sense I always feel like I owe the audience. Someone comes up to me, you know, I owe it to them not to have bad breath and be grumpy.

BG: Tell 'em, "Get the fuck out of here, I'm eating," that kind of stuff?

WC: Well, right. You know, and I've met people like John Waters, where I walked away from meeting him and he's perfect, just the way I wanted

him to be. It just seals it in your mind forever when you feel like you've smelled them and you've touched them, that they are what you thought they were going to be. And then there's other people that you meet and just, frankly, don't even like, and I would never want that to happen to this great thing that's become the Flaming Lips, I would just ruin twenty-five years of all these great accidents and all these wonderful things that have happened to us in two seconds, when someone says, "Ah, fuck, he was a dick. I don't like them." I value every fan—they've given me this life, and if they want to talk to me for a couple of seconds, no big deal, right?

III. GERMAN JOURNALISTS

WC: Do you still have awkward moments when people who are interviewing you ask about things you don't feel comfortable answering?

BG: At times, but I kind of feel like I get a read on people pretty quickly as to how the interview's going to go. When the first question is "How did you get the band name?" and the next question is "What are your influences?" you kind of get a sense of how the interview is going to go, and you can only give them so much. But when I start talking to people and I find that there's a rapport and they're intelligent and they have a similar sense of humor, I don't feel that there's anything I really feel uncomfortable talking about outside of broadcasting where my family lives and stuff like that. Or when we're in Germany, and we end up answering questions in translation like, "So your last record was one of the greatest records ever made by mankind. Your new record is—'swill'? Am I saying this right? 'Swill'? How do you explain why you made such a horrible record after making such a great one?" And we're like, "Well, I don't really know how to answer *that* question."

WC: I know! Fucking German journalists! They don't even realize how real that is, and I don't think they know that they know that they're being so fucking harsh or so critical. They just act like, "Well, I'm telling you the truth, that's what you want to hear." And you're like, "Well, fuck." I was

talking to one guy, and he actually said, "Excuse me, I need to take a shit very bad, so it will take me a couple of minutes." You know, if I need to take a shit or something, I just say, "I need to go to the bathroom," or whatever, but he was like, "Excuse me, I have to take a shit and it will take me a couple of minutes."

IV. THE MAJORS

WC: Well, you guys have done it. You guys have done it, man. I mean, when people come to your shows and people see you, even when people read about you and stuff, you guys have really done the thing that I was hoping would happen: that it wouldn't be like, "Oh, everybody loved us when we were on an indie and now we're on a major and you see the disaster that's happened." You guys just sort of seamlessly said, "We're doing our thing and it's just not going to matter." And it's just worked perfectly. That's the secret—the secret is that it could have gone—

BG: Oh, without a doubt, it could have been a horrible mistake.

WC: And you guys could have just said, "Oh, the majors suck, and nobody knows what they're doing, and the world sucks," and all that. And the other side of it is that you have to sign up for the work, you know, the work starts.

BG: I think the most important thing about making a transition like this is not looking back. Or maybe "not looking back" is not the right term, but doing it unapologetically, to say, "You know what? We want our band to be successful, and we want people that haven't heard our music to hear it."

WC: And this idea that the major labels are obviously the enemy of indie music—well, whoever still believes that is obviously tripping anyway. It's just not real. Each band seems to take control of their own destiny more than anybody gives them credit for. And that's the part of it that I like about you guys—that part of the story doesn't really seem to matter

anymore. It's really about you guys, and the major label and the indie part—who cares? It's you guys and your music making it work. It's not about a label making it work, it's you guys and the audience.

BG: I can't imagine what it must have been like for you guys starting out when the indie labels were these seemingly way, way, way left of center kind of entities that put out records and there was no way to get your music into any—

WC: You know, I don't think we even considered major labels or anything like that. I think our biggest goal was to be on SST Records. We never dreamed that it would be anything else. I didn't even know what a label was when we started. I just thought that there was this band with music, and what's a label, what's a promoter? I didn't give a shit about that, I was just a guy in the audience who wanted to make music, you know? And I think that most of the audience is still like that. I think that when people go on about labels, and about radio, and all that, I think that most of the audience is like, "What's all that? Who cares? I thought it was just about sex, drugs, and rock and roll." ✦

KHAELA MARICICH

[OF THE BLOW]

"MAYBE BY THE TIME I'M SIXTY, I'LL BE OVER MY LOVE STORIES."

The stages of Khaela Maricich's career as a performer:
A girl who was just playing the guitar
A girl who was just playing the ukulele
Get the Hell Out of the Way of the Volcano
The Blow

 few years ago I was in this very intimidating week-long screenwriting workshop. Most of the other writers were from L.A. and New York; most of them had made movies. I was from Portland, Oregon, and not only had I not made a movie, I was wear-ing leg warmers that were made out of sleeves I had cut off of sweaters. Meals were the hardest, walking around with a tray, shyly trying to figure out whom to sit next to. At dinnertime the mail was handed out; most of it seemed to come from people's agents. One day I got a letter. It was a big envelope from my friend Khaela Maricich. I opened it and slowly pulled out a strange mass of paper. I started unfolding it. And unfolding it. The Hollywood screenwriters began looking up from their conversations

251

to watch me unfold. Eventually I had to stand up because the thing was so long. It was a life-size paper version of Khaela herself. She must have sensed I needed backup. There she was, carefully painted and cut out, one arm punching the air, wearing jeans and a T-shirt that said TEMPORARY VERSION. *Oh and look, the jeans even had a tiny paper pocket. Everyone watched as I reached into the pocket and took out a letter. I sat down and read it with Khaela folded over my arm. This was the official beginning of my confidence that week. There is maybe a myth that freaky-artist types are either total loners or members of packs, scenes. I've never been either of these things, but I have two or three friends who are my touchstones. Khaela is one of these. We don't hang out very often. Sometimes we fight, sometimes it takes hours to warm up to each other, but sooner or later the gates are flung open and everything comes crashing out of our hearts. Our hopes and insecurities become spiritual when she talks about them. If you've heard her band the Blow, then you know what I mean; she's the same way in her songs. Last time she passed through town we only had time for one conversation. Here it is.*

—Miranda July (June/July 2007)

I. ACE INVESTIGATIONS

THE BELIEVER: We're drinking a tea, which I didn't really tell you about. This tea that we're drinking, it's really special longevity tea, and so we're more or less going to live forever. It costs like nine dollars, to live forever.

KHAELA MARICICH: It's like fifty cents a year, or less.

BLVR: I thought we would trace a little bit of your history for those who aren't as familiar with it as I am. Also, to be honest, there are some things that happened when I first met you that I don't understand at all, because we weren't very good friends. For example, Ace Investigations.

KM: [*Laughs*] You never really understood it, huh?

BLVR: No. So when I met you, in Olympia, because I was dating some-one who lived in Olympia and I would come up from Portland and visit, I one time heard that the new thing that you really wanted to be a part of, if you were anyone, was Ace Investigations. And I wasn't quite sure, like I was never asked to be an investigator, or detective, or whatever, but I had deep respect for whatever it was they did.

KM: Well, that's funny, because Ace Investigations was an investigative agency. My friend started it, and the idea was that *everyone* is an inves-tigator, everybody is always investigating something. And that's what's interesting about people, is what they're paying attention to, what they're investigating. So, really, anybody could be a part of our investigative agency if they wanted to. So, you were welcome to.

BLVR: I wish I had realized that.

KM: We rented a space and had biweekly meetings, the idea being we would each have our own personal investigations and then manage this space so that we could give evidence of the investigations we made. Basically art shows. What's funny is I remember someone told me [*whis-pers*], "You know Miranda, who's been hanging around town? She said she was interested in being an agent." Which meant you got an agent name and an agent card.

BLVR: Yeah, I wanted that card.

KM: And I remember seeing you at a concert—but I didn't know you at all, and you were standing there and I was like twenty-one at this point—

BLVR: And I'm, like, what, twenty-two?

KM: Yeah, maybe twenty-one and a half. And you were standing behind me when you had your really big white hair and wore the most mysteri-ous clothes possible. I didn't understand what you thought you thought you were doing, with your awesome tights *over* your big shoes. I just

didn't understand it [*laughing*]. So I turned around to you at a concert and was like, "Are you spying on me?" Like, giving a clue about Ace Investigations, and you said, "Well, if I was I wouldn't tell you." [*Both laugh*] And then I was too scared to offer anything more about the membership card.

II. "KEEP AWAY FROM THE MOON, IT WILL FUCK YOU UP."

BLVR: It took a little while, on both ends. Too many code words and not enough regular words. The first time I ever saw you play music was when you played your ukulele, at some show. It seemed so precarious—you know, girl comes out with a ukulele and you're like, "Uh-oh. This could be bad." But it was perfectly pop and emotional and precise and sort of efficient, you know? Not too long and not too short. I had completely misjudged the situation. Now I've learned to trust you, more or less. But you've kept that precariousness with you, and it seems to be part of what's really valuable about what you do. Was that called the Blow?

KM: No, that might have been just me, or it might have been called Get the Hell Out of the Way of the Volcano.

BLVR: Get the Hell Out of the Way of the Volcano. In short form, that title would be the Blow, i.e., the blow that comes out of the volcano.

KM: Exactly.

BLVR: And what do you think of as the Blow? Do you even think of it as something that only exists as music? What is the Blow?

KM: That's an interesting question. What's the Blow?

BLVR: What's everything the Blow could be?

KM: Oh god, what a challenge you're throwing down to me, Miranda! [*Laughs*] That's what's so good about you, you're always asking what is the best possible thing this thing could be in the whole world, ever? It should be that, just pushing yourself to make it be that. And I'm kind of resting comfortably and not having to define it specifically, everything it could fantastically be. Well, the Blow was just me, for three releases. But also under that name, the Blow, I've done performances. The one that I'm really most proud of was "Blue Sky vs. Night Sky."

BLVR: I loved that performance more than anything.

KM: Since people didn't really know me back then, I could just get up and start singing as a girl who just was playing guitar. Which I'm really not great at, so it didn't seem like it was going to be anything very impressive.

BLVR: Like you with the ukulele.

KM: But now I was performing as a character, I was playing this show as if I was an eighteen-year-old girl who was caught up in a boyfriend that she wasn't super into.

BLVR: I remember you coming onstage and saying, very nervously, "This song is for my boyfriend."

KM: And then it continues and it becomes clear that she's actually in love with a girl she'd been with at camp, she's staggered by an experience that happened with her.

BLVR: Did the experience have to do with the moon? I remember there was this message—oh, I get shivers thinking about it—there's a recorded message that is played backward, but you sing it.

KM: I can explain that. It's actually a story that I experienced, which is why I feel like it was really easy to tell in the show. Just the experience of,

through the grounding of holding somebody's hand, a girl that I met at one point, really experiencing the vastness of what it is to live and exist and look at everything which is—I'm not even really able to communicate that in words right now in the interview because it sounds—I mean, you can't get that into words. In the performance the girl gets home from camp and tries to talk to her mom about it, about what she'd heard—for the first time she'd looked at the sky and really *heard it*—but her mom is just like, "You can't talk about it. We don't want to talk about that. Don't talk about it."

So the girl's waiting for her mom to tell her more about why she's not supposed to talk about it, and in the investigation of trying to figure out what is wrong about talking about that thing that she heard—she tape-records her mom, and then is trying to hear—there must be some secret message in what her mom's been saying—so she plays the tape backward—

BLVR: And you perform this, you somehow made the exact sound with your mouth of a tape being played backward—

KH: And backward, the mom is saying, "Keep away from the moon, it will fuck you up, it will fuck you up." The mom knows all about the vastness of the sky and she is terrified of it. That is really the only place in my life I kind of felt like I was ever actually standing in front of people talking about the weirdness, just of living. That was the Blow. So I did that, and I just played songs and shows and experiments of different kinds of ways of performing and sharing that in front of people.

And then I decided to just try making a couple of pop records because it reaches a lot of people, and you can talk to a lot more than just people who like janky low-fi indie music performance. So the last two records of the Blow has been me and Jona [Bechtolt], and in the future I don't know what. Jona's mom played "Parentheses" at her wedding.

BLVR: So you know I drive around and listen to the new record, *Paper Television*, all the time. It's really amazing being your good friend and then hearing you sing about these things that we talk about

sometimes—you know, all my friends should make albums for me to drive around to. And you know, I can't sing at all. You've never heard me sing, really.

KM: Once.

BLVR: OK, but I sing along to you, Khaela. While I'm driving.

KM: Ooh!

BLVR: One thing I sing along to is that part—I think it's essentially from the point of view of a shit, more or less, passing through a body. What song is that on?

KM: "Babay."

BLVR: It's that part where you sing, "I will always be around." It's so valiant, like a cry out into the night, "I will always be around! I am *that* big!" And then a moment later, sadly, in retrospect, "Because I thought I would always be around." The realization of impermanence.

KM: And I'm straining my voice on that part too, to sing it. I was singing a little bit out of my key. I think it's in my range now, now that I've recorded this record—because I've stretched my range a little—but it's like, "I will always be," and my voice kind of cracks because I'm not quite there yet.

BLVR: Yeah, I love that.

KM: As we recorded it, and as I wrote it, I felt really sad, and at the end of the day when Jona was playing the beats he'd made and I was singing the thing, I was like, "It's sad, isn't it, Jona? Listen, listen how sad." It felt like it'd gotten it into my hand, though. It was better to have the sad in my hand than running and not being able to catch it.

BLVR: Yeah, I know. That's often the place that I'm making things from, like, I can't stand to feel this way. At least if I can have it in my *hands*, it's like being sad, but with money.

KM: Or the sad is money.

III. "IF SOMETHING IN THE DELI AISLE MAKES YOU CRY..."

BLVR: Another beautifully sad lyric on that record is the one that goes, "If something in the deli aisle makes you cry..."

KM: What's funny is that I made that up in my head around you.

BLVR: Really?

KM: Yeah, we were in the Whole Foods, when I was visiting you in Portland one time, and I was staring at the overwhelming mass of all the food, kind of personal but really so impersonal. I had that really overwhelmed feeling—just wanting someone to come up and see that, and see me, and see that they should walk me outside.

BLVR: Right, but I guess I didn't walk you outside, did I? That's not the punch line—you were waiting and then I walked you out? You probably didn't even tell me.

KM: I don't think I would have taken the risk to expect that from you at that point. I think my eyes were a little watery, and I was like, "Do you ever want someone to walk you out the door? Just put their arm around you and walk you out?"

BLVR: I was probably like, "Get it together, Khaela!"

KM: You were just like, "We need food."

BLVR: That's so funny, because I've imagined those two women in the deli aisle. So just say the lyrics so we have it.

KM: [*In a normal speaking voice*] If there's something in the deli aisle that makes you cry / You know I'll put my arm around you and walk you outside / through the sliding doors / Why would I mind?

BLVR: OK, but you sing it much less flip. I love the "why would I mind?" part. It implies that someone else is saying, "Do you mind doing this for me? Is this OK?" That's the part that breaks my heart, because it's very female to feel like that's too much to ask.

KM: Yeah, yeah, totally.

BLVR: Even in your fantasies there's an implicit apology. That's the extra part that you probably don't even think about, I'm guessing. I don't, when I'm writing. When people ask me, "Is there a female point of view in your work?" I'm always like, I don't know. I'm just me, and am I even human? But when I heard that line, I was like, Oh, no guy would have that fantasy of someone saying, "Why would I mind?"

KM: It seems like a lot to ask.

BLVR: Yeah, it's so much to ask! [*Both laugh*]

KM: That's the first song I ever really felt like I was trying to write from, like, "I love you." All the other songs I have written on most of those other records are like, "I tried to love you! I'm trying to love you!"

BLVR: "I'm trying to figure it out! Give me a second!"
 OK, here's a fun one; this is a question about how you look, and how aware of it you are, how much do you control it. I'm only bringing it up because you're reaching a wider audience. More people are looking at you.

KM: That's the one aspect where I really feel like a dude. I really try, and sometimes I have a brave notion about what I'm going to wear, but really the coolest things I have are things a couple of people have given me, including you.

BLVR: Nonetheless, you are willing to be up there onstage in front of people. It's so often tied, a woman in front of her fans, with a *look*. Even on the most indie level. I love Karen O, and I love her *look*. You do have a look, but it's actually probably very startling to people because—

KM: Startling? That's putting it nice.

BLVR: I don't know, I think it's pretty powerful that you're up there alone, in front of all these young girls, you're really smart, you're clearly the coolest thing in the world and you're not all dressed up, you're not wearing makeup, and yet you still want to be seen, you're a total performer.

KM: Really, what that's about is that I don't have the attention span to make things any nicer than they are. Any time I've tried to wear makeup I just feel like a fool. Really I'm trying to do the thing that's least embarrassing to me. I try to make sure my hair looks reasonable and put on some clothes that don't fall off or anything.

BLVR: OK, I won't put you through this anymore.

KM: No, it's funny!

BLVR: I have a lot of love for that part of you.

KM: Thanks. I've been thinking about wanting to grow my hair a little longer again. I mean, I don't want to come off like a big lesbian or something.

BLVR: You have an inherent style that you can just skate on forever.

KM: Oh, thanks.

IV. IT'S TIME TO HAVE GOOD SEX

BLVR: But speaking of lesbianism, tell me about your mom's favorite song on the new record.

KM: Oh yeah, well, I thought she would think that the music was too bumpin' and too fast. So I was really surprised to hear her call me and be like, "I think it's great, I just really love it, and I just think that French song—I mean, *I don't know what it's about*, but I really think that's just the best one on there—but because it's in French *I don't know what it's about*." It's totally about me hearing these girls having sex in the room next door and then hearing, at my other friend's house, a girl and a guy having bad sex, and the fantasy of going up and taking the girl, knocking on the door, and the girl having the bad sex, just getting her to come, and leave, you know? I mean, basically it's about... it's basically about me feeling like it's time to have good sex, you know, and doing whatever it takes to make that happen [*laughs*].

BLVR: And on some level, your mom's really supporting that.

KM: She's really feeling it [*laughs*]. No. It was funny to me that the one song I would have been most afraid she would have not supported—because she hasn't been the most supportive of me, doing what I need to do to be happy—she loves.

BLVR: And the song has English lyrics too. Plain as day.

KM: I know, I said that, I said, "Mom, it's actually in English too. All the words are there." And she was like, "Hmm. Well." And I was like, "I actually kinda have to go, because we're driving in the car right now, Mom," and she said, "I have a story to tell you! I just have to tell you, my friends who came to the reunion, when we had our class reunion..." and I said, "Ma, I really gotta go, I have to just get in the car and drive,"

and she said, "I'm going to tell you this story. There was this woman, she was one of the really pretty girls and she just got married right out of high school, and when we went back to the class reunion..." and I said, "Ugh, I've got to go, Mom," and she was like, "And she came back with a woman, and she just walked right in and they were just a great couple and it was really nice."

BLVR: [*Laughing*] Oh, god, you never told me that!

KM: I don't really think it was actually her consciously endorsing anything. I don't think any of that is conscious, but maybe on some really deep level she's wanting to try and accept me where I am. She's got the pulp, she just doesn't have the conscious thought that it's OK.

BLVR: As opposed to you showing up with your girlfriend—a song that does effectively contain the feeling can get into anyone—you can have the feeling yourself, you can try it on.

KM: That would be the intent, right? That's the hope.

BLVR: I kind of wonder about that sometimes. *Paper Television* has reached more people than your previous albums, and it also happens to be the most radical. The lyrics are love songs and songs of longing, but they turn back on themselves and question themselves and are totally lesbo, and I wonder how much—

KM: [*Laughs*]

BLVR: [*Laughing*] Do you have a sense of how much people are getting that? Or is it like your mom, where they're getting it on enough of a level that it's affecting them?

KM: *Punk Planet* reviewed the album and was like, "She just sounds, like, really angry, these songs all sound really angry, like she got dissed by some boy and now she's swearing off boys forever, and she just has a

really cold heart." Making examples of songs I wrote about girls. I was thinking, *Angry?* These songs sound angry? I think they sound like...

BLVR: Very vulnerable.

KM: And mystically speculative, or something, you know?

BLVR: Yep, I do.

V. YOU HAVE TO HAVE THE MOST DELICATE TOUCH TO TALK ABOUT WHAT THE WORLD IS LIKE

BLVR: Is there anything you're not doing that you want to do? Like a dream project?

KM: My dream project... Oh, it's so embarrassing and vulnerable-making! I can't say specifics about what it would be, of course.

BLVR: Right, because of theft.

KM: The privacy of my own desires.

BLVR: Oh, right.

KM: I don't even know exactly what it is yet. When you look out at the world, wouldn't you want to be able to address something gigantic? I would like to be able to talk to people about a little bit more than just my own feelings about relationships.

There's greater problems to deal with, but that's so subtle; you have to walk that so delicately to talk about anything bigger. I wouldn't want to do this as a pop record. I'd like to do it in other formats, because I like to make things with my hands, like the things you have here in your house.

BLVR: Yes, I have a lot of things in my house that Khaela's made for

me, they're exquisite. One of them is a beautiful paper light that looks like something that was made in Japan or something. It's very structural and it's a working light too; it glows from the inside out. I think it's a representation of—you made representations of all your friends' souls?

KM: Well, not really their souls, but if the light is what's good, then the architectural structure surrounding it is the way they are getting their light out.

BLVR: I'm always aware that the light I own isn't actually *my* soul. It's like, who is it? Someone in Olympia?

KM: Yeah, I don't know if it was a specific person.

BLVR: When you talk about other forms than a pop record, I realize that, yeah, I think of you as an artist, but not everyone knows about the other work. I've seen you perform and make objects and paintings, and everything is all of the same caliber. Your album is not better than that light, but it takes so long for everyone to come over to my house and look at it, it's just easier to make the album.

KM: I would like to try fleshing out some ideas on a couple other topics in the span of my life. Maybe by the time I'm sixty, I'll be over my love stories. I'll be more and more solid, and I'll feel able to address the things I find troubling, without doing it in any cheesy way. But it's a pickle. It freaks me out that people sleep on the street; it freaks me out. And that's a really deep feeling to me, as deep as how I felt when I realized that I wasn't going to be able to be with the person that I was in love with, ever. But any kind of venue to communicate about that—you have to have the most delicate touch to talk about what the world is like, to address that at all. You have to be pretty genius to pull it off. So that would be the dream, right? Just to feel more empowered in addressing how the world feels to me beyond the realm of feelings that surround me. I don't know if it's possible.

BLVR: You are already doing that, so I don't doubt that happening, long before you're sixty.

KM: Yeah, I want to do it, and not just on a record.

BLVR: Yeah, yeah, got that written down, Universe? She wants that. And not just in record form, by the way—we're open to other venues!

KM: Thank you. This is Miranda, my agent. Thank you for dealing with the universe. Metaphysical agent.

BLVR: OK, that seems like a good place to stop. Now we can figure out how to talk as friends again. ✱

NANCY WILSON

[LEAD GUITARIST OF HEART/FILM COMPOSER]

"IT WAS ALWAYS MORE ABOUT IMITATING GUYS, LIKE ZEPPELIN AND THE STONES. ANN'S SINGING IS MUCH MORE ABOUT ROBERT PLANT AND ELTON JOHN, FOR EXAMPLE, THAN IT IS ABOUT ARETHA OR JANIS."

Rules for building a fake mid-level '70s midwestern rock group:
All songs must be about either a vague father complex or the road
Songs must be sung in 1972 rock accent (black blues
translated through English inflections)
Guitar may not be worn too high
Guitar player must not stare at his hands too often
Slouchy body language is good
Hair should be styled with shaving cream

Despite the fact that she's a rock star, Nancy Wilson has never hogged the spotlight; she's always shared it with the people she loves most. The prime example: she kicked off her professional career by becoming the lead guitarist in Heart, a band founded by her older sister, Ann, in the mid-'70s. Heart's first album was produced in 1976 by an obscure Canadian label, Mushroom, after nobody else would touch it—and that effort, called Dreamboat Annie, went platinum. Since then, Heart has had six mega-platinum albums and two gold ones; they've sold more than thirty million records. The sisters tied for the number forty slot on VH1's list of the 100 Greatest Women in Rock 'n' Roll—beating out Cher, Sarah Vaughan, Alanis Morissette, and Melissa Etheridge, to name a few.

These days, Heart is still going strong: Wilson and her sister continue to write new music together, to play concerts every summer to sold-out audiences, and to release albums. Their most recent was 2004's Jupiters Darling, *and they'll be recording another in 2008. "We'll never be just a jukebox band, recycling our greatest hits," Wilson has said. Yet jukeboxes all over the country—as well as movie soundtracks—are filled with their anthemic songs, like "Barracuda" and "Straight On."*

Wilson has also had a long-standing personal and professional partnership with movie director Cameron Crowe. Not only has she composed music for many of his films, like Almost Famous *and* Vanilla Sky, *but she's also been happily married to him since 1986. And in 2000, at the age of forty-six, Wilson gave birth to their children, twin boys.*

After talking to her over the phone for a few hours on a recent afternoon—and getting hooked on her infectious laugh, on the optimism her down-to-earth cheerfulness inspired—I found myself wishing there was some way I too could work on something with Nancy Wilson. Then I realized I already had.

—Maura Kelly (August 2007)

I. TINY ROCK STAR

THE BELIEVER: Is there a single moment—maybe seeing a concert as a kid—that made you say, "All right, that's it, I'm becoming a musician"?

NANCY WILSON: The lightning bolt came out of the heavens and struck Ann and me the first time we saw the Beatles on the *Ed Sullivan Show*. My family was living on the marine base in Camp Pendleton, California, and we'd all gathered around the little black-and-white TV at our grandmother's in La Jolla. Most people didn't have color sets at home back then. There'd been so much anticipation and hype about the Beatles that it was a huge event, like the lunar landing: that was the moment Ann and I heard the call to become rock musicians. I was seven or eight at the time.

BLVR: What was it about watching them that inspired you?

NW: The whole thing. They were really pushing hard against the morality of the times. That might seem funny to say now, since it was in their early days and they were still wearing suits. But the sexuality was bursting out of the seams. They had crazy long hair. They seemed to us then like the punks seemed to the next generation—way out of the box for the time. And they were so good-looking too!

But we didn't want to marry them or anything—we wanted to be them. Right away we started doing air guitar shows in the living room, faking English accents, and studying all the fanzines. Ann always got to be Paul, and I was mostly George or John—

BLVR: Poor Ringo always gets the shaft.

NW: Sometimes we'd be Ringo! Luckily, our parents were both musical and supportive about us getting into music. So it didn't take all the begging in the world to convince them we had to have guitars. We taught ourselves to play off the Beatles' albums and the trusty old Mel Bay chord book. Pretty soon we knew every Brit pop song that was out.

BLVR: There probably weren't a lot of women rock stars around then, huh? But when you're a kid and you're dreaming big, I guess you don't stop to say, "Wait a second. There's no way I can do this, not if no other chicks are." Do I hear some Joni Mitchell in your '70s stuff? And was there a little Janis Joplin in your look early on?

NW: Joni Mitchell became a huge influence on us. But it wasn't till after the initial Beatles explosion that you started seeing women come forward as their own songwriters. For Ann and me, it was always more about imitating guys, like Zeppelin and the Stones. Ann's singing is much more about Robert Plant and Elton John, for example, than it is about Aretha or Janis. And Janis—well, we weren't as interested in being like her. We were coming from middle-class America—suburbia, really—and believe it or not, Janis seemed more foreign and strange to

us than the Britpop guys. Her music was much swampier. More rhythm and blues than rock.

BLVR: One of my all-time favorite movie scenes is the one in *Almost Famous* where they're all on the bus, tension's running high, everybody's kind of pissed off at each other, and it seems like the band might split up or something... but then "Tiny Dancer" by Elton comes on. And suddenly, everybody's singing along to it. The mood lifts, and it becomes this really hopeful moment. You did a lot of the music for that movie— did you play a part in creating that scene?

NW: Just to root for Cameron to get it on film. It was an "in-between" moment, as scripts go. That's the first kind of scene that gets cut in the process, because supposedly "nothing happens," plot-wise. But Cameron fought for it, and fought for the time to film it. Because the "in-between" moments are often what you remember most in a movie. The funny thing is, years later, it's the most hardened rockers that come up to us and sort of whisper to us, guiltily, "We had a moment like that on our bus— except it was a Neil Diamond song..." I just loved how that scene, and the whole movie, was a love letter to music and how the right song at the right time can transcend everything. It was the peak of the whole movie, and really, the reason for the whole movie. Like Fairuza Balk's groupie character says—explaining why she follows all these bands around: it's not the sex or the drugs, though that can be fun, it's really all because of... "some silly song that means so much that it hurts."

When it came to putting together the soundtrack we rediscovered "Feel Flows" by the Beach Boys. It plays during the closing credits but that song wasn't even available on CD at the time. I had to dig the old vinyl out of Ann's basement. Brian Wilson remixed it for the CD but the version we used was copied straight over from the vinyl, so that it would retain the warmth and the character of the original. There's a beautiful velvety thickness that you only get from vinyl. That was a real college song for me. If you listen closely, you can hear the crackles.

BLVR: By the way, what did you study in college?

NW: I was forced to declare a major, so I chose art and German lit. But by that point, Ann was already up in Canada playing in Heart with Roger Fisher and his brother Mike, who was the manager of the early version of the band. There had always been an open invitation for me to join them, and I knew I would join after I got some college under my belt. So after a couple years I dropped out of school to seek my future in music.

BLVR: What made you decide to go for it?

NW: My mom and dad were also stressing the college tuition money, and I wasn't making much at the local pub, so I was ready. I went up to Canada and joined the band when I was nineteen. By the time I was twenty-one, our first album was taking off.

I feel incredibly lucky because I've never had a real job other than music. I did a lot of babysitting, tutored math, and taught little kids guitar lessons, but that was it. I tried to get a job once as a busgirl, clearing and washing dishes; I tried to apply at a gas station, but both times they said, "It's only a man's job"! Ann had a job for two days at KFC before they fired her.

I think we were both better off in music!

II. MAGIC MAN

BLVR: I read that Heart was in Canada for a while. There's some really great music coming out of that country right now—the Arcade Fire, Wolf Parade, Sunset Rubdown, Neko Case, and Destroyer, to name some of my favorites. But those musicians are all born-and-bred Canadians. For you guys, why the north country?

NW: Draft evasion. It was during the Vietnam War. Michael Fisher, who was the Svengali behind the band and Ann's boyfriend, was evading. There was all kinds of drama surrounding that situation—like, when Ann came back over the border to get home for Christmas, she got the full-on third-degree interrogation and cavity search. She showed

up really shaken that night, feeling like she'd been raped. The feds were all over it.

BLVR: They knew about some random rock-musician guy who was trying to get out of dying in Vietnam?

NW: It was the Nixon era. There was a lot of invasion of privacy stuff going on.

BLVR: Funny, that sounds familiar.

NW: Yep. Michael didn't enlist when his number came up, so the army broke in to his house late at night to get him—which was illegal, as we found out later. Luckily, he jumped out the window and ran before they could get him. He hitchhiked his way up to Vancouver and settled there. But at one point, he snuck back down illegally to visit his brother Roger, who was playing in a Seattle band with Ann. That's when she and Michael fell in love. She followed him up to Canada, and the band followed her. We lived there for years.

Not long after I joined the band, amnesty was instated, and Michael wasn't hauled off to jail. Which was doubly great, because that was around the time that Heart started to have some success, and the pardon freed us up to tour anywhere in the world.

BLVR: And didn't you end up dating Roger Fisher? What was that like—two sisters dating two brothers, all of you in the same rock band?

NW: It wasn't the best plan. Roger was after me, though I wasn't quite smitten by him. But he was a good friend to me during a scary and lonely time: my first experience after school being away from home. And being together kept costs down! I mean, it was cheaper to share a hotel room when we were traveling around, doing gigs. We were such hippies. *Houses of the Holy*–style. We'd walk through fields near the hotels, play-ing our mandolins. We'd sit on the bed nude and strum our guitars. It was a more innocent time then. Now it's really different. Now music

stardom equals sexiness. Now pop icons have to be sex icons. There's not a lot of poetry left in it.

BLVR: Wait a second! What do you mean? Sitting naked on a bed playing music sounds pretty sexy to me. And I've got the cover art for your first album, *Dreamboat Annie*, right here in front of me—you and Ann are looking hot on the front of it.

NW: Our ideal of sexuality was much more natural—like nymphs running through the woods! It was a free sexuality, without the repression of our parents' generation.

BLVR: I think I see what you mean—like today's sexuality is more in-your-face and manufactured?

NW: Yes. Today it's a world of breast-augmented sexuality.

BLVR: Another great movie scene is the one in Sofia Coppola's *The Virgin Suicides* where Josh Hartnett struts through the high school to Heart's song "Magic Man"—and everyone in America who didn't already have a crush on him got one. I really felt the power of music, watching that.

NW: That is such a great moment! You know, Sofia contacted me when she was making the film and said, "Listen, I don't have much of a budget, but would it be OK if I used your song?" She sent a rough cut of the movie and I was so impressed by the way she used the song to make a story point that I said, "Go ahead, it's yours, no charge." I also gave her permission to use "Crazy on You." We didn't have a manager at the time, so I could get away with handing things out for free. Anything for Sofia. She's got a musician's soul.

BLVR: How did *Dreamboat Annie* come about in the first place?

NW: That album came together when we were in Canada, playing

clubs—or cabarets as they say there—at night, writing songs during the day. After being turned down twice by every major record label, we met a cool producer, Mike Flicker, at one of the club gigs, from a small label called Mushroom, who wanted to record us. So we got to record in a real studio, and then the album came out in 1976.

It's funny, because in the '90s, Ann and I went back to that studio. And we'd remembered it as this huge, majestic, cavernous thing—it was so important to us at the time—but in actuality, it's just this cool little hole-in-the-wall.

III. MOVIE MUSIC

BLVR: What was it like to compose the songs for *Almost Famous*?

NW: One thing that always seems to sink most fictional movies about rock: the fake songs. So we tried to be as authentic as possible. Before the movie started shooting, Cameron and I were taking a break at the beach, and thought we'd just launch headlong into the whole fictitious world of this midwestern mid-level rock group circa 1972. We wanted them to feel like a blend of Bad Company with a little Led Zeppelin, Cream, and some Allman Brothers mixed in. All their songs, we decided, were either about a vague father complex, or the road. Nothing in the middle. You have no idea how fast and how fun those songs were to write! Every song is either about "Babe, I have to ramble" or "Father, father"… and sometimes both! And then, once we had the songs done, the problem became finding the right singer, because there was a certain rock accent in 1972 that no longer exists.

BLVR: A rock accent? What do you mean?

NW: There used to be a certain bluesy way of singing that people don't really do anymore. In the '90s, the Seattle sound developed—less of a drawl and closer to a warbly yell, the sound of Layne Staley, and somewhat Eddie Vedder and Chris Cornell, Kurt Cobain, or any number of those guys who channeled their rage through a prism of Kiss and Cheap

Trick. It changed everything! And it really changed the rock accent. You still hear that grunge influence today in all the "alternative pop" stuff, or whatever you call it. But the singer for a band like Stillwater would've had that '70s rock sound—more of a black blues translated back through the English bands' inflections. Eventually, we chose Marti Frederiksen [an L.A.-based musician and producer who has cowritten songs with Aerosmith, Def Leppard, and Sheryl Crow, to name a few]. Before we found Marti, it was my mock vocal on the songs and it was pretty funny to see Jason Lee (who played the lead singer) lip-synching to my vocals…

Peter Frampton and I gave the actors lessons on how to be rock stars. One thing we did was to tell them how you have to be ready for anything, because while you're onstage, the fans can be really unpredictable. Stuff is hurled at you, like CDs and jewelry. You'll be in the middle of a song, playing a huge Les Paul, and they'll come up to the lip of the stage demanding you sign some piece of paper. And you'll be like, "Uh, well, I'm actually a little busy right now! My hands are kind of full!"

BLVR: That's hysterical. What's the worst thing that someone has ever done?

NW: The ones who just jump up onstage really scare me. They usually have pinwheels for eyes and get whisked quickly away by the crew.

BLVR: What other things did you teach the Stillwater guys? Like, if you're a television anchor, I heard you're supposed to sit on your blazer, to keep it from bunching up. Is there anything like that for a rock star?

NW: Yep, there are some cardinal sins. Like you should never wear your guitar too high, because it looks dinky. Another thing a guitar player should never do is stare at your hands too much—it's lame.

And it's better, believe it or not, to have slouchy, sloppy body language that guys like Jimmy Page are known for. To help the actors get it down, Cameron had them study live concert footage of bands like the Who and Led Zeppelin. And by the time the movie rolled, they looked like

a real rock band. Jason Lee had a head start because he already knew how to play the guitar. Billy Crudup [who played the lead guitarist] had the farthest to go, but he applied himself so much that he really nailed it in the end. He had only played piano before, and picked it all up in six weeks. He still plays; sometimes he leaves a phone message that's just him playing "Smoke on the Water." Just to let us know he's still rockin' the Stillwater sound.

So much care went into making that movie look and feel authentic— down to the types of chords we used in the songs, the guitar straps the actors used, the floor monitors on the stage. Nothing is anachronistic. There's even a moment when you can see a roadie asleep on a case in the background, which is something that always happens if you're touring. We even had Jason Lee put shaving cream in his hair to style it.

BLVR: Shaving cream? In his hair?

NW: That's what we'd do in the days before there was mousse.

BLVR: It's kind of amazing to pause for a moment and reflect on the fact that there was a world without mousse.

NW: Yep. Back before there were a million products, we'd heard David Bowie used shaving cream in his hair. So we'd use it in ours.

BLVR: What about the other films you've worked on? Were you writing background music?

NW: Well, that's completely different from writing songs for rock bands, real or fake. It's all instrumental, first of all. And you need to make sure it doesn't call too much attention to itself. Otherwise, it's going to step on the dialogue or the visuals. Rather than making a big statement, it needs to be subliminal.

BLVR: That sounds so different from being a rock star, where you are *so* visible. Was that an interesting switch for you?

NW: On a live rock stage, I get really amped, literally and figuratively. I feel really inspired to move and perform. Commandeering a big screaming electric guitar is such a thrill. But yeah, when you're using music to help depict a movie, it's a very different discipline. Much more cerebral. I think about the emotional arc of a scene, and then try to paint musical colors around it.

BLVR: So how do things work? Do you start by watching a movie with dialogue but no other sound?

NW: While the movie is being filmed, I lay down different things on my own. In *Almost Famous*, much of that method worked. Carl Kaller, my music editor, can also create new cues from existing music and cut and paste things around to fit the picture. It happens every which way.

With *Vanilla Sky*, I spent about nine months working on the score in a closet of a studio. We were trying to balance out the heaviness of the story with sugary pop-culture music. We made sound collages of all kinds. We were channeling Brian Wilson to a large extent. I was recording things through hoses, around corners, playing guitars with cello bows, and with Carl Kaller, we tried all kinds of wacky stuff. In the murder–sex scene sound collage, Cameron even used Brian Wilson's speaking voice from a *Pet Sounds* mix session.

The whole process was really fun. It began with reading the script together in the kitchen. Near the end I enlisted Jon Brion, who does so much great work, to help me with some string arrangements. He's got some strange instruments we used as well. He's done a lot of great songs and scores himself—*Magnolia, I Heart Huckabees, Eternal Sunshine of the Spotless Mind*. Those temporary string pieces were really great sounding, but sadly not right for the film. Again, it all sounded a little too dark when it joined to picture. But a lot of my other stuff got used.

IV. HIT-MAKERS

BLVR: It's amazing that you and Cameron have been married so long and you also work together. It seems like one of the themes of your life is working closely with family members—not only your husband but your sister, of course. That seems to me like such a difficult thing to pull off.

NW: I'm the youngest of three sisters and I grew up during the cultural revolution of the late '60s. So I learned a lot when I was young—especially at the beginning of the Heart era, I'd say—about how to be a peacemaker and get along with others. Almost to a fault: sometimes I'd be giving all this support to people, but forgetting a little about what I needed. That's how I am, though. I'm really good on a team and I'm not into drama. I like to stay focused on what we're trying to get done, so we can hopefully make something great and maybe even uplifting. Because I think that's what we were put here to do.

But you know, Ann and I have been through some challenging times together, especially trying to lead our band through the '80s.

BLVR: What was tough about that time?

NW: The way that MTV was changing the landscape. Things were shifting away from the artistry of rock music—away from writing good songs—and tilting toward the commercial side. Suddenly record companies were putting a lot of pressure on bands to look a certain way, to have a certain image, to sound a certain way… and to sell a lot of records.

One of the things that happened as a result was that certain bands, like Heart, who used to have their own voice were suddenly forced to start performing songs written by other people.

BLVR: Who were those other people?

NW: A whole stable of L.A. hit-makers. The labels made us and other bands record those songs because they wanted a sure thing—something that would become a radio hit. Before that point, we'd always written all

our own stuff. We barely even did covers, except for some Led Zeppelin songs. But when MTV came along, things got a lot more corporate, fast. And we were not naturals to that way of doing things.

Of course, we were lucky to be able to put our stamp on some songs, to really make them ours. I mean, I still loving singing "These Dreams." Bernie Taupin wrote the words for that one.

BLVR: The guy who wrote all those songs with Elton John? Like "Tiny Dancer"?

NW: Yep. Those are his lyrics in "These Dreams." And there are other songs we still love to perform from that era, like "Alone"—although when we do it now, we take the wedding cake production element out of it. But the real problem of the '80s was the hit we took in terms of artistic integrity. Though we were able to put songs we'd written on every single one of our albums during that period, the ones that the label would focus on—the ones that would get turned into the big singles—were written by other people.

BLVR: I think there's a public perception that since you were a big rock band—since you were Heart—you could always do whatever you wanted. But it sounds like there weren't real choices so much as things you had to do to survive.

NW: Yep. It actually makes my feet hurt right now, to think about it.

BLVR: Your feet?

NW: Oh, yeah. For the videos, we'd get stuffed into these awful outfits—tiny stiletto boots and corsets and bustiers. Then there'd be all these smoke machines. [*Fakes a choking fit*] And a ton of hair spray was involved! It seemed like a fun dress-up party at first, but it got kind of old when we were expected to do it all the time. Ann or I would be like, "Uh, why don't we try something different?" And the label would say [*faking a deep-throated voice*]: "No, babe! That's the image that sells,

babe! Lick your lips and suck in your cheeks!" We had our own ideas about what our image should be. Softer. More like what it used to be. A kind of Led Zeppelin look. But when we'd take those ideas to the designers, they'd come back to us with clothing that looked nothing like what we'd described.

And shooting videos during that period could get pretty ridiculous. We'd do them in two or three days; and everyone would be on cocaine, especially the director; and no one would sleep; and they'd call you in for your close-up at six in the morning.

BLVR: Looking back, is there any one video that you just wish you could just strike off the map?

NW: [*Singing like Cher*] "If I could turn back time!" Although, there was another one—I think it was "What About Love" but I can't remember; one of those power ballads—and for it, the director wanted me to put on a harness and jump off a tall building in a fog. He worked on me for days, trying to convince me to do it. I really didn't want to, but finally he wore me down. I said, "If it looks stupid, we don't use it—and I get the final say." He was like, "OK, OK, just put on the harness!" So I totally did it. And of course, it looked stupid and felt even more stupid.

BLVR: Did it go in the video?

NW: Nope. But that kind of thing was the epitome of the '80s. In every video, people wanted a big rock punch line—a visual hook, something no one had ever seen before. You know, like: "Act Three really has to *rock*, dude."

BLVR: I'm thinking of the kind of attention you must've been getting in those days, when your videos were all over MTV. Did you ever get jealous that Ann was the lead singer? Did you want to be?

NW: Well, it's funny, but the first time we had a number-one song, it was "These Dreams"—which happened to be a song I did the lead vocal

on. That was very strange for us, and especially daunting for Ann: she'd started the band, and then her little sister came along with the first huge single. But only a few months after that, we had our next number one—it was either "Alone" or "What About Love"—and she sang it. She was actually really cool about it and joked that she'd give me her firstborn child to get that song from me. She's one of the coolest, funniest people I know. And I know some really cool, funny people.

Singing was a little weird for me—being up onstage without a guitar to hide behind. I didn't know what to do with my hands. With a guitar, I could channel Jimmy Page or Pete Townshend, but without one? My mom came to see one of our shows and she said, "Uh, honey? OK, what's that thing with your hands? You look like you're doing the hula."

I figured it out after a while. I started channeling Joni Mitchell, doing her movements.

V. CAMERON CROWE

BLVR: Tell me about the first time you met Cameron Crowe.

NW: It was 1982. He was just finishing the *Fast Times at Ridgemont High* script—adapting it from the book he'd written—and production on the film was about to start. Our relationship was the brainchild of my best guy friend, Kelly Curtis, who's the manager for Pearl Jam, and Cameron's best friend, Neal Preston, the great rock photographer. He and Cameron used to tour with Led Zeppelin, for *Rolling Stone*. Kelly and Neal knew each other and they decided Cameron and I would be perfect for each other. They were like, "You two really need to meet each other. You'll be soul mates."

We resisted, though, because Kelly and Neal had built it up so much that we felt a lot of pressure. In fact, the night Cameron and I finally connected, it was very casual: we went out with a bunch of people we knew to see a taping of this show called *Fridays*—kind of a takeoff on *Saturday Night Live*.

Meeting Cameron was amazing, right off the bat. I thought he was the funniest, coolest guy—and also kind of nerdy, in the best way. I'd

been with two rock-star dudes, these heavy-lookers… but guys who were emotionally unavailable, frankly. Cameron was a whole different breed. I could talk to him about everything. Plus, we both had a deep love of music, and our tastes were very similar. So instantly, there was this great friendship—and it quickly turned into romance.

BLVR: Don't leave me hanging. How quickly? How'd it happen?

NW: Well, we actually tried to take it slow. We just went on dates for a few months, but I lived in Seattle and he was in L.A. It was sort of old-fashioned, in a way. But we didn't want to put any sexual pressure on ourselves for a long time—we were so into each other that we were worried about spoiling it. We'd both been in some difficult relationships in the past. And then once we finally got together, we waited another four years to get married because we were still worried about spoiling it. But we had a very deep connection—and here we are, twenty-five years later!

BLVR: Did Cameron write that cameo you did in *Fast Times* just for you?

NW: He was like, "Hey! Come visit the set!" That's how I got the chance to be "Girl in Corvette." I was really excited that I was going to be in a movie—even though I had to wake up at some ungodly hour to do the shoot.

BLVR: What'd you do in the film?

NW: The character played by Judge Reinhold has just been fired from the burger place where he worked, and he's sitting at the stoplight when I pull up. He thinks I'm making eyes at him, but I'm actually laughing at the ridiculous burger-joint hat he's wearing. Then I peel out. That was my big-screen moment.

BLVR: So what kind of music did you and Cameron bond over in the

beginning?

NW: When we first met, we were way into Elton John…

BLVR: *Madman Across the Water*?

NW: Yep, there was that album. And we also loved *Tumbleweed Connection* and *Honky Château*. There's only one band Cameron and I never could agree on—the Guess Who. He likes them and I don't. Not a bad average.

VI. LED ZEPPELIN

BLVR: Who are some of your inspirations when it comes to movie music?

NW: I love what David Byrne and Ryuichi Sakamoto did for *The Last Emperor*, and what the Argentine musician Gustavo Santaolalla did for *Brokeback Mountain* and *The Motorcycle Diaries*.

When it comes to choosing existing songs to go with scenes—well, you think something is going to work and then you see it with the scene, and it's all wrong. That happens over and over and over. With *Almost Famous* in particular, we had so many moments where we thought, This song is going to work for sure… and then it didn't.

At times it can be really challenging and other times it just slides together; it just comes to you. All the moments in *Almost Famous* when we used Led Zeppelin music are examples of when absolutely nothing else would've been right.

There's a funny story about what happened when Cameron took the film over to England to show it to the Zeppelin guys. During one scene, Stillwater goes to a fan's party where some kids are taking acid. Russell [played by Billy Crudup] winds up on the roof yelling, "I am a golden god! And you can tell *Rolling Stone* magazine that my last words were… 'I'm on drugs!'" Then he dives into a pool. After Robert [Plant] saw that, he looked back at Cameron and said, "That *was* me."

BLVR: You had your kids—twin boys—at the age of forty-six. Was it a conscious decision on your part to wait? Did you want to put it off as long as you could so you could keep going with your music?

NW: I always thought I'd have kids at some point, but there's so much to do when you have a career. And with Heart, when we weren't riding the crest of one wave, we were trying to catch the next one. As it turned out, it was good to wait and have a full life of my own first; you relinquish so much of your life to your kids once you have them. But you can't be absent. They only come around once. And they are the most beautiful things I've ever seen.

BLVR: Was there any moment recently that reminded you of the power music can have?

NW: Since I live in L.A., I'm always reminded of it. Music's the only way to survive the traffic out here. ✶

IRMA THOMAS
[THE SOUL QUEEN OF NEW ORLEANS]

"I WOULD RATHER MAKE SOME NEW MEMORABILIA."

Things Irma Thomas was able to salvage from
her Hurricane Katrina–destroyed home:
Posters
Old records
The Christmas tree

T*he Soul Queen of New Orleans" is sitting on a squeaky black leather couch in the television room of her newly renovated home in New Orleans East. Everything is echoey and new: the pink marble floors, freshly painted peach walls, every stick of furniture, a boxy flat-screen TV wedged into a corner, and the sparkly gold and crystal chandelier that dangles over our heads. A freshly cleaned swimming pool twinkles through the glass sunroom off the rear of the house, and in the living room stacks of cardboard boxes filled with furniture await assembly.*

Irma Thomas and her husband Emile Jackson have only recently settled back into their home after the post–Hurricane Katrina flooding submerged their neighborhood. They had been staying in Gonzales, Louisiana, near

Baton Rouge, while they worked on getting their home back in shape. Before the storm, the now-sixty-seven-year-old Thomas was set to record her seventeenth album at the legendary Ultrasonic Studios in New Orleans. But like so much of the city's musical history, Ultrasonic was washed away in the floods, so Thomas and her producer pulled the best area musicians into Dockside Studio in rural Maurice, Louisiana, and laid down After the Rain, which just may be the best record of Thomas' nearly fifty-year career.

The Recording Academy agreed, awarding the album a Grammy last year, Thomas's first (after two prior nominations, in '91 and '98). On After the Rain, there are no horns, so her voice is more on display than ever, and unlike many singers whose instruments get thrashed as the years roll on, Thomas's voice has only refined with age. She has been called the best female R&B vocalist of all time, albeit one who didn't have the industry push that folks like Aretha Franklin, Gladys Knight, Dionne Warwick, and Tina Turner had.

Thomas started singing as a teen in her church choir, and by age twenty she had four children and was twice divorced. While waitressing at New Orleans's Pimlico Club in the late '50s, she occasionally sat in with bandleader Tommy Ridgley, who helped set her on the path to recording her first hit single, "You Can Have My Husband (But Don't Mess With My Man)," in 1960. The song reached No. 22 on the Billboard R&B chart, setting in motion a slew of recordings for Minit (later Imperial) Records, including charters like "It's Raining," "Ruler of My Heart," "Wish Someone Would Care," and "Time Is on My Side" (well before the Rolling Stones bit her take in their cover of the song).

Thomas has reached that rare point in a life where memoir is actually appropriate—if a little overdue. Two women affiliated with local colleges are encouraging Thomas to "get it all down" on tapes that will eventually be combined with recollections from fans into the singer's memoir. The book project is a constant in the back of her mind, but I caught Thomas deep in the midst of recording her eighteenth album with her longtime Rounder Records producer and collaborator, Scott Billington. The new album is called Simply Grand and is set for an August 2008 release; it features Thomas alongside various pianists including Randy Newman, Norah Jones, Ellis Marsalis, John Medeski, Marcia Ball, and Dr. John, among several others.

This interview took place over the course of an early December 2007 day, during a period when hundreds of Katrina's homeless were still huddled in boxes beneath overpasses and living in tents in downtown's Duncan Plaza. The city was a week away from dispersing everybody from the plaza and erecting a fence around the area to keep them from coming back. The front page of the Times-Picayune *was decrying rampant corruption surrounding property assessment and the subsequent appeal process in the wake of the storm. I don't know how to describe it other than that there was a palpable pall over the city of New Orleans, a place I called home for a few years in my early twenties—and a place that truly never leaves your blood once it anoints you as one of its own.*

—T Cooper (July/August 2008)

I.

Irma Thomas's husband Emile Jackson shuffles into the room in house-slippers, followed by a dapper older gentleman with a square suitcase swinging beside him. The man had just cut Jackson's hair, the clippers buzzing and clicking softly from a room behind the kitchen. Thomas pulls a blue fleece blanket over her thighs and pushes the lever to recline her section of the couch. When she kicks her feet up, I can see that her white socks read "No Nonsense" in gray lettering, as she casually waves goodbye to her husband's barber over a shoulder.

THE BELIEVER: OK, so let's get into what everybody was fretting about a couple years ago: How'd you learn that you were "missing" after Katrina?

IRMA THOMAS: Watching television. We had played a Saturday night gig at Antone's in Austin, Texas, and Antone offered us to work one more night, and we did. So we go to bed on Sunday night—of course the storm hit Sunday—and we wake up Monday morning to see how New Orleans made it through, and we get this newsflash that the levees had breached, and there was water in the city.

So later that day we're checking CNN, and they're saying, "We're concerned where two of New Orleans legends are located, we haven't been able to find them: Fats Domino and Irma Thomas." And I said, "*I know where I am!*" But I couldn't contact anybody, because all the 504 numbers were blocked, and I wasn't able to tell anybody until we got to Baton Rouge on Wednesday. All that time they thought I was missing in action—or resting in peace somewhere.

BLVR: Was your record company trying to find you?

IT: They were able to get the word [out], and as soon as they caught up with me, the interviews started up. I was inundated.

BLVR: Was it weird to be doing all these interviews on TV when back home—

IT: Yeah, it was weird. And humbling, and kind of struck me as odd, because I know I'm known all over the U.S. and some parts of Europe, but the magnitude that they were concerned surprised me, because on a normal basis they couldn't care less.

BLVR: All of a sudden everybody's worried about Irma Thomas—

IT: Now I'm an important entity. Look at me!

BLVR: I remember watching the end of the Grammys that year after the storm, and there you were with a few other artists that they were all of a sudden celebrating and including.

IT: Here we are in a city where it's like pulling teeth to get your records played on the radio, but all of a sudden…

BLVR: Was anybody here at the house during the storm?

IT: Nobody. We had left, locked down like we normally do when we

go out of town. We packed just enough things, because we expected to come back Sunday. When we left, the storm was still out in the Gulf somewhere, and they weren't sure if it was coming to New Orleans.

BLVR: Was there a part of you that wanted to get back and, I don't know, *do* something?

IT: I wanted to get home, but nobody in their right mind wanted to be where the water was. The only reason I wanted to get back this direction is that, when everything was down, I wanted to see what I could salvage. We could see our house on TV, and where the water was in reference to the roof. But those days after the storm when the waters were subsiding, my husband was able to come in and check on some things. But I didn't come back to this house until October.

BLVR: Was he able to grab some things when he finally got in?

IT: Well, there wasn't much to grab, because the water sit here for three weeks, and by that time the walls had disintegrated, and the National Guard had broken our garage door because they were making sure nobody was inside. Well, two of my neighbors died in their attic, so they weren't doing a really thorough search, because if they were, my neighbors wouldn't have died in the attic.

BLVR: The neighborhood doesn't seem super populated at this point.

IT: Well, you can't tell in the daytime, but in the evening come through here and you'll see a lot of 'em working on their properties. This house next door [*pointing*] is up for sale, the one across the street, we don't know what he's going to do.

BLVR: Did everybody straight-up lose everything?

IT: Literally, you could say everything. Those things that I was able to salvage were some of my posters. The things in the loft are still in the

loft. I didn't take much out of there except some old records that I wasn't sure how they were going to make out in the heat. But everything else that was up in the loft made it: some blankets and quilts, and my tree. [*Points out decorated Christmas tree in living room*]

BLVR: That thing made it through the storm?

IT: [*Laughs*] That made it. Because the water initially came up just below the ceiling inside [*indicating wall in front of us*], what, six or seven feet. Then when it sit, it sit at about four or five feet, it just sit there so long. And the smell was unbelievable. But I had some posters, some Jazz Fest posters higher up on the walls upstairs that we were able to restore.

BLVR: Years ago, a friend gave me that pink Jazz Fest one of you, signed from, what, '92? It's up in my apartment. But before I came down to interview you I had this flicker of generosity, like, Maybe I should bring this to her, because I've been reading about all these people sending you memorabilia since you lost so much.

IT: No, no! Well, make note that I would rather make some new memorabilia. Thank you for offering the old, but I'd rather just make some new. [*Laughs*]

BLVR: And your two Grammy nomination medals were replaced?

IT: Before I went out there to perform for the Grammy Foundation, I had done an interview and mentioned [losing the medals in the flood]. They got word of it, so that night when I finished my performance, they gave them back to me. I was just floored, I wasn't ready for that, I was just bawling away. I've never been extremely materialistic about things. Yes, you're going to feel a little sad because you're looking at forty years of your career and sixty-some years of your life gone down the drain. But by the same token, you got life, so you can make new memories, you know?

BLVR: And your family, was everybody safe?

IT: Everyone got out safely. There was one set of kids we weren't sure about, but they'd gone to Lake Charles.

BLVR: And the neighbors? You lost two, but the rest?

IT: The rest got out but, I mean, we would've been one of the ones that got plucked off the roof, because we had left before and nothing happened. So they decided to stay and of course they weren't prepared for what happened, because no one was prepared for the flooding. What people don't understand about the people who lost their lives is, normally, when there's a hurricane coming, you have people—and we are among them—who stay up all night to see what the storm is going to do. Well, after it passes, you go to bed to catch up on the sleep you didn't get the night before. A lot of folks who lost their lives in this flood were caught asleep.

BLVR: It happened so quickly.

IT: One of our church members said he woke up and was walking down the street, and he saw this water coming and he ran back to his house; he didn't realize the levees had broke. So that's what happened to a lot of folks who died. In fact, up until the end of last year, and some early parts of this year, they were still finding bodies in some of the homes in the Lower Ninth Ward, for that same very reason. People couldn't understand, like, "Why did these people stay?" Well, the storm was over when the levees broke, so these people were catching up on sleep.

BLVR: And these are generations of people who stay—

IT: Thank you, thank you. Even after Betsy [in '65]—the Lower Ninth was hit hard in Betsy—they had gotten into that comfortable zone, I would call it. Once the storm had passed, they would go to bed. And some of them just never woke up.

II.

In the early '80s, Irma Thomas and her husband opened their own club, the Lion's Den, on Gravier Street across from Orleans Parish Prison. She used the club for her own shows during Jazz Fest, as well as a practice space for her and her band, the Professionals. During my first week in New Orleans in 1994, I went to one of these open Thursday night rehearsals, and was instantly hooked by Thomas's rich voice and unforgettable, generous stage presence. She even personally home-cooked red beans and rice on most nights, setting out a plentiful buffet for customers to enjoy in between dancing and listening to music.

BLVR: At the Lion's Den, there was this older couple who always sat at one table to the right of the stage. I saw them every night I went, and they would just get up during certain songs, dance a little, and then sit back down.

IT: I can't think of their names, but I know who you're talking about. I haven't heard from them [since the storm].

BLVR: I think the lady worked at Harrah's as a dealer. They let me sit with them once. So the Lion's Den was flooded? What's going on with it?

IT: It's now Chocolate Bar! [*Laughs*] Well, we were in the process of trying to sell the club before the storm.

BLVR: No!

IT: A lot of folks were disappointed we didn't reopen, but with the schedule I'd been keeping, I would not want to be in the bar business. It wouldn't be operating at a profit because they'd steal us blind because we wouldn't be home. We were getting tired.

BLVR: I guess you need a really trustworthy person to leave it with.

IT: Everybody was trying to get their lives back together, and the other side was getting help. Since the storm, there hasn't been affordable housing for people who did that kind of work—hotel workers, waitresses, and cooks and stuff—they can't afford to live in New Orleans now; the rents are just ridiculous.

BLVR: Hurricane Camille [in '69] also really changed your life. Was that when you moved to L.A.?

IT: Yeah, about six months after. Camille killed a lot of my work along the Mississippi coast area, so I decided to make a clean start and go to California.

BLVR: Is that when you worked in the department store?

IT: I got a job at Montgomery Ward. I had *children* to take care of.

BLVR: Did you ever think you'd go back to the music business when you were working there?

IT: I figured eventually I would, but at the time the priority was to have a job and take care of your family.

BLVR: Were you a general sales person, or—

IT: I started out in lingerie and wound up in automotives.

BLVR: Quite a progression.

IT: I was offered a position to sell sewing machines and vacuum cleaners, which was a commissioned department. I knew about sewing machines because I sewed, and what woman doesn't know about vacuum cleaners? So I worked in that department about six months, and I used it to my advantage because I used to sew for my kids while I was at work. I'd cut out an outfit at home, bring it to work, and then demonstrate the

machine by putting something together.

And then from there, I went to furniture part-time, then to large appliances, which was refrigerators and stoves, that was commissioned too. I didn't really like it; it was too cutthroat. So I think it was in '71 that the federal government had a law passed or something, that if a female was qualified and wanted to work in a male-dominated section, then they had to hire them. So the store put out a bulletin, and automotive was one of them, and I signed up.

BLVR: Did they train you?

IT: I [already] knew a lot about cars. Traveling in the late '50s and early '60s in the South, you know, black folk couldn't stop anywhere to get their cars fixed. And I've always been a curious person, so whenever we'd have a breakdown, I'd stick my head under the hood.

BLVR: Could you make a decent living at that?

IT: It was commissioned again, and I always made over my draw. The first thirty days I was in that department, I sold five engines, and none of them were returned. Whenever I sold a new engine, I would sell everything: points, new spark plugs, carburetor, the whole nine yards.

BLVR: This was after you'd already had a few hits. Did anybody ever recognize you?

IT: This is really going to date me. It just happens that there was a bin of 8-track music, and one of my old albums was in there. One of the sales people was going through them and he said, "This looks like you," and I said, "Well, that *is* me."

"Well, what are you doing at Montgomery Ward?" he asks, and I say, "Because California don't believe in paying people what they're worth, and I need a day job." I had talked to some [club] managers about performing, and they told me what they were going to pay me, and I said, "No, *this* is what I want to make." So I got a day job. And back then,

$1.75 was minimum wage.

BLVR: And you were supporting four kids on that?

IT: Uh huh! [*Laughs*]

BLVR: The time before that when you went out to L.A. to do a session for Imperial Records, did you think, I'm gonna be a star?

IT: You know, in all honesty, I had no clue. They had big plans for me, but I didn't have any managerial guidance, somebody saying, "Look, this is an opportunity you need to take advantage of." My producer at that time, Eddie Ray, he wasn't really explaining to me what was going on, and he was taking me around to all this stuff, the William Morris Agency, clubs. They even brought me to a party that Ike and Tina Turner gave up at their house in Baldwin Hills, and I stayed maybe fifteen minutes. I'm not a party person.

BLVR: You weren't into the whole schmoozing thing.

IT: I wasn't into the schmoozing—or anything *else* that was going on at that party either! I didn't feel comfortable in that environment, and I had no clue as to what was happening. They say hindsight is 20-20; *now* I know what was going on, but nobody told me then. And I just look back as that not being my time. My records hit the charts—

BLVR: I know, that's what's so crazy, you'd think it'd have been up, up, up from there. What do you think it was? Did you not act or look or play the game the way they wanted?

IT: No, I was a seasoned performer by then. I knew how to dress, I knew how to act; that was not the problem. I was just naïve as hell.

BLVR: Any regrets?

IT: I realize I missed a nice opportunity, but I'm not sorry that I did, because I look at it this way: In 1964, I was twenty-three. And the influence of things going on in the world at that time—which is a hell of a lot worse now—I may have not been prepared for the magnitude of stardom that may have hit me. So I feel that I got mine when I was ready to deal with it.

III.

The phone rings, and Thomas points at the tape recorder, indicating that I should switch it off. She begins talking real estate with the person on the other end of the line, and they settle on a time to meet the next day. Thomas ends the conversation by asking, "You had that baby yet?" and then shares a hearty laugh with the applicant, who was answering an ad in hopes of renting one of the local properties owned by Thomas and her husband.

IT: I have to go show this apartment tomorrow.

BLVR: So you just roll up and you're like, Irma Thomas, showing them property?

IT: I'm just me.

BLVR: Do they say, "Wait, aren't you…?"

IT: Yeah, that happens all the time, because I don't go under "Thomas," I go under "Irma Jackson." [*Laughs*] These are properties that were rented before the storm, but those folks didn't come back. We had to redo them like we had to redo our house.

BLVR: So what's up with the pink things in the Lower Ninth?

IT: Oh, that's the thing Brad Pitt did. He's going to start building some "green" houses, and according to him, set up families to where they can be in their homes and not have the overhead high expenses of electrical

and everything.

BLVR: And the pink part of it?

IT: That's his way of making a statement to draw attention to that area, to raise money. He's looking at building a hundred and fifty homes, and they raised enough in one day to build seventy-five of them.

BLVR: Seems like there's a concentrated effort over there.

IT: That area is one of the lowest points in the city, but by the same token, it was a viable part of the city where a lot of the music came from.

BLVR: Didn't they do the Musicians' Village near there, too? Do you know some folks who've taken advantage of that?

IT: Oh yeah, a couple musicians I know very well. Smokey Johnson, who's a well-known drummer, he's in the Musicians' Village. Michael Harris, a young man who plays bass. It's open for musicians who qualify, but the sad part is that a lot of musicians don't have a paper trail. I mean, they're helping them create one, but a lot of musicians from that old school, they didn't want to get a check, just wanted to be paid cash.

BLVR: People don't understand how New Orleans works.

IT: [*Laughs*] Oh yeah…

BLVR: So do you feel optimistic about your city? You feel like things are moving in a positive direction?

IT: I have to. I live here, I love this city. As far as I know, I'm the most optimistic person to come back from wherever, in terms of wanting to be here. I had a lot of options, I mean, I could've gone back to my home-town, Ponchatoula; the door was open there. Hammond opened their doors to me. Amite, all the way up along Highway 51. But I don't want

to live in the country! I got my start here, my roots are planted here, so I don't want to be anywhere else.

BLVR: Yeah, you can't be the Soul Queen of, like, Amite.

IT: I don't want to be the Soul Queen of anywhere. I mean, I just happen to be the Soul Queen of here! [*Laughs*] Officially.

BLVR: How'd that happen?

IT: When I came back from California and I started working around the area, they didn't really know how to introduce me. Then I got my own backup group together, and the drummer Wilbert Widow—he's deceased now, God rest his soul—he was with me for twenty-seven years. He was the one who did the introductions, and first he was calling me "the singing grandmother," since I've been a grandmother since 1975. But he said, "Naw, that doesn't fit. I'm gonna call you the Soul Queen of New Orleans."

I said, "Whatever you want to call me, just get me up on stage!" [*Laughs*] And it stuck. And in 1989, the mayor at the time was Sidney Barthelemy, and they wanted to do a fundraiser and officially crown me the Soul Queen. So I did a performance and it became official on February 17, 1989. I remember because that's the day my dad died.

BLVR: And you went on with it?

IT: I was in a fog, but my canceling any of it was not going to bring my dad back, and he had been ill with lung cancer for a long time. On top of that, *CBS Sunday Morning* with Charles Kuralt was filming me for an episode, they'd been filming on and off for over eight weeks. I was totally out of it that day.

BLVR: Was your dad a smoker?

IT: He was a smoker who waited too long to quit, smoked all my life.

BLVR: When you drive around the city, I mean, there must be blocks and blocks and buildings and haunts that bring back so much of your family legacy.

IT: We were like gypsies, we lived all over this place.

BLVR: How did you meet Emile?

IT: We met at a club in 1975; he brought to my attention that I had a ravel hanging on my zipper on my skirt or pants, whatever I was wearing. And being a women's libber, I said, "Since you saw it, you take it off." [*Laughs*]

BLVR: Did he?

IT: He did, and he offered to buy me a drink, which I don't drink, so I think I got a lemonade or something. I was sitting at the bar, and he started talking to me, then some old ladies came in and he left me to go talk to the other ladies. And while he was talking to the ladies, I left. [*Laughs*] I went to say hello to Tommy Ridgley, who was playing at another club. Emile showed up at the same place and we had drinks again. We've been legally married thirty years now, but we've been together thirty-two.

BLVR: And he's your manager, too?

IT: Yeah, I gave him that job. The reason I did is because the manager I had was, for lack of a better word, *screwing* me royally. And Emile brought it to my attention in a quiet way, no big to-do, he said, "Pay attention," and he was right. And he says, "What you gonna do for a manager now?" and I said, "Well *you're* gonna be my manager."

BLVR: So he just naturally picked it up.

IT: I told him what he needed to do. And I said, "What you and I don't

know, we're gonna ask and find out." And it's been working ever since. I married my 15 percent. [*Laughs*]

BLVR: Do you get to throw fits, or does he just say, "Irma, stop"?

IT: When I do a show he doesn't think was up to par, he'll say, "That show was shitty." [*Laughs*] And he goes on sometimes: You should've done this or that, or, Do an encore. And I just sit there and look at him, because I'm going to do what I'm going to do anyway.

IV.

From her home, Thomas and I take separate cars to Piety Street Recording in the Bywater neighborhood. The studio is housed in a 1927 structure which had been a U.S. Post Office, and after that, the Louisiana Center for Retarded Citizens. The good ol' "Streetcar named Desire" rolled right by the front door; now it's the less-poetic "Bus named Desire." It's a steadily gentrifying neighborhood, one largely spared by the post-Katrina flooding. But there's still a dose of old New Orleans tucked into the sundry hidden corners of the Bywater.

As I park in front of the studio, I see Thomas in her pink sweatsuit, crossing Piety in front of me. She's headed to Frady's on the corner of Dauphine, where she picks up what seems to be a standing po' boy order ("I got shrimp; my husband likes spicy sausage"). While awaiting her sandwiches, Thomas shoots the breeze with a jocular middle-aged gentleman sipping a forty-ounce bottle of Bud. He gives her the phone number of a mutual friend named Eddie, whom she apparently lost track of after the storm.

Inside the studio across the street, three backup vocalists practice the chorus of a haunting John Fogerty tune called "River Is Waiting" while Thomas fields a quick call on her cell phone. "Sail on, sail on. Sail on, sail on," they are harmonizing perfectly next to me on a comfortably worn plush couch. The featured pianist for this track is the legendary Henry Butler, blind since birth, and during the session clearly displaying a mind of his own on the keys; when he plays the same part a few different ways

on a couple takes, Thomas hollers into the microphone from her booth, "You've got a menopausal woman in here singing. Stay the course!"

There's a drummer, another on congas, and probably the best upright bassist in town, James Singleton. Thomas is sealed away in her booth, swaying back and forth—and nailing her vocals on most every take. "They don't do sessions like this anymore, do they?" the producer Billington says to me over his shoulder after one particularly good run-through. He's completely correct; I literally get chills a few times during the recording. Tears well up in my eyes and I have to look up at the rusty, pressed-tin ceiling to encourage them back into my head—it's simply the sight and sound of so many beautifully talented people doing what they do, all together at once, the way music's supposed to be made and experienced.

After a couple hours of recording, we listen to a final playback. Thomas claps along while the other musicians bob their heads. "See you at the Grammys," she says as the song fades out. "Only this time, we gonna perform."

BLVR: OK, tell me about Grammy night last year.

IT: Well, I don't know if you've had the pleasure of going, but it's interesting just to look at all the people walking around with, you know, this air about them. I guess I'm not your typical entertainer. I've never been full of myself, thank you Lord! [*Laughs*] So when I go to these events, I just sit back and watch people. There's a lot of tension, everybody hoping they're going to get, well, that's the brass ring for us—though it's the early session.

BLVR: The *Shmammys*.

IT: Yeah, and they broadcast the winners on the show. So I'm sitting there when they got to [my] category, and I've got my head down: "Lord, let me lose graciously, let me, you know, not act stupid or say anything that I'll live to regret. If it's your will, I'd love to win the Grammy." I was literally praying that I wouldn't have that mean look on my face if I didn't win, because this is my third nomination.

BLVR: Emile was next to you?

IT: He was on the end, and I was second seat off the aisle. And I'm sitting there, and they're running down the names, and when they said, "And the Grammy goes to…" it's like this wall of silence builds up around your ears, and in the midst of this I hear [*whispering*] "And the Grammy goes to Irma Thomas," and I said, "Lord, did I hear what I thought I heard?" By this time Emile is on his feet and grabs me by the arm and says, "Honey, you do have to go up to get it." [*Laughs*] I didn't realize I wasn't up. I heard this scream, and I didn't realize it was me. I had nothing prepared whatsoever, but I rattled off something.

BLVR: What happened afterward?

IT: I took five minutes to get myself together backstage, and then you go through a series of interviews. One of them decided to ask me, Did I feel that I had received the Grammy because of what had happened to New Orleans?

BLVR: No he didn't.

IT: Oh yeah. So I counted to ten, swallowed real hard, and I said to myself [*singing*] "Put your brain in motion before you put your mouth in gear," and I said, "Well, if that's the reason they gave it to me, then I take it back to the city of New Orleans and hope that it brings hope to all of my people."

BLVR: I don't know how you managed that. You're the quintessential professional.

IT: I almost—as we call it, "go ghetto"—but like I said, I counted to ten and took my time.

BLVR: Has the Grammy changed everything?

IT: Not really, to be honest with you. The first nomination I received, back in '91, the bottom actually dropped out, and I got less gigs. They thought my prices were going to skyrocket, but I don't think we raised it more than two hundred dollars. But I was working profusely before the Grammy, and I got a little boost afterwards.

BLVR: Are people sending you a better selection of songs now, though?

IT: I am getting a better selection [for the new album]. It's been a good thing for me career-wise, and I'm happy. You know, I wish that it would've happened sooner, but it wasn't meant to be.

BLVR: Can I see it? Where do you keep it?

IT: I had a mantle built for it.

BLVR: Will you promise me you'll get some sort of emergency evacuation system with a satellite-controlled crane, or something that will suspend it the next time there's a storm?

IT: [*Laughs*] It's going to go with me. ✶

ALAN BISHOP

[SUN CITY GIRLS/FOUNDER OF SUBLIME FREQUENCIES]

"IN TERMS OF PERCEPTIONS OF THE CULTURE, MOST PEOPLE DON'T THINK ABOUT MUSIC. THEY'RE NOT CONCERNED WITH IT. THEY DON'T TAKE THEIR MUSICAL LEGACY SERIOUSLY."

Western influences on Thai music:
A surf band named the Shadows
The guitar riff from "Jumpin' Jack Flash"

Thai influences on Western music:
The Butthole Surfers' "Kuntz"

.

In 1981, in the golf course purgatory that is Phoenix, Arizona, a pair of half-Lebanese brothers from Detroit and a SoCal transplant formed Sun City Girls (named after a nearby retirement community). Unclassifiable from the start, guitarist Richard and bassist Alan Bishop, along with drummer Charles Gocher Jr., were cacti in the hardcore punk scene: prickly, unapproachable, yet strangely beautiful. These "girls" understood that punk at its purest meant total negation of the genre, and for decades they confronted their audiences with the detritus of the music world: Dada, Kabuki, prog, hobo monologues, puppetry, unfettered noise, surf instrumentals, guerilla street theatre, and so on and so forth. Their official discography wavers between fifty and a hundred releases, no two quite alike, but the sounds within

provided mutant genetic code for much of the current American under-ground: bands like Animal Collective, Deerhoof, No-Neck Blues Band, Six Organs of Admittance, Devendra Banhart, and Dengue Fever took the Sun City Girls' cue to elucidate international noise through their own local muse.

At the height of Thrillermania in 1983, the Bishop brothers voyaged to Morocco. Rick stayed for three weeks, whereas Alan immersed himself for two months. By day he jammed on sax and guitar with local musicians; by night he captured snippets of shortwave broadcasts. Twenty years on, he would weave these audio artifacts into Radio Morocco, the seventh release on Sublime Frequencies, the "world music" label/collective he cofounded with Hisham Mayet and his brother (with frequent contributions from Mark Gergis, Robert Millis, and others).

Eschewing the rubber gloves of elevator world-music labels and the ivory towers of academic ethnomusicology, Sublime Frequencies's record-ings and videos dunk listeners and viewers headfirst into the cultures they document. Following the example of Smithsonian Folkways and Ocora, each SF release reveals music and sights that are at once workaday and bewildering to Western ears. From Iraq's Choubi music to Syrian Dabke to North Korean pop and opera, the label determinedly showcases the uncan-ny beauty from purported "axes of evil" and other non-tourist destinations.

Cantankerous, chain-smoking, and obsessive, Alan Bishop is hell-bent on undermining Western hegemony and exalting the cultural contribu-tions of the downtrodden. This interview took place on the phone, with Bishop in his garage office where he was hard at work on the next batch of SF releases and preparing for the final Sun City Girls tour, a tribute to Gocher, who passed away from cancer in early 2007.

—Andy Beta (July/August 2008)

I. OBSESSED LIKE ME

THE BELIEVER: In the liner notes for your *Radio Morocco* sound collage, which you recorded there on your first trip in the early eight-ies, you mention how you came across *Thriller* being shoved down the peoples' throats half a world away and how you hope that the mix can

help unbrainwash people. In collaging this stuff, does the radio mix become a cultural jammer?

ALAN BISHOP: Yes, I suppose it does. I have always been inspired by the Burroughs/Gysin cut-up technique, yet I never needed to put it on paper and actually cut and rearrange words. I've always just done it in my head—sometimes I write as I listen to a language I don't understand and reinterpret the language into English—and also with radio and sound. Sound collage has always been one of my favorite mediums to work in, and with a shortwave radio, it's the perfect tool to create audio collage endlessly, spontaneously, on the spot, anytime and anywhere. The source material just happens to be better and more inspiring to me in the areas I've roamed—North Africa, the Mideast, South Asia, etc.

You hear Police songs or modern R&B or Outkast on the radio. It's so common now, there's not much you can do. You expect to hear it—it's going to be everywhere. There are colonial stations run by American companies, European, U.K., or Japanese, or whatever powerful entities are in all these countries, pushing this culture and its export. In some instances, they don't even have to push it—it comes in through osmosis, this middle management that works on its own to keep the world going in the social engineering direction that it's being pushed to go, without anyone having to manage it. It's already alive, it's got this life of its own, it takes off to where these people get into it and then propagate it them-selves, and the local cultures and people in those cities and towns that are playing songs on the radio are going to like that stuff.

BLVR: Like, do you *really* have to sell Coca-Cola anymore?

AB: Right. Same thing.

BLVR: Traveling as frequently as you do, I'm curious as to how many languages you speak.

AB: I don't speak anything very well. The longer that you travel, you find out that you really don't even need to speak the language to get

around and get things done, to live in those places. If you're somewhat resourceful and perceptive, you're pretty much going to know what's going on because human nature is human nature: they understand it, you understand it, and it works.

BLVR: So how often do you understand what you're dealing with then? When I think about my favorite moments on these discs, I conjure the sound first, be it the guitar tone on those *Cambodian Cassette Archives* or the sounds of chickens and crying babies in the background of this stunning vocal/guitar duet from northeast Cambodia. I almost never remember names and never know what they're singing about.

AB: The lyrics are not an important thing to me. In fact, it can be a distraction. If I knew the language enough to know it was a horrible love song with stupid lyrics—like most of the popular songs are today in the English language that I hear—then it would be much more of a turnoff then if it would allow me to interpret it from the expressive capabilities of the vocalizing or of the sound itself, which allows me to create my own meaning for it, which elevates it into a higher piece of work for me. So it's the same way about a Thai song—the Thai language does that to me because I don't understand exactly what's going on in the song. I can read it into my own way of formulating what it means to me. For the same reason that the guy singing that Thai song may even listen to Western music, but he's not going to know what's going on with the Western music either. He doesn't know the fine points. He doesn't speak English. Let's say that all the Thais are listening to all this Western pop music and they don't understand what they're saying either. But they love it because it's doing the exact same thing to them as their songs do to me. That's the similarity here. That's what is much more interesting than knowing what the songs are about.

BLVR: And each side thinks the other is crazy for liking the other culture's pop music.

AB: Correct. They think that I'm crazy for liking their music. I think

they're crazy for liking ours.

BLVR: When you're seeking out music, do you find most countries have scant regard for preserving their culture?

AB: It's a matter of economy and standard of living—it dictates how much of a cultural legacy that can be not just preserved but promoted, and it's sort of perpetuated through history. And [most countries] just don't have the resources. You have storerooms of old tapes and old films in hundred-degree heat rooms, just baking. Records are warping or developing mold and insects. I've had records come over via cargo and there's still millipedes running around inside them. The culture is left to rot, just like the buildings and the infrastructure. Roads are getting worse. No money is going back into preserving things. The corruption is so obvious there, where it's not as obvious here.

BLVR: Mentioning the cargo of records, how much time do you spend just in terms of processing stuff?

AB: Most of my spare time is spent doing that. There are seventy-five Sublime projects in production right now. Some may not get done for two to three years. Some of them may never get released, many probably will. But when I go overseas, I'm firing on all cylinders: doing radio recordings, looking to record musicians live that I encounter, and sometimes I will find them as I go or performing at a club. I record wherever I can. I'll ask people to perform.

BLVR: Having spent so much time with the Sublime Frequencies catalog, to where I am able to vicariously live through the music and pretend that I am in these far-flung regions, I developed this illusion that this stuff is easy to come by, that there's some sort of Tower Records in other countries where all this music is just waiting for you. Once I was over to Southeast Asia though, it wasn't like that at all.

AB: That's a *big* mistake for people to assume. There's a lot of people that

say that: "Oh, you just turn on the radio and bring it back." To which I respond: "Let's see what you come up with! How much patience do you have? How long are you going to spend on that radio?" You have to put in a hundred hours on the radio for one CD. You've got to work for it.

Sure, you can do searches and hear who's cool online, but [over there] everything's written in Thai. Even if you can say it in English, to sit there and pronounce the name of an artist you think you know how to pronounce, the Thai, even if they know the context, even if they know what you're trying to say, they may just pretend not to know. Just to fuck with you. You don't know how many people go overseas looking for music and they come back and they're just amazed how we do it. They can't find shit. You got to work. We're over there working every day. I've been to Thailand thirty times.

BLVR: Returning each time, do you find things disappearing out from under you due to encroaching globalization and the homogenizing effects of monoculture?

AB: Going back year after year, you can see it's getting harder and harder to find stuff going on live or find stuff on tape. I've watched it dissipate through time. And it's going to continue to do that. There's no apparatus set up to preserve it yet. There will be at some point. People will get to developing a sense of pride in their own musical legacy—to back it up, document it, store it. That will happen.

In terms of perceptions of the culture, most people don't think about music. They're not concerned with it. They don't take their musical legacy seriously. They look at it as signposts of their life: "I remember that old song. You like that? That's funny." Are they thinking about how great that was? Do they know who played guitar, the singer's name? Do they know what year it's from? Probably not. They're not paying attention to it like someone who is obsessed, like me.

BLVR: When I read the criticism about Sublime Frequencies, it almost invariably comes down to the same thing, that you're just taking this music from other cultures and not paying royalties on it.

AB: It's not true. We do pay some royalties. We have contracts with some artists, the ones that we can find or the ones that we can film or that we're in direct contact with. But in terms of archival recordings, it's a lot trickier. It's just not easy to find the original owner of the material, and so we sometimes just go and pay the artist if we can find them, knowing that they don't have the rights, but we feel better about it. Or we don't pay anyone because we can't find anyone to pay. We throw it out there.

II. THANKS TO KARAOKE

BLVR: Coming from that Western viewpoint, where you know about Hendrix and the Rolling Stones, you can hear that even overseas they heard these people as well, from the visiting American G.I.s and stuff during the Vietnam War. It's an odd reflection back on us about our own culture. I think of this one Molam song [Thai folk music] that uses the "Jumpin' Jack Flash" riff that just sounds off. Not to deem it as being "lost in translation," but how they reappropriate our pop music is striking. On the *Bollywood Steel Guitar* and *Shadow Music of Thailand*, you hear how in India they came under the sway of Merle Travis and Chet Atkins's guitar-picking records, or in the case of the latter, an inconsequential surf band like the Shadows.

AB: When I first heard that Stones riff [on "Lam Plern Chawiwan" from *Molam: Thai Country Groove from Isan Vol. 2*], it was killing me. And then it goes into the traditional Molam vibe and it always comes back to that break and there's a screeching violin in there. Not only the influence of Vietnam and the G.I.s and the American military bases being there, but also through their own culture. There would be children in school in the States coming back with this music. All those American kids interested in foreign rock are not any different than today's young Thai kids interested in modern R&B and hip-hop and pop music like Green Day and Blink-182.

BLVR: It seemed that everywhere I went, be it Thailand, Laos, or Cambodia, karaoke lorded over all. It was on the bus, in the clubs. There

are no audio CDs, every single one is a VCD that you use to sing karaoke. The audio portion is just an afterthought. It's cheesy and a bit frightening, but at the same time, pop music was something that people could actually interact with now.

AB: I've had to adjust to karaoke as a modern reality that obscures our hunt for what we're truly after. Karaoke and the workstation keyboard setup eliminates the need for a live band and any further evolution of the ensemble in the club circuit. Almost all the bars in Southeast Asia are lady bars. The listener and participants who interact and frequent the clubs are exclusively male who become actively involved with the ladies, not the music. Coming to them to listen only to the music is not what people do—so we [Sublime Frequencies] are either laughed at for doing so or confusing to the locals by being interested in the music.

But in people's homes, at parties, and at certain other public functions, restaurants, outdoor shows, etc.—that's where the society actively becomes engaged with the music by singing or being encouraged to sing. Everyone's a singer now, thanks to karaoke, for better and for much worse. But the live band is now becoming ancient history in Thailand, Cambodia, and Burma.

BLVR: In compiling stuff like the *Thai Pop Spectacular, Molam: Thai Country Groove,* and *Cambodian Cassette Archives,* I've always wondered if their equivalent here is more like a K-Tel comp, meaning ubiquitous pop radio hits, or something more obscure, like *Nuggets.*

AB: We probably listened to over a thousand Molam songs that we deemed "good tracks," meaning another thousand that were shitty. Of the thousand deemed good, the ones that are on that disc are from a hundred songs as our final cut. They are all highly unique and interesting rhythmically, vocally, or arrangement-wise, and they don't take the usual approach to what the majority of period tracks do. A lot sound regular and normal. We're choosing the most unusual and interesting ones that have the most appealing and unique way of going about the genre of all the pool we had to choose from.

The Thai pop stuff is a different animal. We're covering Luk Thung and Luk Krung stuff. It's a loose term that can mean almost anything: rock and roll, traditional beat pop, slow ballad, or something kind of folky. You familiar with the Butthole Surfers' tune "Kuntz"? That's a Luk Thung. A Thai would make the argument that every song on our comp is a Luk Thung. There hasn't been a true breakdown or effort to break Thai music into genres. They're not into dicing and slicing everything up.

BLVR: Not that you can catch the lyrics yourself, but Molam are generally raunchy songs, are they not? The one concert performance I caught on TV in Roi Et featured lots of hip thrusting and bared belly buttons, which was weird for such a modest people as the Thai.

AB: They can be. Especially today, the new style is completely raunchy. It was more suggestive back then. Modern Lam Sing, the fast Molam style, covers a wide variety of topics. It's storytelling and social commentary, running the gamut from lost love and falling in love to very bitter attacks against a neighbor for sleeping with their wife, or crying in your beer and shooting up the place. A lot of the Molam and Luk Thung stars of the past had really crazy high-profile lives and would get shot and killed on stage. There's some really interesting stuff in the history of Luk Thung and Molam artists, even the Khmer Surin stuff. Darkie, the king of Khmer Surin music in the '90s, was supposedly gunned down in Bangkok, or else died of a drug overdose—no one seems to have the same story.

BLVR: You mentioned in the liner notes to *Radio Phnom Penh* about how the Cambodians go back to their old music and re-record instruments and "remix" it, obliterating the old versions from the public record, and ultimately from the public consciousness.

AB: It's not unusual for them to want to spruce up the old recordings to attract the younger culture to maintain and preserve their musical legacy. There is a conscious effort by a select few, operating out of the States in Long Beach and Oakland, that are into preserving their old

music. What's curious to me is why they want to take the originals off the shelf and think no one will know the difference. They're spruced up with new drum tracks, with modern MIDI keyboards that sound horrible, like a fine shit mist hovering atop the music—and you can still hear the original vocals happening in the background. That's taken over the market. If you want to buy oldies, that's what you're going to find. In our culture, that would not be acceptable: you can get the new remixed *Rubber Soul,* but you can't find the original?

BLVR: Do you think their view of the past and their not holding on to it is a facet of Buddhism?

AB: It probably has something to do with it. It's a different mental approach to their lifestyle. There's a thing about "new is everything." Old is unwanted. You don't find Thais going to the thrift store. They want new clothes. They want the newest cell phone. There's a status system even crazier than here. America went through that years ago. It's all about out with the old, especially with music: "Let's hear something new." ✶

IAN MACKAYE

[OF MINOR THREAT/FUGAZI/THE EVENS/DISCHORD RECORDS]

"MUSIC IS NO JOKE."

Washington, D.C., in the 1970s:
No perceptible rock scene
Lots of cover bands
If you wanted to be punk, you had to move to New York
Some punks stayed in D.C.
D.C. punk was born

In the '80s underground music scene, integrity was everything, and D.C.'s Fugazi had more of it than anyone. They only played five-dollar all-ages shows and their sole merchandise was their music. A mere mention of the band's 1995 post-punk magnum opus Red Medicine *to a once indie-leaning man will likely reduce him to babbling admiration.*

Fugazi's singer-guitarist Ian MacKaye was often thought of as the group's ideological figurehead. Years before, he had fronted what many contend to be the perfect hardcore group, Minor Threat, and founded the D.C. punk label Dischord Records. One of the key Minor Threat tracks, "Out of Step," contains the simple verse "Don't smoke / Don't drink / Don't fuck / At least I can fucking think" that became the unofficial mantra of

the straight-edge movement. Likewise, MacKaye became the movement's adopted poster boy.

After three years with Minor Threat, MacKaye spent nearly two decades in Fugazi until the band went on extended hiatus after the release of The Argument *in 2001. Since then, he has formed the Evens with Amy Farina (of the Warmers)—she on drums, he on baritone guitar, both sharing vocal duties. The songs hark back to Minor Threat's pointed knifing at the status quo, but use a stripped-down version of Fugazi's intricate textures.*

I caught the Evens in New Orleans at the punk-rock collective Nowe Miasto. The band kept the audience rapt for an hour, fielding questions between songs, answering heckles with dry humor, blurring the barrier between the stage and the crowd. "We make the show together" was the pledge he made to the audience. MacKaye was besieged with fans after the show, signing things and congenially answering questions, even handing his guitar over to a curious onlooker, so this interview was conducted by phone, about a week later, after the tour was finished.

—Alex V. Cook (July/August 2008)

I. NEW IDEAS ARE HARD TO PRESENT IN VENUES WHERE PROFIT IS THE PRIMARY MOTIVE

THE BELIEVER: Why do you keep playing alternate venues? Earlier, with a punk-rock audience, it was necessary; it was likely the only sort of place you could play. Why do you still do it today?

IAN MACKAYE: Tell me why you think people always play in the same places.

BLVR: People play the same places to attract the audience they're looking for, and because proven places are profitable.

IM: And why is it profitable?

BLVR: I'm not sure why it's profitable. I guess because those places are where music happens, and people's behaviors are governed by patterns.

IM: Well, my theory is this: Music has been relegated to the hawker, the incentive that pulls people into a certain kind of business. So for instance, you might go to a certain tire store to get your tires on because they give you free popcorn or something; you like a business because it offers a little premium. And music, over the years, essentially has been a proven gathering point. Music is where people are, and at some point, industry has figured that when people are gathered, it's a great opportunity to make a pitch, to sell them something.

Think about the history of music—say, the traveling medicine show people. They would travel around on wagons, and they'd get to a frontier town and set up and have a performance, have music and maybe some comedy, and people would gather, and then between the acts, somebody purporting to be a doctor would step out to sell his various tinctures and potions, you know, snake oil. Most of those things were basically some kind of herbal concoction with alcohol. So what was going on was, the "doctor" was selling alcohol. But if they had just set up the wagon, they wouldn't have the crowd. Music is what grabs the crowd.

So, if you go down the line and start thinking about it, music has been linked to alcohol and that industry, to the point that there is a sense people have of there being an actual connection, that those two things actually belong together. I don't think people realize how powerfully that industry has worked to make people believe that.

It's like a diamond ring—people believe that diamonds are something that everybody has always had, that they have always been considered this incredible symbol—if you want to show someone you love them, you give them a diamond ring. This is something that, if a hundred years ago you'd said that, people would have laughed in your face, it would be such an absurdity—you would wear a diamond as quickly as you'd wear a tiara or something, or a crown. It would be absurd, it was reserved for royalty. But at some point, the diamond industry realized it had this vast untapped market which was all these people, where all they needed to believe was that diamonds represent love, and so they put them into the

movies, with an engagement scene where they'd offer up a ring with a diamond, and the woman would start to cry, and it created a sense that there was this intrinsic value here, and then it got into the fabric of our society. Now it goes without saying that if you get engaged, you get a diamond ring, that they have a value! What value does a diamond have?

So in the same way, music is now considered a natural companion to the consumption of alcohol. That, to me, is a fallacy; it's something that has been foisted upon the people by the alcohol industry itself, and now the rock industry, because the two are intertwined. So what you have is that virtually all music, except the super high-end music like opera, is essentially available only in bars. If there's music, there's booze. And you don't need to look any further than the laws dealing with age limits to recognize how insidious that arrangement is. How could it be that someone under the age of twenty-one is not allowed to see a band? I mean, did you like music when you were under twenty-one?

BLVR: Of course.

IM: Did it mean anything to you?

BLVR: Yes, it meant everything to me, in fact.

IM: Of course it did. It is completely absurd and insane that because of the economic dependency that musicians have been faced with which maintains this status quo, that they are forced to say, "That's the way it is." And I think that's a bunch of bullshit. I know music predated the rock club. I know music predated the music industry. I know music predates the alcohol industry. I know music predates it all. Music is no joke, and the fact that it has been perverted by these various industries for their own profit is discouraging to me. I don't think that people who own rock clubs, people who go to rock clubs, or people in the alcohol industry are evil—I don't think that at all. I do think that music should not be solely relegated to that environment. So Amy and I decided that we would only play music in places where all ages are always welcome, where the evening is not dictated by laws or the economics surrounding

alcohol. We've played places where alcohol was available; we just don't play places where it is the central theme of the room.

Also, we think new ideas are hard to present in venues where profit is the primary motive, and what I mean by that is, the reason that clubs and bars—instead of having football on television—have a rock band playing, is it's what draws people in. It's important to note that, for a club, the band's audience is its clientele. So if a band gets onstage with a new idea, something that's never been heard, that there's no established audience for, there's also no clientele. So clubs are not in the habit of supporting that sort of thing. New ideas are born in free spaces, places like Nowe Miasto—or someone's backyard for that matter, where people gather for new ideas. There's just no money in it. Our interest is that we would like to support free spaces, and encourage people to work on new ideas. We don't need any more old ideas. We have plenty of those.

II. "I THINK OF MYSELF AS MYSELF."

BLVR: That kind of thinking ties in to how Dischord itself is run. For instance, you don't have contracts with the bands on the label.

IM: That's right.

BLVR: To a lot of people, that sounds like an insane business practice. The current music industry is focused, it seems, more intently on the management of intellectual property than it is on the grooming of bands, and what you are doing, operating without contracts—you are opening yourselves up to tremendous liability to be cheated.

IM: If you're a doctor, and you work at a hospital, you think the world is sick. And if you're a cop, you think the world is criminal—it's your environment. The reason people think that operating on a basis of trust is insane is because they exist in a world of mistrust, and it's a perversion of life and the way our society operates. From our point of view, the only time you need a contract, the only time a piece of paper becomes relevant, is in a court of law. The only way it would get to a court of

law—I suppose there are some exceptions, but I don't know of any—is if there is a significant amount of money involved. The lawyers are not going to touch it if there is no money in it. At some point, let's say I have a dispute—and to be clear, we haven't. We've never had a real dispute—but if we did have one with a band, the total amount of money we would be quarrelling about would not be worth going to court over. If you factor in that in December, this label will see its twenty-seventh year of not paying lawyers, that's a lot of dough.

If you're not going to have a contract, you better know the people you're working with. It's one of the reasons that we keep things local, why we put out D.C. bands. We're not making deals with them. We're their partners. They're not being paid on a mechanical basis, they're not part of a profit share. They make the music, they play the shows, we make the records, and we sell the records. And we split the profits. We don't get any money from their shows. They can play shows or not, they can tour or not tour, they can do interviews or not. It is really up to them. There isn't a system that they have to follow.

It's a different way of approaching it, and people can say that it's insane or idealistic but clearly it's real, and has been for nearly three decades. I think we've had one year where we were in the red and that was very early on when we were figuring out how things worked. Every six months, if any of the records show profit, we send out royalty checks. I send checks to people who put out records in 1981. We have six employees, full-time, with benefits. Both Jeff [Nelson, drummer for Minor Threat and cofounder of the label] and I, as co-owners of the company, we're alive, we live in our houses, you know. It's obviously possible. I don't know what to tell people. The proof is in the pudding.

BLVR: Because you're so hands-on with the label, do you ever feel like you're more of a small businessman than a musician, or is it about inter-lacing the two?

IM: It's all one thing. I've never really thought of myself as a musician or as a businessman. I think of myself as myself, and this is what I have to do every day. I come from Washington, D.C., so there was never any

thought of someone else putting my records out. There was never any possibility of that. If I wanted to document something I did, I'd have to do it. Having made the records, I could either have them sit in my room or I could sell them, so I learned how to sell them. I started the label and I run the label because I want to make music. That's the way I look at it. Did I set out wanting to own a record label? No. Do I want to be involved in the record industry? No. If this label was to come to an end, would I look for another job in the industry? No. I think it's a despicable industry.

BLVR: The whole idea of the punk DIY aesthetic is that no one is going to do anything for us, so—

IM: Or as we used to say, and I still think, don't ask for permission because the answer is always no. So you just do it. And you're right. We are definitely punk-rock kids, but I mean, do you consider yourself a fairly knowledgeable music person?

BLVR: Yes.

IM: Are you familiar with D.C. music?

BLVR: Somewhat.

IM: Can you name a band from the last ten years from the District?

BLVR: Q and Not U.

IM: OK, can you name one from the '90s?

BLVR: Well, Fugazi is the first one that comes to mind.

IM: What about the '80s?

BLVR: I don't know the '80s in D.C. that well. Bad Brains, I suppose.

IM: How about the '70s?

BLVR: The '70s—I couldn't tell you.

IM: Well one reason you can't tell me is because in D.C. at that time, there was no perceptible rock scene. There were a lot of great people and bands making music here, but a lot of the bands here in the '70s were cover bands, and if a band were to become cohesive and get it together, they would move up to New York or head out to L.A. In our reality—the first band I was in was in 1979—I was told time and again that if I wanted to make it, I had to move to New York. If I wanted to be a punk, I had to move to New York. I thought, Why would passion, creativity, boredom, constructiveness, outrage—why would these things have geographic connotations? Why would they be qualities that could only be ascribed to you when you are in New York? I was born and raised in Washington, why would I have to go somewhere else to feel these things? The answer is: I don't, and I wasn't going to, and we decided to go ahead and make our own scene. And we did it.

And I think within the rock/punk world—and I make that distinction because D.C. has plenty of other scenes: the go-go scene, a world-class bluegrass scene in the '60s—but just in terms of rock, you'd be hard-pressed to name a rock band from D.C. from then. But we made our own scene, and suddenly in the '80s, people can name bands from D.C., and we did it ourselves. There was no template to work from, no scene before us to tell us what to do. We had people who said, "Here's the number for the pressing plant. Good luck." We were just punks, and made our own scene.

And I was under the impression that kids from all the other towns across the country were going to make their own scenes, and their own fanzines, and their own records labels, and it would be regional. That's really how it started out. You had Touch and Go in the Midwest, you had Alternative Tentacles in San Francisco, Exclaim in Boston, SST and other labels in L.A., one in Texas whose name I can't recall now, but you had all these small labels and fanzines and scenes around the country. It just so happens that we never stopped. The others, they either stopped

or they broadened their vision, or whatever you want to call it. Whereas, from my point of view, Dischord is, by definition, documentation of the music from this particular scene in Washington, D.C., from the beginning to the end. That way, twenty or thirty years from now they can pick up a Dischord record, they will know it's from D.C. and make that connection. I think that's interesting. I like it.

BLVR: I can identify with that. Growing up in Louisiana, we thought nothing was ever going to happen here, we thought you had to go to Austin or New York or wherever to make something happen. And that's such a ludicrous idea.

IM: Well, it depends on what you mean by "making something happen." If you're talking about making a living, then yeah, you might have to. If you're talking about making music, why do you have to go somewhere? You can just pick up a guitar.

I was recently talking to a friend of mine here, and he felt like he should be able to make a living from being a musician in Washington, D.C. I don't believe in that. I don't believe you have that entitlement, to think that just because you want to make a living from music, you can. I don't really believe in the idea of a professional original musician. You can be someone that plays weddings and bar mitzvahs; you can get that kind of work and do covers. But just because you're a musician doesn't mean you get a job.

So, living in Louisiana, you want to do something and there's no scene for it, and if your idea of success is based on renown and financial gain, you may not find success in that sense. I don't see success that way. If you are a musician and you write a song, then you're a success. ✳

NICO MUHLY

[COMPOSER]

"[COMPOSITION IS] LIKE INSTRUCTIONS FOR A SHORT STORY, FAXED TO EVERY ENGLISH STUDENT WHO'S STUDYING IT."

Appropriate subjects for orchestral music:
Jet lag
Columns of light coming at you from cars
Learning Icelandic is hard.
Why do I always forget my phone number?

ico Muhly is a twenty-six-year-old composer. *This is different from the archetypal image of old men with creased suits and wild white hair, but rather more realistic. Muhly lives in New York's Chinatown. His two albums,* Mothertongue *and* Speaks Volumes, *were released not on a "classical label" but on Valgeir Sigurðsson's Icelandic label, Bedroom Community. His work has also appeared in traditional concert format, such as the cantata on Strunk and White's* The Elements of Style *and the various orchestral works premiered by the American Symphony Orchestra and the Boston Pops. He has scored a handful of films, and has also worked as an arranger, performer, and conductor for distinctly nonclassical artists such as Björk, Will Oldham,*

Antony Hegarty, and folk musician Sam Amidon.

Muhly talks like someone who knows he is precocious, but any affecta-
tion is undercut by genuine curiosity and warmth. His music demonstrates
these contrasts, with both the devotional yearning of Philip Glass, for
whom Muhly has worked since college, and a light playfulness that recalls
the composer Benjamin Britten. It's a synthesis of '60s minimalism,
Renaissance choral music, and also some of the bleakness and buzz that
have marked indie folk over the past decade.

Cooking us dinner, Muhly was exact in his inexactness: he measured
quantities by eye, but without sloppiness. We ate pasta, drank wine, and
then watched YouTube videos about military robots and theremins. "The
worst," Muhly said, "is when you just remember, without meaning to, the
last seven digits of the URL for a YouTube video. Like 'Y2078645'—that's
that one with the camel."

<div align="right">

—Sean Michaels (October 2008)

</div>

I. THE SCORE TO STAR WARS IS
LIKE A YAK CARRYING PEOPLE

THE BELIEVER: What's the process like when you compose a piece?

NICO MUHLY: It depends on what you're doing. When you're writing
for an album you can think very broadly, but writing for a commission—
it's a different concept. Someone says, "OK! Six minutes for orchestra.
Two flutes, two oboes, two bassoons. On March 16 of next year. It's got
to be between six and eight minutes, and we're paying you this much
money..." You have a list of facts—so it feels like the best way to coun-
teract the list of facts is by coming up with another list of facts. The
second list of facts is: "OK, for you nice people, you're going to have, um,
a piece of music about... whatever." You can almost say any word and see
if it takes you anywhere. For me, sometimes it's anecdotal and then you
completely erase the anecdote when you're writing it.

So this piece was spurred by when I was at Tanglewood and I was
walking from place A to place B and all these cars were traveling in the

opposite direction and I was walking in the middle of the road—whatever, nothing, a teeny image, a memory.

BLVR: So the music starts from sentiment, from feeling, and not from playing on your keyboard?

NM: It starts in sentiment, usually. Yeah, most things come from a quick little moment, a time I was in a place that was scary, or something bigger, like "jet lag" or "Learning Icelandic is hard." Big ideas or problems— "Why do I always forget my phone number?" And from there you can extrapolate a mesh of things.

[*He flips through a few pages of rough sheet music, but with hardly any notes written onto the bars. Instead, there are words, phrases, squiggles, and even a section of curlicued drawings, like a swath of ivy had grown up and over the staff.*]

NM: Here's how it starts. It's a sort of narrative, creative thing, a map of the central section of this piece. I write out the images that come to me: "a walk at night; columns of light coming at you from cars; it's a nocturne; a music with stars; big swells"—I just write out things I want to retain.

It's a list of ingredients, in a sense, and then, as you can see at the bottom, it says, "a melody with a halo emerges from the texture." I wrote out the melody and then corrected it—added a flat. And then I draw out how it should look eventually. It turns into a shape that matches the emotion that I have planned for it. A lot of this is completely random. But it's a shopping list, shit I have to think about. This ended up being a piece called "It Remains to Be Seen." Idealistic music about how your life should be.

BLVR: Is it difficult writing music for film? It seems like there would be a lot of pressure to compose "Hallmark-y," melodramatic, and romantic scores.

NM: I'm pretty clear about what I'm capable of doing. I can't write in that way. I just don't have emotions like that—or I don't express them in

that fashion. I think that most people who would like to work with me would know that.

BLVR: So what are they looking for?

NM: An approach that is more about texture—music that doesn't do as much work. Look at *Star Wars,* which completely favors the score, which is genius. The score is doing a lot of work. It's like Wagner. It's like a yak carrying people. Whereas if you think of something like *No Country for Old Men,* which was completely silent—hello, best movie ever in the history of ever—well, that's a film that doesn't depend on the score to do the heavy lifting. I like to think of it as a character and less like this crazy emotional dictator.

BLVR: But isn't there something nice, almost democratic, about making music that is obvious—that everyone can join together in?

NM: Yes. Theoretically. But I think that doesn't actually apply to most movie music. Movie music is this trickle-down thing of someone telling you what the emotional content of a moment is.

BLVR: Helping everyone in the theater to feel it—

NM: —to feel the same thing, which for me is not democratic. Democratic is a nudge and then ignoring it. Democratic is a poke and then saying, "You know what? I would have liked if you had cried when she was diagnosed with cancer, but you don't have to." That to me is democratic. Whereas *not* democratic is this insanely manipulative thing where you're being told what to feel. "You're happy—it's the Great Leader's birthday!" And you're like, "I guess so…" For me the best kind of film music is liturgical music. Liturgical music is essentially a million scores for the same film.

BLVR: That's really interesting—liturgical music as an ambivalent film score. It leads a horse to water…

NM: Whereas film music often forces the horse's head into the trough! With church music, at least in the Anglican tradition, you can't depict it. It's not correct and everyone knows that. Even more than in the concert hall, in church there are things you can and cannot do, just out of respect. You would never have the sound of someone being nailed to a cross, or the sound of a child being born, because everybody knows the story. We know that we're meant to feel a complicated raft of things.

If you look at early English music for Holy Week, it's a story as dramatic as it gets, but the music is still one step back—like how in really fancy restaurants they never point to the bathroom, they just gesture toward the bathroom or they'll lead you to the bathroom. The fancier the restaurant, the less pointing there is.

II. ETHNOMUSICALOGICAL LONESOMENESS

BLVR: You've described your music as "a vast feast."

NM: My urge, when I go to the store, is to buy everything. Even tonight it was like, Oh, let me get another thing of olive oil that I totally don't need, and, as you can see, we have four cheeses and there's absolutely no way we're going to eat all of this. I don't even know you and I've gone hog-wild. And it's the same when I'm composing. My first instinct is basically to bring the whole store home, and not make a decision about how things play out. It's just to make a feast and make too much and think about it later. I've avoided the syndrome of things being too long, in terms of time, by having too much at the same time. Oh, you have an eight-minute piece? Well, let's make it a sixteen-minute piece and fold it in half, then that'll be some kind of magical, dense thing. So when I said that, I think it was a confession.

I look back at things I wrote when I was eighteen, nineteen, twenty, and I feel I'm looking at a person in a mania—excess, decadence, too much information, too many ideas at the same time—not to a fault necessarily, but it's an excess. It's the way you look back at a raucous evening and think, Oh my god, at what point did we think that opening that gin was going to be a good idea?

BLVR: So how do you rein that in?

NM: That is the daily question. I try to return to fundamental techniques of how to do something: just one note against another, one line against another.

One of the other tricks is whenever I get asked to write orchestra music or music that is for a lot of players, I try to make it a little sad. I wrote this very sad piece of music for the Boston Pops. I wrote this really sad gamelan piece, like fake gamelan, like postcard gamelan, like racist *DuckTales* gamelan. Just really messed up. It had vibraphone! It was excess in a box, excess in a diorama—ethnomusicological lonesomeness. But that lonesomeness, to me, helps temper it.

BLVR: Are you frustrated as a composer when you make something and then the musicians perform it in a different way than your intention?

NM: Composition is interesting because, in a sense, you always have to let it go. Unless you're a true composer/performer, you're always sending a PDF and then someone else makes it. It's like instructions for a short story, faxed to every English student who's studying it. IF YOU WRITE FOR AN ORCHESTRA, THEIR ENGAGEMENT WITH IT IS THIS: they turn up on, like, Wednesday morning and they read it through for twenty minutes. That's the first time they've ever seen it. Thursday afternoon they run through it, Friday night they perform it. So they've had a total of an hour and twenty minutes' engagement with this thing at the most. If you imbue every little thing with a very deep personal investment, you're just setting yourself up for disappointment. Writing orchestra music, you need for the emotional content to come from everyone doing everything together, adding up as it goes, a crowd mentality. With chamber music you can get people who work on the music for months, rehearsing it every day for a couple of hours, and if they get it in a different way than you do, which is entirely possible, it's not as a result of anything other than their good musicianship.

BLVR: It's very interesting to me, these gaps. There's a gap between the

writing of the composition and the performance of it. And there's this other gap between the performance and the listeners, what they hear. But that first gap is this funny, uneasy space: interpretation as a spontaneous act, an improvised act, in the moment.

NM: As a composer you want to tell musicians two completely contradictory things. You want to say, "Play exactly what I wrote, but bring your own thing to it." In a lot of ways they feel like opposites, but in a sense, my job is to cajole or encourage decisions that I approve of. That's on a level as basic as an accent, the size of the font, all of that shit. It's these really subtle things, incredibly subtle. Almost like getting a horse to do something complicated. Musicians, in a lot of ways—not to compare them to horses—but riding a horse is a relationship with a foreign creature, and with musicians it's a similar thing: "OK, I'm going to put something on the page that will spook you into rushing." Little games you can play.

There's a lot of violence in Beethoven not explicitly suggested by the notes or in his markings, necessarily. There's just a way that it looks on the page that encourages it to be played in a certain fashion. We look at his manuscripts and there's a real awareness of aggression.

BLVR: Like he's writing with a piece of charcoal.

NM: Almost. These articulations that look just like a gash. It's beautiful. So through studying you can see how stuff has been received through performance practice through the ages. Everyone knows how the first four notes of the Fifth Symphony are going to be played. It's just four notes, it's no big deal. But somehow we've received this information that it's meant to be this really [claps] unh! thing.

When you're writing something new, writing something that's your own, basically you have nothing else to do except either invent a trick, use someone else's trick, or have no trick and get a bad performance. Those are your options. And so at school, in a lot of cases, you don't have a trick yet and musicians are like, "What?" You can stick someone on a horse who doesn't know what's going on—it's the same weight—but the

horse is asking, "What are you doing? What's going on up there?"

BLVR: Tell me about the project you're doing with Teitur, the singer-songwriter from the Faroe Islands.

NM: He got asked to do this thing at a festival in Holland: "Classical music and nonclassical music being friends with each other," which is this kind of forced idea that I don't necessarily 100 percent buy. If you need to be told to be friends, you're not really friends. It's like a playdate, when you're a kid and you're screaming [*in a kid voice*], "But I fucking hate him!" And you have to go, even if there's sand in your eyes. It's total misery.

Anyway, I met Teitur in the Faroe Islands last summer. And he's such a natural musician that you are ashamed to have gone to school in the first place. He's essentially a songwriter, and his gift is the song form—it wasn't appropriate to try to write something too abstract. So basically we said, "Let's find something that has an abstract grounding but is also totally commonplace and accessible to everybody." Music videos are one thing—crazy, fucked-up, boring music videos. We found a YouTube video of a guy giving a tour of his apartment in Siberia. He'd just reno-vated it, I guess. And he does this really slow pan around his living room. It's like eight minutes long. And all the comments are like, "You suck! This is really boring! Why did you put it up?" You know? It's totally great. Or there are these people who strap a camera to the front of their car and go for a drive in Nebraska. And the comments say, "I used to live on a road like that in Scandinavia." So we basically have just been arranging songs using comments on YouTube.

Teitur and I have been in each other's presence two times. We talk two or four times a day, and work through this whole crazy project, but by the time we die he and I will probably have beheld each other, like, eight times. And that's wild to me.

BLVR: Do you like always being connected?

NM: I'm trying to phase out my availability on the phone. People call

you when you're walking down the street and say the most random stuff. It's like, "Can you not hear that I'm in a fish market?" There's all these people screaming and the person on the phone is saying, "OK, so next Wednesday at two, what is your availability?" And I have a striped bass in my left hand and your phone call in my right hand—how can I possibly tell you what I'm doing in two weeks' time? So I try to turn off my phone. It was only on three times today—at 8 a.m., at 2 p.m., and when you were coming over.

BLVR: But you check your emails every two seconds.

NM: Yes.

III. A CHILD SNEEZING FOREVER

BLVR: Instead of doing a record for Deutsche Grammophon or another traditionally "classical music" label, you released your albums on an Icelandic indie label. So where did that come from?

NM: I think my generation is a lost generation in a way. I didn't *really* get the internet until high school; I didn't *really* get any of that stuff until college—an MP3 was in my freshman year of college. We're the same age. I had *an* MP3.

BLVR: I remember when I had just one. Third Eye Blind, "Semi-Charmed Life."

NM: I had Cher's "Believe" or whatever. What even *was* an MP3? But you *had* it, you dragged it to this thing called Winamp—it was crazy. So the records that I loved were these beautiful objects—Arvo Pärt on ECM, or all that Adams and Glass on Nonesuch, and you just held these albums and touched the paper, and it felt so delicious. And yet over the course of being in college, that faded away. We collected MP3s and things.

But what didn't fade up at the same time was, in conservatories, an awareness of what any of that was. So I ended up with a completely

analogue experience at Juilliard. Even in my last year of my master's you would still be handed a cassette tape or DAT of your concert—"Here's the stage, here's the microphone, here you go, here's your piece."

So what people of my year found, when we left school, was this landscape of "IM it to me," "Let me hear it." And it was like: "Oh, let me somehow take this cassette tape, plug it in..." We had this essentially undocumented work.

I just didn't entertain the idea that my music would ever become available in any of the ways that I had previously known music to be available. I couldn't imagine that one day the phone's going to ring and it's going to be Nonesuch saying, "You know what? Even though we haven't heard any of your music, because it's all on cassette tape, we believe in you. So why don't you take this money and record your choral works."

It's this weird generational thing about how people access music. The people who were and are still, to a certain extent, in control of the record industry deal with things in an analog way, going to concerts, buying something in a store. Whereas for people my age it's become this more abstract thing. "Oh, you want the new Hot Chip album? Here it is," and then it's suddenly in your house—and it hasn't even been released.

I had been working for Philip Glass for a bunch of years and he has his own way of doing things, too, which is to make everything as available as you can, and I had been thinking of that and just going about my life, and then through Björk I met [Icelandic producer/musician] Valgeir Sigurðsson.

We had been working together for a couple months and he just thought I was a pianist or some kind of arranger or something, but finally he said: "Oh, someone told me you were a composer. What does your music sound like?" And I was like—"Oh, I've got this cassette tape!" At this point I had actually paid forty-five dollars to have it digitized—so you play the MP3 and hear the *khhhhh* of the cassette player. At first, he said, "Wait, are you kidding? What the fuck is this? Where did you record this?" He was adamant. "We're doing something. We *have* to fix this, this is ridiculous." So in a sense, it was a pity fuck.

He was really the first person involved in recording anything who

wasn't like, "Let me hear an MP3. Oh, you don't have one? Send me one when you have one." He was instead, "Oh, you don't have one? Let's make one."

So he and I just started scheming about how we would make this happen, and very quickly we said *fuck it* to having a mic above the stage, let's just say forget about recording everything at the same time. Let's forget that whole [classical music recording] model, just to see what happens. I couldn't have been happier to say goodbye to all that. You would get an ulcer trying to get everything perfect. The performance was *it*, it was all you had—everything I wrote for four years, I only have one tape of it and you have no control. If a child sneezes, it's there forever.

BLVR: You can understand why Glenn Gould went so crazy with his recording studio.

NM: Because I had been in conservatory for so long, I was jealous of my friends in bands. I have a friend named Brian who's in this band called Apes & Androids now, and when I was in college we lived next door to each other, and he had this Pro Tools setup—the Mbox—and he and his band would work and then *that night* they could send you the shit. Whereas I could in, like, five months send you this fucked-up tape.

There was never this idea that we would release what we recorded, even; it just needed to be made. And then at a certain point, Valgeir asked: "Why don't we make a home for this shit? Just figure out a way to give it a system that works." Because what would be death in that situation is having this thing, this record, and "shopping it around." You're bound for disappointment, failure, and misery. Emotionally, I was not prepared to handle that. It's not even about rejection as much as it's about being told by the main model of existence, by something that you don't 100 percent believe in, that it's not right for you.

BLVR: Are there other people in the classical world doing similar things, making records the same way as you did?

NM: All of the minimalists were DIY for a long time—design and build

in the '60s and '70s. "Let's avoid academic shit, let's play for each other, let's form bands, basically—touring organizations." That's an early model of what I'm the most interested in. Or Terry Riley—he's the grandpa of this like-minded community of people who jam together.

For someone like John Adams, who, for me, is such an important composer—it's really good that he's being presented the way he's being presented: a major publisher, a major label… For him, that's the way it should be. So there's nothing wrong with it. But for someone my age it's a different world.

BLVR: So how do you experience music now—albums? MP3s? Concerts?

NM: I have to say the act of listening to music at home is rare now. I go to a lot of music—I buy a ticket and go to see a show. If I'm at home I'm usually writing music or I'm cooking—and there's about forty things I listen to. A Cam'ron album, or Joni Mitchell, or that thing we were listening to before—John McGuire, a two-piano piece. Or Bach toccatas, I love to have them on around the house.

And other times I'm like, "I want to sit down and listen to Sibelius." Or, "I'm going to sit down and listen to this goddamn Beach House record." But that's rare, that's once every couple of days—the concerted effort to listen to something. It's always Sibelius or Beach House, by the way— it's out of control. Every couple weeks I'll listen to Sibelius's Seventh Symphony, just to check in, to see how it's doing. It's doing OK. *

PAT MARTINO
[JAZZ GUITARIST]

"INTERACTION IS AN INSTRUMENT IN ITSELF."

Three stages of Pat Martino's nervous breakdowns:
Inferno
Purgatorio
Dull, dull Paradiso

Pat Martino is among the fabled jazz guitarists of the past two generations. His influence sweeps across musical borders, inspiring musicians as disparate as Carlos Santana and Metallica's Kirk Hammett. Since his debut as a twenty-two-year-old bandleader on the album El Hombre (1967), Martino has always remained a guitarist's guitarist, one of the instrument's war-baby pioneers—with, say, John McLaughlin or George Benson—players who forced themselves, and the guitar, into the vanguard of jazz's electric revolution.

Born Pat Azzara in Philadelphia in 1944, Martino was raised as a kind of musical prodigy. His father, Carmen "Mickey" Azzara, an amateur singer and guitarist, took him to hear music as a young boy, frequenting

the city's jazz matinees, meeting many of the famous traveling musicians and the elite jazzmen in their South Philadelphia neighborhood. At fifteen, Martino quit school and moved to Harlem, where he soon became a regular in a variety of organ-centered groups, a staple of uptown clubs in those days. As a salute to his father, he took Mickey's stage name, Martino, before recording his first album. Gradually, the arc of Pat's career took shape, as he staked his spot, first, on the soul-jazz scene, and then with a variety of jazz hybrids, from international music to fusion to psychedelia.

Perhaps the most remarkable element of Martino's career is that it's still intact, and thriving. In 1980, after suffering more than a decade of increasingly severe headaches, blackouts, and, in 1976, onstage seizures, Martino was diagnosed with a life-threatening brain aneurysm. Two emergency surgeries followed, as did near-complete amnesia. Memories of family and friends vanished. Martino didn't know who he was, or how to play the guitar. Recovering at his parents' home in Philadelphia, he gradually rebuilt his life. He taught himself music again and, in the early 1990s, after a few false starts, resumed his professional career to great acclaim. A British neuropsychologist, Paul Broks, documented Martino's illness and recovery in a 2008 film, Martino Unstrung.

In conversation, Martino is unafraid to explore the darkest parts of his trauma. He's formal—a deep baritone and old-fashioned manners give him a natural distance—and he sways from spare, simple reflections to these labyrinthine tales, informed, as they often are, by his deep reading in Eastern philosophy and new-age literature.

On June 19 and October 13, 2008, Martino spoke with me by telephone from his home in South Philadelphia, the same house where he grew up, and where he returned for good after his parents' deaths, nearly twenty years ago. He now lives there with his wife, Ayako.

—Greg Buium (July/August 2009)

I. "YOU NEVER GOT ME DONE."

THE BELIEVER: You've said that you learned how to play jazz on the streets.

PAT MARTINO: On the streets now are certain forms of music that I don't find compatible with my intentions.

BLVR: When you were a young man, you could find jazz in the clubs seven nights a week. You can't find that anymore.

PM: There are establishments that have specific days of the week where there's a sit-in and young players can drop by. There are smaller clubs that young players can go to, to hear other young players, and to seek social interaction. There are opportunities in that context, but nowhere near the way it used to be in terms of the quality or the essence of what *really* was the soil and the dirt that jazz came up in.

BLVR: You've said that a musical instrument is simply an apparatus, a way to interact.

PM: Exactly. Interaction is an instrument in itself.

BLVR: So the stuff that runs through your mind when you're playing must be unique to each musical situation. Being in the moment is key.

PM: In most cases, the things that go on in my mind during this process are very distracting. There's a demand to reach a stillness, to be able to function realistically, and as creatively as possible, without becoming subdued by the surroundings that it's taking place in.

BLVR: Most people in their mid-sixties are trying to slow down, to ease their professional commitments, but there seems to be an urgency, an intensity, to your career over the past few years.

PM: There's something extremely profound about—gosh, how can I put this?—the years that were reorganized in terms of moment-to-moment responsibility to survive under the conditions that were in play. I'm very optimistic about everything that took place, don't misunderstand. Those years caused a gap, in the sense of my initial intentions, the experience

of ecstasy, what initially generated the hunger, or the need, the desire, for that ecstasy, its continuance since childhood.

BLVR: You're speaking of the years immediately before and after your brain surgeries.

PM: Yes, exactly. There were many things that, one after another, seemingly of their own accord, intuitively, began to reemerge and say, "Listen, don't forget about me, you never got me done. You never finished me."

And, whether I liked it or not, it seems that they fell into place, with opportunities that emerged to take advantage of. A great example was when Peter Williams from Yoshi's [an Oakland jazz club] contacted me [in late 2004] and said, "Listen, we're doing a tribute to Wes Montgomery. And for this tribute we thought about you to possibly come in on Wes's birthday. Would you be interested in doing that?" I said, "Man, I would really love to do that." And of course I didn't know what I intended to do. But something intuitively caused me to respond accordingly. After I accepted the invitation, I then began to look in my record collection, and I began to pull out old records—33⅓ vinyl albums—of Wes's, and I looked on the backs of them. And I saw, in ballpoint pen, inscriptions that were placed there when I was a child, at thirteen or fourteen years old.

BLVR: I'm assuming these were records your father had kept at the family home in Philadelphia.

PM: Exactly, exactly. And I relived those moments and I saw what I really loved and what I really wanted to play.

BLVR: You hadn't gone back to Montgomery's music since the aneurysm?

PM: I hadn't gone back at *all* before this.

BLVR: What happened when you pulled out the albums and saw your thirteen-year-old self's handwriting?

PM: I remembered my dreams as a child. I remembered dreaming about wanting to play like that, to play music like that.

BLVR: These were among the memories you'd lost after the surgeries.

PM: Of course. I never remembered that. In fact, I had left that behind. And that turned into the album [*Remember: A Tribute to Wes Montgomery*]. So the album itself wasn't really a tribute to Wes. The album really was—how can I say this—a restructuring of my own childhood. That's why I titled it *Remember*. I think that's much misunderstood in terms of the evaluation, the critical evaluation, of what that album really was.

BLVR: What do you mean?

PM: Well, most reviews of that album had a great deal to do with my respect of and honor to Wes Montgomery. And a memory of Wes. It wasn't a memory of Wes—it was a memory of my childhood. And it was, literally, finally finishing what I wanted to do as a child—to play the music with chops that I didn't have when I was a child that I do have now, bringing my childhood to fruition.

BLVR: Can we go back for a moment to the aneurysm itself? You were diagnosed in 1980, but you'd been suffering from seizures and blackouts since the mid-1960s.

PM: Exactly. Well, to be specific, I was born with the ailment AVM, arteriovenous malformation. It took place at birth and it began to amplify year after year until finally it reached its climax, and that's what brought about the aneurysm.

BLVR: You were misdiagnosed for many years. At different points, doctors thought you were manic-depressive, schizophrenic, or bipolar. You were placed in locked wards. Why was electroshock therapy recommended?

PM: Depression. Again, one of the diagnoses was manic depression. So along with depression there was also the intake of prescribed medication for depression. Remember, these were the early stages of the pharmaceutical industry's availability of different substances. So all of these things—when I look at them in a cumulative way, it's very difficult for me to define any facet of this experience as being the result of any singular element. It was a unification of all things as one. And the one that they all became unified with is now. And because of that, I find it ludicrous to have a negative viewpoint toward any facet of it.

BLVR: Even toward some of the extreme medical situations?

PM: Exactly. Nor do I have any insight on the phenomenon that took place.

BLVR: But at the time, all of this must have compounded your depression, your anger, your feelings of complete confusion.

PM: But in a way so, too, do certain stringed instruments upon the fingertips.

BLVR: Could you explain that?

PM: They involve a series of painful stages of development that are the basis for the formation of calluses. So, too, does adaptation and temperament. To be able to survive in the midst of such confrontations forms a callus. I know I had three nervous breakdowns in the 1970s, I do remember that, and I noticed that the first was similar to Dante's *Inferno*, the second was closer to *Purgatorio*, and the third was dull, so dull that I began to prepare for *Paradiso*, consciously. So when I see others suffering such human conditions, I look in retrospect and, objectively, I see extremely positive elements involved in this.

BLVR: But this is hindsight thinking.

PM: Yes, I think so. Yes, it is.

BLVR: The Pat Martino of the 1970s, at the height of his confusion, may not have spoken with the same sense of detachment that he does today.

PM: I agree with you.

II. "WHEN ARE YOU GOING TO
BECOME WHAT YOU USED TO BE?"

BLVR: You were diagnosed in Los Angeles. The doctors discovered the aneurysm and said you could die.

PM: They gave me two hours, yeah.

BLVR: Yet at that moment, you felt—

PM: I felt relief. Relief from the misdiagnoses. I *finally* had a diagnosis that fit.

BLVR: You were given only two hours to live, but you still asked to be flown back to Philadelphia.

PM: Yes, because the only family I treasured was here.

BLVR: Your mother and father.

PM: Yeah.

BLVR: The doctors were OK to fly you across the country.

PM: Yes, absolutely. But the detail was set up for me to go straight from Philadelphia International Airport to Pennsylvania Hospital, and right into the O.R.

BLVR: And there were two surgeries.

PM: Correct: one on Good Friday and one on Easter Sunday.

BLVR: Do you recall waking up?

PM: No. I don't remember.

BLVR: But you had near-complete amnesia for a full month afterward.

PM: That's where it becomes difficult to get into details. I don't remember the exact conditions in terms of stages of change. I just remember certain points of change that were cumulative. I remember when I decided to become active as a guitarist again. I remember when I decided to have fun with the computer.

BLVR: Tell me about deciding to become a guitarist again.

PM: It was an extension of social enjoyment.

BLVR: Wanting to be around people.

PM: Yes. Not on the basis of professional achievement or a repetition of career-oriented success—to try becoming something that I used to be. I picked up the guitar for healing purposes. To lose myself in it like I lost myself in any of the toys I did when I was a child.

BLVR: Your father was playing all of your old records, too.

PM: Yes. That was very painful.

BLVR: To hear them.

PM: Yes, of course. Because it really had nothing to do with me. It had everything to do with the past, and it had *nothing* to do with now. He

was extremely concerned about the future.

BLVR: What kind of music were you playing at first? Did it sound like the Pat Martino we knew from the recordings?

PM: No. It was almost like basic classical music: simplicity, profound simplicity, very similar to Erik Satie's *Trois Gymnopédies*. Profound in the sense of its isolation as a soloist. It was a state of mind that was far from public responsibilities, idiomatic responsibilities.

BLVR: Acoustic guitar.

PM: Yeah, acoustic guitar.

BLVR: Ego wasn't part of it, but—

PM: Oh, no. Ego was part of it. Sure. Of course.

BLVR: In what way? In the ability to master this instrument again?

PM: The ability for me to retain my own realistic state of mind, when around me was the suggestion that "When are you going to *become* what you used to be?"

BLVR: When are you going to become Pat Martino again?

PM: Yes. Exactly.

III. "WHEN I PUT THE GUITAR ON, I SEE THROUGH IT."

BLVR: What do you think jazz's place in American culture is today?

PM: The only thing I can be definitive with is an example. Take the students of jazz in our conservatories and universities. They're studying

harmony and theory, which is not jazz, that's music. Number two, they're studying and transcribing artists of the past—past cultures, or stages of our culture, and that is not the reality of today. So it [jazz] is not alive the way it used to be. And they're studying something that is encaged, and they're analyzing it to participate in something that no longer exists.

BLVR: Was it a given that you would go back to being a jazz musician? Why not other musical genres, or even other fields? Your mind was a blank slate. Still, when I listen to your music now, it sounds like Pat Martino in late middle age, as if your work had evolved naturally, as if there'd never been a pause.

PM: It happened because of practicality, realistic practicality. I do remember periods of—I'm avoiding one word that would normally be used for what I'd like to describe, and the word that I'm avoiding, which I'll bring to the forefront just for description, is *recovery*. I don't particularly care for the word *recovery* because it has a tendency of leaning toward a repetition of what *was* prior to the disruptive interruption of what causes it to be staggered. In my case, *recovery* should be replaced with the word *refinement*. During that period of refinement, the one thing that was concrete, and available, in a practical context, was the history of what this so-called "Pat Martino" did prior to its interruption. And I had the opportunity to take advantage of that, even though I found that extremely, complexly difficult.

BLVR: At that moment, did you identify yourself as this so-called Pat Martino?

PM: I had to accept that. I had to accept that in terms of its own promotion: the photos, the album covers, the relationship with Gibson, and many other things.

BLVR: It was a concrete reality, something you could grasp: there are these albums, and your father is putting them on for you.

PM: It existed whether I accepted it or not. It was history. And in the long run it became a functional tool to use accordingly.

BLVR: Even though you went through long bouts of depression, you realized, I'm stuck with this history, why don't I just look at it directly?

PM: Well, I don't think I felt I was stuck with it. To this very day, I remain on the outside of it, and I'm not really subject to it.

BLVR: Outside of the man who existed?

PM: Outside of being a musician or being a jazz guitarist. Or being *anything* that is dealing with that. It's second nature to me. It's very similar to any other practical facility that is at my disposal. What I use it for is to provide what it's going to offer for the work. I see the guitar as I see a pair of glasses: when I put the guitar on, I see through it. And I see clearer in terms of that particular form of attention, as well as intention, what I want to use that for, and what I want to activate it for.

BLVR: I find it amazing that, apart from the technical skills required to play the guitar again, you'd lost all of the language, the vocabulary, of a jazz musician. That's altogether different than, say, the physical skills needed to get around the fretboard.

PM: Sure. But please keep in mind that there were in storage quite a number of documents and materials that I had written earlier. There was text that I had worked on for years, in terms of analysis of theory, and all of these things were in storage. And when the time came that I began to find an opening, in terms of socially becoming a little bit more active, these implements were very useful, in the sense of giving me what was necessary to function within the musical community once again.

BLVR: For most of your life you had been completely obsessed with the guitar.

PM: Prior to the operations it was time-consuming, it was demanding, it was magnetically addictive. It was one thing and one thing alone: you're a guitar player, be a guitar player, be the greatest guitar player. I was obsessed with the competition of the business I was in.

BLVR: After the operations, you had to overcome the hurdle of learning how to play again.

PM: What caused me to overcome that was when I took a job [in 1983, at a club in Cape May, New Jersey] as Pat Azzara. And I went and played, though I was under the impression, because I used Azzara, that no one would know I was there. I did this intentionally. But I was wrong and the place was packed. I was stuck.

IV. JOE PESCI, WILT CHAMBERLAIN, AND JOHN COLTRANE

BLVR: What about all of the nonmusical memories? Joe Pesci, a friend from the early 1960s, when you were a fixture at Smalls' Paradise in New York, just came up to you on the bandstand a few years ago?

PM: Yeah, at the Blue Note in New York City.

BLVR: And he said, "Hey, Pat, remember me?"

PM: Exactly. "Do you remember me?" I said, "Of course I remember you, you've been in some of my favorite films." So I told him the names of the films. And he says, "No, no. You don't remember me, do you?" Then he told me, "I remember when you used to drink. When you were seventeen." I said, "Wow, far out." I said, "What drink would that be?" The drink, whatever it was, a mint julep or something. And I said, "Holy smoke." And I got a blast of images at that moment. And later on, Ian Knox [the producer of *Martino Unstrung*] and a cameraman, we went up into Harlem and we went to Smalls' Paradise, which at this time is an IHOP, it's just nothing but an International House of Pancakes.

Well, when we went up there, I then got pictures of many things, of many, many people. And somewhere in that line of memories came Wilt Chamberlain. I remembered giving Wilt Chamberlain a lesson. He was stimulated by me as a guitarist, and he said, "I want to learn how to play guitar."

BLVR: This is when he owned Smalls', in the early 1960s.

PM: Yep. And he came to my hotel room. And he sat at the edge of the bed and he put my guitar in his hand and, god, his thumb and his first finger wrapped all the way around. I said, "You need a telephone pole for a neck. [*Laughs*] You'll never be able to play this." [*Laughs*]

BLVR: John Coltrane was a formative influence. Do you remember meeting him?

PM: Yeah, sure. It was Dennis Sandole [a Philadelphia guitar teacher] that introduced me to John Coltrane. I met 'Trane and I met Benny Golson there [at Sandole's studio]. I met James Moody there. I met so many—Philly Joe [Jones] and Paul Chambers.

BLVR: Tell me about the first time you met him.

PM: The first time I met him I was just astounded at the opportunity to have met a giant. And Dennis took this little boy, I was thirteen or fourteen years old, and said, "Pat, I want you to meet John Coltrane. John, this is Pat Azzara [*laughs*], and he's studying with me and he's a great guitar player." And 'Trane was very warm at that time. A little later on, maybe a month later, he took me out for some hot chocolate down the street. We talked and he said, "What do you want to do?" He said, "Make sure that you're going to enjoy doing what you want to do." He says, "It may not be the way that you want it." But he says, "Are you having fun?" I said, "*Yeah*." He talked to me like a father.

BLVR: You must have been an impressive little kid.

PM: Yeah, I guess so. Being carried around by Dad like a child prodigy.

BLVR: Did you talk much in those situations or were you just quiet, soaking everything up?

PM: I soaked up everything around me, primarily because I found it very uncomfortable being a prodigy. In a sense, I still feel *that* to be uncomfortable, because I still feel [like] a prodigy, because that's what I was born and raised as, and at this point in my life what I'm really there enjoying is the moment, and everybody in it. A lot of times, their respect for me as a guitarist is inhibiting.

BLVR: I guess you'll never shake this.

PM: No, you can't ever shake that. I just want to enjoy the moment, with everybody there.

BLVR: After the surgeries, you must have felt like a prodigy once again, learning how to play from scratch.

PM: Then I wanted to live up to being a guitarist, a jazz artist. Now I just want to continue enjoying, and compassionately enjoy everyone no matter what they ask. If it's an autograph, yeah, fine. I don't mind. I love doing it. I like to embrace at this point. It's a lot more practical at this point in my life than it was when I was younger. I think when I was younger I was still caught up in the circus—in portraying the part, and competing with other players and worrying about whether I would get the gig and so on and so forth.

BLVR: When you think back now, are there still breaks in your memory or has everything come back?

PM: No, there are many things that are missing. I constantly have people contact me in one way or another, to remind me of things that I would have never remembered. It's an ongoing surprise. ✱

THOM YORKE

[OF RADIOHEAD]

"WE BELIEVE THE PEOPLE FIND MUSIC EXTREMELY VALUABLE AND WE'RE GOING TO PROVE IT."

Album-art inspiration:
Knocking over a table covered in candles
NASA's website
Something top secret that can't be discussed at the moment

t the turn of the twenty-first century, when Radio-
head became the new gleaming hope for innovation
in rock and roll, the band began renovating the
dismal state of the music industry. At concerts they
banned corporate sponsors; they attempted to mini-
mize the heavy ecological footprint of traditional touring; and, recently,
they released their seventh album, In Rainbows, without a record label,
in a digital format on their website, allowing buyers to pay as much or as
little as they liked.*

*Along with all these experiments came furies of hype that Thom
Yorke, primary hype-target and living-legendary singer of the band,
described as "being the Beatles, for a week." Yorke has been reticent in*

his interactions with the press, and in past interviews, especially those from the OK Computer *era, Yorke acted downright spiteful: hissing at questions he didn't like, ignoring others, and criticizing the interviewer with Dylan-esque zingers: "Next question..." "It's not your business..." "Answering questions like that's a fucking waste of time."* Meeting People Is Easy, *the only of several Radiohead documentaries the band endorses, is mostly an investigation into the conflicted relationship between the press and the music.*

I met Yorke in the lobby of his hotel, the Chateau Marmont in Hollywood. Before the interview, he had spent the day shopping with Nigel Godrich, Radiohead's longtime producer, and during the interview he took a few minutes to talk about Australia with Neil Young's manager, Elliot Roberts. He wore cargo pants mottled with white paint. He apologized four or five times for his jet lag, but responded to every question with thoughtfulness and patience, demonstrating what seemed to be a newfound acceptance of his place amid the stars of rock.

—Ross Simonini *(July/August 2009)*

I. WINDOW-DRESSING AND NICE PROGRAMS ON THE TELLY

THE BELIEVER: You've talked before about the environmentally awful aspects of touring and how Radiohead is trying to find more sustainable options for traveling. Have you come to any conclusions about a touring industry that would be less disastrous for the environment?

THOM YORKE: Well, when we started talking about touring, I had just been reading about David Bowie's *Station to Station* tour. I'm not sure if this is entirely true, but as far as I can tell, he did actually go station to station. He didn't get on a plane. He even did the Trans-Siberian Railway. And he did it across the U.S. as well. So the first thing that I said, with a sort of pouty lower lip, was, "I don't want to fly, I want to go by train." But then it was completely impossible. There was no way to do it. The infrastructure is no longer there. I mean, it wasn't really there then either,

but Bowie wasn't taking a great deal of gear. So I don't know. The whole thing has become a massive compromise, and the nature of flying, which is the absolute worst disaster situation… Well, actually, that's not entirely true. The biggest disaster—'cause we had this study done—the biggest disaster is people getting there. People driving.

BLVR: That makes sense.

TY: We tried to set up carpooling things. I don't know how effective it was. So we tried just playing cities, and that had its limits as well. But anyway, even if you ignore the flying thing, there's still the basic lack of infrastructure and public transport, and that has the most significant effect on touring. And in fact, most of these issues, you go round and round until you sort of get to a point where unless, say, Obama decides to change the infrastructure, we're all just pissing in the wind, especially in a city like L.A. I mean, did you know that it used to have fucking trams? I found that out when I wound up downtown one day. There's fucking tram lines down there. And then a friend of mine gave me a book about it.

BLVR: Reading anything good right now?

TY: Yeah, I'm reading Bram Stoker's short stories. Just read *The Secret Agent*, but I didn't enjoy that very much. I'm a very slow reader. I don't want anything heavy at the moment. But what was the last heavy thing I read? Borges's *Labyrinths*. That was pretty cool. The idea is the story, you know. I tried reading it a few years ago, and I was like, "What the fuck is this?" and then some guy in the pub explained to me what was going on and then I actually really enjoyed it. And then I read that L.A. public-transit book.

BLVR: I remember when I first realized that *Who Framed Roger Rabbit* was really about the death of L.A.'s red-car system. That sort of blew my mind.

TY: The same thing happened in Europe. The car industry made a concerted effort to destroy public transit. And the Western government's running around all like, "Oh no, what are we going to do? Blah, blah, blah." Well, you fucking let it happen. You let it happen. So you figure it out.

BLVR: So on future tours, do you think you'll stick to the standard touring style?

TY: At the moment, there's a limit. Or we could just not do it.

BLVR: That shouldn't have to be the answer. Should all international touring artists stop playing live to minimize emissions?

TY: Well, I don't know, because at what point is it all a self-fulfilling ego thing? "Hey, I'm doing everybody a favor here." Are you really? Are you sure about that? Or are you doing yourself a favor?

BLVR: What about your day-to-day life? Have you made any changes there?

TY: We've had a house by the sea for eight years. It's got one of those systems that go into the ground. Uh, what is that called? I know this. I know this, but I've got jet lag… *Ground-source heat.* Yeah, so that house has basically become carbon neutral, barring the energy it took to do it. So that's exciting.

BLVR: Was that difficult to do?

TY: Well, we first looked into it two years ago and, yeah, it was a nightmare then—because again, the government hadn't decided to encourage companies to invest in this sort of thing. But now they have decided to, so it's a lot easier. So now companies know that they can make money doing it. So it's the same thing. If Obama now said, "I want shit to happen," it would make a massive difference. 'Cause no matter what

way you look at it, once companies know they can make money out of it, they're gonna do it. But they ain't gonna do it if the government is standing in the way. Sadly, as individuals, you learn pretty quickly that this is about the big shit. It's got to be at the level of law and infrastructure. It has to feel fair to people. I'm being vague, but I got involved in this campaign in the U.K. where we got bills through Parliament to commit to reducing carbon emissions.

BLVR: The Big Ask?

TY: Yeah, and straightaway the thing we realized is, well, *infrastructure* is actually what this is all about. Everything else is window-dressing and nice programs on the telly that make you feel good. Everybody has to do it 'cause they have to do it. A friend of mine, an environmentalist, was explaining it like a war scenario. It's exactly the same as a situation in the Second World War and rationing. People should start thinking that way right now. Rationing only worked because everyone knew that was the rule. That was it. That's what it's all about.

BLVR: So you think the government needs to step in?

TY: Well, say a Western government came out and said, "Now we're going to ration your energy consumption." I mean, that's going to mean some serious shit to people. But that's what's going to need to happen.

BLVR: Would you say that the Big Ask was successful?

TY: It was successful because it made the government do something it absolutely did not want to do. But really, it's not succeeded because, in a sense, it hasn't done anything at all.

II. THE MUSIC BUSINESS WAS
WAITING TO DIE IN ITS CURRENT
FORM ABOUT TWENTY YEARS AGO

BLVR: It's looking like people aren't going to listen to music in a physical form for much longer, since CDs and records are being replaced by digital music.

TY: But then the CD was never physical, because it was digital.

BLVR: Right.

TY: But yeah, you don't have the artwork with digital. I mean, I always hated CDs. Me and Stanley [Donwood, Radiohead's longtime album-art designer] always hated CDs. Just a fucking nightmare.

BLVR: Based on the way you released *In Rainbows*, it seems as if you have no problems with the digital switch.

TY: I'm happy to see the CD format disappear. But what about laser discs?

BLVR: Let's switch to the most impractical medium of all.

TY: Yeah, completely. [*Laughs*] But, no, I'm not too bothered with it. I'm more interested with the way things sound. Because of the nature of the music software, within the music itself, the tendency is toward soft synths and soft effects—and I use these too—which are all internal, inside the computer. And I think that's making a big difference to music as well. Some of it's really exciting but some of it's a bit lame-ass. It gives everything a softness which is not very exciting to listen to. I know Modeselektor would love me for saying this.

BLVR: Plus the tinny, low-fidelity quality of MP3s has become the standard way to hear music.

TY: Yeah, that's a bummer. But I'm out of my depth here. Nigel [Godrich] is the one to talk to about this.

BLVR: It's funny, because the loss of palpable CD artwork seems like it would effect Radiohead more than other bands, considering that your artwork collaborations with Stanley Donwood have become so linked to your aesthetic. How do you normally work with Donwood on artwork?

TY: Has it? Well, the *In Rainbows* artwork came literally from him knocking a table over. He had some candles on a table and, well, we were gonna do some pornographic etchings, which didn't work out for a number of really good reasons… They were pornographic landscape etchings.

BLVR: Pornographic landscape etchings, huh? Is that how I would describe them if I saw them?

TY: No, you'd say, "That's a bunch of fucking scratches on a piece of paper, mate." [*Laughs*] But in the process of doing that he knocked all these candles onto his paper and thought, Well, that looks nice, scanned it in, and went from there.

BLVR: And weren't NASA pictures somehow involved?

TY: Me and my son got into watching the shuttle live. And one day I ended up at the gallery to the NASA page, which is fucking amazing. So all my input ended up being, "Here, look at these NASA pictures."

BLVR: So you'll continue collaborating with Stanley on artwork? This isn't the end of Radiohead album art as we know it?

TY: No, we've actually got a really good plan, but I can't tell you what it is, because someone will rip it off. But we've got this great idea for putting things out.

BLVR: In a digital realm?

TY: In a physical realm and a digital realm. But, yeah… no, I can't tell you what it is. [*Laughs*] Sorry to be so vague about everything.

BLVR: Other than just the physical quality of the music, the move toward digital is killing the traditional music label.

TY: Yeah, there's a process of natural selection going on right now. The music business was waiting to die in its current form about twenty years ago. But then, hallelujah, the CD turned up and kept it going for a bit. But basically, it was dead. So you have this top-heavy infrastructure. The press is top-heavy in the same way. You think, Why are these people surviving? Well, because they just started reissuing the back catalog.

BLVR: So it seems like you don't really consider this transition a loss in any way whatsoever?

TY: Vinyl sales have gone up, you know. It's no great shame that labels and CDs are gone.

BLVR: Will less physical musical production mean less plastic and carbon energy?

TY: That's not entirely true, because, you know, all the servers have to run. All the big providers are trying to work out a way to reduce the energy waste of the servers. It's a massive ecological disaster. The servers themselves are built like small rack things and they're all running at the same power, day in, day out. But they're not being used at capacity at all. And there are fucking huge buildings full of them. It's apparently a huge expense for the providers and it's a huge energy waste.

BLVR: And that's worse than all the plastic?

TY: Well, I don't know. I don't know how to weigh them. That's when

you have to pay the twenty thousand dollars to the experts. The virtual world is not going to be environmentally safe until they find a way to rationalize it.

III. FORTY MINUTES OF BLOOD AND SWEAT ISN'T ENOUGH

BLVR: One of the aspects of your pay-as-you-will method was that people could pay up to $99.99, right?

TY: Yeah.

BLVR: So why did you set that limit? Why would you say it's OK for people to pay you a hundred dollars for this album?

TY: It's not. You're barking mad if you do that.

BLVR: But people did it, right?

TY: Yeah, yeah. Uh, why did we do it? Honestly, those meetings were so, so intense. I mean, they were really fun, but we were making it up as we went along. The ninety-nine-dollars thing came as a limit, because we didn't want people showing off, saying, "Look how much I've spent!" But I guess the ninety-nine dollars was bad enough.

BLVR: How many people paid full price?

TY: I don't know. There were a bunch. I've got all the figures somewhere, including a country-by-country breakdown.

BLVR: So you can see which nationalities are the most frugal.

TY: Oh yeah, but I'm not going to talk about that.

BLVR: People talked a lot about paying as little as they want for an

album, but you didn't hear a lot about people paying as much as they wanted. If you keep thinking about this idea a little, with people giving money to musicians, you start thinking that artists could start functioning, at least financially, almost like nonprofit organizations.

TY: Sure, but that sounds mawkish. For us, it was more about a statement of belief, like, "We believe the people find music extremely valuable and we're going to prove it." Everybody else was like, "Oh, it's the end of the world, the sky is falling in," and we decided to figure a new method. But then again, it depends who you talk to in the band, because, to me, the whole name-your-own-price thing was definitely secondary to being able to leak it ourselves, rather than having some guy at a record plant do it. And that was where I was coming from. But we're a funny bunch. All these ideas came from a group of fifteen of us, sitting around a room, saying, "Yeah, that will work." Most people would think, That will never work. A lot of it came from Chris [Hufford, Radiohead's manager]. If it didn't work, we could've just blamed him.

BLVR: Do you think it worked?

TY: Oh, yeah. It worked on two or three different levels. The first level is just sort of getting a point across that we wanted to get across about music being valuable. It also worked as a way of using the internet to promote your record, without having to use iTunes or Google or whatever. You rely on the fact that you know a lot of people want to hear it. You don't want to have to go to the radio first and go through all that bullshit about what's the first single. You don't want to have to go to the press. That was my thing, like, I am not giving it to the press two months early so they can tear it to shreds and destroy it for people before they've even heard it. And it worked on that level. And it also worked financially.

BLVR: Do you think this method would work for other bands who aren't as known as Radiohead?

TY: With the press, we're in a lucky position where we don't really have

to rely on a reviewer's opinion, so why would we let that get in the way? If people want to play it for themselves, why don't we just give it to them to listen to? I just don't want to have to read about it first.

BLVR: And that style of release definitely promotes the album as a work of art, rather than as a bunch of singles floating around the internet.

TY: Oh, that's interesting. I appreciate that. Unfortunately, a lot of people got the album in the wrong order.

BLVR: What about the idea of an album as a musical form? You think that format is still worthwhile amid iPod shuffling?

TY: I'm not very interested in the album at the moment.

BLVR: I've heard you talk a lot about singles and EPs. Is that what you're moving toward?

TY: I've got this running joke: Mr. Tanaka runs this magazine in Japan. He always says to me, "EPs next time?" And I say *yes* and go off on one, and he says, "Bullshit." [*Laughs*] But I think really, this time, it could work. It's part of the physical-release plan I was talking about earlier. None of us want to go into that creative hoo-ha of a long-play record again. Not straight off. I mean, it's just become a real drag. It worked with *In Rainbows* because we had a real fixed idea about where we were going. But we've all said that we can't possibly dive into that again. It'll kill us. It's also linked up to this whole thing about what is the band, what is the method of how we get together and work. But you know, Jonny [Greenwood] and I have talked about sitting down and writing songs for orchestra and orchestrating it fully and just doing it like that and then doing a live take of it and that's it—finished. We've always wanted to do it, but we've never done it because, I think the reason is, we're always taking songs that haven't been written for that, and then trying to adapt them. That's one possible EP because, with things like that, you think, Do you want to do a whole record like that? Or do you just want to get

stuck into it for a bit and see how it feels?

BLVR: Certain ideas seem like they aren't meant to be forty-five minutes long.

TY: Yeah. I mean, obviously, there's still something great about the album. It's just, for us, right now, we need to get away from it for a bit. But it's important to keep it going. The CD-reissue thing almost killed it, because all the labels were like, "Seventy minutes! Let's fill it up! Blah, blah, blah." So you get all the bonus-track shit. The majors used to put huge pressure on us and everyone to put extra stuff at the end—you know, to give the shop something extra to sell. All that fucking crap. As if your forty minutes of blood and sweat isn't enough. But basically, they were charging too much for the CD—they knew it, and they were trying to justify it with extra stuff.

BLVR: Thinking about it, digital albums could really be any length these days. You could make it five hours or you could do a Stockhausen thing and—

TY: What? With the helicopters? [Stockhausen's *Helicopter String Quartet* was written for string quartet and helicopter.]

BLVR: Yeah. He also wrote an opera that lasted seven days.

TY: Nigel wants to do this thing where, I mean, I know it would be awful, but hey…

BLVR: But hey…

TY: He says, like, OK, we book in for three days, and at the end of the three days we put two tracks up every week and we do it for six weeks. I mean, it'll never happen, but that idea of, we put it out even if we don't know what it is and then, oh dear, it's out.

BLVR: Almost like an automatic-writing process.

TY: To us, that's completely against everything we normally think. This may be shit. We don't know. We haven't had time to realize it yet. You know, that sort of thing. But that kind of gives the game away, because, actually, we are shit. And that's why it takes three years to uncover the stuff underneath. The lyrics, I know, would be appalling. Jonny's really big on increasing our output, though. He has a better way of saying it. Like "knocking shit out" or something. He can't stand it anymore, the pace of the way we work. It's fallout from all our false starts.

IV. THE DEATH KNELL
OF AN AGING ROCK BAND

BLVR: In some ways, the way internet singles work is close to the way things used to be with the music industry in the '50s, before full-lengths were the thing, and radio singles were what defined artists.

TY: Right, and if you forget about the money issue for just a minute, if it's possible to do that—because these are people's livelihoods we're talking about—and you look at it in terms of the most amazing broadcasting network ever built, then it's completely different. In some ways, that's the best way of looking at it. I mean, I don't spend my fucking life download-ing free MP3s, because I hate the websites. No one seems to know what they're talking about. I'd much rather go to sites like Boomkat, where people know what they're talking about.

BLVR: Boomkat is great.

TY: It's brilliant. To me, that's a business model. It's like when I used to go to music shops in Oxford. You're looking at this and you're looking at that and there's a whole line of other things going down the side saying, "You'll probably like this," and, "You might like this."

BLVR: I love those stores where everything's hand-selected and the

clerks write little descriptions about the music.

TY: Yeah, and you can listen to it all. I mean, Boomkat is very specific with the type of stuff they flog there, but I can't see why that wouldn't work for all music.

BLVR: Actually, I think it was on one of those types of blurbs where I read the "return to form" phrase for *In Rainbows*, which I've heard about twenty times since.

TY: [*Snorts*] But have you not noticed that they always say that? That's the death knell of an aging rock band right there.

BLVR: Well, it also doesn't seem like there's a form to return to.

TY: We're formless motherfuckers.

BLVR: Do you feel like there's any definitive sound that you've been solidifying over your career?

TY: I fucking hope not.

BLVR: There's this idea of Radiohead as a band who is always in transition.

TY: It just always feels like, we've gone down that road now. We've done that now. That's that. *In Rainbows* was a particular aesthetic and I can't bear the idea of doing that again. Not that it's not good, I just can't… bear… that.

BLVR: Do you think it's really possible for artists to stay static anyway, to take one idea and develop it on the micro level over an entire career?

TY: Solo artists can do that.

BLVR: Yeah, seems like it would be impossible to stay static in a band.

TY: Absolutely, completely, utterly impossible, at least in our band. I mean, because everybody wants different things. Everybody brings different things to it. Jonny's got his thing. He'll always be trying to get extra things in there.

BLVR: Extra things?

TY: Yeah, come on, we need some wrong notes, he's always saying. OK, you got 'em.

BLVR: So what's the next sound?

TY: As a band we haven't gotten together much. I've just been working on stuff.

BLVR: Electronic?

TY: Well, yeah, 'cause my inability to play drums dictates certain electronic drums. Computers are pretty nice at tidying you up. It's great. Actually, it's not that great... but I've been working, keeping myself going. It's like a limb. I need to keep exercising it. Otherwise it goes dead, floppy. ✶

TRENT REZNOR

[MUSICIAN]

"LET'S CUT THIS PARASITIC MIDDLEMAN GANGSTER OUT OF THE EQUATION, THE THUGGY RECORD LABEL BACK-DOOR BULLSHIT. HOPEFULLY WE CAN GET A BRIGHT LIGHT SHINING ON IT AND, LIKE A COCKROACH, IT'LL DISAPPEAR."

Musical roots of Nine Inch Nails:
Melody
Choruses
Traditional Beatles-esque pop-song skeletons

Few comebacks in pop music are as well laid and well-timed as Trent Reznor's return as Nine Inch Nails in 2005. The high-water mark of the band's cultural relevance had come and gone eleven years prior, with "Closer," a single from their sophomore album, The Downward Spiral, announcing the height of industrial metal—a marriage between samplers, sequencers, and distorted guitar riffs that was equally informed by Big Black and Europe's electronic body music. The album galvanized the band's cult, but its success apparently stunned Reznor, and the immaculately produced, eerily insular follow-up, The Fragile, took a full five years to appear. Though the album was manna to fans, it also threatened to paint Reznor as a one-dimensional angst merchant.

In the last four years, Trent Reznor has managed to be nearly as produc-
tive as he was in the entire first fifteen years of his band's existence. NIN
2.0 consists of Reznor embracing social media and taking more control
over his marketing—changes that coincided with some major develop-
ments in the music business. His latest release, 2008's The Slip *(The Null*
Corporation), was distributed as a free download, and an alternate-real-
ity game surrounded the release of his album Year Zero, *part of which*
involved strategic leaks via MP3-loaded USB drives planted in unassum-
ing locations.

On the eve of taking a hiatus from touring, Twitter, and potentially
the NIN moniker entirely, Reznor met with me backstage at the Shoreline
Ampitheatre before the band's last Bay Area show (for the foreseeable
future). After meeting his fiancée, Mariqueen Maandig of the L.A. band
West Indian Girl, I sat and Reznor stood as we discussed the origin of his
Twitter avatar (a screenshot from vintage arcade game Robotron: 2084*),*
his future plans, the state of major labels, and why "Make cool shit" is his
new imperative.

—*Brandon Bussolini (February 2010)*

I. THE COLLECTIBLE MINDSET

THE BELIEVER: Right now, people talk about albums less as stand-
alone artistic statements than as advertisements for the live show, where
most of the money is being made. Is this true of NIN at this point in
its career?

TRENT REZNOR: What's happened the last few years, certainly since
we've gotten out of being on a record label, is I've noticed the amount
of time I spend thinking about stuff that wouldn't have been considered
the artistic portion of being a musician—the marketing, presentation—
stuff that, under the shell of the old system, you didn't have to think
about because you didn't have much say in it anyway; your job was
clearly defined as making music, work on the art part, fight the label
to get your vision out, see what happens. As that system started to not
work anymore, and the record labels have collapsed, it really feels like

your role as a musician today, whether you want to accept it or not is to think about... you now have a lot of power you never had before. That's the power of distribution—all the strangleholds that those labels had sewed up—are gone. Anybody is a broadcaster and a publisher. I can get headlines now from a Twitter tweet rather than going through a publicist and hoping the journalist says what I said accurately, whatever it is, and doesn't portray me as an asshole. You do spend a lot of time as a musician now, at least I do, thinking about how you're going to present yourself.

I grew up in the era of vinyl, there were records, the album—whether or not the reason it came about as a way to make more money for a record label doesn't matter—I looked at that as an art form. That thirty-to-forty-five-minute chunk of music, with songs that relate to each other—that's the format that Nine Inch Nails works best in. That's the format that I prefer as an artist. As a fan of music, I never listen to greatest-hits records. I've never put shuffle on my iPod. I like to hear things the way they were meant to be heard. That might make me a Luddite or outdated or antiquated or whatever, but as a band that's how I think about it. And forgetting about business for a minute, forgetting about selling records and all that, but just as an artist, what I've found these days, let's say you spend six months to a couple years working on an album—that masterpiece, that hour of greatness. The second it leaks—the consumption rate to the public is so fast now that it's been reviewed, criticized, critiqued, put on the shelf months before it's even available traditionally for people to buy it. If I had a fifteen-song full-length record now, ready to go today—if it lent itself to it, I might split it up into five three-song EPs that come out every couple weeks. And that would give me five spikes of interest instead of one. Because as soon as your record leaks, it's like your cards are on the table, and everyone's on to the next thing: the collectible mindset.

BLVR: So the physical release would be a collection of the EPs with deluxe packaging, along the lines of what you did with *Ghosts I–IV*.

TR: As the artist, I want as many people to hear it as possible. There is

no radio anymore. How do you get it out there? Let's remove all hurdles from you listening to my stuff, which usually means make it free and make it not complicated to get it and encourage you to share it with people. It does also mean it's a bitter pill to swallow coming from the structure of a major-label contract where you do this work and you get paid for people buying this piece of plastic. If your job suddenly said, "Hey, guess what, we don't want to pay you anymore, but keep doing it…" I remember ten years ago—it must be more than ten years ago now—going into a college kid's dorm room and realizing everyone listened to music on their computers. What? Where have I been? Maybe I should give this iPod thing a chance.

BLVR: Do you feel like these new responsibilities take away from time you'd lavish on the act of making music?

TR: I have thought about that, and I would agree that, right when we got off Interscope, there was a period of time when all I did was think about this puzzle—there's got to be a solution to this riddle right now. And I kind of got obsessed with it, I spent time reading everything I could on the internet: what's this new startup, what's the business model that makes sense, and why it sucks and why the record labels are wrong about this and this, and why this band fucked up, and why subscription models on a band-by-band basis don't make sense. Every minute I'm spending working out this problem I'm not spending writing a song. And the problem is there's nobody else that is figuring it out—the record labels aren't, and most managers aren't because they're as caught in the headlights as everyone else is. If you're doing anything that's remotely indie or interesting or outside the KROQ playlist, there's no upside whatsoever to giving away the rights to everything else you have to be on a label that doesn't know what to do anyway.

I'll tell you what feels great—and I would encourage any artist to strive for the day they can pull this off. With the last couple records, it was literally: finish in the studio Friday night, Saturday morning drive it over to mastering to get it EQ'd, and put it up on the internet the same day. That was wildly exciting. I mean, it may not sound exciting to the nonmusician,

but usually there's a two-to-eight-month gap between when you last listen to it and the day it shows up in the stores. I've had some young bands say to me, and rightfully criticizing me, saying that what I've come up with for Nine Inch Nails works for a band like Nine Inch Nails, that has an established fan base and has a track record and also has reaped the benefits of years of support from labels. That's a valid criticism because giving a record away free as an unknown band doesn't do you any good, because no one knows who you are and you're not going to make any money from live shows because nobody knows who you are.

BLVR: You've also been on the other side in the '90s, running your own label. How does doing what you now do with Nine Inch Nails, taking control of all facets of its existence, compare with running Nothing?

TR: Nothing Records was an interesting and ultimately failed experiment, where Interscope at the time had money to throw around. The success of that was finding Marilyn Manson, finding them, and I do believe having the barrier of me helped let them do what they wanted to do, to allow it to come out and be in a pure, un-watered-down form.

In the case of Manson, you got to see an egomaniac turn into what he truly is. I got a taste of being the bad guy, running the record label and being blamed for everything that doesn't work out right, and that kind of sucks. It did what it did; we kind of got lazy, to be honest with you. It wasn't the full-time thing I was thinking about. Plus, at the time I was also getting sucked into a world of addiction. So it ran its course. It mainly taught me what I'd never want to get into in the future. If I can provide an infrastructure that helps the musicians get going, then great, I'm all up for that, and I'm actually working on trying to pull that off.

I think the downfall of most major labels—most labels in general—is the way that they choose to spend money and recoup it. The scam of what labels have done is traditionally complete thievery—you lend me money to make a record, you make the lion's share of the profits. When I pay it back, you still own it? How does that work? "Oh, well, that's the way it is." Who the fuck says that's the way it is? "Starting with Elvis Presley, that's the way it is."

II. AN AIR CONDITIONER IN THE BACKGROUND, A WEIRD BUZZ, AND YOUR STOMACH HURTS

BLVR: Looking at your history as a musician, and what I can gather about your personal life as well, it seems like the way record labels have traditionally operated may have contributed to a sort of drawing away from the world. When you look at the release schedule of the last couple of albums, you've released—in the same amount of time you'd usually take between albums when you were on Interscope—about the same amount of material that you put out in the preceding decade.

TR: A lot of that has been dependent on getting some of my own demons out of the closet and getting my head screwed on straight and getting sober, and also identifying that the prime factor causing these big delays was my own fear. Not thinking I was good enough—what if it was just luck that I wrote a good song once, just crippling myself with unrealistic expectations and setting myself up to fail by saying, "Here's a blank piece of paper: write the best song ever. Go!" "Uh, I'd rather have a drink."

One thing I do think is good now, with the collapse of all this and the splintering of niches: nobody can get real big, but lots of people can get attention. Nobody's going to sell five million records today that I can imagine, aside from Coldplay, but if you're into alt-country postpunk, there's some blog, there's some radio station out there on the internet that plays that sort of stuff. There are like-minded people you can find that somehow know the same bands that you do. "Make cool shit" is a much greater statement today. There are no Kevin Weatherly superprogrammers that get paid to pick who the next stars are; they don't have any power anymore. An interesting, weird time. Let's cut this parasitic middleman gangster out of the equation, the thuggy record label backdoor bullshit. Hopefully we can get a bright light shining on it and, like a cockroach, it'll disappear.

BLVR: You launched the band in Cleveland, where you famously worked in a studio as a janitor and got access at night to work on the NIN demo.

What were you recording before you started there? NIN is very much a beast of studio perfection, so I wonder how you were working before you had access to a professional studio.

TR: My first real intensive songwriting was NIN-based. I wasted a lot of time avoiding writing because I was afraid it would suck—a recurring theme. I could play keyboards in your band and I could tell if that song wasn't that good, but I was afraid to find out if my own stuff sucked. So I became sideman to all bands in Cleveland at one point. By the time I really got into writing my own stuff, I had access to that studio. I could use a real 24-track tape machine if I knew how to work it. It was a good place to cut your teeth. Many years later, anyone who's got a computer basically has a full recording studio, and that's a great tool to have.

BLVR: Do you rely on computers for sketching out ideas that you flesh out with outboard synthesizers or a more expansive studio?

TR: My setup at home now is pretty small—it's basically a computer with a small SSL console, so if I get an idea, it's recorded at full fidelity. We actually mixed the last couple records there. But the computer has become so integral to how I write music—the computer *is* the sketchpad. If I'm on the road I use Ableton Live. I love that program because it runs on everything and it's inspiring. It's like a songwriter hanging out in your laptop bag with you. The line is blurred now, where a lot of a demo I record in Ableton becomes the final recording. I learned that long ago with vocals—good luck trying to beat the first take, 'cause that's the one you're going to end up using on the record, so try to get it recorded well the first time. You try to go back and really record it right, but you don't realize what made it right the first time was that you couldn't hear yourself. There's an air conditioner in the background, there's a weird buzz, and your stomach hurt. I learned to treat every moment like it's the real thing.

BLVR: In addition to your recording, your look changed markedly when you came back for *With Teeth* in 2005. Do you subscribe to any particular diet or workout regimen?

TR: I'm sure it's some kind of midlife crisis. It really was trying to take care of myself. I was very afraid when we started touring in 2005 because it was the first shows I'd done sober. I'd had a terrible experience on the tour before that, in 2000, where I was sick all the time. If I didn't drink before I went on, I'd get sick and throw up. It was terrible. I felt like when you go on stage, it's like going into combat, you get picked apart by everybody. I wanted to go in feeling confident in myself. I thought I'd get in really good shape—that's the incentive, walking on stage thinking, I can get through this, I've got some kind of armor on. It was also about discipline. I learned about discipline getting clean; I went from a life of excess and lawlessness to realizing the upside of discipline, work, work ethic, and all that.

III. EIGHTEEN YEARS OUT IN THE CORNFIELDS OF RURAL PENNSYLVANIA WITH NOTHING BUT FM

BLVR: As far as genres are concerned, Nine Inch Nails has been pegged as an industrial band for a long time. But the band is unusually songful in comparison to canonical industrial groups like Throbbing Gristle or 23 Skidoo, and there are strong whiffs of techno, pop, ambient, and metal in your sound. How much do you identify with the term?

TR: I always liked the sound of Skinny Puppy; it sounded like Skinny Puppy. Now, the range of that was pretty narrow, but it definitely was discernable—you could tell that's what that was. I realized over time that, from my own perspective, we weren't as narrow as that, for better or for worse. I don't mind the term *industrial*. I understand where it's coming from. I also understand why it's polarizing to those who know what it really means and where it really came from. I highly respect those bands—the Throbbing Gristles and Coils and Test Depts of the world—they've influenced the sound, and the use of noise and texture, and I appreciate the experimental nature of them. Nine Inch Nails has been rooted, whether I want it to be or not, in pop-song structure: melody, choruses, traditional Beatles-esque pop-song skeletons. I can't

say that that was a formula I came up with, I think it's more the result of spending eighteen years out in the cornfields of rural Pennsylvania with nothing but FM, mainstream radio, and AM radio, and getting hooks drilled into my head my whole life. I like the idea of presenting something that was complex but tangible, that had entry points. The frustration with a band like Skinny Puppy for me is that I wish there was a chorus once in a while, and I wish there was something you could hum, something you could come back to.

BLVR: I found myself looking at Nine Inch Nails' history as one of pop-music fandom—the records that Nothing was distributing by acts like Autechre and Meat Beat Manifesto, or the bands you're bringing on tour with you, like Deerhunter or White Williams. How are you finding out about music now?

TR: There was a period of time that kind of coincided with being a drunk—I was convinced that I was gonna dig within for inspiration. Usually that meant going back to stuff like early Bowie or exploring Lou Reed's stuff. Everything felt like, today's coolest new band is basically just Joy Division, and the other great new band is just Gang of Four, kind of preying on people that aren't that familiar with Gang of Four to know it's exactly the same thing with a new name, minus the cool political lyrics. I started exploring out and over the last several years I've found lots of things that I think are really good. That usually comes to me from *Pitchfork, Brooklyn Vegan,* or *Stereogum.* I don't get it from the radio, which I don't listen to unless I'm in a rental car and there's no other option. If I stumble across bands like that that I think are cool, if I think that it might be respectful for them and I think that they might have an OK time in front of our audience, then I'll approach them if we're in a touring situation. We're faced when we go on tour with the question at the beginning: are you big enough to fill the space that you're going to play? And the answer usually is no, you're not.

The last several tours, I've tried to take bands that I like and that I think it would be interesting to them to be thrown in front of a strange environment, take them out of Spaceland and put them in an arena

somewhere. And not set them up to fail, but prop them up as much as we can. Make sure they have a sound check and use our lights and do whatever you want with the sound and see what happens. I figure if one out of ten people who go to that concert leave at least knowing the name of the band and think, Hey, that was pretty cool, or, I fucking *hated* them: mission accomplished. You've made some kind of impact.

BLVR: On the subject of touring and the hiatus you've just announced, does this mean Nine Inch Nails is going to continue as a sort of home-recording project, or are you looking to move forward altogether?

TR: We've toured so much since I reemerged in 2005 that it's on the verge of feeling like it's a duty versus something I love to do. It hasn't crossed into that yet.

Here's what it feels like to me:

—Hey, guess what, we're pregnant with a new kid.

—Wow!

—Guess what! It's his first birthday, do you want to come over?

—What?

—Guess what, he's two now, come on over and…

—Wait, it seems like it was only a couple months ago that you were…

Because the real world has been progressing on, and my world has been touring around, living the same day over and over again in different hotels. The other thing is that there are some ancillary things I've been wanting to do for the last five, six, seven, eight years that I never get around to because there's a tour or there's a record—your main job has become something that's eating up time. Part of that falls into the whole *Year Zero* thing, and the narrative that went with that. We've actually just pitched that to the BBC as a limited TV series. And I'm also working on, as I mentioned, a kind of infrastructure that may work for other bands, that's not a label. I'm sure there's going to be a NIN tour at some point, maybe. I will definitely tour in some capacity and kind of get myself into the unknown a bit and see. I don't wanna stay comfortable, and it feels comfortable to me right now. I want to fuck some things up, lose my audience and have to gain them back. ✶

M.I.A.
[RECORDING ARTIST]

"ART GETS REDEFINED ALL THE TIME
BY WHOEVER NEEDS IT MOST. IT'S
ALSO ABOUT REDEFINING YOUR NEW
ENVIRONMENT. NOW THE INTERNET
HAS BECOME OUR ENVIRONMENT."

Useful tools for an artist:
Critical thinking
England
The internet

I n early May, the Believer *sat down with M.I.A., a London-born Sri Lankan, former art-school student, and current Interscope recording artist, on the eve of her third album. Her new music seems to come from everywhere and nowhere, appropriately enough for an era when "pop" and "world music" are no longer opposed categories but increasingly one and the same. For the music biz, this is the meaning of "globalization."*

And yet the music also comes from a person: Maya Arulpragasam, slight, chattily articulate, intensely watchful. As we spoke, she referred frequently to images and sounds on her customized computer: a laptop in "M.I.A. colors" that her fiancé, Ben, had gotten her special, in anodized yellow gold with blue keys and a red trackpad.

Like her music, M.I.A. has a paradoxical relationship to place, alternately wandering and being stranded throughout the world. At the time of this interview, she was fixed in London, unable to get a visa home, in this case to Brooklyn. This is a family tradition: her mother (ostensibly because of connections to Maya's father, a significant Tamil figure in the Sri Lankan civil struggles) had been unable to travel for some time.

This is not M.I.A.'s only contradiction. After releasing the no-samples-cleared bootleg Piracy Funds Terrorism—*a title almost no other artist could say and mean—her breakthrough single, "Galang," went on to sound track a Honda commercial, and consequently earn skepticism toward her politics. And yet her second proper album,* Kala, *managed to have the most thrilling political anthem of the decade, "Paper Planes." Elsewhere on the album, hiding from nothing, she insisted she was "dogging on the bonnet of your red Honda."*

Rioter or passenger, outsider or insider, revolutionary or sellout? The categories don't work so well these days, if they ever did. This is the point, inevitably, of the music, and it is the music that matters. It is art for a moment when categories aren't working very well, when things are falling apart and centers aren't holding. It does not try to contain this situation but to register it, to give it a feeling, to get a sense of whether it might indeed be late in something—pop music, history, the U.S. empire. We discussed these matters, her family, terrorism, and, most of all, the internet.

—Joshua Clover (July/August 2010)

I. THE DAY THAT ISRAEL AND PALESTINE SOLVE THEIR ISSUE IS THE END OF THE WORLD

M.I.A.: It's a really interesting time for musicians because you really have to be a distraction now. You need to be ready to be exploited at all times, to be a distraction when there's real shit going on. And that's what Lady Gaga does so flawlessly and amazingly, and that's why I'm such a liability. But I'm just optimistic about the long run, because I think that's what it's about—you have to train your brain not to believe the hype.

THE BELIEVER: What do you have to train your brain to do as an artist?

M.I.A.: Critical thinking.

BLVR: Critical thinking. What does that mean to you?

M.I.A.: You are the same as everybody else; just because you're an artist or a musician doesn't elevate you into this—yeah, it does, actually. It elevates you into a bubble and then you go crazy and then you die.

BLVR: How's that going for you?

M.I.A.: I've managed to burst my bubble about three times, so I've saved myself a few times. The important thing is teaching yourself critical thinking—to take in everything from everywhere and judge it from what you see in front of you. I'm here in London, but I live in my mum's council house right now with my baby and my fiancé. I think it's a good reminder, the everyday issues that my mum has. It's important for me to go and observe it and watch it and listen to her and what her lifestyle is like, and not get caught up in it. I have the opportunity to escape it, so I'm going to. I think what she's going through is not unique to her, but it's what a lot of people are going through in London. It's expensive, can't do this, can't do that, da da da. This area's changed, there's more guns, you know, knife crimes down the street.

BLVR: She's entirely disallowed from traveling by the government, and she's a grandmother now? That must be hard for her not to be able to visit.

M.I.A.: It's interesting that with all the sophistication and intelligence of both these governments, the person they've discovered is the center of this thing is my mum. That's what it takes, millions of dollars of intelligence.

BLVR: You say you feel at home in different ways in London, Brooklyn,

Los Angeles. Where do you think your son is going to feel at home when he's your age?

M.I.A.: China.

BLVR: Can you tell me how to pronounce his name?

M.I.A.: I-Kid. If you were in a Muslim country it would be Ikhyd. It's an Israeli and a Palestinian name put together.

I was watching this, you know, History Channel thing. America's obsessed with the apocalypse and the end of the world. That's where I got it from. I was 100 percent optimistic before this, but now I have, like, issues of things creeping in from watching this shit everyday.

BLVR: If you were in a country that had run the world for eighty years and it was coming to an end and you knew that, wouldn't you make a lot of movies about the apocalypse, too? It's a way of people trying to understand the end of the era.

M.I.A.: Yeah, it's true, it's true. It's interesting watching it from inside. But, yeah, when I was watching all this stuff and they had one documentary about Isaac Newton, who'd decoded the world, and they were like, the day that Israel and Palestine solve their issue is the end of the world. That was the latest.

BLVR: In a good way, I hope.

M.I.A.: Yeah, that's when they said the Antichrist would come down…

BLVR: Good to know. I'll prepare myself.

M.I.A.: Yeah, well, that's why we named him Ikhyd—because we hoped it would happen in his lifetime, you know, and that he would symbolize that. Those were the two things that were on the forefront: the internet versus mankind—you know, man and machines—and Israel and

Palestine. Those are two things that are gonna be carried over into the future. I think the rest are pretty irrelevant. I always say he's the poster child for oppression because he's a Tamil black Jew.

The latest news that did that to me is the Moscow incident [the bombing of two subway trains in Moscow in March 2010, allegedly by Chechen rebels, including the teenage widow of a martyred leader] where you had a seventeen-year-old girl who went and blew herself up. It's interesting because whenever her face came up on the news, it's so amazing and it's the best photo I've seen in years and the most iconic photo—but they never talk about why she did it and what happened, even though that message they put with the dude, you know, the leader, going, "We did it because you bombed us." I only actually heard that once in about 250 different stories I've probably seen this week, and that's the problem. Nothing ever goes to the root of the issue.

BLVR: It seems that when you get a case of marginalized people, one of the forms of marginalization is that they're not allowed to believe things. Once you get past a certain level, it's not belief, it has to be something else. Either it's crazy passion, or love, or madness, or whatever, you know, but it's not possible that she believed a thing and acted on that belief.

M.I.A.: Yeah, yeah, yeah, they wanted to do the romance thing! You know, a modern-day Bonnie and Clyde. I think it's nice and I like that. I am a sucker for one of those—I would totally have that as a symbol of romance. But I actually want to know what the hell happened before it. I want to know how he died, but I also want to know what the campaign was before that, by the government, that pissed all these people off and how many people died in that situation. No one's ever gone back that far.

I feel really bad for these people on the train, but I also feel really bad for her. Why was she put in the situation to want to end her life at such a young age? Summing it up, you're either a propagandist or you're this or you're this. You know, and not actually being responsible enough to be like: actually a lot of governments are really greedy. What is going on under the surface never really gets discussed. And in America it certainly doesn't get discussed, and I think, I don't know, it puts me off the press.

II. "I HAVE A CHILD. I CAN'T WEAR
A TELEPHONE-HEAD HAT, IT'S
JUST NOT GONNA WORK."

BLVR: I want to go sketch a history that raises questions about the future of art. If I think back to the Italian city-states in the fifteenth century in Florence and so on, the Renaissance era is defined by painting; so is the Dutch empire, more or less. The British Empire is very much a literary era, novels and poetry—and then you get the American era of the twentieth century, the century of movies. On the one hand we're coming to an end of the long twentieth century. It's going to get uglier, but I think its gonna eventually end, transform. You said "China," and that's one of our best guesses about what the next center of the world will be. So the accompanying question is: what is the art of that era going to be like?

M.I.A.: It's interesting. To me, the best bit of art that I've seen in the last ten years is, I think, the execution video from Sri Lanka. You know, where all these Tamil guys are blindfolded and shot in the head. It's filmed with a telephone. And the second bit is the photo of the seventeen-year-old girl who blew up the subway train in Moscow, and her first name is Dzhanet, which sounds like "internet," and her last name is Abdurakhmanova, which sounds a bit like "burkaman"!

I just think on the internet art is like that photo for me, and that's her name, and it's one photo released to the whole world, everybody saw it, it went out. So what do you want? You want a billion hits on YouTube of your crappy video. And then a girl like that has a cause, and she died for it, for what she believed in, and she got more than a billion hits in a day, you know? Those things are really, really interesting to me. I feel like I believe in that. I'm one of those people that vote for that. The internet was created to give people the power, and it's gonna be whoever—whether they die for it or not, and whether what they have at the end of the day is art or not—we're the people in the middle who are going to contextualize it.

BLVR: That puts you in a funny position, though. You're an artist in the sense of an intentional artist. You think very carefully about what you want to say and the sounds you want to make, and then you do it, but the person who took that photo, the person that took that cell-phone video—they didn't wake up that morning saying, "I'm an artist."

M.I.A.: I think that they are the ones that own the internet, those people who are not waking up every day going, "I'm an artist." All artists are product sellers, so the blanker you are, the better you can sell some shoes.

BLVR: But isn't that a style too? Like the style of no style? Where I don't have a stylist, I don't wear the shoes, I don't play the game. Isn't that a game too?

M.I.A.: No. I wake up in the morning and I have to, like, deal with my son and all the shit he's doing, jumping on sofas and doing backflips and feeding him and duhduhduhduh. Then I deal with the phone calls, then I get in a cab and I have to go somewhere. Whatever I could throw on in the morning is my style. It's not that I'm consciously like, "I'm not doing a style." And in terms of sorting out a style, I just don't want to look like Lady Gaga, that's just not practical for my lifestyle. I have a child, I can't wear a telephone-head hat, it's just not gonna work. I can't wear those Alexander McQueen shoes, because I'd never be able to chase after him fast enough.

BLVR: So what's art for? Politically or in other senses, what's art's function?

M.I.A.: Art gets redefined all the time by whoever needs it most. It's also about redefining your new environment. Now the internet has become our environment. A lot of us stare at the screen for a long time, and you need eyes to redefine that space.

My position in the world, in the future (which I do have to think about), is different. It's our duty to teach critical thinking. And that's the thing about China and the future of the internet—it's interesting

because intellectually, they're probably the most sophisticated people, who can take this tool to a level we don't even know yet. But at the same time, creatively, the ideas are not there yet. So the creativity and the ideas come from the West, but technical ability and the tools come from the East. India is a perfect example, because India can produce *Star Wars* for a million dollars, you know, where in America it costs 250 million. But the day they work out how to write that script that's not cheesy and hasn't got eight songs in it with a big fight scene that's like da-da-da-da [fake punching noises]. The day they figure out how not to make soup and gumbo out of film and do culturally tuned-in ideas that appeal to the West, then we're gonna be fucked.

III. NECESSITY PEOPLE

BLVR: When the internet was first sort of getting its shit together, it seemed like it was a place where people who didn't have a lot of money, didn't have a lot of access, could get their message out. I think about the Zapatistas in the mid-'90s who used the internet and email in these adventurous, virtuosic political ways. But now, as you say, inevitably, the money moves in. So you think that era is over, where the internet is a sort of Wild West?

M.I.A.: Yeah. It's really depressing. But that's why creatives exist. They have to work out how to get around that. To keep it free, to keep it good for people, to keep it accessible, to keep it cheap, and keep it, you know, dictated by values that are not run by money.

BLVR: So let me ask you to be your own shrink for a second. Obviously, this album is interested in the internet, and the space of the internet as a place for art. How much does that come out of a really insightful analysis of what the future looks like, and how much does that come out of your own sense of being attacked on the internet all the time—it being a place where people can talk shit about you freely?

M.I.A.: That's just knowledge. If you open up *Forbes* magazine, you

know that all the blogs are owned by, like, two companies. Which is the trickling of owning every small blog. In England, for example, all the middle classes are broke, businesses are shut down, everyone's closed their shops, the shops are for sale. You take California, where the internet is the most prevalent industry—the businesses are closing down, all this stuff is happening. Then you go to a small blog, and you're running this sort of blog-run company, and then people find you and buy you out, and you take the money, and the next minute you have to put the banner on there that advertises something that you don't really care about, but it works. Before, you could just be on YouTube and look up, like, a Depeche Mode video, and now when I look it up I see an army advert.

I don't know, I was watching this documentary on Google, they were saying it's the biggest corporation in the world and they're stronger and bigger than any governments in the world because they collect all this data and they've got everybody's data, but they don't know what to do with it yet. But the day they work out what they do with it, or the day they decide to hand it over to the government, we're all going to get off Google. Which means someone, somewhere, has got to be developing the next Google. Right now, because that day is coming. It's already in the making. And that's what it's about. It's about having places that people could go.

BLVR: Are you going to keep on releasing songs freely over the internet? You've been doing it for a while, going back to "Sunshowers," and then recently, with the video you released on Twitter. Is that something you're going to keep on doing?

M.I.A.: Yeah, of course. I mean, you have to. I want to be able to release other things, not just music. I think the future's interesting as an artist. It's cool because I feel like that thing is not even invented yet. And those things are going to be invented out of necessity, and not because, you know, it's something to do. Once corporations have worked out that this is how you do that thing, then the creative people go somewhere else.

BLVR: So there are two forces of invention. Corporations want to make

more money, so they invent stuff all the time. And then you have people who in their own lives have problems to solve, and so they have to invent things. And you want to side with those people.

M.I.A.: With necessity people.

BLVR: There's this book called *Planet of Slums* by Mike Davis, about the development of these vast slums—these sort of rings around major cities, Dhaka and São Paulo and the like, filled with superfluous populations who didn't have any work at all, and they've developed informal economies and roughly made shelters. And for me, *Kala* was the sound track to that book. It was a way not just to be about one place, but to be about this particular problem of the dispossessed around the world, and especially in the third world and the global south.

M.I.A.: Well, *Kala,* I did the production on that record, which is why I took more of a sort of chilled approach. Me and Dave [Taylor, a.k.a. Switch, the album's producer] traveled everywhere. Sometimes I'd go on my own and then call Dave and they'd all bring the files to Dave and stuff. It's just what I'm used to, and what makes you feel good. A lot of the sounds from that album came from when I grew up in Sri Lanka for ten years. We lived by a temple, and every day you wake up at six in the morning to drums, every day. On "World Town," that high sound is an instrument called a nadhaswaram. So that's a temple sound. This particular one you play when people are getting married. That's the bit when they're actually tying the knot. I've always tried to make sense of that stuff. And I think *Kala* was my album to do that. This one's more… this one's different, this album.

BLVR: Different how?

M.I.A.: I think because I was, like, locked up in America, and I was only connected by the internet, it's more about that. And the sounds are working within the parameters of the internet. I was really thinking about the fact that the government now has invented the sound cannon,

where they can make people explode with sound, and use sound weapons to disperse protests and people. I actually felt like, that's my shit, and I don't want it to be used to exploit anyone, you know?

BLVR: But what about your lyrics: "Hands up, guns out"? Right? There's something pretty militant there. It's not just like, "Let's all hug, here's my sound." You're the one who says, "Guns out." You're the one with the Molotov cocktail on your shirt. What does that kind of militancy mean for you and your music?

M.I.A.: Well, I think, you know, if 65 percent of the U.S. budget is being spent on weapons, then people have to be prepared to think like that a little bit. Because while you're holding daisies and ring-a-ring of roses, if a big intercontinental ballistic nano-missile lands on you and wipes out your whole country, then, yeah, you'd better be saying, "Hands up, guns out," or something. But when I said, "Hands up, guns out," I actually meant guns out the window, not like guns out! So let me back in!

BLVR: No, right, of course.

M.I.A.: Because it's not just the U.S. It's every government, that's the point. It's not: "The U.S. is bad and everybody else is great." It's not. It's one government versus the other, which is everybody who stands up. You know, if you don't want to pay your taxes, and you kick up a stink, you're going to be a terrorist, I'm sorry, whether you come from Britain or England or France or… If you have anything to say against the government, you're going to be classed as a terrorist. You know, your phones are tapped, your email's tapped, they're watching you all the time. This is the future.

BLVR: What was that, oh, 1992, '93, when Onyx had that song "Throw Ya Gunz." They could say that all they want, and no one's going to stop them from traveling, right? But you're obviously in a different context. Part of it is figuring out what the government's relationship is going to be to "the other." You get to be the other. Do you experience that as an

opportunity or a curse?

M.I.A.: Of course it's both. You've got a lot of Europeans who get it. I'm not "the other" in London. Or in Paris, or anything like that. I have friends in London who are far more in tune with getting on with everybody else and the other, and everyone's got friends from everywhere. And everybody sort of culturally contributes to sounds, fashion, you know, music, magazines, which is why, creatively, there's more of a pioneering spirit in Europe. The thing about America now is that, the thing that you were saying is that, because it's on a coming-to-an-end phase, they want to slow that process down—to put the doors down and fill the moats up. They want to contain information and not let information get out, and not let information get in, because they want to keep making the American people feel really great, and boost their confidence all the time, to be like, You are great, I love you, you're doing so great, we are still winning, we're the shit, we're the best, look at this movie, we did it in 3-D, it's great, you know what I mean? Like everything is perfect and you're still in there, and hope is coming, change is coming, all these things. Which is all good, but I think it's contradictory to the internet, and it's contradictory to what we're preaching.

The thing is, you know, it's fucked up because, since I fall in "the other," I also fall in the category of—if you divide the world into good and evil—I'm in the evil section with the terrorists.

BLVR: Obviously evil.

M.I.A.: I know. Which is really cool on the one hand, which is why I've gone there, with all the graphics and stuff. I've let Tamil people shoot my press photos, I've got hijabs left and right and center, internet Burkaman all over the place, and we're just going to go there. And I didn't choose it. I'm a product of what they made me. Not what "they," but what the West made me. Because in the beginning I started off going, "Thank you so much, I got to come to England, England saved me," which is the truth—they put me through school, paid for my school, you know, put me through art school, and I could have been just some random person

who got killed in some random shell attack in some random fucking town in Sri Lanka.

But here I am, you know. And it was supposed to be a good thing. And the fact that my stuff on the internet is affected by—especially this next album—what we're going to be saying is, Bill Gates gave the Sri Lankan government $700 million to upgrade their internet service, and a lot of those millions are going toward people who are going to be getting paid to do anti-M.I.A. blogging every day. Because the government's got more money than I have. And that's the imbalance that we're going to see in the future, and that's what I'm going to be highlighting on this album—propaganda on the internet and who gets to dictate what the internet looks like. Is it money? Or is it mass? ✶

LADY SAW
[QUEEN OF DANCEHALL]

"I'M FAMOUS BECAUSE OF MY SLACKNESS."

Inspiration for songs:
Good sex with a good man
Bad sex
A date that doesn't pay for dinner
Just being out in the world

I n the early 1990s, when Lady Saw exploded onto the Jamaican
music scene, she was best known for displaying in her songs and
act a degree of raunchy "slackness" unmatched by any previ-
ous female artist. Since that time, she's retained her dancehall
crown by dint not merely of her outsize charisma and talent,
but of the searching sensibility of an artist who's scored Jamaican hits
employing styles ranging from the tender twang of her country ballad
"Give Me the Reason" to the exultant toasting of step-off anthems like
"Chat to Mi Back." The first female dancehall singer to headline shows
outside Jamaica, she also entered North American pop consciousness via
her hit-making appearance on No Doubt's "Underneath It All," the Orange
County punkers' 2002 smash that won her triple-platinum status and a

Grammy for Best Record by a Duo or Group.

Born in 1972 to a large family in a small town in rural Jamaica, Marion Hall (as Lady Saw calls herself offstage) spent her girlhood racing wooden carts and learning to sing in church. In her teens she moved from her island's countryside to its capital's swelling slums, working for a time as a sweatshop seamstress before becoming Lady Saw and, as she puts it, "getting famous." In addition to the hundreds of dancehall singles she's authored or graced with a verse, she's also released three full-length albums. All are marked, like their creator's style of conversing, by a Prince-like affinity for veering joyously in tone from pious to lewd. This summer she will put out My Way, her ninth LP and her first to be released independently, on her own label, Divas Records.

On the warm December evening we were scheduled to meet in Kingston, our plan called for me to go see the Queen of the Dancehall at her home high in the hills over the city. Just before the appointed hour, though, she called to say she was hungry and to meet her at T.G.I. Friday's instead. Arriving at the restaurant in a posh section of uptown Kingston, I found Marion and her sister settled into a corner booth, laughing and sipping their drinks, across the street from the fabled house where Bob Marley lived but never quite settled in the 1970s, writing songs about wanting to disturb his neighbors after riding his own musical success out of Kingston's ghetto. While we ate and talked, Marion paused often to laugh and pose for snapshots with admirers. I had the Cajun chicken sandwich and two Red Stripes; Marion had a virgin strawberry daiquiri and the alfredo salmon pasta with a glass of white wine.

—Joshua Jelly-Schapiro (July/August 2010)

I. THE GUYS WERE DOING IT, WHY COULDN'T A WOMAN DO IT?

THE BELIEVER: I wonder if you could talk about your childhood. How did you you get started in music?

LADY SAW: I started singing in church, when I was about seven, eight

years old. When I was a girl, my father started taking us to a Seventh-day Adventist church; he and my mother raised six of us. He got us all baptized. I'm not talking like baby baptism—I'm talking about dipping under the water, you know, in the name of the Holy Ghost and all them things. [*Laughs*] So I used to go up and sing in church every Saturday—that's the Sabbath for Seventh-day Adventists—and people there used to say I had a very good voice. And then I used to listen to the radio, to Barry G—he was the radio disc jockey on JBC who was very popular at the time—and listen to all the singers on there. People like Sister Nancy, who I really admired.

I also started going to the dance hall when I was young. Sometimes when my mother and father would go night-fishing, we'd sneak out and go the place where everyone danced. I had an older sister who'd sneak us up by the window. The dance hall was very close to where we were living. And I used to hide, and look in the window and see my grand-mother dancing there to all those old songs—shaking her legs like that, you know—and I used to try to dance like her.

BLVR: I understand the old folks in your hometown in St. Mary Parish had a name for you as a little girl—"Winey Winey."

LS: [*Laughs*] Yes. I got that name from the man in town who had the sound system—Leyton was his name. He was right across from our house. Leyton would put that sound system on, string those speakers up, I'd be out there *wining* ["dancing, gyrating" in Jamaican slang]. And he started calling me "Winey Winey." I was wining like it was going out of style! And Leyton gave me that name, "Winey Winey," and that's what they called me.

So I was always dancing. Singing too. When I was a girl, I would make up songs for fun. Then I realized, after making them up, that I could remember how they went a week later—I remember that's when I thought: Maybe I'm gonna be a singer.

BLVR: It was after you moved to Kingston, where you worked sewing in the Free Zone, that you got into making records, deejaying. How'd that happen?

LS: I linked up with a number of different producers at the start. A lot of them were reducers, not producers. [*Laughs*] But then I did some stuff with a female producer, and she *was* a producer: she didn't make promises she couldn't fulfill. She recorded me. And then one day I was home listening to the radio, and I heard myself, and I was like, "That's me, that's me! Turn it up!" The song was called "Half-and-Half Love Affair"—it was about having an affair with a man, you know, when he's someone else's man: so it's a half-and-half love affair.

After that I met a lot of producers—Derrick Barnett and Castro Brown from New Name Musik, and they start recording me. And then I met "Sampalue"—Garfield Phillips, from Diamond Rush, and he started recording me too.

BLVR: Your first big hit with Sampalue was also one of your most controversial—"Stab Out the Meat." How'd that come about?

LS: I met Garfield one day when he was down visiting from America—he was living up there at the time. And he said he'd heard one of my songs. He'd heard this particular song, and thought it was by a different artist, a more established woman in music, but a friend of his had told him that it was this new girl—"Female Saw," as I was called at the time. And he liked the song and wanted to meet me. And he liked me, and I liked him too. At first I said, Let's keep it professional. But then, you know, we started dating. And then, boom! He started producing me. We made some nice little clean songs. But then I made that X-rated song with Garfield—and that blew up. I blew up. When I was making the clean songs, no one paid attention. I was just another girl. But when I became outspoken, raunchy and X-rated, then everyone was like, "My god! Did she say that? She's raw, she's raunchy, she's bad"—and that's what really got me out there.

But you know, my other big song at that time was a very different kind of song. Garfield also produced that one—"Work a Miracle." "Find a Good Man," as they called it.

BLVR: That was your first song to go number one in Jamaica.

LS: Yes. And that was a real female anthem—so many women would come up to me then and say, "I'm so glad you made that song, because I'm asking God for a good man too." I became like the female adviser. I became known as someone who spoke for women, who was always defending them.

BLVR: When you first blew up, there were very few female deejays in the dancehall—and even fewer doing slackness that matched the men. But you came out discussing sex frankly from a woman's point of view—songs like "Backshot" and "Sycamore Tree." I know there were people saying that a woman shouldn't be doing these kinds of songs, or dancing how you did, simulating sex onstage—there was a lot of resistance and ridicule.

LS: Ha! The boys were doing it and people wouldn't say anything. But when I came out, all kinds of people were saying, "She's too rude, she's raunchy, she's too X-rated." There was a time when they said they didn't want me to perform in Montego Bay—the mayor there tried to get me banned. But he was just a damn drunk anyway, so what kind of example was he setting? But I had a lot of fans who said, "Hell no, he can't tell her she can't perform here." Big controversy.

BLVR: Many people celebrate you as someone who challenged a double standard—that men are allowed to be explicit when singing about sex, but women weren't allowed to do the same. Were you consciously aiming to address that double standard, or just trying to express things you wanted to sing about?

LS: I did it to get attention! [*Laughs*] The guys were doing it, why couldn't a woman do it? But I stand behind every song I did. People questioned me, but that slackness—it made me famous. A lot of high-society people—we call them "uppity uppitys"—were saying I was too rude. I was inappropriate. But when a lot of those people would meet me, and they'd say, "She's such a nice person!" They'd see that I wasn't a rude person at all, and some of them would take it all back. And some

of them, the high-society men, they'd come over the room and say, "My wife loves you." [*Laughs*] But they couldn't let the people know that they approved of my kind of music.

BLVR: People were opposing slackness to "legitimate" culture. But there's a long tradition in that culture of liberated Jamaican women making their voices heard, no? I think, for example, of the great folklorist and comedian Louise Bennett—those lines of hers: "Jamaica oman cunny say! / Is how dem jinnal so? / Look how long dem liberated / And de man dem never know."

LS: I loved Louise. We all did. She did it a different way [from me], though—with class, and funny. So she was different. But you know—she did do a song called "Under the Sycamore Tree" too. My version's X-rated. But Louise did a song [*singing*]: "Under the sycamore tree / dar-ling…" It's about getting her first kiss under that tree. But you know she got laid under there! [*Laughs*]

Even when I was a young girl—"Winey Winey," sneaking in the dancehall—I remember a song that went [*singing*]: "Gyal, I hope yuh baggy get wet." The man sings, "Turned off the pipe last night, turned the cock very tight." That's not even that slick. [*Laughs*] I was very young, and I knew it was X-rated. But when a woman like me is being slack, all these problems?

BLVR: Today you're a great hero to many women in Jamaica. Who were some of the women you grew up admiring?

LS: In music, I loved Sister Nancy. When I used to watch her, she was so good—she still is, actually! I just saw her recently. She really inspired me. A strong woman, a good performer. But then it was all kinds of women around me who I admired. I had a teacher called Miss Gracie, for one. I used to go around her house, spend lots of time watching her. She was independent, took care of her house and herself. And she had all kinds of progressive friends, too. I looked up to those women—anyone who was progressive, who took care of themselves.

I've done songs about my mother [e.g., "Mama G"], all that I owe her. [But] my mother was very quiet, laid-back. My father used to talk shit to her, and that used to kill us as kids. So I never had any experience from her, really, about how to deal with a man. Because I never saw her talk up to a man. Like I'd do—if any man gives me any shit at all, I say, "Kiss my ass." In a way Mama never could. So I never got any of that energy from her—she always told me to behave myself. She'd be like, "What is it that you're doing that these people are trying to have you banned?" She didn't really know I was saying some things. [*Laughs*]

II. "THE MUSIC'S DIFFERENT NOW. BUT EVERY TIME IT STARTS CHANGING, I CHANGE WITH IT."

BLVR: I wonder if you could talk about your early influences, music-wise. You came up during a time when Jamaican music was making that transition from the roots reggae of the '70s to the dancehall of the '80s—"from the red, gold, and green," as the dub poet Mutabaruka put it, "to gold chains"—with drum machines coming in with Steely & Clevie, sped-up rhythms, more explicit toasting about sex, violence, life.

LS: I heard all that old reggae when I was a girl. There was that sound system, always played it across the street. But then when the music started changing, King Toyan came out with "Spar Wid Me" and Barry G started playing it on the radio—and Sister Nancy came back with her version. When that new music came out, that new style—that's when I decided I really wanted to be a deejay.

BLVR: You took your name from another one of those '80s dancehall greats, Tenor Saw.

LS: I loved Tenor Saw. Tenor Saw—and Pinchers, too, who lived in the same community as me, in Kingston 13. They were my favorite. I used to go watch Tenor Saw even when I didn't have any money, through a crack in the zinc fence, enjoy his performance that way.

He had that melodic style, you know—[*singing*] "Ring the Alarm." And at the start I tried to sound just like him. I was *all* about Tenor Saw. But I caught on pretty early that the way to making it is to be original. And so I came up with my own sound, my own style—more aggressive and raw, more aggressive than any other female.

BLVR: When you came out in the early '90s with VP Records, you were part of a generation of artists that was bringing dancehall to another new stage—a number of producers were coming out, vocalists like yourself, Bounty Killer, Beenie Man, Buju Banton; all those people were coming out then. It must have been an exciting time.

LS: It was exciting. But you know, all times are exciting. I grew up listening to ska, merengue, old-time music. I'd go to "nine nights"—which is what they set up when people died—and people used to use graters, the graters they used to grate coconuts, to make music. We'd call it "dinky minny." The music's different now. But every time it starts changing, I change with it. Like now: I'm [nearly] forty now—I never hide my age—and the music's even faster. But I'm kicking asses harder than any of these young chicks coming up. They can't stand beside me. I spit like a real deejay. Like the best men—I can spit harder than most of them. I spit from way down here [*motioning to gut*]; I can work for hours. I don't have competition, because that's how good I am. I love it.

BLVR: You've done hit duets with a lot of those people—Beenie Man, Shabba Ranks. But then you've also worked with a number of foreign artists—Missy Elliott, Eve. No Doubt, of course, with whom you won the Grammy.

LS: I love doing the collabs with overseas artists—you know, they tend to get on the Billboards, the Grammys, all that. We're international artists here [in Jamaica]—we're internationally known. But sometimes we need that push. That's how you get yourself out there. And with Jamaican artists, I don't have a problem working with you, if you got talent. To help you get out there, keep myself out there. Once it's good music, I'll

do it. No problem.

BLVR: How did recording with No Doubt come about?

LS: [Legendary Jamaican producers and rhythm-section drummer and bassist] Sly and Robbie called me up—they're my darlings, I love them. They said, "No Doubt is in Jamaica and wants to do a collab." And I said, "OK, on my way." [*Laughs*] So I went to the studio, and they played me the song, and showed me where my spot was. And I started writing, and I was done in a minute. And Gwen [Stefani] and the whole group, they were all like, "Bravo! You're so good. You're so quick." And it was done in a minute, and boom: it was a hit. I loved that.

BLVR: Is that how you write your toasts usually—listen to a riddim and see what it inspires? How do you come up with songs?

LS: I can do it either way. Every way. Sometimes I get the riddim and write to it. Sometimes I come up with the song and do it all. I can do it all ways. I'm inspired to write songs by all kinds of things. Good sex with a good man, that might inspire a song. Bad sex—that might inspire a different kind of song. [*Laughs*] If we're having dinner and you don't pay, that might inspire me to write a different kind of song, too. Or just being out in the world, seeing certain situations, the way people are living. Anything. I'm thinking of songs every day.

BLVR: When you won the Grammy for the No Doubt collaboration, a lot of people in Jamaica were pissed that you didn't get to go onstage to accept it.

LS: Yes—like I wasn't a part of it. I went on a few of [No Doubt's] shows on tour, and I mashed it up. But then when it was time for the Grammys, my name wasn't listed. I just got a certificate, not even the real Grammy. My people called the Grammy people, and the Grammy people said they got the information from No Doubt's people, and No Doubt's people said they put my name there—it was a whole runaround. So when they announced

we won, I was getting up to go up there onstage with my manager at the time, but the damn security guy in the aisle was like, "Where you all going?" And we were like, "We just won, and we're going to go up there." But by then their speech was almost done, you know. Fat Joe was sitting right there. He was nice. He said, "Don't worry, Mama, your time will come." He said, "It's all right, Mama." He was very nice about it.

But I remember when Gwen did get up there, the first thing she said was, "Thanks to Lady Saw, and Sly and Robbie." We're cool—we been cool. I like her personally. She's just a cool person. We were on tour and she'd be talking about how she wanted to have babies. Girl-to-girl talk, you know. She's cool. We'll do something again.

III. "THERE'S TWO SIDES TO ME, A LADY SAW AND A MARION HALL. AND I LOVE THEM BOTH."

BLVR: To many people, Lady Saw is synonymous with slackness. Part of what makes your career and work so interesting, though, is all the work you've done that gives voice to Marion Hall, the woman behind the Queen of the Dancehall—and done so in different styles. In fact, your top seller ever is a country song—"Give Me the Reason."

LS: Yes, I love that song. There was even some country artist in Nashville who covered it. You know, at the [Jamaica] Jazz and Blues festival, they even put me on the bill as Marion Hall—a lot of people didn't know it was me. And I blew their minds, singing gospel, country. I gave them a taste of Lady Saw, but not the really raw Lady Saw, you know. People were telling the promoter, "Are you crazy putting her on like that?" But there's two sides to me, a Lady Saw and a Marion Hall. And I love them both.

BLVR: How are they different? Do you separate from the Lady Saw people see in the dancehall when you're not onstage?

LS: You know, a friend of mine recently told me how she saw me onstage one night, and I came down off the stage, and a man said something to

me. And I told him: "Lady Saw—she's done right now. That was Lady Saw there, she's done now. I'm Marion Hall, talk to me." Marion Hall is a homegirl. You see how hard it was to get me out? [Laughs] I stay home, you know? I don't have a lot of friends. I have a lot of fans, not so many friends. I stay home, I feed the dogs, I bathe the dogs. I have a farm up in Ocho Rios, I'm there. But I'm boring, you know—until it's time to touch the stage.

BLVR: A lot of people outside Jamaica don't know how popular country music is here. Did your own love of country come about because it's so popular in Jamaica, or out of your own innate love for the music?

LS: I grew up hearing it: Kenny Rogers, Dolly Parton, lots of people whose names I don't remember. There was a man in my town who always used to play country songs on his sound system. And then my father too—after he went away to America to do farm work. He stayed up there, he was trying for the American dream. Hoping to bring all his kids up there. It didn't work; he never got his papers—his green card. He said a lot of people used him. He'd be up there doing work for someone, and they'd say he'd help him get his papers at the end, but when the end would be coming, they'd start acting funny. Anyway, he used to bring home music too.

One song I really love, that [Loretta Lynn] song [*singing*]: "You've come to tell me something you say I ought to know / That he don't love me anymore and I'll have to let him go / You say you're gonna take him oh but I don't think you can / 'Cause you ain't woman enough to take my man." And then here's the part I really like: "Women like you / they're a dime a dozen / you can buy 'em anywhere." [*Laughs*] That's gangster right there! She's singing, "For you to get to him I'd have to move over and I'm gonna stand right here / It'll be over my dead body, so get out while you can / 'Cause you ain't woman enough..." It's something I'd say in the dancehall, you know, that I'd sing about: "Bitch, don't be coming over here and trying to take my man." That's gangster; similar to some situations I might sing about here.

BLVR: Another of those songs that maybe falls on the Marion Hall side is "No Less Than a Woman (Infertility)," which you wrote after your second miscarriage. You've said that that was a song about that sad event, trying to deal with it—but also that it was "aimed at negative people in Jamaica who curse women who don't have any kids." I wonder if you could say what you mean by that—and how it was received at home.

LS: The song came about in part as a response to what some other people were saying. You know, people call me "Mumma" in Jamaica— the mother of dancehall. And there was one female in particular who was throwing words, singing about how Mumma can't have a child; she's the mother of dancehall but she can't have kids. Calling me a mule. And I said to myself—I'm a great mom. I have three kids, I adopted them. I'm a great mom. And sometimes the worst moms are those who carried a child all the way [to term]. So I touch that topic. And when I perform it, people cry—I cry, men cry. Everyone. I had a man sitting next to me in business class on a plane, and he started talking to me about his experience, and how long he and his wife had been trying to have a child, and how my song touched them. And women come up to talk about their experiences. It was a topic that's taboo in Jamaica—but it's something I had to address.

I don't hide anything about my life, I talk about everything. I talk about it—all kinds of things. I've done songs about bad experiences, a couple about growing up in the ghetto and being abused, sexually. Being raped. And I talk about it. And I have young girls come up to me with their stories, talking about how they want to kill themselves because some man just raped them. And I use my story to connect with them—to say I been through this. And it didn't break me. So don't ever talk about killing yourself. You'll never see God's face if you do.

Those are the topics I use to uplift women. I have another song called "Not the World's Prettiest." It's about women who think they're not beautiful because they weren't born with a straight nose or brown skin. Girl, if you weren't born with no smooth hair and you want it, go out and buy it! I buy it. It's mine.

IV. DOUBLE STANDARD IN THE BEDROOM

BLVR: You've attracted some criticism for making some songs that don't uplift women but degrade them. What's your response?

LS: The boys used to say all kinds of things, talking about women's vaginas, all kinds of rude things. And I didn't like that. So I made songs like "Pretty Pussy"—it goes "Girl, put up your hand / you have the pretty pussy," and I talk about how you dress the pussy or put a ring on it or take care of it. And the girls love that. It's not degrading, or putting them down, it's about uplifting them.

Now, there is another type of song—songs where I'm cussing a girl. You know, there will always be some situations where women are cussing each other. And you know I'll cuss your ass out. There's a song I have called "Walk Out," about all these girls who like to walk up in your face, acting all crazy. And that song is saying, you know, if you walk up in my face, I'm going to slap you. So that's real. I do those kinds of songs. But those songs have their places. Every song has its time and place.

BLVR: The song of yours that maybe gets the most critique about being degrading to women, though, is "Stab Out the Meat."

LS: They say that one is degrading? I like it! I like the song.

BLVR: Some people say it's objectifying. But you know, there are those who have defended it on feminist grounds. Your friend Carolyn Cooper, for one, the leading dancehall scholar, wrote that it's alluding to women curing meat in the kitchen. I have to tell you—all due respect to the esteemed Professor Cooper—that I'm not sure I buy it. What do you say about that song today?

LS: Well, Carolyn may think that, but I know what I was thinking about when I wrote it. [*Laughs*] I didn't want to say, "Do it hard, have sex with me hard." So I say it different, just beating around the bush. All these boys are coming with: "Cut it up, jack it up," all that. So I'm just saying,

OK—come on, bring it. When a man's talking about he wants it hard, a woman's got to take it, and all that—that's OK, but it's not OK when I say I want it hard, keep it up so I can ride it? It's a problem? Please. Double standard in the bedroom.

BLVR: Which maybe brings up a larger point: that the violent mores of the dancehall are a reflection of this violent and sometimes messed-up country. That's a point you implicitly make in that brilliant song you wrote responding to people who call you "too slack" ("What Is Slackness"). You say, "Society a blame Lady Saw / fi di system dem create."

LS: "Wanna know what slackness is / I'll be the witness to dat… Take the beam outa yu eye / Before u chat inna mi face / Cause slackness is when the road waan fi fix / Slackness when government break them promise / Slackness is when politician issue out gun / And let the two party a shot them one another down." That's right. I remember that mayor in Montego Bay was calling me the queen of slackness. So I was showing him, telling the government—another side of slackness that needs to be addressed. What the word really means. 'Cause I can control my slackness, you know? But there's so many other things—guns being issued out to youths in the ghettos, killing each other; sufferation and hardship; people can't get a job when they finish school. That's *slack*, that's the meaning of the word.

But you know what? Whatever. [*Laughs*] I'm famous because of my slackness.

BLVR: Do you ever find, though, that being the Queen of the Dancehall can limit what you want to do as an artist?

LS: Darling, you do anything you want when you're the queen. You do anything. I could go off and change, do more Marion Hall—but I'll always give them a little Lady Saw. If I start doing just Marion Hall, people would curse me out. They'd be like, "What you doin' now, bring it." The emcee would call me onstage and say, "We're going to welcome the Queen of Dancehall, the *queen*… though lately she's been toning it

down." And then I have to give it to them hard and say: "I still got it, baby. Don't be pushing me now." ✳

"WEIRD AL" YANKOVIC

[SONG PARODIST/ACCORDION PLAYER]

"I SORT OF FEEL LIKE I'M AT WORK WHEN I'M LISTENING TO A TOP 40 STATION."

Consequences of parodying a song:
Being limited by other people's perceptions
Possibly-Amish people throwing eggs
Upsetting Billy Joel

O ther than the Segway in the foyer and the accordion by the fireplace, "Weird Al" Yankovic's house is not so weird. A modernist, multilevel compound steep in the Hollywood Hills, it blends with its ornately anonymous neighbors.

A kumquat tree by the front gate is studded with small orange fruit. Up a flight of concrete stairs, a swimming pool lies shaded beneath overhanging stories. Another flight up and inside, Yankovic's living room is bright, white-walled and -tiled, hung with colorful but subdued abstract art, vaulted floor-to-ceiling windows giving a long, smoggy view westward to the Pacific. On his coffee table, surrounded by glass art and stacks of family photos, sits the book Bird by photographer Andrew Zuckerman.

In the ninety minutes I talked with Yankovic on a mild April morning, the accordion went unplayed, but trying the Segway, he declared, came with being invited to his home: "the indoctrination." I took it for a short, swerving ride across the living room.

In this setting Yankovic himself was rather genteel, articulate, and light. He answered the door barefoot, in Diesel jeans and a floral-print polo, long, angular face maybe a day unshaven, long, kinky hair past his shoulders. His voice revealed little trace of the goony croon of joke-pop classics like "Like a Surgeon" or "Eat It." Yankovic—who's earned a degree in architecture from Cal Poly University, a handful of platinum records, and three Grammy Awards—started our conversation with an almost-formal tone but eventually relaxed into a less-restrained tenor.

This is a man who for thirty years has made a living—a good one—by out-farcing the farce that is popular music. Yankovic is so associated with the pop-music parody that a fan-managed website, The Not Al Page, *exists to correct falsely attributed songs (125 and counting).*

Yankovic's most recent album was a greatest-hits package released late last year; preceding it was a download-only EP highlighted by the Doors-inspired send-up "Craigslist" ("You got a '65 / Chevy Malibu / With automatic drive / Custom paint job, too / I'll trade you for my old wheelbarrow / And a slightly used sombrero / And I'll even throw in a stapler, if you insist / ...Craigslist!"). The album before that, 2006's Straight Outta Lynwood, *was Yankovic's twelfth and his first turn on the Billboard Top 10. Last year he debuted a multimedia, celeb-studded educational film, Al's Brain in 3-D, at the Orange County Fair and the Puyallup Fair, outside Seattle. It ran again this year and once again attracted record crowds.*

Yankovic's annual summer tour runs through September and in December makes its first-ever stops in the United Kingdom. His first children's book, When I Grow Up, *is set for publication by HarperCollins in February of next year.*

—Jonathan Zwickel (September 2010)

I. THE ARCHITECT

THE BELIEVER: This house is beautiful. What's the story behind it?

"WEIRD AL" YANKOVIC: When we bought it we thought it might be a Richard Meier, but it turns out it's not. Have you heard of Richard Meier?

BLVR: No.

WAY: I have a degree in architecture, and I did my senior project on Richard Meier. He designed the Getty Center here and a bunch of stuff like that. My wife and I both really like modern, although it's really hard to warm up a modern house. [*Looking out the window*] I wish it were a little bit clearer. You can actually see the ocean on really clear days.

BLVR: We spoke back in 2006 in a phone interview I did for Rhapsody. com. It was an interesting time for you because "White & Nerdy" had just come out, "Trapped in the Drive-Thru" was all over YouTube, and we talked about, and I sorta predicted, and I feel vindicated by, this unironic embrace of Weird Al by the hipster music cognoscenti. We talked about that a bit, but it seems like that's actually happened.

WAY: In a way, you know? It's really cool, the stuff that's been happening just in the last few years. I've always been kind of outré, but in the last year I got to perform live with the Pixies. I've been hanging out with the Upright Citizens Brigade crowd—a lot of very hip kind of alternative comedy icons.

BLVR: As far as the brightest minds in comedy, I think of Tim and Eric, whom you work with.

WAY: Yeah, absolutely. A lot of comedy that I'm a fan of is not something that I would incorporate into my own comedy. But I think Tim and Eric are brilliant. I love that they're so polarizing. After I've just been on *Awesome Show*, people will stop me in the street and they'll either say,

"Oh, that's so great! You're on the Tim and Eric show! They're so great and they're so funny!" Or they'll say, "Why are you wasting your time on that stupid show?" There's no middle ground: you either love them or you hate them. And I fall into the former camp.

BLVR: It seems like the Pixies guest appearance was the cred kickoff. Like, that's it. Out of all the iconic indie rock bands, they're held in the highest esteem, and to appear onstage with them is a validation of sorts.

WAY: I've always had the support of my fans, but I've also always had the feeling that I've never really been accepted in either the music world or the comedy world. In the last few years it feels like maybe, just as a factor of how long I've managed to hang around, or maybe it's the people that were inspired by me when they were young, growing up, being able to express their affection in a more adult manner. I don't know what it is, exactly, but it's nice to get that kind of appreciation at this point.

BLVR: Something else I wonder about being a contributing factor is the ascendance of the nerd.

WAY: There's been a lot written about that in the last few years. I don't know if "White & Nerdy" started it or it was just riding the crest of it, but it seemed like there was a period a couple years ago and probably extending to present day where there's been a lot of focus on the nerd in pop culture. I don't know if it's still happening; there was some sort of Broadway musical being done about nerds. At the time I spoke a lot about how nerds now rule the world. They have the money, they have the power, they're in charge. It's really *Revenge of the Nerds* in a major way. I think *nerd* is no longer such a derogatory term. Some people wear the badge proudly. In fact, one thing I wanted to do with "White & Nerdy" was make it more of an anthem so people could own their nerdiness.

BLVR: Those *Al TV* episodes you did a while back are perfect for YouTube. I can't believe you could've predicted that back then, but those little vignettes are so well suited to the format that it almost seems like

they were created for it.

WAY: Thank you. A gentleman who interviewed me for *Wired* magazine a year or so ago—that was sort of the thesis of his whole piece: that I was sort of the godfather of YouTube. I don't know if I would go as far as to say that, but there's some validity to that. I was doing YouTube-friendly stuff way back before YouTube existed.

BLVR: It seems like you're more of an early adopter than a godfather.

WAY: I didn't actually get on YouTube until, probably—well, certainly later than I should have, because other people's pirated versions of "Amish Paradise" have about a hundred times as many hits as my own. [*Laughs*]

BLVR: Cover versions?

WAY: No, they would like upload it off my video collection or off TV or something and they would have like 10 million hits and on the Al Yankovic YouTube site it's got half a million hits. Which is not too shabby either, but still—it's like some guy who happened to upload a year before I did got all the traffic.

BLVR: It's in your best interest that you're online—Twitter, MySpace—as yourself. Just look at the *Not Al* page—the list of all those parodies that aren't yours.

WAY: Right. That's important. It's really great that my fans have my back that way, because I don't wanna take credit for other people's stuff, especially when a lot of the other people's stuff is pretty bad. It does me no favors to have my name attributed to somebody else's material. And a lot of the material that has my name attached to it is off-color or not family friendly. I've had a lot of upset parents telling me they're never gonna let their kids listen to me again because of some song that I wrote, which in fact I never did.

And some people, I assume, put my name on their songs just as a way to get hits. Because people think, Let's hear the new Weird Al song, and it's some guy in his basement in Arkansas, not me.

II. THE AUTEUR

BLVR: I look at *Al's Brain* and I think, What a great idea. This is another way as a musician, as an artist, to present your work. It seems like a brand-new venue that's particularly suited to the type of humor and performance that you do. I hope that musicians are looking at that and seeing that as this whole other realm, this real-world realm, that doesn't require the typical avenues that you might use to put your music out there.

WAY: It was actually my manager, Jay Levey, who thought, Why don't we do a 3-D movie about the brain? The 3-D movie might've been [Orange County Fair CEO] Steve Beazley's idea, but Jay was the one who touched on the brain. And they pitched that to me and I thought, That's really a great idea, because I can come up with some fun stuff for that, and it'll be educational, and at the same time I can go on a lot of different tangents and have a lot of fun with it. It took a while to actually sell to the fair board, because it was very different for them—they're used to allocating money for tractor pulls, not 3-D movies.

I've been playing the Orange County Fair for many, many years, and I always do extremely well there. It's not really my hometown, but it's close to my hometown. It seems like every time we play the Orange County Fair we break attendance records, it's just crazy. People start lining up, like, ten hours early for the show, it's just sick. And Steve Beazley always wanted to do something more, something to bring it to the next level.

BLVR: What's it like?

WAY: It's a ten-minute movie. I wrote the script and directed it. And it basically tells the working of the human brain through man-on-the-street

Q&As. I had random friends asking the questions, including Paul McCartney. He's the last person to ask a question. He asks, "Exactly how does the brain work?" and that leads into a two-minute-long music video which is this pretty cool CGI trip through the human brain. The response from the fair attendees was great. We had focus groups and people filled out cards; they learned a lot and they had a great time.

BLVR: How did you hook in Paul McCartney?

WAY: It's kind of funny how that all came to be. In the script I always had some huge celebrity ask this last question. We had the whole thing shot except for this one thing. We were like, We gotta find a huge celebrity. Paul McCartney was obviously one of the first people we approached. I thought, If I could get anybody in the world, who would I get? And Paul might've even been the first person we approached and kinda put the feeler out. And we just didn't hear back. We just kind of wrote it off, like, who's next? Brad Pitt? No, he's in Germany. All these un-gettable people, you know? And out of the blue one morning, I get a call at eight o'clock in the morning, and I could barely hear on the phone, but it was somebody calling from England. "Yes, this is Paul McCartney's office. When exactly do you need Paul to do this?" And I was half-asleep, going, "Uh, whenever's good for Paul, really." [*Laughs*] It just kind of blew my mind that he actually wanted to do it. He actually wanted to do it originally at his house in England. I don't know what happened; he either forgot about it or never got around to it, and now the deadline was approaching. And we kind of gently reminded them: Paul said he was gonna do this. I see he's playing Coachella on the seventeenth. How about if I just, like, set up a camera in the dressing room and we shoot him then? And finally they said OK.

III. THE PARODIST

BLVR: I read that before every parody, you call the original artist and try to gain approval in order to proceed. Is that true? Was there a phone call between you and, say, T.I.?

WAY: It's more often the case that my manager will talk to their manager. If I know the artist personally, then I'll call them personally. But in most cases it's more like my peeps talking to their peeps and trying to work it out. And if for whatever reason my manager can't get a response from the artist's people, then he'll say, "Al, if you want this, it's on you. You gotta figure it out." Sometimes then I'll have to stalk them. I had to do that not too often but a couple times. And Kurt Cobain was one of those, because the Nirvana camp wasn't returning phone calls. And it's sort of a famous story, it's been on, I think, *Behind the Music* and a couple other things, that I finally had to call a friend of mine on *Saturday Night Live* the week that Nirvana was performing for the first time and say, "Nobody's returning my phone calls. Can you please, like, put Kurt Cobain on the phone?" And she did and I talked to Kurt personally and was like, "Hey, man, I'd love to do a parody and what do you think?" And he was like, "Yeah, sure, that's great."

BLVR: Then you have guys like Chamillionaire giving you props for assisting with his record sales and his Grammy win. Is it possible that the parody somehow improves the original?

WAY: I don't know if I can say that. It would be a nice thing to think, but I think the song is the song. Certainly I think it raises people's awareness of the original song. There's a certain part of my fan base that hasn't heard a lot of the songs that I'm doing parodies of, and it's only through exposure to my material that they're even made aware of these artists. Certainly raising awareness is a big positive aspect to what I do. In fact, if you go back to the Nirvana example, I heard from an executive at Nirvana's label that flat-out told me that Nirvana sold an extra million copies of *Nevermind* because of my parody.

BLVR: Has anyone ever been offended by a parody? I think of "Amish Paradise." And I don't mean Coolio in particular, but the Amish. Or the inner-city people whom Coolio's song might've been speaking to.

WAY: Well, I used to be flip and say the Amish don't have MTV so they

shouldn't even be hearing the song. I don't know. I'm not setting out to offend anybody. The humor of that song was the juxtaposition of the Amish culture with the gangsta culture. And I'm really not trying to demean either one; I'm just trying to have a laugh. No offense should be taken. And again, this was sort of an isolated incident, but I was doing an in-store appearance I think in Pennsylvania about the time that "Amish Paradise" had come out, and somebody threw an egg or something in protest. [*Laughs*] But I'm not sure if that was an angry Amish person.

IV. THE ICONOCLAST

BLVR: Is there anything you've ever wanted to produce that didn't seem like it jived with the Weird Al image? Like, have you ever wanted to make a message song or say something serious or create art that was separate from this identity you've cultivated, but felt you couldn't do that because of fan expectations?

WAY: I never put those limits on myself. There's nothing that I've wanted to do that I felt, Oh no, I couldn't do that because I have this Weird Al persona. I've never had any desire to do any heartfelt, tender love ballad…

BLVR: Never?

WAY: Not really. Maybe when I was thirteen or fourteen years old, I tried to write a straight-ahead rock song with "important" lyrics, and it was just abysmal. That was never really me, that was me trying to fit in, I think. I've never been embarrassed by my niche. I enjoy what I do and I'm comfortable doing it. And the things that I've wanted to do are basically doing what we talked about, kind of expanding into other areas—directing, and producing, and writing, doing stuff for TV and feature films, stuff like that. I don't think I've ever limited myself because of people's perception of who I am. I think I have been limited by other people who've taken their perception of me and thought, Oh, Weird Al couldn't possibly do *that*, he does *this*. And they put me in a box and

they figure that's all that I do and how dare I think I can do something else. So that's the only thing—I'm limited somewhat by other people's perceptions of who I am and who I am not.

BLVR: Did you go ahead do those things anyway?

WAY: Well, I've been making efforts to do those things.

BLVR: This is a recent development?

WAY: It's sort of an ongoing thing. There are some things I can't talk about which we're trying to develop. It's always a fight to do anything other than what I'm famous for. I would certainly do more feature films, but I think—either people want me to be Weird Al, which, in the case of the *Naked Gun* movies, that's great because I love those movies and I'm happy to do it—but people just can't fathom me being a character where I'm not Weird Al. Which is one of the reasons why I love doing Tim and Eric's show. Because even though I was obviously me—they didn't even have me made up to look differently—I was playing characters. I was never Weird Al on *Tim and Eric*, I was Uncle Muscles. Or I was Simon the creepy guy that escorts these weird ladies down the aisle in a church. They allowed me to do something different, and that's something I really appreciated.

BLVR: What do you listen to for pleasure?

WAY: I listen to Top 40 radio, sort of because that's my job, to keep my finger on the pulse. But for pleasure… I don't wanna start giving a laundry list of band names. But I like alternative-rock stuff that I listened to in college, and listened to again in the '90s. Most of the bands and the artists I like are a little quirky. They're not necessarily comedy rock, but they definitely have a sense of humor and they're not afraid to, you know, let their freak flag fly.

BLVR: Is it all research? Are you always listening with an ear for parody?

WAY: I have to admit, if it wasn't my job to be aware of the state of pop music, I'd probably switch to a more obscure station that was playing more underground stuff, more alternative stuff, because that's where my personal taste would be. But I don't dislike popular music, certainly. But I sort of feel like I'm at work when I'm listening to a Top 40 station.

BLVR: You know, I dug up a "Still Billy Joel to Me" video on YouTube.

WAY: Video?

BLVR: It was someone's own video with your song. They put your song to their random video.

WAY: I was thinking it might've been an early, early live performance, but they could've done their own low-budge video.

BLVR: That's something you refrained from releasing. Why is that? Too mean?

WAY: Well, that's part of it. I wrote the song back when "It's Still Rock and Roll to Me" was out, which was, like, 1979, 1980. It was one of those things I recorded for no money. Where did I do that? I think just at the college radio station that I worked at. I think we recorded it there. But it's just me and the accordion. They played it on the local radio stations around San Luis Obispo. Somehow Billy Joel heard a copy of it way back then. Some magazine show did a segment on Billy Joel, and they played him a little of the song, and he listened to it and… he had some kind of snide comment about it. I could tell I kinda hurt his feelings a little bit. I thought, Oh, gosh. You know… [*Laughs*] I didn't wanna get on Billy Joel's bad side.

That's maybe where my whole nonbiting thing started. I go through pains not to step on people's toes or make jokes at their expense. If I can help it. I still do from time to time—I break that rule all the time. But my general policy is if you can get a laugh without stepping on some-body's toes, that's a better way to go. So that was part of it. I didn't wanna

hurt Billy Joel's feelings. Also the references got dated very quickly. He probably wouldn't understand a lot of things that I refer to in the song. There's a line in the song, like, "Now everybody thinks the new way is super. Just ask Linda Ronstadt or even Alice Cooper." I mean, I get that now, but the year that I wrote that song, Alice Cooper had just broken out of the mold and done his new-wave album. And he was getting a lot of flack for it, because he was Alice Cooper and all of a sudden he was new-wave. And Linda Ronstadt wasn't so much new-wave but her hit was considered kind of a nod to the whole new-wave thing. At the time you would've gone, Hah. I get it. And nowadays you're like, Linda Ronstadt? What? [*Laughs*] So it's one of those songs that didn't age very well, on top of being meanspirited.

BLVR: Someday before you die, a streak of meanness will emerge. It must be there somewhere.

WAY: [*Laughs*] If you wanna see me being mean, just go to my YouTube page and see some of my interviews. I did a fake interview with Kevin Federline which is really… harsh. [*Laughs*] I feel kind of bad about it, but I think a lot of people think it's funny. Being funny covers a multitude of sins. ✶

TREY ANASTASIO

[OF PHISH]

"I TRY TO REMEMBER HOW INSIGNIFICANT MY EXPERIENCE IS, AND HOW PEOPLE'S EXPERIENCES WITH MUSIC ARE THEIR OWN THING."

Helpful precursors to improvisation:
A childlike approach
Knowledge of tonal convergence theories
Headphones you can wear while chopping wood and changing diapers

I n a time when jazz is barely a smudge on the cultural radar, the marriage of improvisation and popular music continues nowhere more apparently than with the Vermont rock band Phish. Other artists may be touring and improvising—and they are—but they don't sell out Madison Square Garden for three nights in a row and continue to host a series of annual, one-band festivals that draw upward of seventy thousand people, all for the adventure of musical improvisation.

A highly divisive band, known best for their obsessive, vagabond following, Phish remain a baffling success in the music industry. Since they began, their musical style has continued to be a fluid spate of genres, most of which have very little in common with contemporary music, and

some of which are laughably silly. A typical live show will include streaks of calypso, '70s hard rock, jazz fusion, salsa, labyrinthine prog rock, old-timey music, new-wave and barbershop quartet, and, at any moment, one of these genres might be stretched out to forty-five minutes of wordless improvisation. Unlike many equally successful rock bands, Phish are relatively ignored (or dismissed) by the media, and do little to engage with the publicity cycles that dictate the peaks and valleys of most bands' careers.

Trey Anastasio, the singer, guitarist, and sometimes composer for the band, is one of the revered, old-fashioned rock guitarists from the last quarter decade, playing the type of soaring, lyrical guitar melodies that have been all but banished from pop music since the early '90s. Phish—and Anastasio in particular—are often cited as the musical heirs to the Grateful Dead and leaders of the new generation of so-called jam bands, but while the audiences may overlap, the band's music bears little similarity to the bluegrass rock of the Dead or the electro-psychedelic "livetronica" style that dominates the current jam-band culture.

Over the last decade, Phish has gone on hiatus, disbanded, dispersed into solo projects, and reunited. During breaks, Anastasio performed solo acoustic sets, founded a new band with a full horn section, and composed a lengthy composition, "Time Turns Elastic," which has been performed by the New York Philharmonic at Carnegie Hall. Currently, Phish is preparing for a summer tour and for Super Ball IX, their next three-day summer festival, to be held in upstate New York.

I met with Anastasio in New York at Soho House for a conversation over soup. He talked about his long-standing interest in the art of improvisation, playing seven-hour-long shows, set lists, and the problems of conjoining art with daily life. After we spoke, I attended a Phish show at Madison Square Garden at which the audience was at full, standing applause for forty-five minutes before the band even stepped onstage.

—Ross Simonini (July/August 2011)

I. ANYTHING BUT YOURSELF

THE BELIEVER: Do you remember when you first cared about improvisation as an art form?

TREY ANASTASIO: I started listening to improvisational music when I was in high school. Before that, I was more interested in composition. I listened to *West Side Story* and Sly & the Family Stone—really listening to their arrangements and how they laid all the melodies. But, in that way, good improvisation has a structure. It has a form. I remember, like many guitarists, being obsessed with Hendrix's *Band of Gypsys*. It was *the* record. I listened to that solo on "Machine Gun" a million times.

BLVR: With that one amazing note.

TA: Yeah, *the note*! And I started noticing that, in his playing, it was almost like he was speaking in paragraphs. His solo has a thinking, or vocal, quality to it. It starts off thin, and then he rolls off the tone, pauses, and starts another paragraph. Maybe I'm thinking about it too hard, but, you know, from everything I've read, Hendrix used to sleep with his guitar and practice twenty thousand hours a day. So I think that's what it takes. It doesn't just happen. There's a certain level of elegance that I only hear in a great improviser like that.

BLVR: Would you say that with improvisation you're trying to get to a place where it's as fluent as speech?

TA: More fluent. I feel a lot more bound up in a conversation than when I'm playing the guitar. I don't necessarily sit there and practice scales every day, but I do get up and start making some form of music from the second I wake up.

BLVR: Who were the important improvisers for you?

TA: I liked Clapton, Jimmy Page. But there was this one year that

changed me. It was when I saw Pat Metheny. He came to Richardson Auditorium, and he was playing with a jazz, harmonic vocabulary but with a pop sensibility. I saw King Crimson around that time, too. Robert Fripp was playing these crazy mathematical patterns. He'd be playing in a time signature of 7/4 while the other guy, Adrian Belew, played in 5/4, and they'd meet up thirty-five notes later. This kind of thing. But you have to put yourself in 1978. I was born in '64. So I was fourteen. I saw Stanley Jordan in that same place. And Wynton Marsalis. All those concerts were in one year, and that's the year I got into improvisation. That was the year before I left Princeton, New Jersey.

BLVR: In what ways do you work with Phish on improvisation? Like, improvising as a full band, rather than as four individual soloists.

TA: We had this series of exercises that we developed, called "Including Your Own Hey." It sounds weird, but we did them a lot. They start off with a pulse. [*Snaps in time*] The first level is, I play a four-note phrase [*sings "do-do-do-do"*]; Page [McConnell] is on my right, and he imitates it on the piano; Fish [Jon Fishman] does his best to play it on the drums; then Mike [Gordon] does it on the bass. Now everyone goes around the room in a circle and everyone starts one.

BLVR: It's a copycat listening exercise.

TA: Yeah, and then there were more levels. The next level is, I start a pattern and then Page harmonizes with it. We make a jigsaw-puzzle pattern. Then Mike finds his place in the pattern, and Fish finds his place in it. And we're all listening to each other. Now, only when you hear that all the other musicians have stopped searching, once you hear they've locked in with what you're playing, you say, "Hey!" So, since we're still listening so intently to each other, we should all say "Hey" at the same time, but if we don't—if someone says "Hey" when you're still searching, they've basically just told you, "I'm not listening to you." So we found, very quickly, that it meant you had to always be listening to three people other than yourself. And the music, we found, improved immensely by

not navel-gazing. So now the idea is, I'm not paying any attention to myself at all. I'm just responding to what they're playing.

Then there were other levels, where you'd leave a hole in a musical phrase, and the other person could only play in that hole. That was called "Including Your Own Hey Hole." [*Laughs*] So the bass lands, then the cymbal, then the guitar. [*Sings, "Ba-bo-da-bing, ba-bo-da-bing."*]

BLVR: And this helped solidify you as a band?

TA: Oh, yeah. We should do it again, though. We haven't done that stuff in years. Then, in the early '90s, we started realizing we were having tempo battles onstage. Fish would decide he'd lie back, and I'd want to rush. Every band who's ever improvised goes through this. Then someone gives the angry glare. What are you doing? Oh my god! The gig is falling apart because you're rushing! So one day we went into the practice room and we decided, we're never doing that again. We did "Tempo Heys" for a week. So we'd play one note. I'd slow down. Everyone follows me. I'd speed up. Everyone follows me. I can't lose them. And there's no fear. That's the important thing. Slowing down is cool. Speeding up is cool. Then we say, "Hey." Now it's Page's turn. Page is speeding up and slowing down. Within two days, it stopped being a problem. When we were onstage and someone sped up or slowed down, instead of glaring, we all looked over at each other and followed them.

BLVR: This is all a pretty analytical approach to improvisation, where I think a lot of people consider Phish's music to be just "made up on the spot."

TA: We're the most analytical band, in some ways. We'd talk and talk for hours about this stuff. I see improvisation as a craft *and* as an art. The craft part is important. There's a lot of preparation and discipline that goes into it just so that, when you're in the moment, you're not supposed to be thinking at all.

BLVR: I've heard you guys had a no-analyzing rule for a while. You

wouldn't talk to each other about how the show went.

TA: That was for about a year. You come offstage and no one can say anything. At all. At all. Because everyone's got their own perspective.

BLVR: Someone might think it's a horrible show and another person could think it's a great show.

TA: Today what I do is—I do this every night we play—I have a little quiet moment where I picture some guy having a fight with his girlfriend, getting into his car—the battery's dead—then he gets to the parking lot and it's full. Meets up with his friends. Comes into the show. I try to picture this one person having their own experience, and I picture them way in the back of the room. And I try to remember how insignificant my experience is, and how people's experiences with music are their *own thing*. We put it out there, and if it's of service to someone, great, but I try to get away from the idea that it's even starting from us. And when you do that listening-exercise stuff, when I actually get into a moment where I'm only listening, I find that the music gets so much… beyond us. And I can tell that from the reaction I hear from the audience. It always feels more resonant if I can get my hands off it. If all four of us were here, they'd all be saying the same thing. It's great as long as you listen to anybody but yourself. Anything but yourself.

BLVR: Seems to be true of life, just walking around.

TA: Right. It's when I start applying my own fucked-up perspective to a show—so I had a bad day, whatever—that I start adding judgment to it. Or I play something and start judging what I'm playing. It's just like that, walking around in life, that's true! How often do I find myself walking around and being aware of my surroundings and not having some fucked-up internal dialogue in my head that never ends?

II. FREE

BLVR: You put out a free-improvisation record [*Surrender to the Air*] a while back. What does *free* mean to you in that context?

TA: I'd been studying with a composer and writing a lot of fugues. Fugues are very disciplined. It's one theme and all development. You're never allowed to bring in fresh ideas. So there may have been an element of rebellion to that record for me, because I knew my teacher absolutely loathed that kind of music. During the recording, people were just walking in and out of the room, picking up instruments. It was great.

BLVR: Did you ever learn anything about improvisation through a book?

TA: A lot. A lot. I studied with a guy named Ted Dunbar at the UMass Jazz summer workshop. He taught me the system of tonal convergence. When I give guitar lessons, I recommend his book. There are twenty-eight scales that converge or bombard the tonal center. They are all tension scales, and they all come with a series of chords. If you listen to the great improvisers—Pat Martino, Sonny Rollins, someone on that level—these guys all studied this stuff. Yusef Lateef. All those '60s jazz guys. They're not playing the diatonic notes of the chord. They're playing outside the chord, but it's a very natural thing to do.

BLVR: Natural how?

TA: Let me see if I can explain this. There are only three chords in music, period. Minor, major, and dominant. A dominant chord wants to go somewhere because it has a tritone in it. A G dominant chord wants to go to C. That principle is physics. That's not something that was assigned to music by theorists. When two strings are vibrating together a tritone apart, there are so many overtones that all you feel is tense, and the notes want to squish together into the home chord.

Stewie sings about it on Family Guy. [*Sings, "You've got your G chord*

right here / It's like your cozy house where you live / That's where you start your journey / Here I am in my house nice and cozy / and then you poke your head out the door with a C chord / And everything looks OK out here / Maybe I'll take a walk outside to the D chord / Walkin' around outside, look at all the stuff out here / And then we go to an A-minor, gettin' a little cloudy out here / lookin' like we might get some weather / Then we go to E-minor, oh definitely got some weather / Things are a little more compli-cated than they seemed at first / And then we go back to my house."] It's great. The twelve-bar blues are based on this, too. But the jazz guys from the '60s took this concept to Mars. They came up with twenty-eight scales, all of which were basically substitutions for that dominant chord. The music is still simple: Major is happy. Minor is sad. Dominant is tense. That's all there is. It never goes further than that with chords.

BLVR: And you're working with these sorts of "tonal convergence" theo-ries when you improv onstage?

TA: If you're going to be doing a long improvisation, it's boring to sit on one scale and just go up and down. There's a lot of jam music like this, and that's why people don't like it. It never goes beyond that. Sonny Rollins isn't doing that, even though he's playing over a G-major chord for eighteen minutes. It's not just a G-major when Sonny Rollins plays it.

Herbie Hancock has this thing about an informed vocabulary but a childlike approach. He plays simple, simple, catchy melodies, but all his chord voicings have forty or fifty years of this theory in them. So when he gets onstage it can be all childlike. Not childish. But if you ever stopped a Hancock recording and looked at a few measures of what he's playing, you'd be floored. The voice leadings are filled with all these ideas. It doesn't sound complicated, but it's a more mature, elegant palette of emotions. These guys can hit an emotional chord that a lesser player couldn't. It's the same way a great writer with a great vocabulary can bring out subtler emotions.

BLVR: And you're still practicing this type of thing at home?

TA: Yesterday. It takes forever, because once I learn one of these scales, I can just play it from my brain. It doesn't sound right—if I'm playing it from my brain. I have to play it so much—until it sounds tossed off, until it *is* tossed off.

BLVR: There's that Charlie Parker quote: "You've got to learn your instrument. Then, you practice, practice, practice. And then, when you finally get up there on the bandstand, forget all that and just wail."

TA: That's what he did. It sounds like water when you hear him play.

BLVR: It's impossible to think that fast.

TA: You couldn't. They were all doing this. Coltrane. All those jazz guys. I heard that Ted Dunbar's theory of convergence is like the Holy Grail. There's stories about this legendary dinner these guys had where they wrote it on a tablecloth, and nobody knows where.

BLVR: There's actually a Coltrane quote I wanted to ask you about. He says, "I'd like to get to the point where I can capture the essence of a precise moment in a given place, compose the work, and perform it immediately in a natural way."

TA: I love that. I love that he said "compose the work."

BLVR: Right. And I wanted to ask you, do you think composition and improvisation are the same thing? Or are they inherently different?

TA: I think they're the same thing. The struggle is not giving up the best element of composition, which is the time to figure out that it's all right, and also to not give up the best element of improvisation, which is that it's happening in real time, so you can't stop to ruin it. You don't have any time to screw up.

BLVR: So you think in the best instances, improvisation and composition

would produce the same results?

TA: Yes. Yes. I'll give you an example. On the song "Billy Breathes," there's a guitar solo I like a lot. That's a composed solo. I didn't labor over it. What I did is, I walked around the kitchen—my daughter had just been born and we were living out in the woods in Vermont. I was in my union suit, chopping wood. I was not thinking about anything, and then I just started singing [*sings melody*] the first four notes of the solo. I had a cassette player and I'd run over and get it recorded. Then I'd forget about it. And then the next part came. It was a lot of wearing headphones while walking around. Cassette player in my pocket. Change a diaper, go to the store, and whenever I can disconnect from whoever I'm talking to in the room, I'd put on my headphones. So the point I'm making is that it still felt like improv.

BLVR: You were just capturing moments out of your daily life.

TA: I would just wait for the moment to come. It didn't feel any different than what happens on stages. I was busying myself with other things. I wasn't sitting there working, like capital-*W* work, but, in the end, it took days and days.

BLVR: You write a lot that way?

TA: Yeah. And since you're feeding the cat and you're not paying attention and then you listen to what you just recorded, you can really hear when it's wrong. If it's wrong, it's like when you put on bad music in the background. But going back to Coltrane, it sounds like he just wants to be doing that in an immediate way when he's onstage. I'm starting to think that patience is the biggest part of the whole thing. And, you know, another thing that just popped into my head, and I'm not sure if this answers your question, but like a week ago, I was writing this thing. Single lines and chords moving and blah, blah. I was going for about four days, and I wasn't really thinking about it. I had six minutes' worth of music, and then all of a sudden it just stopped. And I didn't really realize

that it stopped until I put all the pieces together. It's everywhere: on my cassette recorder, on my phone, on a 4-track recorder, on the laptop. It just stopped. All of a sudden. It's the concept of being a channel.

BLVR: You've said that before.

TA: A lot of people end up saying it.

BLVR: Otherwise you point at yourself and it becomes an ego-y thing. That's dangerous.

TA: I mean, it's still craft. It's still work. I got to play with these orchestras recently, at Carnegie Hall. One of the best musical experiences of my life. You go in and there are all the walls covered in photos of great conductors. A picture of Mark Twain standing on the stage. This is what you walk by before you go onstage, in case anyone ever wants to try and have an ego in that room. But so I get a two-hour rehearsal with these musicians, with the New York Philharmonic—maybe the top orchestra in the world—and every single musician on the stage is so far beyond anyone I've ever played with. All ninety of them. They were the top in their school and then the top at Juilliard and now they're playing second cello. And the humility is as high as the musicianship. Let's say you're playing a Beethoven piece in a room where the same piece was played one hundred years ago. They're sitting in the same chairs, wearing the same shoes and suits, playing instruments that are one hundred years old, playing the same sounds with the best conductor of their time, who is standing under photos of twenty of the greatest conductors. And when the music started playing, I had this idea that the music was coming through this little channel—for lack of a better word—for years and years. Musicians come and go and they're stewards of the music for a brief period of time. But once the music plays—it's really between Beethoven and the listener at that point. The musicians are there to get their goddamn hands off of it. All that training! Thousands of hours! Sight-reading every day! All so they can get the hell out of the way because nobody gives a crap about them at all. The less you notice

them, the better it sounds. I mean, it was the highest level of art in music that I'd ever seen, and it was performed by people who had spent countless hours of work just to be invisible.

BLVR: In music, you never notice that quality anywhere more than in the orchestra.

TA: And the challenge of getting ninety people to play together! Try getting four people to play together.

III. TALKING TO COPS

BLVR: Your early music sounds orchestral in a way, or at least compositional. But you've since moved further toward the tradition of songwriting.

TA: I'm starting to go back to the compositional side a little more. Recently, I just wanted to sing more songs. That's a simple answer. But Tom [Marshall, Anastasio's cowriter] and I went through a period in the '90s where we started going on these songwriting junkets. They were just a lot of fun because we would turn off the world. It's been a long time since we've done that, what with cell phones and everything. We would lock ourselves in a farmhouse. A lot of the songs off of *Undermind* and *The Story of the Ghost* and *Farmhouse* were written during that period.

BLVR: And a piece like "Time Turns Elastic," the one you played at Carnegie Hall: how does that get written?

TA: I wrote that over the period of a year. It was supposed to be an orchestral piece, and it was first recorded and released that way. But then Phish got back together and our producer, Steve Lillywhite, said, "You know, this wouldn't be a Phish record without a big, long thing," so we put it together and played it. There was a lot of process skipped when it went to the Phish version. The orchestral version is the real version, to me. It took a real long time for a piece like "You Enjoy Myself" to work. It

needed tender love and care. This one didn't get that. If you want to hear what that piece is supposed to sound like, listen to the orchestral version.

BLVR: How did that process work?

TA: I wrote the form. Don [Hart] did the orchestration. But that's a bit of an oversimplification, because the guy who did the orchestration is a close friend of mine, and we were on the phone for a year, working on it. He would fly up, and we'd spend three days on it, sketching it out. I orchestrated a couple of Phish pieces, like "Guyute," and basically found out that I'm a crappy orchestrator, but I knew enough to know it would be cool if, say, the brass took off in this spot. We would have conversations like, How are we going to keep the rhythm going here? And we'd go online and listen to some Afro-Cuban bands—because an orchestra has three percussionists. So we'd try to comp that kind of a vibe and then go home and work on it.

BLVR: And that's pretty different from the way the song-y music is created.

TA: Yeah. Tom and I just have a blast writing the songs. It's our social life. We go out and by the end of the night we have three new songs. We basically talk to each other in song. This is how it's been since eighth grade. I text him songs.

BLVR: You guys have interwoven music into social life.

TA: I have. I think that's the truest thing that has been said in this interview so far.

BLVR: There's no off and on switch.

TA: Yeah, but that can be dangerous. People in my immediate family think I'm losing my mind, because I don't know how to turn it off. I really don't. As a matter of fact, I've been encouraged by my wife and those

around me to, on New Year's Eve, hand over my phone for a month. This is actually something I've never talked about before. This is what I've done to my life. Anybody who comes into my life, I start collaborating with. It's not just Tom. It's Steve, the Dude of Life, who wrote "Fluffhead" and "Suzy Greenberg"—a lot of good songs. And then it's my first pal [Suzannah Goodman], who wrote "Bathtub Gin" with me, and then my friend Dave [Abrahams], who wrote "Runaway Jim" with me. It's my daughter, who I wrote "Goodbye Head" with. It's like it's always happening. The only problem became when we started employing all our friends. That kind of thinking got out of control. I didn't know where life began and music ended.

BLVR: Is that bad?

TA: There shouldn't have to be a separation, but sometimes reality sets in. So I'm writing songs with friends all the time, and then you start getting phone calls, years later, like, "I need more money to write songs." I mean, anybody in the room gets a songwriting credit. That's how I do it. You open up this door, and all of sudden people are calling and saying, "Let's do more." What starts out as a sort of gift turns into a situation where you're on the phone all day, fielding these kinds of issues, and you're not walking down the street, looking at architecture, thinking about music. I just say *yes* too much. I'm working on a Broadway musical and a Phish record and a solo record and a quintet thing.

My family recently made me change my phone ringer to a barking dog so it sounds like *no. No no no.* The problem is, if I don't learn to have boundaries, which, historically, I don't, then a lot of moments become, well, talking to cops or whatever. You can get a little crazy. It's a blessing, but there's a certain point at which you have to go to bed.

BLVR: Right. You have to stay healthy, I guess.

TA: I'll sleep when I die!

IV. MUSIC AND ENDURANCE

BLVR: Your set lists are analyzed by fans and published in books. What is your thinking about the art of the set list?

TA: In the mid-'90s I was incredibly obsessed with it. I'd always be thinking about key changes between songs. So you'd put one song in D, and then the next one in E, and then rise up to it. Then there was an attempt to make everyone onstage sing. Much of the songwriting was written to the set list, not the album. We'd say, "We need a set-closer. We need a big whopping set-closer." Or we'd need a song for Page to sing. Or we'd write a song for a piano solo. But then later in the '90s it became more organic, spur-of-the-moment. We'd just let it rip. The problem is, there are so many songs now.

BLVR: I heard you don't use set lists at all, sometimes.

TA: Yeah, since Phish came back, I'll just walk around backstage and ask everybody, "What do you want to play?" and people will say, "Oh, I want to sing this or that," until I have thirty or forty songs on a piece of paper. It's like the writing. The set lists are all over the place. A mess. Then we go out onstage and just forget about it. We give a set list to Chris every night and he just laughs and rips it up. We never even play the first song.

BLVR: Do you call it out?

TA: I'll lean over and ask Mike or Page. It's kind of like a big therapy group up there. I'll yell out, "Is everyone cool with this?" But, yeah, usually, I just scream something out.

BLVR: For every song?

TA: Yeah, you never know until you get up there. It's a sort of controlled chaos. Meaning, there's a lot of walking around and asking questions. Like, I'll walk into the venue and—I remember at Alpine Valley there

was a girl standing by the fence, and I asked her, "What should we play tonight?" and she yelled, "Play 'What's the Use?'" And so I'll write that down. The problem is that some of the songs are so complicated that, if we don't run it beforehand, then it sucks and there's lots of self-flagellation. Like, "Oh my god, I messed up 'Peaches en Regalia.'" You know? Which is exactly what happened when we played it last time. I felt terrible.

BLVR: You guys have played some seven-hour shows, right?

TA: We played on New Year's Eve '99 all night. We played from eleven that night till about 7:30 a.m.

BLVR: What thoughts are you having at 7:29 a.m., when you've been playing all night long?

TA: Oh, that was one of the best nights of my life.

BLVR: Does the music get better or worse when you play that long?

TA: I don't know. That night felt like a big dream. Have you ever stood in a field with a buddy and hung around until the sun came up? Well, it was that, times eighty thousand people. It was winter and we were outside. It was at Big Cypress. It wasn't even a venue. We built it. It was a small city. One of the great nights on earth, for me. But I've never listened to it or anything. I don't want to. The sun came up. It was all pink.

BLVR: I've heard you want to play even longer shows.

TA: We want to do the LG, which is some random gig, in the middle of some tour, in some random venue in Ohio. We'd shut the doors and say, "The only rule is, if you leave you can't come back in." And all your cell phones have to be handed over, and if you have to make a phone call, there's a pay phone, and you're only allowed to say, "I'm not going to be there." There's a big burly guard by the phone and he's got his finger on

the thing. There'd be food and everything. And then we'd play for two days, at least. So you'd go in when the sun was setting, and then you'd come out two mornings later. So it'd feel like you were up all night, but really you were in there for two days. I wonder how many people would stay? Ten?

BLVR: What's the interest in music and endurance about?

TA: We used to do long practices. Really long. It's another way to get away from the ego. You stop thinking. All this stuff all sounds so silly when you talk about it. But it happens. It also happens over the course of a tour. The first show, you walk onstage and you're thinking about the shirt you're wearing. By the end, it's completely different.

BLVR: You have such a large community of people surrounding Phish, and I wonder what your thinking is about music as a social tool. Can music change society?

TA: That sounds like which came first, the chicken or the egg. Because I always think society changes music. In a big way. Think about the '40s. My teacher was fifteen when Woody Herman was touring around the country. It was one of those ripping big bands, with four trombones. If you were there, it was like the rock and roll of the time. People were dancing and sneaking drinks in flasks and going out to the parking lots with their girlfriends. And then World War II came, and all those guys got drafted, there was rationing on rubber. Overnight, it ended, as soon as World War II hit. So society changed music there.

BLVR: That was a time when improvisation was actually a form of pop music.

TA: Yeah. If you look at the '40s, it was the last time when rock—for lack of a better word—and high art and pop music were all one thing. They had the best singers and arrangers and drummers all in a three-and-a-half-minute song. My teacher would always talk about this. He'd

go with his girlfriend, ditch her, and then run up with his guy friends to the front row. They all knew who the best trumpet player was. This was at Roseland. Same place we're playing. So then World War II comes and then everyone's sad for a while—a simplification of history—and then everyone wants to be cheered up, so along came the Beatles, just in time. "Whooo! Let's have a party. I'm sick of these grown-ups talking about war all the time."

BLVR: So you never consider your music to be a tool? You're in a position where you have such a large community mobilized around you. And yet, you never seem to try to use your music to directly shape the community.

TA: No, but I feel like we're a part of something that's bigger than ourselves. When those first four Phish festivals happened, there were seventy thousand people in Maine. It was crazy. It's like ten hours north of Portland. We didn't know what the hell was going on. But then, look at what's going on in culture. The internet wasn't quite invented yet. MTV was still huge. Pop music had become, in the '80s, this horrible plastic thing where you had to make a video before you made music. It was a terrible time in music, for me, other than some of the great punk bands like Bad Brains. I mean, there's always good stuff going on—Prince, Talking Heads—but in pop culture, it was horrendous. And when we started doing these festivals, it just exploded. This whole community popped up. It was weird. Today, you couldn't do a festival in Maine with every band in the world playing and get seventy thousand people to go up there. Think about it. A lot of these new festivals draw just eight or ten thousand people. It's almost in Canada. It's really far away. But was that us? I don't think so. Again, if World War II didn't end, you wouldn't have the Beatles. You need a cultural landscape. Something just happened with those festivals—for about four years there, everyone wanted to be gathering. ✶

GENESIS P-ORRIDGE

[MUSICIAN]

"THE BOTTOM LINE IS THAT THE HUMAN SPECIES HAS TO REALIZE THE HUMAN BODY REALLY IS JUST A CHEAP SUITCASE."

Ways to think about DNA:
As the perpetrator of an artificial duality
As a tool of control
As a parasite

hen Tim Leary called and asked if I'd pick up Genesis P-Orridge on my way down from San Francisco to Los Angeles, I knew enough to be afraid—but not a hell of a lot more. As founder of industrial music pioneer Throbbing Gristle and cult-inspiring acid-house follow-up Psychic TV, P-Orridge was known for soliciting mail-in pubic hair and semen samples from his fans, tattooing his wife's labia, and staging mock abortions on video. When those tapes were interpreted by clueless police as real satanic murder rituals, it became impossible for Genesis and his family to return to England without danger of imprisonment.

The near-universal notoriety he received in the U.K. was even more than

Genesis had bargained for, and his marriage didn't survive in exile. Sensing a kindred spirit, Leary—who had once lived in exile as an escaped convict—invited Gen to decompress at his Beverly Hills home, just one cliff down from the Sharon Tate house, which was then being occupied by Trent Reznor.

When I found Gen at the designated coordinates—an underground shopping mall parking lot—I was surprised to find him with his two daughters, then about seven and ten. They spent the entire six-hour drive fighting in the back seat as Gen tried every threat and bribe he could think of to quiet them. Over the next decade, it was the challenges of the mundane that we bonded over more than any artistic or cultural ideals.

Sometimes he'd come stay at my apartment when he'd get in a fight with his second wife, Lady Jaye (Jackie Breyer P-Orridge). Meanwhile, I'd come to Gen for encouragement whenever my personal courage didn't quite match the temerity of my ideas—or if I was getting pounded on a bit too hard by a critic or an online forum. Gen's the one who convinced me to get remarried ("See what's behind door number two"). Yes, we contributed to one another's projects and conceptual framework, we worked on a few book projects together, and for a year or so I even played keyboards for the newly reformed Psychic TV (PTV3) and experienced Genesis from the other side of the stage and recording booth. But our real value and connection to one another always concerned navigating or, in his case, erasing the boundary between our personal and creative lives. For while my life might be dedicated to understanding and exploiting media, his life and body became the medium itself.

Gen's most recent project is a cutup experiment called Pandrogeny for which s/he and Lady Jaye underwent gender-challenging plastic surgeries to look more like one another. Jaye's sudden and unexpected death left Genesis Breyer P-Orridge as not just one half of a couple but one half of a real-life art project.

S/He wanted to talk about it with me, and for posterity, as soon as possible. So, just a week after Jaye was buried, I showed up at their Ridgewood apartment with a tiny handheld video recorder, and we took a subway ride into Manhattan for Gen to do a bit of the kinds of banking one does after a spouse dies.

—Douglas Rushkoff (August 2011)

I. REBELLING AGAINST DNA

THE BELIEVER: Maybe we should start at the beginning, for those who might have no idea what pandrogeny is about. I mean, you have big breasts and wear women's clothing. What's the difference between pandrogeny and transvestism or transgender?

GENESIS BREYER P-ORRIDGE: Well, the main difference is that pandrogeny is not about gender, it's about union. The union of opposites. One way to explain the difference is very easy: with transgender people the man might feel that he's trapped—the person feels they're a man trapped in a woman's body, or a woman trapped in a man's body—whereas in pandrogeny you're just trapped *in the body*. So pandrogeny is very much about the union of opposites, and, through that reunion, the transcendence of this binary world and this illusory, polarized social system.

BLVR: Doesn't that happen in sex, anyway?

GO: Of course, the orgasm. When people have an orgasm together that's a moment of pandrogeny. And when people have a baby, the baby is pandrogynous, sexually. Because it is literally two people becoming one.

BLVR: So then these memes—this ability to transcend polarity and gender—are already at our disposal. Why do it the way you are, through surgeries and implants and all this medical activity, all the social challenges of getting into the ladies' room as a pandrogene? How do the literal cutting and pasting of gender traits dissolve these polarities any more than they underscore them?

GO: Well, as you know, it went in steps. In the beginning it was very much romantic. Jaye and I decided we didn't want to have children. but we still got that urge to blend, to merge and become one. I think the heart of a lot of the romance in couples, whatever kind of couple they are, is that they want to both just be each other, to consume each

other with passion. So we wanted to represent that. First we did it by dressing alike. Then we started to do minor alterations to our bodies. Then we decided that we would try as hard as we could to actually look like each other in order to strengthen and solidify that urge. So it was initially a very self-centered thing to do. But once we started to think about it, we realized that it was a bit like William Burroughs and Brion Gysin in *The Third Mind*, where they said the two of them together would no longer be the writer of the piece; it's the two things cut up and being reassembled. That was the product of *The Third Mind*—the cutups. We thought if we used each other as separate artists, or individuals, and we cut ourselves up, maybe we could create a third entity, which is the pandrogene. So that's very much the third being, a new state of being. Burroughs always used to talk to me about how you short-circuit control. And Jaye and I talked a very long time about that. And we decided that DNA was very much the recording—the tool of control. Perhaps even DNA is a parasite and we're just the vessels at its disposal.

BLVR: Yeah, we used to talk about that. "Breaking sex" as the rebellion against the code of the DNA. Even death might be an SNA program and not—

GO: —a necessary one.

BLVR: Which formed the basis of Tim [Leary]'s and Bob [Robert Anton Wilson]'s ideas about life extension, too.

GO: So we decided to start approaching that and what that would do— what the effect of that was. Obviously, one way human beings have to change is to change their behavior, and change the binary system that's been in place in all societies for thousands of years. So that's when you get into evolution. You know, in the beginning, in prehistoric times, people were… This isn't easy for me, because I keep just thinking about Jaye being dead.

BLVR: Well, that's the thing; I mean, the real question under the questions we've been asking…

GO: The bottom line is that the human species has to realize the human body really is just a cheap suitcase. It is not sacred. We do have the potential to radically redesign ourselves, for better or worse. Our destiny as beings is to keep on evolving. It's not to think you have reached a perfect state and all we need is new toys. The human species is still behaving in prehistoric ways on both the macro and micro levels. "If it's different, attack it; if it's other, attack it; if it threatens our resources, if it threatens our perception of how we replicate, then it must be eradicated…"

BLVR: So then instead of activism being this thing you do, it's this thing you are.

GO: Or want to become.

BLVR: But, then, Jaye's passing. Do you experience that on two levels, then? On the level of half of the pandrogene?

GO: Yeah. But I also experience it as a person who is fifty-seven and has been indoctrinated for most of my life to accept a binary world. And feeling a great sense of loss just in a romantic way, as an emotional person. Conceptually, I see that she has just broken through the final perceptual barrier. The human species won't exist if it carries on replicating pointlessly. I think it's very clear what we were concerned about when we began this, which was the ever-increasing polarization and reduction of ideas into dogma and paranoia, and this posturing that there's a right way and a wrong way: I'm right, you're wrong, and therefore I must attack you. and the whole idea of pandrogeny is to make that irrelevant, and to bypass that. If we were all pandrogynous, physically and/or mentally, it would be impossible to be at war, because there wouldn't be a sense of difference all the time.

BLVR: So does the project continue? You as a lone pandrogene?

GO: It's not convenient. Because there are lots of things we had in mind that would use both of us in the projects. So I have to try and figure out ways to represent those ideas anyway.

BLVR: Or start on the new ones. I mean, gender may be an artificial duality perpetrated by DNA and all… but what about death? That's got to be the biggest, baddest duality of them all. It's not so very hard to see through gender as a social construction. An illusory divide, like you've shown. But death is entirely more convincing. We die, and the people to whom we've passed our genes take our place. Death feels like DNA's last laugh, its final tyranny over us.

II. PERFORMATIVE MASH-UPS

BLVR: I played our PTV3 record for a *Rolling Stone* critic who shall remain nameless. He said, "Well, it's competent. But this song is a copy of the Doors, this song is a rip-off of old Pink Floyd, this song is the Velvet Underground." I always understood that we were emulating certain things about the Doors with one song, maybe, or emulating certain things about Floyd with another, but I didn't see it as stealing, copying, or even as tribute, in the sense of some tribute band. PTV was "sampling" this way before samplers even existed. It's not just mindless appropriation, is it?

GO: No, it's a knowing cross-reference, because young people today don't have any sense of the history of their own music. You can go down St. Marks to those record shops and mention the Doors and they'll say, "What? Who?" They don't know who any of these people are. They buy Interpol but they don't know about Joy Division. [I've] always found it really suspect when musicians or writers act as if everything is divinely inspired and they've never been influenced by anything. It's just all theirs. They're unique. Brilliant. And, in fact, I've always felt that everything is a continuum. It's important to serve as an educational foundation as well as just an entertaining or a conceptual one. So you cross-refer people to what *did* influence or inspire you. Every band that's around today starts

off by trying—consciously or not—to be like their favorite band at some point or other in its career. That's how you begin.

BLVR: Without ever saying it.

GO: Absolutely.

BLVR: And without even knowing what influenced that band. Or, better yet, they try to hide the influence by camouflaging it or changing a few chords. They deny the influence because they're ashamed of it—as if it undermines their claim to originality. Unlike, say, the Talmudic rabbis: whenever they would talk they would say, "Well, as the great Rabbi Eliazar said to the great Rabbi Hillel said to the great Rabbi Moshe…"

GO: Mm-hmm.

BLVR: And only then would they add their own insight to the tradition. Acknowledgement of lineage makes the new contribution stronger and more pronounced. But in this culture of copyright and ownership and money, it seems as if claiming unique ownership is somehow more valued than claiming lineage or reference or heritage. To have been influenced might mean you owe someone some money.

GO: Well, for a start, you've got to remember that we grew up in the '60s. There was a point in 1969 where we actually did light shows for Pink Floyd. We would hitchhike down to the UFO Club and the Arts Lab in London and be in the squats in 105 Piccadilly. That is my era, and I've been consistently creating music and art ever since then, without any break. So if anyone has the right to sound like or cross-reference their own era, it's me. They seem to forget that we're a '60s band in terms of the person leading the band. And so we're not actually plagiarizing, we're merely being absolutely consistent with our origin, and actually deliberately directing people toward the more exciting parts of that heritage.

BLVR: And PTV predates computer sampling and mixing… I mean, so

the way you cut and pasted in that era was not by cutting and pasting tape of other bands, it was by cutting and pasting styles and sounds that you actually performed. It was a performative mash-up as opposed to a digital one. And for cutup to work, there has to be a loosening of our sense of ownership.

GO: Absolutely.

BLVR: And this reaches an extreme in an era of Napster and hip-hop and remix and even television commercials using pieces of songs reinterpreted by others.

GO: But we've done all those. We've already done all those. The only thing we never did was a straight-ahead psychedelic-rock band, which is my first love in my record collection. And, yes, it's absolutely and utterly selfish to make an album that we really enjoy all the way through. So what? You know, we've always made albums for our own interest, anyway. The audience is somewhat of a luxury on top.

III. IT'S ALL REVOLVING AROUND BATHROOMS AGAIN.

GO: In Phoenix, there was that whole furor about PTV playing in the bar, because I was transgender and he wasn't letting anyone come into the club who was transgender. And that got mentioned on a little local newspaper site, and then I was getting phone calls from Fox News and ABC. Same day!

BLVR: You would think that would be good for business, though.

GO: Well, not really, because the gig was the same night, so what you're basically talking about is not being able to play exactly when we were going onstage.

BLVR: They were claiming it had to do more with the bathrooms,

because they wouldn't supply a transgender bathroom?

GO: Apparently, what happened was that at the first club, called Anderson's, a few months before, one woman came from the women's bathroom and said she had looked under the door of one of the stalls and seen somebody with their feet pointing the wrong way, which to her meant somebody who was transgender or a transvestite was standing up to pee. And she was appalled, shocked, outraged, and she complained. So the owner of the club then banned all transgender people from the club. Oh, of course, I assumed when he said "tranny" he was referring to transvestites, but there's a difference. *Transvestite* is very different than *transgender*. Many transvestites who are heterosexual males feel that they have to dress up as a woman sometimes.

BLVR: Or would like to.

GO: Yes, or would like to. And transgender women identify as being female and would never stand up, no matter how far along in the change they are, because that would be strange to them to stand up, because they always sit down. So it's really only about transvestites, it's not about transgender people at all. So he banned everyone from the club, and then there was this little local scandal about it, a big story of was it violating rights to free expression and civil liberties and so on. And then they discovered Psychic TV was coming to play—some of the more active gay/lesbian/transgender people—so they started emailing us, saying, "Did you know that the club you're going to play at has banned 'transgender people' and transvestites?" Of course we said no. Then one of the activists told the owner of the club, "Do you realize that you've got Psychic TV on tomorrow and the lead singer is a tranny?" So he of course was caught off guard and said, "I had no idea; I have nothing against transgender people, per se." So they said, "Well, we want to come see them play, but we're not allowed to go! Isn't that a little bit of a contra-diction in terms? The singer can sing—lead tranny—but we can't watch."

BLVR: No, it's like the old days: big black performers in the clubs that

black people couldn't go to.

GO: Yeah, it is very much like segregation. The whole thing. It's interesting to me that it's all revolving around bathrooms again, and the use of facilities, shall we say. So at that point the promoters talked to the owner of Anderson's, and he said for this one night he would let me use his personal private bathroom. And that way the people in the women's toilet wouldn't be bothered, the guys in the men's wouldn't be bothered, and I would have somewhere to go pee. And I said, "Oh, that's not appropriate." He also said he would put armed guards in all the bathrooms to prevent anyone from misusing them. I said, "No, I can't play under those conditions." So then the promoters tried to find a new venue, and they found a new venue called The Sets, which is another club.

BLVR: Right.

GO: We moved all our gear over there, and we'd just started to load in around six. And then the promoter came over with the guy who ran the club and said, "We are ever so sorry, but you can't play here tonight." So we said, "Why?" " Well, we've been getting phone calls, threatening phone calls from the extreme right-wing people in town, the Christians and so on. And we have also been getting phone calls from the transvestite/transgender/gay/lesbian alliance saying they will demonstrate outside." And it turned out that the club owner said that's not really it, it's that the people who own the building, which was a shopping mall, had rung him up and said, "If you let those people play they will take away [my] lease." And the insurance company rang up and said they would close insurance coverage as well, because they were afraid there might be a riot because of this tension. So then we were suddenly stuck with having to move again, and by then it was around eight o'clock in the evening. And we finally ended up at a really run-down biker club. They were more than happy to let us play, but it was a tiny stage. I couldn't even take my bass off, and Eddy had to play with three drums. It was not the appropriate space.

BLVR: Did people come?

GO: Oh, it was packed. And there was a really nice moment about half-way through. Because it was so packed—it had been 110 degrees that day, and everyone was drenched with sweat. So I just said, "You know what? This is when the whole gig goes topless." So I took my shirt off, then the rest of the band did, and then about half the audience did.

IV. COYOTES AND KALIS

GO: All the ways Jaye and I experimented with pandrogeny while she was still alive, they all kept leading us to the fact that the human species is stuck in a primitive behavioral loop: underlying behavioral patterns that are still based on a sort of clan mentality from the Stone Age. That the male of the species protected the women and children because they were a resource that they needed in order to continue the clan, and how any other clan would steal that resource, literally, but also try to encroach on the food supplies and shelter and resources of every kind.

BLVR: In the current conversation, you're either supposed to be pessi-mistic and ecological, or to accept the infallibility of human ingenuity and evolutionary capacity.

GO: But our evolution—mine and Jaye's—is about behaving, it's not about resources. The basic point is that in the very early stage of human existence, when we were fighting to survive the ice age and for survival against saber-toothed tigers, it actually served humanity's purpose for the male to be controlled by an embedded program to attack anything that threatened its resources.

BLVR: Anything *other*.

GO: Anything that's different or other. That helped us survive! But that was a very different environment, and we haven't bothered to change that behavior pattern at all. We've just made more and more incredibly

complex and sophisticated and intricate environments.

BLVR: And natural selection is inappropriate in this situation because…

GO: …because there are so many people at risk for the sake of a few who still work with that basic template. and unless we change that behavior—which is based on a very polarized dualistic system and very much about using violence and intimidation to maintain a status quo—if we don't change, then we're doomed.

BLVR: So you change the self? Through external changes like breasts?

GO: It's all to help the human species change its behavior. It happens because humans see themselves differently. That's the thing. If you change the way you are physically, we all know that it changes the way you perceive things. For example, somebody who becomes a quadriplegic perceives the world differently.

BLVR: Just as someone who gets what are ultimately artificial breasts will end up perceiving things differently and being treated differently?

GO: This is what we felt was at least symbolically represented in the pandrogene: the commitment to absolute change, for the greater good and for the individual good. It's the whole thing: change the means of perception and you change the world.

BLVR: Well, they definitely changed for the people immediately around you.

GO: Then I think it could happen on a macro level, and that level, too.

BLVR: Yeah. I mean, the funny thing—the thing I've always enjoyed about it most—was how it played with the minds of some of your hardcore fans. I always found the original group, the boys and girls calling themselves "coyotes" and "kalis," somewhat sexist—entrenched in very

stereotypical gender roles.

GO: Well, that's not what it was about.

BLVR: But it's certainly where a lot of guys, especially, took it. You were the most pierced, scarified, and scary person they had to look up to. For many, the neo-primitive thing was at least in part a form of daring machismo.

GO: It's funny because Jaye used to walk down St. Marks Place with me and say what you were just saying, basically. She'd look around at all these people with their piercings here, there, and everywhere, and their tattoos, and she'd say, "I blame you for this."

BLVR: And when we played that first Psychic TV show after you got the tits—to be onstage and see those guys' faces when they realized they had to come to terms with seeing Gen like this. They had all been modeling what they thought was Gen's, for lack of a better word, *machismo*. "Oh, he can stick a spike in his balls and survive… But now the person I've been 'modeling on,' whose tattoos I have on my skin, is now crossing a boundary that is really frightening to me." That was the greatest gift you were giving them, I thought. ✶

LAURIE ANDERSON

[MUSICIAN]

"BEING AN ARTIST IS A TOTALLY GODLIKE THING TO DO—AND I HAVE A GOD COMPLEX."

Guys who really get it:
A guy who knows absolutely everything about boilers
A guy who built a bicycle from seven hundred parts off the internet
Alain de Botton

I met Laurie Anderson in early 2006, when I invited her to participate in a literary and music series I run and host in New York, called "Happy Ending." I ask the artists to do something they've never done before—to take a risk onstage. The risk she chose was to tell a story through PowerPoint presentation. The audience was completely enthralled, but when I reminded her about her risk in our interview, she was mortified. Hosting in front of Laurie Anderson felt like a personal risk for me: she is one of my artistic heroes. But the instant we shook hands that night, she put me at ease with her ease. I carried that onto the stage, and the show went well.

Born in Chicago in 1947, Anderson quickly found her place in the experimental art scene of 1970s SoHo. Her first performances were

spectacles: a symphony of car horns at a drive-in bandshell, a violin concert in which she wore skates frozen into slowly melting blocks of ice. Her reputation in America and Europe quickly grew, and, less than a decade into her career, the New York Times *recommended her live performances to "anyone remotely interested in where American art is going," calling her "the best and most popular performance artist of her age." Her work has been described as "avant-garde pop," "cryptic yet warmly accessible," "popular, but epic; showbiz, but avant-garde," and "entirely idiosyncratic." By age thirty-five, Anderson possessed something very rare in performance-art circles—mainstream popularity—when her rock single, "O Superman," reached number two on the British charts.*

For four decades, she has created work that employs a variety of media: sculpture, music, video, spoken narrative, projected imagery. She has scored orchestral compositions and invented musical instruments, including the "tape-bow violin" (on which recorded magnetic tape replaces the horsehair in the bow and bridge) and the "talking stick," a wireless device that can access and produce any sound. She has published books, released seven albums on the Warner label, shown at major museums, and was employed as NASA's first artist-in-residence. She has said that she feels her sensibility is "closer to the attitude of the stand-up comedian... not only because I believe that laughter is extremely powerful but because the comedian works in real time."

I visited Laurie Anderson at her Canal Street studio overlooking the Hudson River. She sat there, comfortably barefoot, asking perhaps even more questions of me than I asked of her.

—Amanda Stern (January 2012)

I. "AM I IN A STRUCTURE OR JUST A DIAGRAM OF A STRUCTURE?"

LAURIE ANDERSON: I did a show inspired by Alain de Botton—he has something called "The School of Life" in London. It's a really wonderful storefront, and in it are twenty books—they're not for sale, but they're the twenty books that you go, "Oh my god, why is that book not in my collection, why don't I know about that book?" And he curates

them, and it's on one of these streets that has a name like Bruised Lamb's Ear Lane, in the old meat-market district. The idea of The School of Life is that a lot of people go to school and learn how to make money or get a job, and then they kind of stop learning things except for the things they have to learn—like Photoshop or Pro Tools, which is a technique, not a discipline, although some people have turned it into an obsession. Anyway, he figures that everyone has one book in them, which I totally agree with—at least if they could figure out how to tell their story, they do—and so he opened The School of Life, and people come by and they talk for however long they feel like, and it's a kind of—not a class, but a presentation of some kind. I love that idea, because I know a lot of people who have weird specialties that are not taught in schools; they're things that you learn in life.

So I was asked to curate a month at The Stone, which is John Zorn's club on Second and Avenue C, and in addition to programming music every night I also had Sundays, which became The New York School of Life, to which I invited a bunch of people. I had one guy come and talk about boilers—boilers are his love. He knows absolutely everything about them. He gives tours of boilers in New York. For most people, they're something that's down in your basement, and you don't know how they work, and the less said the better, but he adores boilers and sees them as works of art, and he gives tours of buildings that have the most interesting boilers, and it is so fascinating to hear him talk. He gave an evening that was a double bill with a friend who built a bicycle from seven hundred parts he got on the net, and it was a beautiful English bicycle, and the bicycle-boiler show duo was one of the greatest shows I've ever been to, because it was just these regular people talking about these things they were just really, really passionate about; it wasn't artists or writers talking about "why I do what I do." You know, I've heard all of those reasons, and they never ring the right bells for me. It sounds like someone talking about their résumé, "why I write." You're like, Uh, better to keep it to yourself and just write if you feel like writing. You know what I mean? So we didn't want to hear why people do their work, we wanted to hear what they do.

THE BELIEVER: Where did you find the boiler guy?

LA: He's just a friend of mine. I mean, if you think about it, you can come up with about twenty people who know a lot, and if you give them a platform… Now, Alain de Botton is somebody who has a Balzacian sweep of how things work. I really like his work. He just starts at the edges and goes, "OK, what goes on in this town? Let's see… First, let's go out to the port and see how things come in…" It's almost the way Balzac will describe a breeze moving through the city, you know, under a door, and then it goes into the baker's nostril, and then it goes floating out the window into the seamstress's house, and he glues the city together with the breeze or whatever mechanism he's using. One of my favorite things Alain de Botton did was he was the artist at Heathrow, which I thought was a great job, and then he wrote a book about Heathrow. Have you read that?

BLVR: No.

LA: Fabulous book. Because you go through Heathrow or any airport and you go, What's behind that hollow cardboard wall? And he decided to find out, so he spent time there, and every time I've been through Heathrow since then, I know what's behind those walls. The way the whole airport shakes every time an airplane lands, you're like, Am I in a structure or just a diagram of a structure? You're not really sure. Added to the fact that there are no clocks there, either, so you're sort of lost in this flimsy world, which is the way they would like to keep it. But Alain is a very sharp observer of detail; he described in a couple of pages, really accurately, what happens when you come into arrivals and what everyone does—

BLVR: They look to see if someone's come to meet them!

LA: Even though they know no one is coming to meet them. Your boyfriend is not coming, your mother has been dead for five years, absolutely everyone is out of town, no one is going to meet you! You still scan

very quickly and in under a second—"No, it's true, no one has come to meet me"—but also, the next quarter of a second, "I am an adult, I am going to get a taxi and go home by myself to my apartment and I will be grown up about it and I will accept the fact that no one has come to meet me, yet again." He tracks those eye motions, and tracks what's going on with people in situations as fraught as an airport, and makes it very vivid. So he's one of my favorite anthropological observers, and also just because he doesn't see writing books as something that's special and stylized, but as something that's really integral to learning things and putting them into a context. When you're in a context, it's very hard to understand, unless you read the rule book about what context you're in to give yourself one. So you may be like, "Um, I'm an artist of the minimalist school, and so I go to these openings," but without that context of being a minimalist, I think a number of artists and musicians and writers are really just lost—they are lost. I mean, why are you doing this? Who are you doing it for? Having a little bit of a context gives you this illusion of its having meaning, but what is the meaning, really? Then it becomes beyond terrifying. What are you doing it for?

BLVR: Right.

LA: Most people can't answer that, myself included.

II. "GET ME A BUNNY, ANNNDY!"

LA: Let's say I'm asking you why you write. What would you say?

BLVR: I'd say if I knew the meaning, I wouldn't do it.

LA: Uh-huh.

BLVR: In some way it's that elusive, intangible struggle that propels me forward—it has no end.

LA: So you're doing something that's endless, and you will never find

out what it means, but you do it anyway.

BLVR: Yes. I mean, I know what it means viscerally; I can locate the meaning inside myself, but it's more of a feeling. Even if I could name it or put it into words, I can't control whether people are actually receiving the intended message or the meaning I'm putting inside the work—

LA: Well, do you think anyone ever does? I mean, it's like—I especially feel sorry for painters, or writers, too, because they don't get a chance to see their audience. I mean, that's one of the reasons I like working in live things. That's the way I edit. I look at people's faces, and if they're falling asleep, I'll take it out—not to please people, but because it has to jump across. But, I mean, you do readings and public performances, right?

BLVR: Uh-huh.

LA: Don't you watch reactions, or do you ignore them?

BLVR: I don't ignore them. I feel like I sort of absorb the information as different temperatures inside my body—as gut instinct, I guess. At the reading series I run, I'm trying to bridge this gap between the audience and the performers, to include the audience so that they become a part of the event, a part of a shared experience. I want the audience to care about the author's onstage success, and not secretly hope they fail.

LA: But don't you think that audiences always want people to succeed?

BLVR: Yes, and... no.

LA: I mean, they're there.

BLVR: They're there, but an audience builds a relationship with these people, and sometimes they don't like them—

LA: I always feel like if someone has stage fright, I really try and say,

"Listen, these people want you to succeed, they want to have a good evening. They want to see something really great. They don't want to see something crappy. They don't. They want to be at something really special."

BLVR: I feel like there are moments people have onstage where there's a fuckup, or they flub, and their nervousness becomes the audience's nervousness.

LA: But that's part of the whole thing, because then the performer has shaken your faith in them. It's like suddenly you see, well, actually this person might fail, so maybe we better turn on them now while they're down.

BLVR: Right, and that's such an interesting dynamic, because all of a sudden the audience is not rooting for you, and they are now—

LA: The audience creates its own personality, I've noticed, in the first five minutes. They will either be generous, funny, silly, withholding, academic, analytical, grudging. And I'm fascinated with how that gets constructed, because it happens right away—

BLVR: It does.

LA: And then if it doesn't—I mean, I'm sure you know this as a comedian—you'll never get them back. Good luck. I mean, it's a cliché, but it's really true. Even in an academic setting, even in a lecture, people size it up and they want to know really quickly. That's why I always put a jump cut in the first two minutes—

BLVR: Smart.

LA: A really wide jump cut, really wide, so that it functions to throw things off.

BLVR: Right.

LA: Because audiences, whether they're seeing a film or a reading or whatever it is, a concert, they decide very quickly what kind of show it is, and then they judge it. They judge the rest of the thing by whether it conforms to their rules for what a good symphony orchestra would be. Now, maybe they're looking at a really bad symphony orchestra, but a really wonderful display of narcissism, but they just put it in the wrong category and are judging it the wrong way. They want it to conform to some rules. So if you can create a jump cut that says, "You know what, I'm not going to let you know where to go or how far to jump"—because people jump to the punch line or to the next thing you should be saying, and if you don't say—that's what I adored about Andy Kaufman when I first saw him, in a tiny club in Queens, and he was playing the bongos and sobbing—

BLVR: Right, right, I've heard about this.

LA: And I thought, I must meet this guy, and I went up to him and said, "I love what you're doing," and I became his sidekick. I followed him around for a couple of years and did his straight-man stuff in his clubs. You know, he wrote an incredible book that was never published.

BLVR: Really?

LA: Yeah—it should have been published. He came over here and read it to me on a lot of nights. I don't know what happened to this book. But in terms of expectation, he was the beyond-master of anyone that I've ever come across. He was a genius of disrupted expectation. For example, we'd go out to Coney Island to just practice situations, and we'd get on the roto-whirl where the bottom drops out, and we'd just be spinning around, so there's a minute where everyone's locked in—

BLVR: Yeah.

LA: And that's when he began to freak out: "I think we're all going to die on this ride! Look at the way the belts are done, they're really flimsy!" And everyone is like, "Who is this moron?" and second, "Maybe the belts *aren't* attached that well," and it was chaos. Or we'd go over to the test-your-strength thing, and my job was to help him make fun of the guys who were doing it. [*Doing Andy's voice*] "Ah, look at this weakling"—and everyone got so angry at that for a while. They'd go, "OK, you try it, wise guy," and so he would—and I'm supposed to, like, nag him. [Doing a whiney voice] "Get me a bunny, Annndy. I want a big bunny. Look at these guys, you're a lot stronger than they are!" And, anyway, so he would try, and it would hardly register on the scale at all, it wouldn't even get up to "Try Again, Weakling," it just went *beep* [*flatline noise*], and at that point he would demand to see the manager: "I don't know why this happened!" And everyone is like, "Oh god," and he goes way beyond what's supposed to happen.

BLVR: Did *he* talk about why he was doing what he was doing?

LA: He didn't have to. The hardest part was wrestling with him, because he would be doing these club shows where he was very abusive to women, *very* abusive: "Those broads think they are… Who do they think they are?" You know, "I will not respect a woman until she comes up here and wrestles me down," and that was my cue to come up there and wrestle him down, and I'm like on my third whiskey—I don't usually drink, but trying to get up the nerve—and he would fight, and he wasn't pretending. He'd twist my arm.

BLVR: Did you ever get really hurt?

LA: No, he wouldn't break my arm, but he would really twist it around, and I fought back. It was definitely not pretend-wrestling. He wasn't acting, and neither was I, but at the same time it was a game. There are plenty of ways you can play the game of fighting and really seem to be fighting without going for the jugular. Anyway, he was just curious about taboos. To be playing bongos and sobbing—I mean, everyone in the club

is looking at that and going, "My god, this is so embarrassing." You're not supposed to cry while you sing or play. That's our job as the audience. *We* get to have a tear roll quietly down our cheeks, but not the performer.

III. THE PARANOIA OF THE PERFORMER

BLVR: When you feel that the audience is stoic and not with you, how does that affect you? Does it affect your performance?

LA: Of course it does. Doesn't it for you? It's a challenge.

BLVR: Yeah, but there is something maybe slightly masochistic about me that almost enjoys it.

LA: Maybe you enjoy the challenge of, OK, why are they doing that, and how can I free them from that? Because it is about freeing people.

BLVR: It's funny—I mind if I feel awkward socially, at a party, but when I'm onstage in front of all these people, and they're not laughing or giving me any sense that they understand me, and they're putting me in this position where they want me to fail or they want me to melt—

LA: I think that's a little over the edge.

BLVR: Maybe [*laughs*], but that's the feeling.

LA: That's what you are adding to this mix of—

BLVR: Perhaps.

LA: I really trust audiences as having excellent taste, for the most part. I genuinely have never been in an audience where most people want that person to fail. I've never been in an audience like that, and I've never seen it as a performer. Only in my dreams, in which case they are always throwing tomatoes and going, "This is the most boring thing I've

ever seen."

BLVR: Well, I guess they're not actively wanting me to fail, but they know what's expected of them and they're not giving it—

LA: That's different than them wanting you to fail.

BLVR: I guess so.

LA: It is. It's the paranoia of the performer. You're adding a lot to it that's not there.

IV. FALLING INTO THE SKY

LA: Our dog Lolabelle died.

BLVR: Oh, I'm sorry.

LA: Yeah, what a sweetie pie. She was my best friend. When you're very physically attached to something—not so much mentally, but physically, something that is always at your knee, you know—it's very different when they evaporate. So in *The Tibetan Book of the Dead*, for forty-nine days you're in the Bardo, and it describes in a really fascinating way how you lose your senses and how your mind dissolves as you prepare for another cycle. At the end of that forty-nine-day period, you are born in another form, and, in my dog's case, what was at the end of that forty-ninth day was my birthday. I'm kind of a believer in magic numbers, in a way. So I wanted to study that particular Bardo, and then I found that that's only one of the many Bardos. The other Bardo that is happening is the Bardo that we're in right now—in which we both believe we're having a conversation in a studio by the river when, in fact, we're not.

BLVR: What are we doing?

LA: Well, I think illusion is one of the most interesting things that I've

found to think about. I don't really know how it works, but I know that in some way we are and in some way we're not having this conversation. Just look at yesterday, and what you were doing, and how important it was, and how nonexistent it is now! How dreamlike it is! Same thing with tomorrow. So where are we living? Tibetans have unbelievably fascinating answers to that. This is what I'm studying because my dog died.

BLVR: Do you have thoughts about death and what happens after death?

LA: Well, no single person who has ever lived will be able to tell you what happens. Period. Nobody's right and nobody's wrong. So what do you do, then? With my experience, and how my mind works, and what I think about—let's call it "the disappearing mind stream"—when you follow your thoughts and watch them attach to certain things, it makes certain things real and other things unreal, and you realize that this is all created by your mind.

BLVR: Yes.

LA: The main thing that attracts me to Buddhism is probably what attracts every artist to being an artist—that it's a godlike thing. You are the ultimate authority. There is no other ultimate authority. Now, for some artists that's difficult, because they want to have the art police. They want to have the critic who hands out tickets and says, "That's too loose." They want to have that person—it's very important. "Oh, I got a great review!"—they need to have that. One of the things that's improved my life enormously in the last two years is that I haven't read one single thing that's been written about me, and that is fantastic! I realize that I am a professional artist and I probably should read that stuff, but it never hit me very well. I didn't like it, and it always made me feel bad, whether it said I was fantastic—and I knew that was a lie—or whether it said that I was a complete fraud, which of course every person thinks is probably true, but you fight that idea. Either way, it would make me feel creepy, and I didn't like it, and it's been great. I didn't need it. It was

hurting me in ways that either pumped me up or pushed me down. I thought, What am I doing this for, anyway—the whole thing? And then, of course, it made me realize that I'm not doing it to please *x*, *y*, or *z* critic. I never have been. And I don't care about being famous or having a lot of people go, "She's really good." I don't care about that, so it was very freeing to realize, Well, what do I care about?

BLVR: And what did you arrive at?

LA: It's fun! Part of it is the pure fun of making things and thinking about things, and, like I said about Buddhism, being an artist is a totally godlike thing to do—and I have a god complex.

BLVR: A godplex.

LA: Yeah, a godplex! I'm thrilled by the fact that I made something out of nothing. There it is! It wasn't there before: there it is—I made it! That's pretty powerful, and that's the power that Buddhists give to every single person. There is no one judging you; you *are* the Buddha. And that's a frightening thought and a liberating thought, that you are the ultimate authority. Every single person and bird and ant has that ultimate authority—so if you can find that and appreciate that, it's a kind of a revolution. I have two brothers, identical twins—and I've noticed this with other twins as well—they have a different kind of happiness. I won't say it's so for all twins, but for my brothers—they never had to look for anyone to love them or understand them. They were born with someone who understood them perfectly and looked just like them, and they didn't have to spend their life proving themselves to anyone or working at being available or desirable or anything. And that's really a very different experience: You don't have to look to be understood. You're already understood.

BLVR: So what's their life like?

LA: They have a wonderful life. I mean, of course it's easy to idealize

other people, but they have an ease that other people don't have.

BLVR: Would you want that?

LA: I don't know. I'm not talking about whether it's a perfect way to be, it's just a different way to be. People who were born alone are defined by feelings like "Who's gonna be with me when I die? Who will ever understand me? Will I always feel so alone? Maybe if I write a book..." and you forget that that doesn't help you so much. It's like when young artists say to me, "I'm afraid to call myself an artist, because what would other people think? What would my parents think, and my friends? I mean, artists are van Gogh, they're not me." And I have to say, "You know, I hate to say this, but not many people care what you do. They care about what you do as much as you care about what they do. Think about it. Just exactly that much. You are not the center of the universe."

BLVR: A lot of your work is about interconnectedness and giving everything a voice, and how everything is vibrationally connected in some way. I was thinking about that, and about the Large Hadron Collider, and about the God particle, and in some ways your work is like "String Theory Live!" It's like a manifestation of string theory in a lot of ways, and I was thinking about the God particle and wondering, Well, what if they find it and it answers these enormous questions that we all have and struggle with and that we create art about? What if they find it and it's answered?

LA: We can get rid of all those museums and stop doing those concerts! And be proud of it and hang out. I mean, what's so great about the striving aspect of humans? Maybe when we're gods we'll be more into just chilling, and we can just appreciate instead of looking for—

BLVR: So will there be no art?

LA: Five thousand years from now—let's say we didn't find the God particle. We're still looking. I think we probably won't be making things

of the nature that we are now. I think we'll just be trying to appreciate things more. Maybe we'll design better ears. I mean, our hearing's crappy. We'll have huge ears and we'll be able to tune in to Mars, or we'll have a hundred lenses through which we can look onto the surface of Mars with our so-called "bare eyes," or look through our hands. We'll be able to be in the present more effectively.

BLVR: We'll be our own projects.

LA: Well, I don't think it's projects. We'll be able to use our senses, because art, in a way, is stuff that teaches you to use your senses. We'll still have these little Assyrian gold horses that taught humans how to appreciate form and solidity and certain types of beauty, but once you know that kind of beauty… It's just a Cageian idea of "Everything is here already." Works of art are just ways to pay attention to different things, and to appreciate what is there, and more and more art is like that. Rather than creating more stuff—"Oh, that's a nice blue!"—I mean, there are lots of nice blues already that you can focus on everywhere! So focus on that blue.

When I was four, I was a kind of sky worshipper. I would look at the sky, and I wanted to evaporate into the sky—I loved the sky. I loved looking at the trees, just because they touched the sky. I'd think, I am that—

BLVR: You *were* that. You *are* that.

LA: I was that and I am that. And we're all that. I knew that as a kid really clearly, and I never forgot that.

BLVR: See—you *are* a theoretical physicist.

LA: [*Laughs*] No, I'm a midwesterner. That was our perfect landscape: 180-degree sky. There was not some big crashing ocean or big majestic mountains, just this flat thing made of sky, and it's always been my abso-lute—my most comfort of anything—and the great thing about the sky

is that it's available, twenty-four hours, to everybody, unless you're in jail, and then you have to go to your mental sky, which is there as much as the physical one, so you can have that. If I'm confused, I just spend some time looking at the sky and, you know, falling into it. It's not a meditation that anyone taught me, it's something I've done my whole life, and liked doing, and it made me feel like nothing. I enjoy that feeling. That's what I go for—not to be here.

BLVR: Did it make you feel like nothing or everything—or is that the same thing?

LA: Same thing. It was a fabulous feeling—of lightness and happiness. There are things in your childhood where you have to say what your name is and pretend you're a person, but I'm still not really a person, and I never really had to be a person in that way, because I feel like this other way of understanding the world makes more sense to me. ✶

LUCINDA WILLIAMS

[SINGER/SONGWRITER]

"WHEN THE MUSE HITS ME, OR THE MOOD, OR WHATEVER IT IS, I GET MY GUITAR OUT AND I EMPTY IT OUT."

Reactions to Lucinda Williams's first demo,
from L.A. and Nashville, respectively:
Too country for rock
Too rock for country

L ucinda Williams's songs are like a catalog of intimate sufferings, mostly of the romantic kind—suicidal poets, unfulfilled loves, long, sad drives across the South— which she represents in meticulous detail. And there's always an edge of determination to her thoughtful, scratchy voice, whether she's singing with anger or utter desperation; you feel the energy of a torrent pushed through a pinhole.

Born in Louisiana in 1953, Williams grew up sitting in on the poetry workshops and lectures of her father, the poet Miller Williams. She spent a few decades traveling around the country, playing in bars and on the street, and developed a following before her first commercial success, Car Wheels on a Gravel Road (1998), which was her fifth album. Since that

time, she has released six more albums, has been named "America's Best Songwriter" by Time *magazine, and has been nominated for Grammy Awards in country, pop, folk, rock, and Americana.*

A few years ago, Williams married her manager, Tom Overby. The marriage took place onstage after a concert in Minneapolis. ("We had this idea of getting married, and I asked my dad, 'What do you think about that?' My dad said, 'Hank Williams got married onstage.' And I said, 'Really?' And he said, 'Yeah!' And I said, 'OK, well, that settles it.'") Since then, she has been pursuing a wider range of topics in her songs, and is currently working on a song about the execution of Texas inmate David Lee Powell, whose sentence she attempted to commute.

—Madeleine Schwartz (July/August 2012)

I. THE LEAVES FALL AND THEY FALL TO THE GROUND

THE BELIEVER: How did you figure out how to use your voice?

LUCINDA WILLIAMS: When I started out playing guitar and singing, I was about twelve, going on thirteen. The role models for me back then were the folk singers. They all had these high, really nice voices and ranges, like Judy Collins and Joan Baez, and then later, of course, Joni Mitchell and Linda Ronstadt. I decided early on that I was going to learn how to write songs really, really well, because I didn't want to have to compete as a singer. I didn't feel that it was my strong point.

It wasn't until I discovered Bobbie Gentry—she was one of the first singers who had more of a low, raspy voice, and I really connected to that—and then when I discovered some of the blues singers like Memphis Minnie and some of the other Delta blues women singers, with their scratchy, different kind of voices, that I started finding other role models to identify with. I remember being at a restaurant with Emmylou Harris one time, and a couple of other people, and there was someone singing light opera, and I turned to Emmylou and said, "Oh, listen to that range! I wish I could do that with my voice!" And she said, "That's the beauty of your own voice—you've got your own style. You

just need to learn to work with your limitations."

BLVR: What were you like as a child?

LW: I was an indoor kid, you know. I liked to stay inside. I did my share of hopscotch and cartwheels and climbing trees and that kind of thing, but for the most part I liked to do indoor stuff like drawing and writing and reading. I started writing little short stories and poems as soon as I learned to read and write. I think I was six years old. And then when I got to be eleven, twelve, and into my teens, I was just listening to records all the time, and I got a guitar. I started to take guitar lessons when I was twelve. That just became my whole world. I used to listen to records and go to music stores and look for songbooks, and I still have this big collection of songbooks. I would try to find the songs in the songbook that were on the albums, because I couldn't read music. So I would learn the words from the songbooks and learn the melody from listening to the records, and sit with my songbooks and learn songs, you know, before I started writing and all.

I started dabbling in writing when I was thirteen or something. The first song I remember writing was called "The Wind Blows." I didn't realize the double entendre at the time. It was very much like Peter, Paul, & Mary, kind of a folksy song. It was like,

The wind blows and it blows through the town and
people in the town hear it blow.
The wind blows and it blows through the town and
people in the town hear it blow.
And then:
The leaves fall and they fall to the ground.
Na na na na na na na na na…

BLVR: Were you getting a lot of encouragement?

LW: Well, you know, I was getting encouragement from my family, especially my dad and his friends and stuff. I was too young to go play in bars or anything. I was just sitting around the house. My friend and

I played. I think there was a talent contest at our school, and we got up and sang some songs. I had quite a bit of drive and ambition of my own, something that kept pushing me forward.

BLVR: What was it pushing you toward?

LW: I wanted to be able to do it for a living. That was my big dream. Not necessarily to be famous or anything. I just thought, Wouldn't it be great if I didn't have to work a day job? My dad encouraged me to go to college and get a degree, because he wanted me to have something to fall back on, because he was publishing books of poetry but he was also teaching creative writing. Anyway, I went to the University of Arkansas and started there and dropped out and went for another semester and dropped out.

My major, when I started there—I didn't choose music, I chose cultural anthropology. I don't know why. At the time, I wasn't interested in formal music training, I guess. In between semesters—this was 1971 or 1972—I went down to New Orleans, and I got offered my first regular gig at this little tavern in the French Quarter called Andy's—they were open all night. I think they opened at three and closed at three in the morning. It has since burned down. It was just for tips. Back then you could do pretty well just for tips. It was pretty easy to sustain yourself as a musician because rent was cheap.

Anyway, I was asked if I wanted to do a shift two or three nights a week—I think it was in the afternoons—from four to six. It was a real small place, right on Bourbon Street, so they had a lot of walk-ins. You'd sit on a stool, you got a couple microphones and put a jar there. And boy—I was all excited. I was just walking on the moon! This was what I wanted to do! I called my dad and said, "Dad, instead of coming back to school, I want to stay down here and do this." And he said OK. That was probably one of the big early turning points, maybe *the* turning point.

II. "THEY DIDN'T KNOW
WHAT TO DO WITH ME."

BLVR: I wonder, were you ever worried about not achieving success? It took you a long time to break into the music industry.

LW: Once I set myself on that path, that was it. I was real good at being in the right place at the right time—I followed my instincts.

I went out to L.A. late in '84. That was the next big breaking point. I didn't know anything about the music business before then. I didn't have a manager, a lawyer, a booking agent, a band. I was just playing with whoever was available, usually just me and a guitar player. When I came out to L.A., that's when I had my first exposure to the music industry and record labels and all this kind of thing. I started playing around in some places, and then a band starting forming around me and some agents started sniffing around. But they didn't know what to do with me, because, as I would find out later, I fell in the cracks between country and rock. There was no Americana, there was no alternative country. All that kind of stuff that now there's a big market for and a whole genre around—

BLVR: How were people letting you know this?

LW: I had gotten what they used to call a "development deal," where they would give you a certain amount of money to live on for six months, and you would do a demo tape. In this case it was for Sony, or for CBS Records, whatever it was called, before all the labels started merging. The head of A&R, he took an interest in me. He said, "I want to give you a development deal, and we'll pay for you to go in the studio and make a demo tape of your songs. We'll set it all up." Here I was on top of the world, thinking, Wow, here I don't have to work a day job for six months, all I have to do is write songs, and, you know, make a demo tape, and I've got a little apartment, and I thought, Boy, I've made it now! Because the whole premise was that I would go and make this demo tape, and he would then take that tape to his colleagues, and they would then decide

whether they would give me a record deal.

It was during that time that I wrote most of the songs that were on the self-titled album, like "Passionate Kisses," and "Crescent City," and "Changed the Locks." Those same songs are those that were being bandied about and listened to by different A&R guys at different record labels, so I went in and did a demo tape, and they turned me down. The reason was, they said, "At Sony records here in L.A., it's too country for rock, and so we sent it to Nashville," and Nashville said, "It's too rock for country." There you have it.

Here I had this demo tape and it was pretty good; there were some good musicians on it and everything. It started getting passed around, and I continued to play in little bars. I had one meeting with this guy from Elektra Records, and he said, "I think you need to go back to the drawing board and work on your songs some more." And I said, "Well, why's that?" And he said, "Your songs are just not formulaic enough. None of your songs have bridges." What he was talking about was the formula way of writing a song, which is verse, verse, chorus, bridge, verse, verse, chorus, or something like that, and he said, "None of your songs have bridges." Well, a lot of my songs didn't have choruses, for that matter!

Of course, I was somewhat devastated and pissed off. But I was just pissed off enough not to listen to him. He left, and I went, and right away I pulled out a Neil Young album and listened to it. I looked at it and studied some of the songs that he'd written. Bob Dylan also. And I looked at it and said, "Screw that guy! Look at these songs! This Neil Young song only has two verses; there's no bridge." I went back and reconfirmed what I already knew, and I just stayed with that. Because I knew these guys just weren't hip enough.

BLVR: You've said in the past that your career was hampered by men telling you what to do.

LW: When you say "men telling you what to do"—I mean, that's true, but what you have to remember is that the music business was and still is predominately male-dominated. It could have been a woman telling me

what to do and I wouldn't have, you know… I feel like people talk about this a lot, and I sort of get credit for being the strong woman standing up to these guys or whatever. But I don't really like giving myself so much credit. I *am* strong, but I think at the time it was more a stubbornness than anything else, and a fear—I had this abject fear of being overproduced. I did not want to sound commercial. I did not want to sound slick.

There was an event that occurred, when I did that second Folkways album, *Happy Woman Blues*. I was out in Houston with some guys I'd been working with there. We went in and cut it in, like, three days. We didn't have a drummer—just a couple of guitars and a bass. We were working with this guy—it was called SugarHill Studios—and I went back into the studio on the last day to listen to what we had. The guy who was engineering it—he was kind of a combination producer and engineer—he decided to have a drummer come in while we were all out of the studio, and he put drums on the track! Without talking to me or anyone! I absolutely just couldn't believe it. I walked in and he turned it on and said, "Listen." And I was like, "What did you do?" And he said, "I thought it needed some drums. Doesn't it sound good?" And I was like, "That's not the point!" He thought he was doing me this big favor, you know? I was completely floored. Not to mention I felt manipulated. That was my initial step into the manipulative, controlling arms of the music industry and recording. I think it put me on the defensive. I couldn't always explain what I wanted to do in the studio, but I knew what I didn't want.

III. "I PUT MY CRACKED LEATHER SHOES ON."

BLVR: You are very good at writing about sex—about liking sex and wanting it.

LW: Yes! I've always been adamant about that. I have to credit my upbringing to this. It never occurred to me not to ask for or want something, or not be able to have something, just because I was a woman.

I was encouraged to have a career—not necessarily to get married and have kids and stuff. I was surprised when people first started hearing my songs and they were kind of like, "Wow! This is so sensual." Like that song "Essence," you know? To me it was kind of a natural thing. It's probably because I grew up around poets and novelists and my dad wrote poems about everything—from a cat sleeping in a window to a car wreck he passed on the highway. I learned not to censor myself: that was one of things I learned in my apprenticeship, my creative-writing apprenticeship with my dad. I didn't study creative writing formally, but I learned as much as you could just by watching him, and sitting in on his workshops at the house, and hearing him teach, and all of that. He taught me about not censoring myself. He taught me about the economics of writing and editing. He's a great editor.

BLVR: Are you surprised when people tell you your songs are sensual or sexy? I was reading a description of one of your concerts. As soon as you started playing, everyone started making out.

LW: [Laughs] I hear that a lot, yeah. When we were in New Orleans, and it was during Jazz Fest, we did a gig at the House of Blues. This was not too long after Hurricane Katrina, so it was kind of a strange energy in the crowd. At any rate, we played "Essence." We found out afterward that this girl—she wasn't making out with someone, she was basically making out with herself, let's put it that way. She was touching herself. Somebody in the crowd called the cops, and the cops came. She must have been on some kind of drug. She must have been on Ecstasy. So anyway, that was pretty wild.

BLVR: What other works were you learning from, besides your dad's?

LW: I loved contemporary short stories and Flannery O'Connor. I ate her stuff up. I was pretty young—fifteen, sixteen. Her stuff was so descriptive. You could just see it—a picture of what she was talking about. I loved that kind of writing, that very descriptive, realistic writing. I learned that instead of just saying, "I just left this last town," why not

say the name of the town? Describe the town. Don't just say, "I put my shoes on today," say, "I put my cracked leather shoes on."

BLVR: You met Flannery O'Connor when you were little, right?

LW: I vaguely remember it. I was only four years old. She was one of my dad's mentors. We were living in Atlanta. She was in Milledgeville, Georgia. She invited my dad over, and he brought me. She lived in this big old house. She was so disciplined with her writing. She would write from eight in the morning until three in the afternoon. She would draw her shades, and if her shades were drawn that meant she wasn't finished writing and we had to sit out on the porch and wait for her to finish. Then her housekeeper came out and let us in. She raised peacocks, and they were running all over the yard. My dad says I was chasing the peacocks.

BLVR: Do you have a routine like that?

LW: I'm not disciplined like that. I collect ideas and lines. My mind is always going. I am always jotting down lines, and stream-of-consciousness stuff. And I keep everything in a folder. I have a lot of songs from the last songwriting sessions, from previous songwriting sessions, songs I wrote that I have to go back and work on some more, and then bits and pieces of lines and ideas. When the muse hits me, or the mood, or whatever it is, I get my guitar out and I empty it out. I just start going through things to see what's going to happen.

IV. LIFE DOESN'T WORK LIKE THAT

BLVR: How do you know when a song is finished?

LW: It helps to have someone else to play it for, who you trust, which in this case is my husband, Tom. But I feel like I usually know. Sometimes I know if I cry. If it's so emotional for me, that I get so far into it… It's so cathartic when I'm writing, most of the time. It's therapeutic and cathartic and everything, and I'll just be overcome with emotion and

I know right then: OK, there might be some editing that needs to be done, but I've got the crux of the song. I've got it. Because I've reached that place—I've gone inside and reached that place. Then I just need to clean it up a little bit.

BLVR: What place is that?

LW: That place where it hits me—so I know it's going to hit other people—where I reach deep down in my psyche and pull stuff out. Like if I'm writing about my mother's death or something, you know?

One time, a long time ago, this young songwriter was asking me, he said, "I want to be a songwriter. I want to do what you do. But I don't know how to do it. Tell me how you do it." And I said, "You have to be willing to dig way deep down in yourself, and go and look at those demons and monsters and things and stuff that happened. Just go down in there. Because that's where the wealth of material is." And he said, "I don't think I can do that." I'll never forget that moment. He looked at me with this look in his eyes, and he said, "I just can't do that." And I just said, "Well," you know? That was a very sad moment. I'll never forget that. He knew what I was talking about and basically he was saying, "I can't do it. I'm too afraid to do that." It had never occurred to me that someone would be too afraid of doing that.

BLVR: You never get afraid?

LW: No, god! I have to. It's my survival. You just have to get in there and deal with all that stuff, unless you just want to write about sunshine and flowers, and unrequited love.

BLVR: What do you think of the idea that artists need to suffer before they can produce good work?

LW: I think we start suffering as soon as we come out of the womb. I think that people tend to stereotype. When they think of suffering, they think of abuse—physical abuse, emotional abuse, poverty, that kind of

thing. There's different levels of suffering. I don't think that it has to do with how much money you have—if you were raised in the ghetto or the Hamptons. For me it's more about perception: self-perception and how you perceive the world.

BLVR: People associate suffering with your work, so much so that they've started distinguishing your last albums as "happy albums."

LW: That's just such a misnomer: the idea that all of a sudden, overnight, I met Tom and we got married and now I'm happy? Life doesn't work that way. Life goes on and you still—I'm glad I met Tom and I love him and, you know, but I'm still an artist, and I'm still writing about different things. I still suffer and feel pain and everything. There's a lot of other stuff to think about and write about besides unrequited love. There seems to be this misconception that because I'm not running around with a bad boyfriend, that now that I've found one person, what am I going to write about? That this is my "happy album." And it's just absolutely ludicrous! It just shows a lack of awareness. It's just so pedestrian. Believe it or not, people went so far as to suggest that I might not be able to write songs anymore because now I am married. I tried to explain again that there are other things to write about besides boy meets girl, girl meets boy, boy breaks up with girl, girl is sad. What about my mother's mental health and her whole life and my life? I carry that stuff around me like an albatross around my neck. A therapist told me one time, "You're carrying her baggage; you've got to let go."

This is the stuff. That's what keeps me going. I have to write. I've written a couple of songs about my brother who's suffered from mental illness, which I am convinced is genetic because my sister has it, too. Another therapist told me I had survivor guilt, because I am the eldest of three and I did survive, and I'll never quite know why, except that I was real close to my dad, and bonded with him and drew a lot of strength from that, and from writing.

BLVR: How will you be writing about this?

LW: I've been trying to write a song about my mother, about when she was growing up. She had quite a childhood herself. Her father was a fundamentalist Methodist preacher and chewed tobacco, and she grew up in a fairly repressive kind of environment. This was being a woman in Louisiana in those days—in the '40s, the '50s, the '30s. She had four brothers. She was emotionally, if not somewhat physically, abused. Yeah, she had a rough time. Her mother had mental illness. Passed it down to her. It got passed to my sister and my brother. Somehow I managed to survive.

BLVR: It must be difficult, then, to have to try to reach into someone else's memory instead of your own.

LW: I want to reach back into my own childhood, too. I've got a lot of songs already about myself—stories surrounding me and my beautiful loser men, you know? I want to write about children. I've gotten some songs started about children, about child abuse. I want to write about that.

V. THE SUGARCOATED COUNTRY GIRLS

BLVR: Do you think you are responsible for the creation of an Americana niche within music?

LW: I guess by default. There were other people doing it besides me, but I think the success of *Car Wheels* had a lot to do with that, probably. I remember I was living in Nashville when they were establishing this Americana Music Association, and they were trying to think of a name for it. I, along with a lot of singer-songwriters who had been doing this, were responsible. I mean, I don't want to take credit as far as the market goes. I think they were thinking, We need to find a home for this kind of music within the record industry so it doesn't fall through the cracks.

BLVR: What's your opinion of the country-music scene more generally? Do you listen to what comes out of Nashville?

LW: I don't listen to it at all. I'm not a fan. Occasionally, something will slip out that I think is pretty good. But I don't like the production, I usually don't like the songs, the whole thing. It's too slick. It's just not good country. It's not country in the sense of what I think country should be, like the old style, like Loretta Lynn and a lot of the Outlaw Country, like Waylon Jennings and Johnny Cash. It's more bottled-up and marketed in a certain way. They're aiming to a certain audience, I guess. It's just not something I want to put on and listen to at home. It's not rough enough around the edges, at least the stuff that gets successful. I've heard stuff that's come out of Nashville that's cool, but it has trouble competing with the sugarcoated, fluffy, pretty, calendar, country girls.

BLVR: Where does this problem come from?

LW: A lot these artists aren't writing their own songs. They've got all these people cowriting. They've got all these people moving to Nashville from Connecticut and Long Island, and sitting down with three or four people and writing songs. You don't have that personal, gut-experience feeling when you're listening to a song that's been written by three or four people. That's the writing machine that goes on in Nashville now. That takes away a lot of the soul. The artists I look to—Bruce Springsteen, Neil Young, Elvis Costello—those are artists who've become successful and big stars and maintained their integrity, you know? An individual writing a song about his or her experience.

I think in the world of rock music or whatever it's called—anything outside of Nashville—there's a lot more freedom within that industry to do whatever you want to do. Nashville tends to fall into this cookie-cutter syndrome. All the records are trying to sound the same. All the people coming to Nashville, who didn't know anything about country music, they're all coming to town, saying, "Hey! I'm going to write a country song! I'm going to jump on the bandwagon. There's money to be made here in this country-songwriting business." And the artists who were a little different and a little edgier—the industry didn't support them. They have a tendency not to support the music that sounds like the older country stuff. I don't know why that is.

BLVR: Right, and your work does not fall into that cookie-cutter syndrome. One of my favorite lines from one of your songs is where you're talking about seeing a guy you find attractive, and it's not on a beach or anything—it's in the supermarket buying tomatoes.

LW: And that's what you don't hear in modern-day country music. It would be on the beach.

BLVR: What's the nicest thing anyone has ever said about a song of yours?

LW: My birthday was January 26. I had all these messages in my email and on Facebook and on my fan page—these sweet, lovely messages and birthday wishes. A couple of times, speaking of my song "Sweet Old World," I had a couple of people say that they had thought about suicide and had changed their minds—that the song made them change their minds. That's pretty intense, huh? I was playing "Unsuffer Me," and I think this woman called out from the audience, "Thank you, Lucinda! That song saved my life." ✯

LESLIE FEIST

[MUSICIAN]

"I REALLY CAN'T WAIT TO BE ABLE TO STAY STILL AGAIN AND SEE WHAT HAPPENS."

Some significant spaces:
The Calgary Community Centre
A dark coach house
A guest cabin
A barn in Big Sur with the same square footage as Abbey Road

I met Leslie Feist in the men's pants section of Value Village, a huge department thrift store. She was nearing the end of a tour for her latest record, Metals, and was briefly home in Toronto. She bicycled to meet me at the store and smelled like shampoo when she arrived. I handed over one of the two coffees I was carrying, then we relocated to a beige couch that was very 1989 Miami, off in the home furnishings section. Sitting side by side under the industrial lights, our view was of ladies' blouses, and, to the left, books and records.

Feist was born in Nova Scotia the day before Valentine's Day, 1976. She moved west to Saskatchewan, then farther west to Calgary, and by fifteen she was singing in the punk band Placebo. It would be nearly ten years before she dropped her first name and became known by the sultry fight

of her last name. In the interim, she played bass in Noah's Arkweld and rhythm guitar in José Contreras's By Divine Right. She performed as Bitch Lap Lap, with a sock puppet, alongside electro-genius Peaches; she toured with Chilly Gonzales; and, in 2001, she joined Broken Social Scene, around which time she made The Red Demos *(on which you can hear streetcars going by). It formed the blueprint for the Polydor-released* Let It Die, *which was followed by* The Reminder, *then the Grammy Awards,* Sesame Street, *a duet with David Byrne, an appearance on* Saturday Night Live, *a stage dive in a blue sequined jumpsuit, an iPod commercial—and ubiquity.*

Then, in 2009, she lifted her drawbridge and disappeared from the public eye for two years, reemerging in 2011 with Metals. *The title tells you everything; it is of the natural world, and it is incandescent. It is also tempestuous, singular, and elegiac. Part autobiography, part incitement to rebellion, it is sung by a woman who has a ghost in her voice, the same way Nina and Billie did. Accompanied by the heavyweight swagger of her guitar, her songs shake you out of your sleepwalk.*

—Claudia Dey (July/August 2013)

I. A PHANTOM OF THE OPERA NECKLACE

THE BELIEVER: Do you have a certain strategy when you come here, like a certain section you go to first?

LESLIE FEIST: It's funny, because I was here with my friend yesterday. We're the same size, and she would get to stuff before me and I'd be like, "How did you find those?" And she said, "You've got to go straight to the pants if you want the pants; if you want the shoes, you've got to go straight to the shoes."

BLVR: Can we track that image to making art? You've got your shopping cart and you're making all kinds of choices, and then you take those choices into a room where you're alone with a mirror and you try them on and see if they fit, and you discard some, and others you keep and reconfigure. Is it the same thing?

LF: Yeah, it's rifling and then sculpting it down to your ultimate choice that'll fit in your bike basket. [*Laughter*]

BLVR: Can I ask you to describe your teenage bedroom?

LF: I remember moving the furniture a lot. You know how you could give yourself that clean slate when you put the bed in a different corner? You have a domain that's yours and you just want to keep reinventing it and figuring out the most adult association of furniture? I remember the day I got an old armchair, the kind that would be in front of a fireplace in a novel. It felt really grown-up. It was threadbare—kind of an adult affectation to this teen bedroom.

BLVR: Did it reflect your interior life, this chair out of—

LF: Edgar Allan Poe? Yes.

BLVR: I was reading about this photographer who takes pictures of teenagers, and she said that because they're still developing she thinks of them as abstracts.

LF: Ah! I'm trying to think of what else was in there…

BLVR: Posters?

LF: Yeah, I had posters of Calgary gigs. I was pretty unaware of culture outside my own tiny sphere. Nobody ever came to Calgary, and if they did, I didn't go to the shows, because they weren't at the Community Centre, so there were a lot of photocopied posters. I was equally into *Phantom of the Opera*, and had the pewter mask necklace that my mom got me. I was just picking and choosing like a little magpie: twenty-hole, cherry-red Docs, and five layers of ripped fishnets, and then my *Phantom of the Opera* necklace because I still really liked it.

BLVR: Without irony.

LF: It fully brought me joy. I love this French expression, *premier degré*. It means "top layer," hyper-mainstream culture, and there is no shame in loving it.

BLVR: What was it about *Phantom*?

LF: I don't know. I was just flicking through the TV at the hotel the other day and there was the live London stage show, and it's atrocious! It's like *Beauty and the Beast*.

BLVR: Though there is such a draw to that story: Jane Birkin and Serge Gainsbourg, Gwendolyn MacEwen and Milton Acorn. I'm fascinated by that kind of parasitic exchange: he wants her youth, she wants his experience.

LF: I should show you this book, *Shapely Ankle Preferr'd*. It has personal ads from the Elizabethan and Victorian times. The language is so beautiful. Then it gets into romanticized love, maybe in the 1800s or late 1700s, when it's the beginning of it not just being a business deal. And men are putting in things like, "A genteel visage would be preferred and a calm mind and a refined education." Women want someone they can sit by the fire and talk with. One of them says deformities will not be excluded from consideration.

BLVR: How much has that changed?

LF: Well, I don't know. I don't think much. But the language we use to describe ourselves has changed so much.

II. A TINY TAPE DECK WITH A HANDLE

LF: Do you remember the first time you held a cell phone?

BLVR: It was like a shoe phone!

LF: I remember the exact moment. I was in Paris. I phoned my mom and I was like, "I'm standing in a square and there is nothing attached to me right now and I'm talking to you." This was long after cell phones were pretty normal for most people.

BLVR: I still can't believe we write to each other on telephones. Did you consciously resist the technology?

LF: I think part of me did, in the same way that I don't want to be involved in Facebook or Twitter. Part of me did resist the modern trappings that everyone in a split second decided to absorb into their life. What an unhealthy direction it pushes my mind, when I am too associated with all of that stuff. But I love coming to Value Village, because you get reminded of the dead technology. Endless shelves of VHS tapes... who is deciding to change the technologies? It's not only that you need to buy a new device to play music. It's also the way you're associating with your friends, the way you're valuing your communication with people. It's these invisible mental tools to live your life by. Facebook and MySpace, all that stuff—this place is a physical reminder of life before that.

BLVR: How do you like to listen to music?

LF: I travel a lot, so it makes sense to have a laptop, but my keyboard player, Brian [LeBarton], recently brought out a little tiny tape deck—the kind with the handle, and batteries in it, and there must be a little shoebox of tapes on the bus. Every time that thing is on, we can have a conversation, and it's not another level of blast coming from every direction. I put old music on it because it sounds like it belongs there.

BLVR: And you're listening to the tape right through.

LF: And then flipping the tape. Brian's and my main goal with the band was to not get bored, to not end up photocopying a photocopy, because then everything becomes pixels. You play two hundred shows and you

just don't hear anything anymore. That's what happened to me the last time on tour; it was just repetition.

BLVR: Like that John Baldessari homework: "I will not make any more boring art."

LF: Who's that?

BLVR: This American conceptual artist, this pop-art guy who looks like an unburdened Hemingway; he put the bright dots on people's faces? He had three tips for art-making. One is: talent is cheap; the second one is: you have to be in the right place at the right time; and the third one, which I love, is: you have to be possessed—which you cannot will.

LF: I love this guy.

III. A CRINOLINE

BLVR: I'm curious to know how you negotiate shyness. Are you shy?

LF: Yeah.

BLVR: How do you deal with that? Do you send out your stunt double?

LF: There is probably some Jekyll and Hyde kind of thing that has occurred in how I deal with that stuff, because I'm not comfortable with it. My sound guy, Brenndan McGuire, was saying that he was working at a bar on Yonge Street [in Toronto] twenty years ago, and Céline Dion was playing, and this was before she had taken off, and she changed outfits between every song. She would sing one song, leave the stage, change her outfit—and it would happen instantly. The band would start the next song and then she'd come back out and be in another outfit. He remembered her hair was up and then down. Even when she was slogging on Yonge Street at some bar, that was as important to her as her singing: changing outfits.

BLVR: That was her stagecraft.

LF: You've got to be groomed to be able to continue in that world the way she does. For years I'd be gazing at my shoes, wondering, How did I get up on this stage? I was playing shows since I was fifteen and it was basically hardcore music, and I was standing there barefoot—ripped tights, nose rings all over—then the next week I'd be into henna and do a hair wrap and put my twenty-holes on and a crinoline. I remember thinking, If I ever wear jeans, that's just such a cop-out; jeans are just this sterile common denominator. Meanwhile, I live in jeans now. [*Laughs*] But there was no development of the external, the way things looked. It was really about playing in the band.

BLVR: Did that make it harder?

LF: Gonzo [collaborator Gonzales] has a quote that served us really well when we had both moved to Paris and it was just overwhelming. I didn't speak French, even—I would go sit at dinner, and I can't understand anybody and everybody is chain-smoking, you know, just sort of not finding my way in—and he would be like: "Put your body in the right place, the place you know is the right place to be, and the rest of it will happen. It will just unfold the way it is supposed to." And I would always be like, "But I don't want to be here." And then you kick in, and you know where the right place is.

IV. A TABLE WITH PERFORATIONS
AND LINES

BLVR: I'm interested in this idea of contrariness and whether happiness is the enemy of art.

LF: That seems to play out in my life. [*Laughs*] There are some happy songs out there, but aren't the bulk of songs about some state of desire and the thing you're not sure about, the horizon? Happy songs are sort of Jack Johnson and not as compelling. Just everything feeling fine. That's

what's on the radio.

BLVR: Yes. I want to talk to you about your record. I had so many responses to it. One was that this is the sound of post-claustrophobia, post-containment. It has this fury to it, but also this lament, this elegy. I pictured you in a headdress and a Victorian morning coat, cavalry behind you, and the Shakers dancing to encounter their god. And that Patti Smith lapel pin, focus thine anarchy. I thought, This is her anarchy focused.

LF: Oh my god, I just got—look at that [*holds out her arm to show goose bumps*]. Those are beautiful descriptions. I wrote the album alone in a little coach house behind my apartment that I soundproofed as best I could, because I have a real thing about people not hearing a peep. I can see now how I developed doing what I do from not wanting my room-mates to hear me. Back in the day when I lived with Peaches, I mean, nobody cared but me, nobody gave a shit—

BLVR: But it's like keeping the door to the darkroom closed.

LF: It keeps it potent somehow. Extreme privacy—it's like pitch black. I really need to be alone and in a really private place away from my life. I read an interview with Jonathan Franzen who said that when he wrote *Freedom* he got the most bland office space in an office building where you can just rent an office with buzzing fluorescent strip lighting and a window looking across at a parking lot or a brick wall, no view, and one of those gross, everywhere desks, and he brought in an old clunky laptop and he put an Ethernet cable in it, glued it in, and then cut the cable so it was basically just his mind and an empty room.

BLVR: You have to be a true hermit to create such an unmagical space for yourself—

LF: It's true! I love authors and that terrifying privacy they need, and that terrifying silence, and then they make these multidimensional people

and they all relate; it's like life-bringers. How do they do that? A song is kind of easy in the sense that you don't have to be responsible to a character and to its entire story arc; a song can be about a split second in time. But in a novel you have to guide people through, and when it's interlaced, like Ondaatje or Franzen or Steinbeck—like any proper, true author—I end up feeling like they're magicians, truly gods, because they are creating these worlds that I get to go and live in.

BLVR: I think it works both ways. Writers look at musicians and at how music is made—

LF: [*Distracted by a shelving staffer*] That's crazy!

BLVR: What?

LF: Oh my god, look, it's one of my albums, getting put in the [house-wares section]… That is fucking… it belongs here, it's the remix record. [*Laughter*]

BLVR: Can you identify the point when the creating began? You were in your dark coach house with no light and no outgoing or incoming sound…

LF: Yeah. I would bring my laptop out there to work. I put it on this old sewing table I found and really liked—you get so superstitious when you're laying groundwork. Everything means something, every postcard I put up in front of the desk. The table had all these perforations in it, and lines. I liked that it had been used by a craftsman who had made tangible objects, because you feel like you're picking strands of smoke out of the air. How can you keep track of the melodies you're working on? So yes, the tangibility of the table where things had been made… it was the only time in my life I've ever written something all at once, too. I mean, it all came in a few months.

BLVR: In a kind of spell or mania?

LF: It was. I always can't wait for the touring to be over because writing's the most fun part—not even fun, but the hyper-private art is the writing of it, and I don't write a lot, and every time I think it's going to be the last time, so there's this sort of thrill when there's something there after I figured there wouldn't be. Then you've got to go out there and play it for a year, and some of that specialness wears off and I forget that it came from a proper, potent well in me. In terms of me caring and standing next to the thing I made, I am happy to do that. It's just that your arms go a little numb holding it up. And then I really can't wait to be able to stay still again and see what happens, and maybe nothing will.

But yeah. I got a little contrary. I knew there would be an expectation for another record. I think, in retrospect, I can say that I was not well. I had just been living in a blur for so many years at that point, and my North Star had been completely obscured—like I was moving toward something, but I no longer knew where. It was like the scales were tipping, where I was maintaining the external shit just by repetition—things like the Grammys or TV shows or whatever. You just start to maintain the outside. And all you're dying for is an apricot or something new, something fresh, something simple and like nature. Something that was born off a tree, not sent through science to become food again… So I landed off the tour, didn't pick up the guitar. I wanted to leave it completely so I could come back on the right terms.

In this case, there were some really good confines; after taking two years away, I was in a total rush to get it all going again. I was a bit afraid that the momentum would get lost. The writing happened relatively quickly, starting in October, maybe September. Then I went to Mexico City and I remember frantically writing one of my managers, begging them to help me back up my computer some way out in the ether world. [*Laughter*] I was terrified it might get stolen or lost—everything was on there—and I didn't have it backed up anywhere. So the thing is: on the Day of the Dead in Mexico City, I was aware that I had a record. Gonzo and Mocky came to my place up north on January 1, 2011. They flew in, drove up, and we jammed and arranged the whole record in my guest cabin for a week—

BLVR: Wow.

LF: Crackling fire, making meals, walking through the snow to the house and back out to this cabin. We went to Big Sur a month later, and it was only a month later because it was like, we have to find a place to record and make this happen fast. Everyone around me was like, "Can you fucking give us some more notice next time, please?" But there was this sense of, what if I lose it? It's like a ball of mercury. How is this tangible? It was so invisible three months ago.

BLVR: Do you get superstitious about it?

LF: Yeah. Or like I was going to lose my—like you said—what did you say? You have to be possessed—

BLVR: And it's something you can't will.

LF: I was really possessed, and I think I was just scared that I was going to somehow lose my will. That can happen. You can't tell yourself to stay in love with someone. You either stay in love with them or you stay admiring them or something clicks and then you don't, and you lose that invisible engine of desire toward somebody. The same thing is true of a record. What if I lose my magnetic protector feeling to this ball of mercury? It's just totally… you have to be fascinated.

V. 1970s SCIENCE BOOKS

BLVR: Do you find more of a kinship with the natural world than with the human one?

LF: I think so, because there's broader strokes out there, less nuance. I have this collection of old 1970s science books. There's a geological explanation in one of why volcanoes occur, what is happening under the surface when they explode. And the other day I was like, Did I fucking get the album title from this science book that I've had in my house

forever? It's called *Noble Metals*.

BLVR: Did you have the title before the album?

LF: After. It was late-breaking. I had a lot of not-as-good titles, but there's no clarity about a title until the very end. *Metals*. It was like how I chose Big Sur. I knew what the songs were about and who I was going to be working with. Gonzales and Mocky being the kingpins, my brothers-in-arms, old witnesses, and I knew the expansion was going to happen. "The Bad in Each Other" was going to be a war cry. I was talking to the guys and I was like, "This has to be like they're coming—there's an army bigger than you've ever seen that is about to come over the rise of the hill, and you're in your fortress, and you're playing, and someone's going [*makes a trumpet noise*] because they're harking to call their brothers out to fight for their lives. It has to be that sense of massive life or death."

I worked with the euphonium and bass saxophone and bari sax and bass clarinet, all with a flag hanging off the end, all these fairy-tale-esque instruments. It was exciting to dream up. When I was in my coach house, all I had was a table and a floor tom and a mallet and one guitar and one Silvertone amp.

At the end of "Undiscovered First"—even when I was alone in that room—I wanted there to be eighty women speaking as one, everyone claiming these words as their own and asking the same rhetorical question: is this the way to live for me to be yours? Is this the way to live? Is it wrong to want more?

BLVR: Does different work come out of different landscapes? You've worked in a manor house in France, and now you're recording in a studio in California on a cliff with goats.

LF: It was a barn in Big Sur. Robbie [Lackritz], my manager, says it was the exact square footage as Abbey Road, even the ceiling height versus width and length. But we're out in this goat pasture on the cliffs of Big Sur. Nothing had been made there before except sculptures and paintings. I thought that was so beautiful. It was a clean slate. With albums,

you want to evoke a feeling, and maybe have it be homogeneous enough that you have a story arc to it. I'm kind of an album-liker. You can like a song and it can be plucked out of a record and it exists still, but how beautiful is it when it's this peacock fan of everything fitting together like storm fronts, the whole story of a storm: you smell the air change and then you're in the thick of it and then it slows down and then everything smells different, and that's a lot of things happening, but it's basically a rainstorm. If an album can have that to it, where a lot of different things happen, and it's capped by some event, or mood or feeling...

Steinbeck, the way he begins so many of his chapters is he pulls way back, and he tells you about the one-hundred-mile-long valley, and it reaches those mountains, and then it reaches the ocean, and then he zooms in and talks about one bee on one blade of grass. That area around Big Sur is where he set so many of his stories. I've read everything he ever wrote so I really felt like I'd smelled it and seen it and tasted it and felt the winter and felt the summer. I was joking with the band. They were like, "No record has ever been made out here," and I was like, "That's not true. Steinbeck made, like, eighty records out here." [*Laughs*] He did the same thing we were trying to do.

BLVR: So when do you call it as being done? When I'm writing, I have a sense of the beginning and I have a sense of the middle; the middle is so hard to articulate, but I felt like the title of the documentary about you and your collaborators does it: *Look at What the Light Did Now*. That film was like the marginalia in illuminated manuscripts—

LF: Like the marginalia?

BLVR: How monks would transcribe illuminated manuscripts for hours and hours, and they wrote in the margins about the process—though their remarks were plaintive, like, "Oh, my hand."

LF: [*Laughs*] Oh my god, that's great.

BLVR: Or, "Deliver me from writing."

LF: My dad is an abstract expressionist, and he's been painting these spokes my entire life—just radiating colors out of the center of the canvas. My whole life, these spokes. With the repetition of anything, you're not looking at the thing anymore, you're looking at the variations on the theme. So my dad's been engaged in the variations on the theme for a really long time—color, light, balance, thickness, thinness—and the spoke has disappeared for him. When we're performing, the songs are like the spokes, because I feel the variations the band puts into the repetition. That's what I've gotten fascinated with.

BLVR: This is the thing that can't happen in publishing. You make a book and it's a fixed object, whereas when you tour a record, you can scissor it up the middle and find other iterations.

LF: Absolutely. My manager, who has more perspective on things than I do, is like, "You might want to play one of the old songs from *The Reminder* in a way people might recognize," because they have all been ripped apart at the seams and put back together. And I'm saying, "The songs got invited to the *Metals* party. If any of the songs from the past made it through the door at the *Metals* party, they have to figure out a way to have something to talk about with those songs." Not all the songs have anything to say to *Metals*. The song "1234" doesn't have anything to say to *Metals*. *Metals* would probably be like, "Come on in, wanna hang?" And "1234" is like, "I don't belong, I'm not cool enough."

That song is almost like a yearbook photo, in that it's a really legitimate era. It felt revolutionarily melodic and simple in kind of a punk way to me. It didn't feel like pop music to me. It felt like this laser-beam lasso, like a weird weapon on a set list. When I wrote it, it was so alien to where I came from previously. I was in rock bands and I was looking for the long way around. I always want to find my own circuitous terrain. I don't want there to be simplicity. It was kind of like the teenage jeans; I don't want to go straight from point A to point B. Even when I'd walk to school, you eventually see the grass that you have tromped in your shortcut, and I thought, That's my grass, that's my shortcut, and then I would make a new one.

What happened to "1234" was not the way I ever saw it playing out, and I'm grateful in a practical, I-am-my-grandmother's-granddaughter-just-don't-be-ungrateful sense, but on the other hand, it oversimplified what I had been doing all those years. So, in a way, it doesn't come to the party now. I have probably played a hundred shows, with an average of three thousand people a night, two thousand people. So twenty thousand people. Not one person has yelled "1234" out during the show. In all these countries, all over the world. It feels like everyone is on the same plot as me.

BLVR: So did you feel like this new record ended up being—like, in terms of lovers, one is always the antidote to the last. You're with someone who is buttoned up, and then you're with Rasputin—

LF: Totally. That's my path, too.

BLVR: So is *Metals* the antidote to *The Reminder*?

LF: Not the record, because the record I made in much the same rapture as the last one, where I felt pure and I belonged in it and it belonged in my life. The whole thing felt like—

BLVR: —the possession you can't will.

LF: Yeah, and it was made in the same state. Totally going to do that again. ✶

CONTRIBUTORS

Brian J. Barr lives in Seattle, Washington. His work has appeared in the *Oxford American*, *Tin House*, *Architectural Record*, and the *New York Times*.

When Andy Beta last spoke with Alan Bishop, they discussed the hardships of travel through India and Egypt (Cairo translates as Al Qahira: "the conqueror") and the idea that in traversing a foreign land, one must "submit to its vast and dizzying realities."

Carrie Brownstein is the co-creator, co-writer, and co-star of IFC's *Portlandia*, as well as a former vocalist and guitarist for Sleater-Kinney and current vocalist and guitarist for Wild Flag. Her writing has appeared in the *New York Times*, the *Believer*, *Slate*, and numerous anthologies on music and culture.

Judy Budnitz is the author of one novel and two story collections, and is currently at work on Untitled Book #4. She lives in the Bay Area with one husband and two sons.

Greg Buium has written about music for the *Globe and Mail*, *DownBeat*, and the *Wire*, among other publications. His recent documentary on digital culture, *Our Fractured Story*, is available online at *CBC.ca*. He lives in Vancouver.

Brandon Bussolini writes for *XLR8R*, *Little White Earbuds*, *Dusted*, and others. He lives in San Francisco.

Jon Caramanica is a pop music critic at the *New York Times*.

Joshua Clover is the author of two books of poetry (most recently *The Totality for Kids*, University of California) and two of cultural history (most recently, *1989: Bob Dylan Didn't Have This to Sing About*). His current work concerns crisis and transformation of the world-system, in its broadest and most local manifestations.

Alex V. Cook writes about music and food, teaches journalism at LSU's Manship School of Mass Communications and blogs furiously at *alexvcook.com*. His most recent book is *Louisiana Saturday Night: Looking for A Good Time in South Louisiana's Juke Joints, Honky Tonks and Dance Halls;* his next is about hole-in-the-wall restaurants, both for LSU Press.

T Cooper is the author of three novels, including *The Beaufort Diaries* and *Lipshitz Six, or Two Angry Blondes*. He is also co-author of a new young-adult novel series entitled *Changers*. Cooper's work has appeared in the *New Yorker,* the *New York Times, One Story,* and *Bomb,* among other publications.

Matthew Derby is the author of *Super Flat Times* and a contributing author of *The Silent History,* the first major exploratory, interactive novel designed specifically for the iPad and iPhone. His writing has appeared in *McSweeney's, Conjunctions,* and *Unstuck* magazine.

Claudia Dey has written plays and the novel *Stunt*. She also makes dresses under the label Horses Atelier.

Jancee Dunn is the author of *But Enough About Me, Don't You Forget About Me,* and *Why is My Mother Getting A Tattoo?,* and co-author of *Cyndi Lauper: A Memoir*. She has written for *Rolling Stone,* the *New York Times, Vogue, GQ,* and *O: The Oprah Magazine.*

Dave Eggers is the author of seven books, most recently *The Circle*. Eggers is the founder and editor of McSweeney's, an independent publishing house based in San Francisco, and co-founder of 826 Valencia, a nonprofit writing and tutoring center for youth.

Joshua Jelly-Schapiro is a geographer and writer living in California and the Caribbean.

Miranda July is a writer, filmmaker and artist living in Los Angeles.

Maura Kelly's essays have appeared in the *New York Observer*, *Salon*, *Glamour*, the *Washington Post*, and other publications.

Patrick Knowles is a writer, editor, and musician currently living in Oakland, California. His music writing has appeared in *SOMA Magazine*, *SF Weekly*, and the *San Francisco Chronicle*.

Josh Kun is the author of *Audiotopia: Music, Race, and America* (University of California Press) and a professor of English at UC Riverside.

Sean Michaels is the founder of the music-blog *Said the Gramophone*. His debut novel, *Us Conductors*, will be published by Tin House in June 2014; it's the story of Lev Termen, inventor of the theremin, and Clara Rockmore, its greatest player. Sean lives in Montreal.

Patton Oswalt is a voracious reader, eater, sleeper, and internet user. He lives in Hollywood, on the western shore of North America.

Jim Roll is a songwriter and recording artist from Ypsilanti, Michigan. He has released three albums. The most recent, *Inhabiting the Ball*, features songs he co-wrote with authors Denis Johnson and Rick Moody.

Douglas Rushkoff is the author of *Present Shock: When Everything Happens Now*, as well as *Life Inc*, *Program or Be Programmed*, and *Media Virus*. His fiction includes *Ecstasy Club* and the graphic novels *Testament* and *A.D.D.*

Linda Saetre runs her own film production company, Saetre Film. She focuses on development and production. Saetre has worked in international acquisitions, sales, promotion, and productions of films. Notable collaborations include the Oscar-winning *March of the Penguins* and Cannes selection *Tarnation*.

Madeleine Schwartz has written for the *New Yorker* online and *Dissent Magazine*, among other publications. She lives in New York City.

Ross Simonini has written for and served as interviews editor at the *Believer* since 2006. He is the executive producer of the *Believer's* KCRW radio show, *The Organist,* and is a founding member of the band NewVillager.

Amanda Stern is the author of the novel *The Long Haul,* and twelve novels for children. Her work has been widely published. In 2003 she founded the Happy Ending Music and Reading Series, an event made popular by guest artists such as Laurie Anderson and Vampire Weekend.

Touré is the author of five books, including *I Would Die 4 U: Why Prince Became an Icon* and *Who's Afraid of Post-Blackness? What It Means to Be Black Now.* He is the co-host of MSNBC's show *The Cycle.* He is also the host of *HipHop Shop* and *On the Record,* and is a professor at NYU's Clive Davis Institute of Recorded Music.

Vendela Vida is the author of four books, including the novels *Let the Northern Lights Erase Your Name* and *The Lovers.* She's a founding editor of the *Believer,* the editor of *The Believer Book of Writers Talking to Writers,* and a co-editor of *Always Apprentices.*

Jonathan Zwickel lives in Seattle with his dog, Edison. He's the senior editor of *City Arts Magazine* and author of *Beastie Boys: A Musical Biography,* published in 2011 by Greenwood Press. During the course of this interview he rode Weird Al's Segway.

ACKNOWLEDGMENTS

Many thanks to the *Believer* staff—a more dedicated, passionate, and bizarre group can barely be imagined. Thanks as well to the kind people at McSweeney's, especially Dan McKinley, whose cover design enfolds these pages, and Jordan Karnes and Sam Riley, who keep our subscribers supplied with their allotted issues. We remain deeply grateful to Charles Burns, whose brilliant portraits have graced our covers for ten years; may they continue to lure new subscribers for another ten.

We are, as always, indebted to all the *Believer* interns past and present.

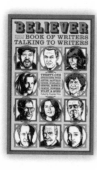

TEN YEARS IN THE TUB
A DECADE SOAKING IN GREAT BOOKS
by Nick Hornby

"How often do you begin reading a book that makes you—immediately, urgently, desperately—want to read more books? Collecting ten years of Hornby's wonderful 'Stuff I've Been Reading' column in the *Believer*, this is the next best thing to having a real-live Hornby to urge you on." (*Booklist*, starred review)

SONGBOOK
by Nick Hornby

This deluxe limited edition of Hornby's National Book Critic's Circle Award–nominated book is an intimate, Marcel Dzama–illustrated ode to the lasting joys of pop music. "A small, singular, delightful collection [about] the power of songs to bind people culturally and to reach deeply into the human spirit, bending the heart into new shapes with new potential." —the *New York Times Book Review*

MAGIC HOURS
by Tom Bissell

"Every one of Bissell's pieces is like some great, transfixing · documentary you stumble on while channel-surfing late at night—something you feel, in that moment, a kind of gratitude toward for redeeming your sleeplessness. Considered alongside his fiction, this new collection makes clear that Tom Bissell is one of our most interesting and ambitious writers." —John Jeremiah Sullivan, author of *Pulphead*

NOT INCLUDED IN THIS VOLUME:
INTERVIEWS WITH
WALLACE SHAWN
NORA EPHRON
JUDY BLUME
LENA DUNHAM
AND SCORES OF ILLUSTRIOUS OTHERS

Published nine times a year, every issue of the *Believer* contains conversations and interviews with people like Maira Kalman, Steve Carell, Rashida Jones, and Neko Case. Each issue also features columns by Nick Hornby, Daniel Handler, Greil Marcus, and Lawrence Weschler, plus terrific essays by writers like Rachel Kushner, Tom Bissell, Jonathan Lethem, Susan Straight, and Geoff Dyer. Subscribe with the form below and, in addition to a special discount, you'll get our latest collection of interviews with writers—*Always Apprentices*—free of charge!

visit us online at believermag.com
or fill out the form below for a special discount.

• •

Please send me one year (9 issues) of the Believer *for just $40—*
a $5 discount from the website!—and a copy of Always Apprentices.

NAME: _____ STREET ADDRESS: _____

CITY: _____ STATE: _____ ZIP: _____

EMAIL: _____ PHONE: _____

CREDIT CARD #: _____ EXP. DATE: _____ CVV: _____

Please make check or money orders out to the *Believer.*
CLIP AND MAIL TO: The *Believer*, 849 Valencia St., San Francisco, CA 94110